£9.50

Political Prints
in the
Age of Hogarth

HERBERT M. ATHERTON

Political Prints
in the
Age of Hogarth

A Study of the
Ideographic Representation
of Politics

CLARENDON PRESS · OXFORD

1974

Oxford University Press, Ely House, London W.1

GLASGOW NEW YORK TORONTO MELBOURNE WELLINGTON
CAPE TOWN IBADAN NAIROBI DAR ES SALAAM LUSAKA ADDIS ABABA
DELHI BOMBAY CALCUTTA MADRAS KARACHI LAHORE DACCA
KUALA LUMPUR SINGAPORE HONG KONG TOKYO

ISBN 0 19 827188 3

PRINTED IN GREAT BRITAIN
BY WILLIAM CLOWES & SONS, LIMITED
LONDON, BECCLES AND COLCHESTER

Preface

Except in the few instances when great artists such as Honoré Daumier or Goya were driven to take up graphic journalism, the professional art historian has had little occasion to busy himself with the vast mass of ephemeral propaganda prints, broadsheets, and cartoons which were produced in ever-increasing volume from the sixteenth century onward. ˣ He is quite happy to leave these puzzling and often ugly images to the historian who may know how to unriddle their recondite allusions to long-forgotten issues and events. But historians in their turn usually think they have more important and more relevant documents to study in the state papers and speeches of a period, and generally they leave the old cartoons to the compilers of popular illustrated histories where these crude and often enigmatic scrawls jostle uneasily with portraits, maps, and pictures of pageantries and assassinations.

> E. H. GOMBRICH, *Meditations on a Hobby Horse*
> *and Other Essays on the Theory of Art.*

This is a study of political prints in the eighteenth century. In modern parlance they would be called 'cartoons', but this word is anachronistic when used to describe these curious artistic pieces of the Georgian era. The word 'cartoon' did not mean a humorous illustration until the middle of the nineteenth century, when it became associated with comic pictures in newspapers and magazines. 'Print' is a generic word, but perhaps most adaptable in a discussion of the graphic representation of politics in the eighteenth century.

Satiric prints have for a long time resided in a kind of 'no man's land' of scholarship: unclaimed and unsolicited by any discipline, though relevant to the interests of many. To be sure, the work of Hogarth has attracted students of art, as well as antiquaries and collectors of prints. Gillray is once again in fashion. Many books have examined the techniques and psychology of caricature. But the bulk of this material, much of it conceived in anonymity, much of inferior artistic quality, has not attached itself to the province of

the art historian. Nor have students of literature attempted any analysis, even though prints share much in common with literary satire.

Most strange of all, perhaps, has been neglect by the historian. Printselling belongs to the history of eighteenth-century journalism; the development of graphic satire and propaganda is not irrelevant to the history of freedom of the press. More important, the prints offer a large corpus of source material for the study of eighteenth-century politics. With their quantity and diversity, if not uniformly good quality, the prints offer an extensive commentary on the political life of the age. They are simple artifacts. They pretend to no great genius of invention or depth of meaning. But they are an interesting aspect of a much neglected subject: public opinion. The prints elucidate in a colourful medium ideas and habits of mind that were a basic part of the political folklore. They are strange remnants of a world that was as much fun and as exciting as it was serious, as vibrant and audacious as it was pretentious.

The golden age of English graphic satire came in the last quarter of the eighteenth century, in the individual achievements of Bunbury, Sayers, Rowlandson, and Gillray. But the middle decades of the century were the 'seed time' of the later flowering: the period during which the English satirical print established itself as a distinct genre. This period of development, except for the contributions of Hogarth, has long needed further study.

Until the 1720s Dutch prints dominated the English political scene, as they had since the Revolution. From the 1730s an indigenous production began. A native institution was fully established at the accession of George III. Printshops existed all over London; a large number of draughtsmen and engravers— some foreign-born, some English—became active in the trade. The old tradition of 'hieroglyphic' prints remained the prevailing style, though caricature and personal satire were gradually modifying it.

The development of the political print was, in part, the result of the emergence of a constitutional Opposition, committed more to the task of persuasion than to violence and conspiracy. The prints shared with Opposition pamphlets a common stock of ideas, themes, and a mythology. The salient features of political rhetoric remained fairly settled throughout the early and middle

decades of the century, until the tone of controversy and the nature of issues began to change in the 1760s.

I realize that the title, 'Political Prints in the Age of Hogarth', may be misleading to some. This book is not about Hogarth. Indeed, he receives little attention. This is not to deny Hogarth's great importance in the history of English graphic satire—or political satire, for that matter. Though he liked to believe himself above the pedestrian traffic of factional strife, Hogarth did produce several political prints, or prints that are, at any rate, of interest to the political historian. His work is, however, a much-covered subject. Other artists engaged in the creation of political satires— George Bickham, Charles Mosley, the Darlys, and George Townshend—have received less attention. I have tried to make up for that neglect here.

The 'Age of Hogarth' is, I think, convenient and appropriate. Hogarth's career roughly coincides with the period with which the book is concerned: 1727–63. His success symbolizes, but does not alone represent, English graphic satire's coming of age. The age was his, but it included the work of others.

I, as a historian of politics, realize that scholars in art and literature would approach the subject in ways different from my own. The questions they might ask, the knowledge they would draw upon, their methods of analysis certainly must follow other courses. The subject is novel; I have felt it necessary to consider its artistic and, to a less extent, its literary aspects. But these happen to be subsidiary to my main theme: political prints as an 'ideographic representation of politics'.

I wish to thank the Trustees of the British Museum, The Pierpont Morgan Library, and Mr. Wilmarth S. Lewis, Esq., of the Lewis Walpole Library, for allowing me to use illustrations of prints in their respective collections. The wax relief of the Duke of Newcastle is reproduced by courtesy of Mrs. Jean Meade-Fetherstonhaugh. Plate 1 is from the original in the Map Collection of the Yale University Library.

With kind permission I have consulted and quoted from a variety of source materials in the Reading Room, Department of Manuscripts, and Department of Prints & Drawings in the British Museum; the Beinecke Rare Book Library at Yale, and the Archives des Affaires Etrangères, Quai d'Orsay, Paris.

Unpublished Crown-copyright material has been reproduced by permission of the Controller of H.M. Stationery Office. I am grateful to Mr. Lewis for making the Library at Farmington, Connecticut, available to me over a period of several years. With pleasure I express my appreciation to Mrs. Richard Butterfield, curator of the prints in the Lewis Walpole Library. To her generous assistance I am much indebted.

I should also like to thank the Seventh Marquess Townshend of Raynham for allowing me to examine his volume of Townshend caricatures. A substantial part of the discussion of George Townshend in Chapter two appeared previously as an article in *Eighteenth-Century Studies*. I thank the Regents of the University of California for allowing me to reprint portions of that article here.

Two historians who tendered to this book from its beginning deserve special acknowledgment. The late A. S. Foord provided valuable counsel during the early research and writing. I consider myself fortunate to be counted among those who have drawn upon his practical judgement and rich, unflaunted knowledge of British history. Professor L. P. Curtis is the book's oldest friend, to whom I owe a sure confidence and support in seeing it through. Because of his imaginative insights, unflagging interest, and attentive labour, the following pages represent an experience we have shared together.

To others whose assistance differs only in degree, allow me a general expression of gratitude.

London
July, 1972

Contents

List of Illustrations

This list provides the plate numbers, titles of prints, and ownership of the originals. Appropriate references indicate to which of the three collections the prints belong. In some instances, different states or copies of a print are to be found in these collections, and this is so indicated. In most cases the measurements provided are of the designs of the prints, which do not usually include titles, verses, and other inscriptions—nor letter-press. In instances where the designs are exceptionally small, several in number, without border, or irregular in shape, the dimensions of the plate-marks are given. If the plate-mark of the original has been cropped, this is so indicated.

Note

Most of the prints mentioned in the book are to be found in the print collection of the British Museum. The prints were first described and catalogued by Frederic George Stephens in the *Catalogue of Prints and Drawings in the British Museum, Division I: Political and Personal Satires* (4 vols, London, 1870–3). References in the text to the prints described in the *Catalogue* (hereafter cited as 'BMC') give the catalogue numbers. The prints in the Pierpont Morgan Library belong to 'A Collection of Political Caricatures, Broadsides, Portraits, etc., 1642–1830. From the Library of Sir Robert Peel, Bart., Drayton Manor, Tamworth.' The collection is bound but not catalogued. Prints belonging to it, but not found in the British Museum, are cited in the text as 'PML' followed by volume, page, and print numbers. Prints in the Lewis Walpole collection, and not found in the British Museum or Pierpont Morgan Library, are cited 'LWL'.

CHAPTER I

Printshops of London and Westminster

The political prints of Georgian England present a curiosity to the modern eye. Musty, dog-eared engravings, etchings, and woodcuts; their artistry indifferent; their symbols occult; their figures so strange; all those 'pinxts', 'sculpts', and 'fecits'— the prints today seem laughable, perhaps childish; sometimes indecent and often unintelligible. They meant something, however, to contemporaries who delighted in their imagery and humour. As artistic concoctions they served the purposes of satire and propaganda.

An irrepressible spate of ephemeral literature flowed from the presses in the seventeenth and eighteenth centuries and, thereby, helped to advance the cause of freedom of the press. Neither the stringencies of the Tudor–Stuart licensing codes nor the arbitrary application of eighteenth-century libel laws could stem the flow. Polemical shafts and licentiousness were irritating to the guardians of political authority and public morals, but the very bulk of material made effective suppression impractical and eventually impossible. Its continued presence, in turn, proved such a nuisance to be harmless and therefore tolerable.

The political print played a small but important part in winning this gradual toleration in the course of the eighteenth century. The South Sea Bubble generated the first large-scale production of engraved, satirical prints of good quality. Many, however, came from the Netherlands. Not until the 1720s did an indigenous graphic satire take hold. The corpus of prints grew rapidly in the 1730s and in the next decade a yearly production, less sporadic in nature, provided a continuous and incisive commentary on political events at home and abroad. The burgeoning number of prints brought, however, a decline in artistic quality, as hastily executed etchings replaced the more carefully done engravings of earlier years.

In time, the individual genius of Sayers, Rowlandson, Gillray,

and the two Cruikshanks rescued the political print as an art form and carried it to new heights. A change in taste, the 'improvement of public morals' with the growth of Evangelicalism, the spread of literacy, and the development of the magazine and literature of mass production, caused the death of the independent, satirical print in the nineteenth century. So the eighteenth century, in England, was its heyday. To many Continental observers, in fact, *la caricature anglaise* was a sure sign of the liberty and licence which Englishmen of that century enjoyed.

The centres of this licentiousness were the many print- and pamphletshops scattered about London, operated by a group of men who belonged—despite the commercial success which some of them may have enjoyed—to the middling and lower castes of the publishing trade. Most were rag-tag entrepreneurs whose obscurity has left little more than their names and addresses. Hawkers, among them many women, belonged to the lowest caste of the trade: peripatetic sellers, who carried their printed wares of ballads, broadsides, pamphlets, and prints about the city; their cries joining the din of carriage wheels, horses' hooves, bullocks' cries, and the voices of other purveyors, in the vital, bustling metropolis.

Hogarth stated in 1735[1] that there were no more than twelve major publishers in the whole of London and Westminster. In the period 1727–63 many times that number of shops were in some way involved in printselling, including those of the major publishers, the proprietors of modest shops and stalls, pamphlet-sellers, and even booksellers who also sold prints.

The printshops were to be found over the entire area of the metropolis, concentrating in the ancient centres of the publishing trade and in those places near to the commercial and social life of London. In fact, the pattern of distribution followed the great artery which stretched from St. Paul's churchyard, east to the Royal Exchange and west down Ludgate Hill into Fleet Street, to Temple Bar, then along the Strand to Charing Cross and Whitehall, and in the by-ways, lanes, alleys, and hidden courts that branched north and south from this major thoroughfare. This pattern followed as a great arc the course of the River Thames, which dominated any distant prospect of the city as its broad

[1] *The Case of Designers, Engravers, Etchers, &c. Stated. In a Letter to a Member of Parliament.* The tract is without publication line.

sweep stretched west from London Bridge and then south towards the Palace of Westminster.

Before the systematic numbering of streets was introduced, a shop was located by its sign, by the street or court in which it lay, or perhaps by a familiar public edifice nearby. The eighteenth century was the last in which the old shop-sign served as a principal means of identification of London's places of business. Numbers and less colourful signs, firmly attached to outside walls, gradually replaced the wooden and metal boards that swung to and fro over the narrow streets. These old signs were still in existence in the reign of George II; their rich symbolism continued to decorate and identify. The symbolism came from several sources, including heraldry, humorous puns, local landmarks, and historical personages. Originally, many of the signs provided symbols of the trade carried on in their respective shops. The turnover in occupations, however, erased most of the old connections. Some signs in the publishing business took the likenesses of prominent writers and artists as their symbols: 'Virgil's Head', 'Pope's Head', 'Addison's Head', and 'Hogarth's Head'. After his naval victory at Portobello Admiral Vernon's likeness decorated the signs of many taverns.[2]

In the environs of the Royal Exchange about a dozen print- and pamphletsellers were in business during the years 1727–63.[3] Separating the old Exchange—constructed after the Great Fire—from Mansion House Square was a cluster of buildings. Through them ran a little street called Castle Alley, which connected Threadneedle Street with Cornhill. At the former entrance the shop of 'J. Eynon' could be found in the 1750s. Also in Castle

[2] 'The four streets—the Strand, Fleet Street, Cheapside, and Cornhill—are, I imagine, the finest in Europe. What help to make them interesting and attractive are the shops and signs. Every house, or rather every shop, has a sign of copper, pewter, or wood painted and gilt. . . .' César de Saussure, *A Foreign View of England in the Reigns of George I & George II*, trans. Madame van Muyden (London, 1902), p. 80.

[3] Information about the location of the printshops comes mainly from the publication lines of the prints and from advertisements in the newspapers, especially the rich Burney Collection in the British Museum. The only authoritative work which considers the subject is *A Dictionary of the Printers and Booksellers Who Were at Work in England, Scotland and Ireland from 1726 to 1775*, edd. H. R. Plomer, G. H. Bushnell, and E. R. McC. Dix (Oxford, 1932). The book is of little use as far as the printsellers are concerned. For the purposes of the discussion that follows, the reader should consult Plate 1, which provides a map of London in the middle of the eighteenth century.

Alley was 'W. Tringham' in the early 1760s and perhaps earlier.[4] From one of these two shops may have come several prints in 1756, including *A Voyage to Hell or a Pickle for the Devil* [BMC 3501].

In and around the Exchange several pamphletsellers had their shops, most prominent being that of Edward and Sarah Nutt.[5] At the White Horse 'under the Piazzer [*sic*] Royal Exchange'[6] stood the business of William Hannel. Next to Royal Exchange Stairs on Cornhill was to be found the shop of Thomas Glass, in business in the early 1730s. Behind the Exchange, at the corner of Bartholomew Lane, which also connected Threadneedle Street and Cornhill, was an engraver and printseller named Thomas Cartwright. He published, in 1756, *Byng Return'd: or the Council of Expedients* [BMC 3367, Plate 77], perhaps designed by himself.

In Cornhill, opposite the south side of the Exchange, and where John and James Brotherton published (books primarily), at least two printshops existed, that of John Bowles and that of Thomas Bakewell. The latter's shop was located on the north side of Cornhill, facing Birchin Lane. Bakewell worked in the business for many years. One of his prints is *The French Gasconades Defeated* [BMC 2585], the subject the battle of Dettingen.

Only a small scattering of printshops were to be found east of the Royal Exchange. North in Cripplegate stood a printshop 'at the Ball in Fell Street'.[7] Another shop was to be found near Tower Hill, owned by T. B. March. And among the many shops on Tower Bridge was that of a printseller named W. Herbert. An enterprising man, Herbert worked as a purser's clerk in the East India Company, made a small fortune while with the company, and then took up the business of printseller and engraver, probably in the early 1750s. In 1754 he published *Foreign Trade and Domestic compared* [BMC 3274], and in 1757 *The Treaty or Shabears Administration* [BMC 3608, Plate 96].[8] In later life (he died in 1795) Herbert interested himself in the

[4] *Public Advertiser*, 16 Sept. 1762.

[5] See below, p. 17.

[6] Several prints came from this shop in the 1760s.

[7] *A Scene in Hell, or the Infernall Jubillee* [BMC 3378]; this poorly executed etching contains a satirical publication line, which locates the shop.

[8] *Gentleman's Magazine*, xxvii (June 1757), 291, indicates Herbert as the publisher of this print.

history of printing and became a knowledgeable antiquarian on the subject.[9]

Between the Exchange and St. Paul's, in Poultry and Cheapside, were a few printshops. Not far from Stock's Market in the Poultry John King sold prints in the 1730s and 1740s. He was one of the sellers of *Truth and Moderation* [BMC 2489], a print of 1741 in defence of Robert Walpole. Further along in Cheapside stood the shop of C. Hill, who published a broadside with woodcut about the same time, entitled *The Picture of Pictures; or, Look upon Him, and know Him* [BMC 2556], attacking Walpole. Towards the west end of Cheapside was 'Hogarth's Head', where John Smith was in business. He sold maps and prints; in 1756 he published *The Apparition* [BMC 3374], a print about Admiral Byng. Smith was probably himself an engraver.

For centuries the great churchyard of St. Paul's and the group of little streets to the north of it—to Smithfield and Bartholomew Close—had been the heart of London's (and England's) printing and publishing trade. In earlier days the vaults of the cathedral itself housed stalls for the sale of books and other articles.[10] Booths and stalls hugged close by the cathedral doors in the sixteenth century. In the seventeenth and eighteenth centuries, in the houses around the yard of the new cathedral, shops for the sale of printed material of all sorts were to be found.

Here was the shop of a most important family of printsellers, the Bowles. Earlier in the century Thomas Bowles set himself up in business next to the chapter-house; here he sold prints and maps of many kinds and he continued to publish for over half a century. Bowles had a younger brother named John, who was the proprietor of a printshop first in Cheapside and then in Cornhill. The brothers specialized in the publication of social satires; they did not produce many political prints.[11] At the death of Thomas Bowles, John's son, Carrington, took over the business in the churchyard.

[9] John Nichols, *Literary Anecdotes of the Eighteenth Century; Comprizing Biographical Memoirs of William Bowyer . . . and Biographical Anecdotes of a Considerable Number of Eminent Writers and Ingenious Artists; with a Very Copious Index* (9 vols., London, 1812–15), v. 264.

[10] See H. R. Plomer, 'S. Paul's Cathedral and Its Bookselling Tenants', *Library*, 2nd Ser. iii. 261–70.

[11] Among them was *British Resentment, or the French fairly Coopt at Louisbourg* [BMC 3332], published in 1755.

Bowles's was one of several printshops in and around the cathedral yard. W. Webb was an important publisher of political prints in the 1740s. Among his prints are *A Cheap and Easy Method of Improving English Swine's Flesh* [BMC 2604, Plate 51], *The H–r T–p Man come again* [BMC 2578],[12] and *The Duke of N–tle and his Cook* [BMC 2684],[13] prints of the early and middle 1740s. Webb also did a flourishing business in the sale of pamphlets and broadsides.

Two other pamphletsellers in the churchyard were Stephen Austen 'at the Angel and Bible' and J. Wilford behind the chapter-house. Near St. Paul's was located the business of A. More (or Moore), a publisher of tracts, who also sold a few broadsides with woodcut illustrations. He published in 1742 or 1743 a woodcut reproduction of *The Treacherous Patriot* [BMC 2538, 2558], an attack on William Pulteney. A bookseller with the name of E. Morris also ran a business near St. Paul's. He was the publisher of one of the editions of *A Political and Satyrical History of the Years 1756 and 1757*, a collection of seventy-five satirical prints.[14]

North out of St. Paul's churchyard, from Paternoster Row, Ave-Mary Lane, and Warwick Lane to Newgate, Old Bailey, and beyond the city gates to Long Walk, Duck Lane, Little Britain, and into the environs of St. Bartholomew's, were gathered many publishers and printers. Paternoster Row was by the eighteenth century a centre of the trade. Here many book- and pamphletsellers did business. 'At the Globe' was Thomas Cooper, who sold innumerable political tracts as well as a few prints. After he died his wife, Mary, continued the business and published much the same material; most of it coming from this shop in the 1740s bears her name. It was not unusual in the trade for wives to take an active part along with their husbands and, in many cases, to carry on the businesses after their husbands' deaths.

[12] An anti-Hanover satire published during the War of the Austrian Succession. See below, chap. v.

[13] A satire on the Duke of Newcastle. See below, chap. viii.

[14] A series of editions which began with *A Political and Satyrical History of the Years 1756 and 1757. In a Series of Seventy-five Humorous and Entertaining Prints. Containing All the most remarkable Transactions, Characters and Caricaturas of those two memorable Years. To which is Annexed, an Explanatory Account or Key to every Print, which renders the Whole full and significant* (London, n.d.). These were collections of prints which had originally appeared separately. See below, p. 19.

The Coopers published several prints concerning Sandys's motion for the dismissal of Walpole in 1741: *The Motion* [BMC 2479, Plate 34], *The Acquital* [BMC 2486], and *The Funeral of Faction* [BMC 2487, Plate 36], all prints attacking the opposition to Walpole. In 1745 Mary Cooper published a satiric tract on the 'Broad-bottom' parliamentary Opposition of the early 1740s, a tract which contained a salacious frontispiece.[15] She also published *Old England: Or, The Constitutional Journal. Extraordinary* [BMC 2582, Plate 50], and was examined in 1744 by the government about the publication of a newspaper of the same name.[16]

North out of Paternoster Row ran Warwick Lane, in which was the business of James Roberts, printer, who published tracts in the first half of the century: political polemic, theological arguments, bawdy tales. Nearby in Ave-Mary Lane stood the shop of Edward Ryland, who published two prints after the popular *European Race* series in 1740.[17]

In Newgate Street, from Warwick Lane, was a shop 'at the Globe', from which came *Bob and the Political Ballance Master* [BMC 2576], an anti-Walpole print, in 1741. Near the old city gate and north of Old Bailey was to be found Henry Overton's shop, 'at the White Horse.' Overton came from a family of print-sellers; his father, John, was in the business in the latter half of the seventeenth century.

A walk from Newgate along Snow Hill led eventually to Holborn Bridge; west of it lay the northern thoroughfare of the city: Low and High Holborn. Then on the outskirts of the metropolis, Holborn was not a major street, though along it were many inns and coaching stations for travellers to and from London.

Near the Middle Row which divided Low from High Holborn was a cluster of buildings on the north side of the street called

[15] *An Address of Thanks to the Broad-Bottoms, for the Good Things they have done, and the Evil Things they have not done, Since their Elevation* (London, 1745). The frontispiece is BMC 2621, Plate 56.

[16] *Old England: or, The Constitutional Journal. By Jeffrey Broad-bottom, of Covent Garden, Esq.* The record of her examination is in the state papers: Great Britain, Public Record Office, State Papers, Domestic, George II, Entry Book 134 (sec. letter book), ff. 37–8.

[17] One of them is in the British Museum, under the title of *A Political Race* [BMC 2441]; another is *The European Coursers*, advertised in *The London Daily Post, and General Advertiser*, 18 Mar. 1740, and not in the Museum. For the *European Race* series, see below, p. 12.

Furnival's Inn. For many years in the first half of the century Benjamin Cole, the engraver, owned a printshop, at the 'Lock of Hair'. Further west on Holborn Hill, 'at the Star', was the printshop of Thomas Kitchin, in business for many years and especially active in the 1750s. Kitchin published several 'hieroglyphicks'[18] and other prints attacking the Newcastle ministry, including *The Vision: Or Justice Anticipated and the Addressers redressed* [BMC 3476, Plate 86]. Kitchin was himself an engraver and was still in business in 1763.[19]

Another engraver-printseller, John Clark, lived in Gray's Inn, just north of the Middle Row. Clark published several prints in the 1720s and 1730s, primarily social satires. He may have published, in 1727, *Ready Mony the prevailing Candidate, or the Humours of an Election* [BMC 1798, Plate 8].

The area south of Holborn and bounded by Drury Lane, Fleet Street, and Fleet Ditch, and having as its centre Lincoln's Inn Fields, contained a few printshops (those immediately adjacent to Fleet Street are considered below). At 'Vandyke's Head' in Portugal Street was a shop run by a man named Phillips in the 1760s. J. Sympson sold prints 'at the Dove' in Russell Court off Drury Lane.[20] He was in business about 1730 and may have been related to S. Sympson, who had a printshop in Catherine Street about the same time.

On Wild Street, between Drury Lane and Lincoln's Inn Fields, Richard Montagu ran a print- and pamphletshop in the 1730s. Near the top of Drury Lane, in Brounslow Street, lived George Vertue, the celebrated engraver and antiquarian.

The stretch from Ludgate Hill to Temple Bar comprised the centre of the printselling trade in the first half of the century. It had a concentration of the book- and pamphletsellers as well. Bernard Lintot and Jacob Tonson, two of the most prominent book-publishers in the eighteenth century, were located on Fleet Street. Here was to be found much of the social and literary life of London; where men gathered for talk and refreshment in the coffee-houses and taverns along the way.

[18] The word had also acquired a special meaning in the eighteenth century: a collection of phonetic rebuses, picture-puzzles carrying a satiric meaning. As examples, see Plates 31 and 79. See below, chap. ii.

[19] Nichols, iii. 486. Kitchin's shop was probably near Ely Court.

[20] An advertisement appears in *The Country Journal: or, the Craftsman. By Caleb D'Anvers of Gray's Inn, Esq.* 14 Feb. 1730.

There were at least four printshops east of Fleet Street on Ludgate Hill in the period 1727–63: that of George and Elizabeth Foster, of John Huggonson, of Bispham Dickinson, and of J. Collyer. Foster's shop was 'at the White Horse' not far from St. Paul's; in fact, it may have actually been in the churchyard.[21] Foster was in business in the 1730s and 1740s. In 1749 the government charged him with printing a seditious print, entitled *The agreeable Contrast* [BMC 3042, Plate 69].[22]

Huggonson was a printer in Sword and Buckler Court, on the north side of Ludgate Street. At one time his business was run in Bartholomew Close and Sergeant's Inn, Chancery Lane. He was the printer of the *Champion*, an Opposition newspaper in the late 1730s. About the same time (the early 1740s) he published prints and pamphlets. One of his prints is *The Night-Visit, or the Relapse* [BMC 2559, Plate 48], published in 1742.

Also on the north side of Ludgate stood Dickinson's printshop, at the corner of Belle Savage Inn. Dickinson probably owned a shop in the Strand in the 1730s, but later moved to Ludgate Hill where he remained for some time. Dickinson was examined in 1749 in connection with *The agreeable Contrast*.

Just north of Ludgate in Ivy Lane was J. Collyer's shop. He published several political prints in the 1740s, including some on the Forty-five. The publication line of *The Rebellion Displayed* [BMC 2662, Plate 58][23] says that his shop was in Ludgate Street, while another print[24] indicates that it was in Ivy Lane.

From Fleet Bridge to Temple Bar were to be found no less than fourteen printsellers. 'At the Feathers' in the eastern end of Fleet Street was John Pridden's shop.[25] He published, for the most part, political tracts, though also a few prints in the 1760s.

Further west near Shoe Lane rested the shop of Edward Sumpter, at 'the Bible and Crown'. Sumpter was an active printseller in

[21] Some prints in the 1730s place the 'White Horse' as opposite the north gate of the cathedral and therefore not on Ludgate Street.

[22] Below, chap. iii.

[23] The print in Plate 52 [BMC 2605; without title] was also published by him.

[24] *All Hands to a Court Martial* [BMC 2682], concerning Admirals Mathews and Lestock.

[25] F. G. Hilton Price, 'The Signs of Old Fleet Street to the End of the Eighteenth Century', *Archaeological Journal*, lii. 348–91, places 'the Feathers' a little further west, near Salisbury Court (p. 377).

the early 1760s. He published *The Butiad, or Political Register*, and *The British Antidote to Caledonian Poison*, two collections of prints for the most part attacking the Bute ministry, in 1762.[26]

Close by and probably on the north side of Fleet Street, 'opposite Salisbury Court', stood the shop of John Ryall and Robert Witby, who sold prints and books. Their business was 'at Hogarth's Head'. Ryall's name appears on prints in the middle 1750s. Also on the north side of the street, near Shoe Lane, lay Wine Office Court—a small lane where Edward Kirkall, the engraver, lived.

West of Wine Office Court were the Globe Tavern, Red Lion Court, and Bolt Court; the last led to Gough Square where Samuel Johnson lived in later years. The *Gentleman's Magazine* was published in Red Lion Court. John Purser, printer, had his business here. He was one of the printers of *Old England: or, The Constitutional Journal*, and the print with the same title [Plate 50].

In Bolt Court lived for a time another printer named John Applebee. His place of business was at one time east of Fleet Street, south near Bridewell Bridge, in Black Fryars. Applebee published and sold newspapers and pamphlets. He gained notoriety in the reign of George I for printing newspapers against the Government. Samuel Negus, who classified printers working in London in 1724 according to their politics, described Applebee as a probable 'High Flyer' or Jacobite sympathizer.[27]

Philip Overton, another son of John Overton, ran a printshop 'at the Golden Buck', near Sergeant's Inn and opposite Fetter Lane. He was in business for many years in the first half of the century and was one of the major printsellers in the city. Overton advertised in 1729 'above Five Hundred Sorts of Prints, Colour'd and plain, Consisting of Landskips, Buildings, Ruins, Flowers, Birds, Beasts, Rocks, Fountains, Gardens, &c.', and described himself as a 'Print and Map-Seller'.[28] Robert Sayer took over the

[26] Below, chap. vii. *Scotch Paradice a View of the Bute* [eye] *full Garden of Edenborough* [BMC 4006, Plate 118] was 'Sold at Sumpter's Political Print Warehouse Fleetstreet'.

[27] 'A compleat and private List of all the Printing-houses in and about the Cities of London and Westminster . . . most humbly laid before the Right Honourable the Lord Viscount Townshend,' Nichols, i. 288ff.

[28] *Craftsman*, 15 Nov. 1729.

shop, probably in the late 1740s, and remained there for many years.[29]

Further west on the south side of Fleet Street, not far from Chancery Lane, and opposite St. Dunstan's Church, was the Mitre Tavern, at what later became 37–8 Fleet Street. Next door to the Mitre stood the shop of J. Williams, book- and printseller, who was one of the most productive publishers of prints in the early 1760s. From his shop came many of the best satires against the Bute ministry. *A Poor Man Loaded with Mischief* [BMC 3904, Plate 110], *The Laird of the Boot* [BMC 3898], and *The Seizure. or give the Devil his due* [BMC 4026, Plate 120] are three of his prints. Williams's announced intention was to publish one political print a week,[30] and a great number of his prints did appear in the autumn of 1762.

Nearer Temple Bar but also opposite St. Dunstan's lay Charles Corbett's shop 'at Addison's Head' next to the Rose Tavern. His father, Thomas Corbett, had also been in the publishing business. Charles published many pamphlets in the 1730s and 1740s. In 1746 he published *Tandem Triumphans, Translated by the Duke of Cumberland* [BMC 2788], about the battle of Culloden. His son continued the business at the same shop, set up a lottery office there, became a Liveryman of the Company of Stationers, and was eventually knighted.[31]

Charles Mosley, one of the major draughtsmen and engravers of political prints during this period, also had a printshop in Fleet Street, at 'the King's Arms and Key' in Round Court.[32] Mosley was active in the trade from the late 1730s until the middle of the century. Born about 1720, he was very young when he began his

[29] Price does not place him there until 1762; Plomer is vague about the date, but suggests that Sayer started at that location in the early 1750s. Sayer's examination by the government in 1749 (in connection with *The agreeable Contrast*, see below, chap. iii) indicates that he was there at that time. A print with his name and location on it, *The Fall and Rise of the British Liberty* [PML ii.47ᵛ157; Plate 44], a satire on Walpole, places him there in the early 1740s.

[30] *Public Advertiser*, 18 Aug. 1762. The publication line of Plate 120 announces that the print is part of a series, entitled *The Opposition*, 'the Publication of which will be regularly continued ev'ry Tuesday, by J. Williams next the Mitre Tavern Fleet-street'.

[31] Nichols, iii.719; Plomer describes Corbett's shop as 'without Temple Bar', but advertisements indicate that it was opposite St. Dunstan's (at what was to become 30 Fleet Street).

[32] The author was unable to locate the exact place of Round Court in Fleet Street; a 'King's Arms and Civet Cat' was at No. 2.

career. In addition to his work with political prints he was an engraver of 'history' studies, and also engraved numerous portraits, including some after Van Dyck.

Mosley's career in political satire began with considerable success: the prints of the *European Race* series, published in conjunction with Overton.[33] Mosley was the engraver of the prints in this series, and possibly their inventor as well.[34] Most of the prints which Mosley produced concern foreign affairs. He seems to have been especially skilful with designs requiring minute detail.[35]

A contemporary of Mosley's was John Tinney, who ran a printshop 'at the Golden Lion' in Fleet Street. His name does not frequently appear as a publisher. Among his prints is *Merlin, Or the British Enchanter* [PML ii.56ᵛ177, Plate 37], published with John King in the Poultry. He sold, and may have published, *The Protest* [BMC 2488] in 1741, in defence of Sandys's motion. Other persons in the trade who had shops at one time or another along Fleet Street were N. Owen, K. Clifton, J. Cooper, and H. Jackson; most of them seem to have been primarily pamphlet-sellers.

If Fleet Street was in the eighteenth century a home for publishers and sellers, the great avenue of the Strand, with its compact rows of three- and four-storey houses, was equally famed for its shops, taverns, and coffee-houses. North of it, in Covent Garden, was 'the acknowledged region of gallantry, wit, and criticism'[36] in the Georgian era.

[33] '*This Day is Publish'd* . . . A Print call'd The European Race, Curiously engrav'd on a Copper-Plate, and humbly inscrib'd to the Politicians of Great Britain. . . . Publish'd and sold by Philip Overton at the Golden Buck in Fleet-Street; and to be had of C. Mosley at the King's-Arms and Key in the same street. . . .' *Common Sense: or, The Englishman's Journal*, 9 September, 1738. The prints of the series included BMC 2333, 2334, 2415, 2431, 2449, and 2455. They represent a clever commentary on European affairs on the eve of the War of the Austrian Succession, as they employ the metaphor of a horse race.

[34] The large number of prints with 'Mosley sculp' on them bear no indication of their designer(s). One print, *The Invasion or Perkin's Triumph* [BMC 2636], a satire on the Forty-five circulated in England and Holland in 1745, does indicate Mosley as its creator. The style is similar to that of the *European Race* prints and *The Political Kalender for the Year. 1740* [BMC 2440; Plate 27].

[35] The prints in the British Museum attributed to Mosley show that he was a draughtsman and engraver of some versatility, and was especially competent with large and complex scenes.

[36] E. Beresford Chancellor, *The Annals of Covent Garden and Its Neighbourhood* (London, n.d.), p. 13.

Wren's Temple Bar divided the eastern end of the Strand from Fleet Street and the City. Somewhere at this eastern terminus could be found the shop of Anne Dodd 'at the Peacock'. One of the many women in the pamphletselling trade, Dodd was a major distributor of some of the more scurrilous material of the day: bawdy tales and allegedly seditious material.[37] She does not seem to have published prints, though she no doubt, like most the pamphletsellers, sold some of them.

A walk west from Temple Bar led to a small complex of buildings in the middle of the street which separated the Strand from Butcher's Row and Wyck Street. Here was St. Clement Danes. Near the church stood the Union Coffee-House, opposite which was the shop of H. Howard, publisher of tracts and prints in the 1760s. An advertisement of his reads: 'An Ode to Lord B— on the Peace. By the Author of the Minister of State, a Satire. Sold by H. Howard, opposite the Union Coffee-House in the Strand . . . N.B. Complete Sets of all the Political Prints, Songs, &c. as above.'[38] Howard published many anti-Bute prints in the early 1760s, including *The Masquerade; or the Political Bagpiper* [BMC 3880, Plate 106], and *The Vision or M–n–st–l Monster; address'd to the Friends of Old England; By Sybilla Prophecy* [BMC 3983, Plate 117].

Past St. Mary-le-Strand and Somerset House was Catherine Street on the north side of the Strand. A few steps west of here lay Exeter Exchange, and across the street, the precincts of the Savoy. The Exchange contained arcades with booths and stalls; there may have been a stall or two for the sale of prints and pamphlets. The building acquired in the eighteenth century an unsavoury reputation as a haunt for prostitutes.

Bispham Dickinson, who had a shop on Ludgate Hill in the 1740s, may have been in business a decade earlier 'at Inigo Jones Head' against Exeter Change. A 'B. Dickenson' published *The*

[37] An example is *The Woman's Advocate: or, the Baudy Batchelor out of his Calculation*, published by J. Roberts and sold by A. Dodd and the above-mentioned Elizabeth Nutt, advertised in the *Craftsman*, 16 Aug. 1729. Dodd was one of the sellers of an edition of the *London Evening Post* and was examined by the government in regard to it (P.R.O., S.P., Dom., Geo. II, General, Vol. 50, ff. 272–3).

[38] *Public Advertiser*, 19 Nov. 1762.

Hierarchical Skimington [BMC 2149] there in 1735. J. Smith ran the shop in the 1720s.[39]

George Bickham, engraver, printseller, and a major contributor to the development of English graphic satire, kept a shop for a time at the Exchange (at the 'Blackmoor's Head against Surrey Street'), before moving his business to his residence in May's Buildings near the western end of the Strand in the early 1740s. From these two shops issued a stream of prints in the 1740s.[40] Quantity alone affords Bickham an important place in the history of the political print.

He was also, however, an artist of particular though limited skills. Though not the draughtsman and engraver his father was,[41] the younger Bickham applied himself to many subjects, including topographical studies and portraiture, but seems to have been especially gifted (certainly prolific) in satire. He designed, engraved, and sold a great many political prints. His style resembled his father's: figures with graceful curves and fullness of form, round, chubby faces, apple-cheeked. Both father and son employed a great deal of flick work and stipple to give tone and contour to the face. The eyes, with special attention to the lids and brows, are prominent.

The name of Bickham begins to appear frequently on political prints about 1740. One of his earliest prints, *A Skit on Britain* [BMC 2423], carries a disguise of his name: 'Ged Bilchharp jun.ʳ inv.ᵗ et sculp.' The subjects of prints which Bickham designed vary. So do the quality and degree of originality. The above print, for

[39] 'Lately published, by J. Smith, at *Inigo Jones* Head near *Exeter* Exchange in the *Strand* A *Curious* and *Exact Prospect* of the *City* of London, Westminster, and St. James's Park . . . *engraved on twelve Copperplates*'. *Craftsman*, 6 April 1728.

[40] It is likely that Bickham, for a time, kept both shops simultaneously. The position of his shop in the Strand is difficult to ascertain because of conflicting information in the publication lines. 'Blackmoors Head' was positioned either against Surrey Street or at Exeter Change itself. Surrey Street was east of the Exchange, but Bickham may have used the latter as a point of reference. A 'Blackman's Head' tavern was in the Strand, as well as a 'Blackmoors Head' in Round Court at the western end.

[41] George Bickham, senior, was a calligrapher, the author of *The Universal Penman*, published in 1743. The styles of the two Bickhams being so alike, it is possible that the father designed or engraved political satires himself. No such prints, however, have been attributed to him. There was also a John Bickham, either the senior Bickham's father or brother. An advertisement in the *Craftsman* of 14 Apr. 1733 offers 'Fables and other short Poems. . . . The whole curiously engraved on 100 Copper Plates, by George and John Bickham. . . .'

example, was engraved on a plate that Bickham had used pre-viously for *The Races of the Europeans* [BMC 2335], which, in turn, was an unimaginative adaptation of the Mosley and Overton series. Bickham was deft, however, in the satiric interpretation of foreign affairs, translating the subject into metaphor. Such is his presentation of Maria Theresa's travails in *The Qu–n of Hungary Stript* [BMC 2512],[42] a print published in 1742. Some of the prints of the Motion series were probably invented or engraved by Bickham, including *What's all This! The Motley Team of State* [BMC 2495],[43] in which both Walpole and his opponents (certain members of the opposition) are satirized. Bickham had great talent for personal satire and ridicule. *Uain Glory: A Pretty Independent Print* [BMC 2615], probably his, is an attack on Lord Egmont; in the design the figure of Fame flies above Egmont, proclaiming his glory with both trumpets and a fart. Bickham produced some of the best anti-Walpole prints; *The Lyon in Love. or the Political Farmer* [BMC 2347, Plate 22], and *The late P–m–r M–n–r* [BMC 2607, Plate 54] among them.[44] *The Wheel of Fortune, or, the Scot's Step, Completed* [BMC 2537, Plate 43], as with many of the above prints, shows Bickham to be an inventive as well as competent draughtsman, talented both in composition and movement.

Bickham kept a large inventory at his shop in May's Buildings. He printed his own material,[45] and offered a wide selection of prints—satirical and otherwise—maps, and cartoons 'for the Ladies delighting in Embroidery, Painting, Japanning. . . .'[46] Some of his

[42] In a similar vein is Bickham's treatment of Frederick the Great in *The Eva-cuation, or, the Sh–tten Condition of the King of Pru–a* [BMC 2611]. *The Consulta-tion of Physicians, on the Case of the Queen of Hungary* [BMC 2514, Plate 39], though it bears approximations of the names of other artists, is very typical of Bickham's style.

[43] *The Political Libertines, or Motion upon Motion* [BMC 2490] is another. Both were sold by Bickham at the Blackmoor's Head.

[44] *In Place* [BMC 2350, Plate 23] might also be Bickham's.

[45] P.R.O., S.P., Dom., Geo. II, General, Vol. 146, ff. 359–60; a series of notes by Carrington, one of the Secretary of State's messengers, concerning some obscene and seditious material (see chap. iii), in which he mentions that 'Geo: Bickham keeps a rolling press in his own house. . . .'

[46] *The Daily Post*, 14 June 1743. The Lewis Walpole Library at Farmington con-tains a volume of political prints, *Caricatures anglaises 1740*, probably collected and bound at the time, containing over thirty prints of the period 1740–5. Many, perhaps most, come from Bickham's shops. In the volume are almost all the prints mentioned above, as well as several anti-Hanover prints which Bickham may have

prints display a scrubby and often bawdy sense of humour. On at least two occasions Bickham ran foul of the government for the publication of obscene and seditious material.[47] *The [Cha]mpion; or, Even[ing] Adver[tiser]* [BMC 2452][48] is probably by Bickham; it contains a sacrilegious parody of the Creed. Though an enterprising artist and businessman, Bickham scarcely seems to have been of high character. He was often involved in litigation, including suits in Chancery for the rights of various publications.[49] After 1749 Bickham ceased to be very active in political satire. A few prints of the 1750s bear his style.[50] He lived on for some years.[51]

Near Exeter Change, 'at Boerhaave's Head', was to be found the shop of William Meyer, in business in the 1740s. He published, for the most part, books and prints of a serious nature and, like Bickham, later moved to May's Buildings.

Across the Strand from the Exchange lay the old Palace of the

produced (e.g. illustrations to *A List of Foreign Soldiers in Daily Pay for England* [Plate 52].

[47] Below, chap. iii.

[48] Also BMC 2453, of which Plate 31 is a copy. Note the inscription on the letter in the upper left. This print was published at Blackmoor's Head in the Strand in 1744.

[49] Ambrose Heal, *The English Writing-Masters and Their Copy-Books, 1570–1800* (Cambridge, 1931), pp. 16–17. Bickham senior was involved in similar difficulties.

[50] *A Nurse for the Hess–ns* [BMC 3478] of 1756, published in May's Buildings, reflect his style. He advertised a print in the *Public Advertiser*, 9 Oct. 1756, and listed his residence in May's Buildings.

[51] There is some uncertainty as to when the younger Bickham died. Some authorities, including the *Dictionary of National Biography* and *Allgemeines Lexikon der Bildenden Kunstler von der Antike Bis aur Gegenwart*, Ulrich Thieme *et al.* (edd.), give the date of his death as 1758 and his father's death as 1771. Heal, however, supporting the contemporary witness of William Massey, *The Origin and Progress of Letters* (London, 1763), argues persuasively that, in fact, the father died in 1758 and that the death of a George Bickham at Richmond in 1771 was that of the son. The argument coincides with the fact that at least two prints of Bickham's appeared in the 1760s: one, without title (BMC 4097) showing William Pitt speaking in the House of Commons and advertised in the *Public Advertiser* of 25 May 1763 ('Sold by G. Bickham in May's-Buildings . . .'); another, *Sir Trincalo Boreas* [BMC 4246], published in 1768, 'sold in Liberty-Row, Richmond where open House is kept all day long', designed and engraved in Bickham's style, and bearing the inscription 'GB: sc.' Confusion of the two Bickhams remains a problem: so many of the few known facts of the two lives are entangled together. The association of Bickham junior with May's Buildings is closer than that of the father, a fact which would probably identify the print of 1763 with him.

Savoy, with many shops. Here lived for several decades a printing and publishing family by the name of Nutt, perhaps related to the family of the same name at the Royal Exchange. Negus described one Richard Nutt as a 'High Flyer'.[52] Sarah Nutt published about 1740 and was a pamphletseller of the same breed as Anne Dodd. Like Dodd, she was occasionally in trouble with the authorities.[53]

Southampton Street, west of the Exchange and the Savoy, led north from the Strand into the Great Piazza of Covent Garden. Around the square and in the street adjoining it were famous coffee-houses, notorious bagnios, residences of artists, Rich's Playhouse, and shops.

In the Piazza and perhaps under one of the arcades on the north or east side lived Elizabeth Haywood 'at the sign of Fame'. She was an author as well as publisher. Haywood published (*c.* 1742) *The Ghost of Eustace Budgel Esq*. *to the Man in Blue Most humbly Inscrib'd To His Royal Highness the Prince of Wales* [BMC 2555], a satire on Robert Walpole.

Russell Street, the main thoroughfare into Covent Garden from the east, contained two famous coffee-houses, Tom's and Button's. In the building which housed the former was Richard Francklin's printing shop. Francklin served as the printer and publisher of the *Craftsman* for several (and for him stormy) years after 1726. He was a major victim of the Walpole ministry's legal actions against the Opposition press. Francklin also published books and pamphlets, with an occasional satiric frontispiece.[54]

South out of Russell Street ran Charles Street, in which 'at the Golden Head' lived Claude Dubosc, the engraver, who also sold prints there. Dubosc was one of several artists and engravers who belonged to the Rose and Crown Club, which met at one of the taverns in the Piazza.

Charles Street joined Tavistock Street, just south of the Piazza. A man named Henery, fan-painter and seller, had a shop here about 1730, 'at Gay's Head'. Ladies' decorative fans sometimes carried engraved impressions as designs, many of them satirical prints.

[52] Nichols, i.311.

[53] P.R.O., S.P., Dom., Geo. II, General, Vol. 63, f. 216.

[54] 'This Day is Published, (*On a large Sheet* of *Imperial Paper, fit to be* Framed) *The Craftsman* against *Pensions*, with a Device Engraved on a Copper Plate, Printed for *R. Francklin* in Covent Garden.' *Craftsman*, 25 Oct. 1729.

At the west end of the Piazza, behind St. Paul's Church, lay Bedford Court at the end of the street of the same name. In this tiny cul-de-sac a few shops and a coffee-house clustered. John Jarvis had a printshop in the court about the middle of the century.

Covent Garden was one of the architectural developments of the Strand in the last half of the seventeenth century. Another of these improvements was the Hungerford Market, west of Covent Garden on the south side of the Strand itself. Constructed as a rival to the food market in the Piazza, Hungerford Market proved to be less of a success. Across the Strand, directly opposite the Market's stalls for butchers and greengrocers, stood a printshop 'at the Acorn', owned by one of the most productive printsellers in the eighteenth century: Matthew Darly.

Matthew Darly, with his wife Mary, was the most active publisher of political prints in the late 1750s and early 1760s. A large number of the Darlys's prints appeared in the several editions of the *Political and Satyrical History*.

Their prints have a distinctive character and appearance. Many are etchings; many are small in size. As several of the plates indicate,[55] there is little skill in design or execution. They do not compare with the laboured and carefully-done engravings of the 1740s. Their message requires scant attention to be absorbed. The merit of the Darly prints rests with the wit, the satire, and the striking quality of some of the caricatures.

A rush of prints came from the shop in the Strand in 1756, many of them bearing the names of 'Edwards & Darly'. The two were possibly in business here earlier than 1756.[56] Darly lived and worked for a time across the Strand while he was making designs for Chippendale.[57] He was in the printselling business as early as

[55] Plates 78, 82, 83, 84, 85, 87, 97, 98, 102, and 103.

[56] In 1755 Darly and Edwards published *A New Book of Chinese Designs with Plans and Scales for Temples, Alcoves, Garden Seats, Pleasure Houses*, etc.; the book was to be had 'in Northumberland Court in the Strand. . . .'

[57] Hugh Phillips, in his useful *Mid-Georgian London: A Topographical and Social Survey of Central and Western London about 1750* (London, 1964), pp. 131, 133, says that Darly moved into Chippendale's house in Northumberland Court after Chippendale vacated it, and at the same time took another shop opposite Hungerford Market (at what was later 467 Strand). He seems to be confused in his chronology, for he says that Darly moved into the shop across from the Market in 1757, whereas he was certainly there in 1756. He also places 'the Acorn' at 39 Strand, further east at the corner of Buckingham Street, which Darly took over in 1765. In 1756 the Acorn was directly opposite Hungerford Market, at the corner of Church Court.

1749, for the record of his examination by the government that year is among the State Papers.[58] The record indicates that Darly then lived in Duke's Court, St. Martin's Lane, and that he was a 'seal engraver'. It also indicates that he had a shop in the 'Exchange'—what exchange it does not say.

Darly did not publish political prints in any great number, however, until the middle 1750s. The several prints of medium size which came from his shop at this time are distinctive: stark, rather poorly executed, with an inky quality; the settings are mainly room-interiors in which a few individuals appear; parallel lines give substance to the walls and floor.[59] A few of these prints are coloured with the same red-purple, royal blue, mustard yellow, and sometimes green hues.

The bulk of Darly prints appearing at this time are in the *Political and Satyrical History*. The prints in this series of books originally appeared separately: many contain their own publication lines, with Darly and Edwards as the original publishers.[60] It is possible that these prints, because of their small size, were originally intended as designs on the backs of playing cards. Satirical card-caricatures were fashionable at this time.[61] Darly published at least one larger print in 1756 in which the figures on court-cards served as characters.[62]

The collection of political prints in books became popular, as several additions and supplements of the series appeared. *The British Antidote to Caledonian Poison* and *The Butiad*, mentioned above, were two books of the same pattern. These collections of prints, of which there were other examples as well, consisted of copies of originals, often reversed and reduced, with explanatory comments, and preceded by bits of verse which had usually appeared separately with the original prints.

By 1762 Darly had a shop in Ryder's Court, Cranbourne Alley, just east of Leicester Fields. Certainly his wife was running a shop

[58] See below, chap. iii.

[59] An example is *The Auction* [BMC 3467, Plate 85].

[60] See Plates 78, 79, 81, 82, 83, and 84. Plates 87 and 88 also appeared in book form but are here without pagination (these plates are of prints in the Peel Collection). *England's Remembrancer: or, A Humorous, Sarcastical, and Political Collection of Characters and Caricatures*, etc., another collection, contains reversed copies of prints in the *Political and Satyrical History*.

[61] See the discussion of George Townshend, below, chap. ii.

[62] *The Court Cards or all Trumps in the present Rubbers 1756* [BMC 3466].

here at this time. From this shop came a great number of prints attacking the ministry of Lord Bute. *We are all a comeing or Scotch Coal for ever* [BMC 3823, Plate 102], and *The Scotch Broomstick & the Female Beesom* [BMC 3852, Plate 103] were probably published here, a well as a print of better quality. *The Evacuations. or An Emetic for Old England Glorys* [BMC 3917, Plate 112]. Mary Darly, who described herself as 'etcher and printseller',[63] was at this time engaged in the publication of prints 'etch'd in the O'Garthian Stile'[64]—probably card-caricatures published in a series for subscribers.

This Day is published, Price 6d. each, Two curious Caricature Cards, one called the Triple Compact, or Britannia in Tears; the other Scotch Provision for the Convent. To be had of Mary Darly . . . Where may be had, the rest of the cards, and the Pack will be continued till the Whole is compleat, and the Parties are tired of play. The Gentleman and Ladies are desired to excuse their not having the Boot and the Bruisers, on account of some curious Alterations, but they may depend on its being ready to deliver to the Subscribers this Night. . . .[65]

The late summer and autumn editions of the *Public Advertiser* are filled with Darly's advertisements for prints in this series, and also for larger prints ('new Folio Prints of true Humour and Decency').[66] Also issuing from her shop were such fanciful innovations as transparencies, in which one impression was fixed on another, so that the design of the latter could only be seen when the whole print was held up to the light.

Mary Darly probably did much of the etching herself, though the designs for some of the prints appear to have come to her as suggestions from outside sources: 'the Drawing signed D. Rhezzio is in Hand, and will be published this Morning, with the Alterations required.'[67]

Darly published *A Political and Satirical History Displaying the Unhappy Influence of Scotch Prevalency, in the Years 1761, 1762, and 1763*. The book follows the same form as earlier collections and the title-page announces that 'Sketches or Hints, sent Post paid, will have due Honour Shewn them.'

[63] *Public Advertiser*, 27 Oct. 1762.
[64] Ibid., 14 Oct. 1762. In this advertisement she states that the prints are 'by the Author of the Political History, from the Year 1756 to 1762. . . .'
[65] Ibid., 13 Nov. 1762. [66] Ibid., 25 Nov. 1762.
[67] *Public Advertiser*, 27 Oct. 1762. This anonymous contributor may have been George Townshend (below, chap. ii).

Sumpter, the publisher of *The British Antidote to Caledonian Poison*, may have had Darly's book in mind when he said in his preface:

In Justice to the Publick, I beg leave to caution them against a base Copy of this Book, stuffed full of loaded and blinded Lions; in which the same Poverty of Invention is . . . drawn from Beginning to End. It is necessary to observe, that no other name but the well-known one of *M. Darly* could with any Propriety, be put to so matchless a Piece of impudent Imposition. I think it needless to say that any Thing more to discourage the Sale of that Book, than that the Vileness of the Engravings renders the Subjects unintelligible.[68]

Matthew Darly's place in the production of all these prints is obscure. His wife, by all evidence, was the manager of the shop in Ryder's Court and quite likely the etcher of the prints which came from there. An advertisement for *The Principles of Caricatura* says that it was to be had of Mary Darly in Ryder's Court but also adds that there was 'Engraving in general by Matthias Darly'.[69] In 1765 he took a shop on the Strand at the corner of Buckingham Street where he remained for a decade; there he published prints of all kinds, including satires.

A contemporary of Darly, Thomas Ewart, had a printshop a short distance west of Hungerford Market, on the north side of the Strand. The shop was in business at the 'Bee-hive', near St. Martin's Lane and the corner of Hudson's Court; and, after 1760, opposite Northumberland Street.[70] Ewart sold prints here throughout the 1750s and early 1760s. One of his prints is *John Bull's House sett in Flames* [BMC 3890, Plate 108]. Earlier Ewart had a printshop in St. Martin's Lane, opposite Old Slaughter's Coffee-house. This street connected Long Acre with the Strand. The area of St. Martin's Lane was in the eighteenth century the home of artists of various kinds, many

[68] An advertisement for the book is in the *Public Advertiser*, 7 Dec. 1762, which seems to predate Darly's book. There were, however, several editions of *The British Antidote* (and the quotation above is taken from the fifth). In the same advertisement Sumpter announces that 'the remaining Part of this Volume is in the Press, and will be published next Week. The above Prints may be had, Butifully coloured, framed, and glazed or in a Book.'

[69] *Public Advertiser*, 2 Oct. 1762

[70] Northumberland Street was not constructed until 1760 (E. Beresford Chancellor, *The Annals of the Strand, Topographical and Historical* (London, 1912), p. 87).

of whom congregated at Old Slaughter's. John Pine, the engraver, kept a shop in the Lane. Hogarth's Academy was also here.

May's Buildings—a street with houses—lay on the east side of St. Martin's Lane; it was constructed in 1739. George Bickham, as mentioned, lived here for many years. A 'T. Butcher', the publisher of *The Wheel of Fortune or England in Tears* [BMC 4154, Plate 121], evidently ran a shop in May's Buildings in the 1760s.

At the corner of the lane, where it joined the Strand, stood the shop of Thomas Jeffreys, map- and printseller, in business about the middle of the century. His shop faced Northumberland House and was just on the edge of the square at Charing Cross, with the equestrian statue of Charles I in the centre. Jeffreys was a major printseller but he does not seem to have published many political satires. Not far from Charing Cross, towards Whitehall in Craig's Court, Peter Fourdrinier, engraver, stationer, and printseller, lived for many years.

Most of the printsellers in the city of Westminster ran businesses in or near the Strand. There were a few, however, who were scattered in the city's western and southern parts.

A nexus of print-, pamphlet-, and bookselling, comparable to that of St. Paul's churchyard, was Westminster Hall. The bustle of activity at term-time, the sessions of Parliament, and the presence of taverns opposite New Palace Yard made the Hall an ideal place for the sale of printed matter and for the gathering of the latest political news. For centuries wooden stalls and booths lined the walls of its dark but spacious interior. Publishers and sellers rented space here on either a temporary or permanent basis, but especially during the London 'season' to increase sales. Rents were, traditionally, by patent paid to the Warden of Fleet Prison.[71]

Westminster Hall. The First Day of Term. A Satirical Poem [PML iii.13ᵛ43, Plate 30] [72] provides a good view of the Hall at term-time, with the Courts of King's Bench, Common Pleas, and

[71] H. R. Plomer, 'Westminster Hall and Its Booksellers', *The Library*, 2nd Ser. vi.381.

[72] The impression from which this copy was made dates from the end of the century; the plate, however, is older, probably made about 1740. The Lewis Walpole Library contains an impression sold by John Ryall in Fleet Street, designed by Hubert Francis Gravelot, engraved by Mosley.

Chancery in session. Along the two sides can be seen rows of stalls, most of them apparently for the sale of prints, with several items displayed on the wall and a few on the counter, behind which sits a woman tending sales. There probably is another stall for prints in the left foreground.

A 'J. Stagg' had a booth in the Hall in the 1720s; he was primarily a pamphletseller. Another pamphletseller of the same period was 'C. King'. Two printsellers named Gillcock and Marbeck worked in the Hall about the same time.[73] Dickinson maintained a stall there when he had his shop in the Strand. Darly kept one in the early 1750s.[74]

There were also stalls in the Court of Requests, as *From One House to An Other* [BMC 2536, Plate 42] and *The Wheel of Fortune*, etc. [Plate 43] indicate. Both prints show stalls against the back wall. The Court was in a building immediately adjacent to St. Stephen's chapel and a few paces from the House of Lords.

A printshop existed about 1740 'at the Golden King's Head' near Whitehall Stairs,[75] perhaps in the small street that ran from Whitehall to the river behind the Banqueting House. Off Parliament Street in Derby Court was a printshop operated by a man named Thomas or Hammond, shortly after Parliament Street was constructed in 1749–50.[76]

The Palace of Westminster marked the end of the central artery of the metropolis, which stretched all the way to the Royal Exchange and which turned with the course of the Thames. There were a few printshops to be found elsewhere in Westminster, in or near what is today called the West End. On Pall Mall where it crosses Haymarket was the printshop of John Hulton in the 1730s. Also in Pall Mall (and earlier in St. James's Street) John Jollyff's pamphletshop was to be found.

Elegant townhouses, clubs, coffee-houses, and taverns decorated Pall Mall and St. James's Street. Piccadilly was little more than a road leading out of the city and was mostly open in its western parts. Two printshops were in the eastern part of Piccadilly about the middle of the century. One of them was operated by James

[73] Gillcock's name appears in an advertisement in the *Craftsman*, 8 Nov. 1729; Marbeck is mentioned in the same journal, 24 Feb. 1733.

[74] Mentioned in the title-page of Darly & Edwards, *New Book of Chinese Designs*.

[75] *London Daily Post and General Advertiser*, 2 Jan. 1740.

[76] These names of John Thomas and a Mr. Hammond appear in an advertisement in the *Public Advertiser*, 3 Dec. 1756.

Verhuyck. At the very end of Piccadilly, in Panton Square, lived Bernard Baron, the engraver, who ran a printshop at his residence. In Princes Street near Leicester Fields was the shop of Daniel Paillet in the 1750s. Francois Vivares and George Vander Gucht, both engravers of some distinction, kept shops at their residences, the former in Newport Street at the top of St. Martin's Lane, the latter in Bloomsbury Square.

In such a way did the printselling trade spread itself from the tight environs of the old city to the newer and fashionable streets and squares, and even to the outer reaches of the growing metropolis. Finding the printshops makes for a delightful tour and it suggests an appropriate setting. For the prints are imbued, in their creation and substance, with the life and character of Georgian London.

Of Prints and Their Makers

Strange as the prints may now seem to us, they belong to a tradition whose ancient vestiges can still be found in the comic drawings on Greek vases and the grotesque, burlesque carvings of medieval cathedrals. This tradition lives, as well, in the heritage of Renaissance and Baroque art. The creative genius of these two eras applied itself to satire and propaganda. Sometimes in praise: Titian's and Tintoretto's glorification of Venice and their many history paintings, the latter's religious frescoes for the Society of Jesus, Le Brun's rhetorical panegyrics to Louis XIV, these are a few examples of graphic experiments in religious and political propaganda. Sometimes it was used for humour or ridicule: the mordant satire of Cranach's prints, Holbein's and Breughel's amusing social studies, Callot's scathing panoramas of war, all displayed the possibilities for critical opinion within the graphic medium.

1. *Sources*

Historians repeat each other; so do artists. Inveterate borrowing from the work of the past swells the current of artistic creativity. The political print not only belongs to a venerable tradition. Many of its tools are taken from the past as well. The names attached to prints in the eighteenth century suggest sources. 'Hieroglyphick', 'emblem', and occasionally 'device' were synonyms. They are a part of the nomenclature of conventional symbolism, developed in the Renaissance. This traditional iconography constitutes one of the principal artistic sources of the political print. 'Caricature', another synonym, represents the other major source: a special technique of graphic satire, an extraneous fashion imported from Italy in the eighteenth century.

A corpus of traditional symbolism was assimilated, extended, and codified in the art of literature of the Renaissance. Codification of this material appeared in a few seminal books of the sixteenth

century. Horapollo's *Hieroglyphica*,[1] mistakenly believed to be a revelation of the meaning of inscrutable Egyptian characters, popularized the word in its title. In fact an exotic bestiary, the *Hieroglyphica* exercised a special fascination on contemporaries and inspired several similar books. 'Hieroglyph', from the beginning misinterpreted, came to mean a mysterious and enigmatic figure; eventually it acquired the more general meaning of any pictorial image with a symbolic association. The original fascination with its mythopoetic secrets helped to develop a taste for symbolic representation in all forms.

At the end of the sixteenth century Caesar Ripa's *Iconologia*[2] appeared, which went into many editions and was translated into several languages in the seventeenth century. The *Iconologia* is an encyclopedia of allegorical figures, containing thorough explanations of their symbolic meanings, intended for the use of artists and for the enjoyment of a wider audience. Paintings, frescoes, sculpture, medals, prints, and tapestries employed and developed this iconography; a heritage that was also conveyed in literary imagery, decorative designs, printers' marks, and even shop signs.

Love of allegory pervaded the sixteenth and seventeenth centuries, and this symbolism generated a large number of personifications. The visualization of concepts and qualities, virtues and vices, took human form. Roman icons, on coins and medals, provided some models, e.g. Fama, Victoria, Abundantia. Joined with them were personifications derived from Christian theology, such as Faith, Hope, and Charity. Artists used these figures to depict such conventional themes as the conflict of the virtues and vices, or such truisms as *veritas filia temporis*. Allegorical figures proliferated. Ripa's anthology contains several hundred.

Attributes accompanied the figures as necessary emblems of their meaning. Fame blew her trumpet; Plenty held her cornucopia. These symbolic accessories, conventional but at the same time subject to variation, show the vitality of this iconography. Subtle variation provided changes in ideographic meaning.[3]

[1] See George Boas, trans., *The Hieroglyphics of Horapollo* (New York, 1950).

[2] *Iconologia overo Discrittione dell'Imagini universali cavate dall'antichita et da altri luoghi Da Cesare Ripa Perugino* (Roma, 1593). The first illustrated edition appeared in 1603.

[3] An interesting subject, for ideography is a bridge between art and intellectual

In the eighteenth century this corpus of traditional symbolism, preserved and sustained in numerous art forms, was settled and familiar. The first English edition of Ripa was published in 1709, 'for the Instruction of Artists, in their Study of Medals, Coins, Statues, Bassorelievas, Paintings and Prints, and to help their Invention'.[4] The taste for allegory continued, now enshrined in the effusive monuments of Roubiliac along the walls of Westminster Abbey.

It also bears witness in the political print. This traditional emblematic imagery is the print's most distinctive artistic element. The time-honoured panoply of allegorical figures appear again and again. On the side of virtue—and the qualities of *salus publica*[5]—stand Liberty with her cap and pole, Justice bearing her sword and scales, the shining figures of Truth, Plenty, Trade, and, though rarely, Mercy, Charity, and Religion.[6] Arrayed against them are the forces of evil and darkness: Pride, Ambition, Folly, Fraud, Tyranny, and the Furies of Envy, Malice, and Discord.[7] Presiding over them is incarnate evil itself: the Devil. A ubiquitous and almost likeable fellow in the prints[8] (a reminder of the evil that lurks in the councils of the nation and amidst her enemies abroad), the Devil usually presents a gracefully drawn figure—

history, and has a rich bibliography. Many excellent studies have been published under the auspices of the Warburg Institute, such as Mario Praz' *Studies in Seventeenth-Century Imagery* (2 vols., London, 1939–47). Other books of interest include the works of Erwin Panofsky, e.g. his *Studies in Iconology: Humanistic Themes in the Art of the Renaissance* (New York, 1939); Samuel C. Chew, *The Virtues Reconciled: An Iconographic Study* (Toronto, 1947), and *The Pilgrimage of Life* (New Haven, Conn., 1964).

[4] P. Tempest, *Iconologia: or, Moral Emblems by Caesar Ripa. Wherein are Express'd, Various Images of Virtues, Vices, Passions, Arts, Humours, Elements and Celestial Bodies; as Design'd by the Ancient Egyptians, Greeks, Romans, and Modern Italians: Useful for Orators, Poets, Painters, Sculptors, and All Lovers of Ingenuity* (London, 1709), preface.

[5] The coronation medals and seals of the Georgian kings are crowded with allegorical figures, showing the qualities of a good polity and good kingship, and what represents a threat to both. See Edward Hawkins (comp.), August W. Franks and Herbert A. Grueber (edd.), *Medallic Illustrations of the History of Great Britain and Ireland to the Death of George II* (2 vols., London, 1885). In the same vein, see *The Rebellion Displayed* [Plate 58].

[6] See Plates 8, 9, 12, 50, 58, 59, 60. [7] Plates 33, 36, 44, 58.

[8] Even in the demonology of the Middle Ages the Devil was never an entirely serious or awful creature. The image of the Devil most familiar to modern eyes developed through the art and popular literature of the sixteenth and seventeenth centuries: a terrible but sometimes amusing antagonist. See John Ashton, *The Devil in Britain and America* (London, 1896).

the Pan-like satyr, armed either with the bellows of temptation or the axe and halter of punishment.[9]

Attending the struggle of good and evil are Fortune, the nemesis of bad and overly ambitious ministers; old father Time with his scythe, the liberator of Truth and the instrument of Justice; and Fame, the winged female with trumpet, who celebrates the victory of right over wrong.[10]

The attributes of these figures and other symbolic devices are part of the workaday tools of the satiric art. The balance, the wheel of Fortune, the axe and halter, the temple of Fame are a basic part of the emblematic imagery demonstrating the reward of virtue, the punishment of vice.

An 'emblem' in the eighteenth century generally meant any pictorial image with a fixed symbolic association.[11] The word called to mind, as well, that combination of symbolic picture, aphorism, and verses, found in the old emblem books—a popular genre in the early seventeenth century and an important receptacle of much of the symbolism later embodied in the satiric print. The emblem books were collections of morals and truisms; their purpose was usually didactic. Wither, one of the English emblematists, described his book as 'a *Puppet-play* in *Pictures,* to allure men to the more serious observation of the profitable *Morale,* couched in these *Emblems*'.[12]

Beginning with Andrea Alciati's *Emblemata,*[13] the father of the genre, succeeded by Goffrey Whitney's *A Choice of Emblemes,*[14] the first English emblem book, and then Francis Quarles, the most popular English emblematist, whose *Emblemes* were published in 1634,[15] followed by others as well, this body of literature mined and preserved a rich lore of symbolism. The emblematists drew their material from both Christian and classical sources. The emblems were not only collections of formal personifications and attributes, but bestiaries as well—what Whitney called 'natural'

[9] Plates 15, 36, 114, 120. [10] Plates 10, 12, 17, 21, 43, 59.

[11] Originally an ornamental, inlaid design.

[12] George Wither, *A Collection of Emblemes, Ancient and Moderne: Quickened with Metrical Illustrations, both Morall and Divine* (London, 1635), preface.

[13] First published in 1531. The author consulted the 1551 edition: *Emblemata D.A. Alciati, denuo an ipso autore recognita, ac, quae desiderabantur, imaginibus locupletata* (Leiden, 1551).

[14] Geffrey Whitney, *A Choice of Emblemes and Other Devises, for the Moste Parte Gathered out of Sundrie Writers, Englished and Moralised* (Leiden, 1586).

[15] F. Quarles, *Emblemes* (London, 1634).

emblems, taken, in part, from Pliny (e.g. the lion as the symbol of courage; the pelican feeding her offspring with her own blood, as representing duty and charity).

Emblem books such as Quarles's were devotional: inspiring, exhortative *psychomachias*, depicting the struggle of the soul to free itself of its earthly cares and attain salvation. Many devotional emblem books were published by the Jesuits in the seventeenth century. As with other forms of religious art, they were believed to be useful in instruction, persuasion, and the deepening of faith.

Also belonging to this emblematic literature were the more profane collections of devices and 'impresa', such as Henry Peacham's *Minerva Britanna*[16] and *The Mirrour of Maiestie*.[17] A decorative figure in heraldic design, the device was usually intended as an illustration of a motto or ideal, as are often found on the legends of coats-of-arms. The devices of *The Mirrour of Maiestie* illustrate the heroic virtue, employing animal imagery (such as the lion of courage and royalty), and conventional attributes like the sword and scales of Justice, the cornucopia of Plenty. A common device is the hand protruding from clouds— divine or providential bestowal—holding some attribute or other (e.g. the caduceus of wisdom).

The popularity of emblem books and devices waned in the late seventeenth century, a decline which coincided with their change from a mature literary and artistic genre to a pedagogical amusement for children.[18] The spread of natural philosophy with its new epistemology helped bring about the decline. Sir Thomas Browne argued that the allegorical and emblematic way of thinking was an erroneous disposition which hindered man's pursuit of knowledge. Browne uncovered many fallacies in the old bestiaries, 'propagated by Emblems. . . .'[19]

[16] Henry Peacham, *Minerva Britanna or a Garden of Heroical Devises, furnished and adorned with Emblemes and Impresa's of Sundry Natures, Newly devised, moralized, and published* (London, n.d. [1612]).

[17] Henry Green and James Croston (edd.), *The Mirrour of Maiestie: or the Badges of Honour Conceitedly Emblazoned* (London, 1870). The book was first published, anonymously, in 1618.

[18] On this subject and the subject of emblem books in general see Rosemary Freeman, *English Emblem Books* (London, 1948), and Praz, *Studies in Seventeenth-Century Imagery*, vol. 1.

[19] Charles Sayle (ed.), *The Works of Sir Thomas Browne* (Edinburgh, 1912), i.322.

The Hieroglyphical doctrine of the Aegyptians . . . hath much advanced many popular conceits. For using a Alphabet of things, and not of Words, through the images and pictures thereof, they endeavoured to speak their hidden conceits in the letters and language of Nature.[20]

These errors, he said, 'are still retained by symbolical Writers, Emblematists, Heralds, and others'.[21]

If the enlightened thinking of men such as Browne considered the emblematic way of thinking a hindrance to man's intellectual advancement, the symbolic habit of mind was difficult to erase. Delight in emblematic representation continued into the eighteenth century. Political satirists found its language a convenient tool with which to disguise their barbs and gibes at a not very tolerant authority.

Whoever is conversant in the Learning of the Antients, will find that originally the method amongst them of communicating their Conceptions . . . was by *Representative Symbols*, by *Allegories* and by *Fables*. . . . The true Father of *Letters* was a *Hieroglyphick*. . . . As therefore this *allegorical* way of Writing is certainly the most *learned* as well as the most *antient*, so I hold it likewise to be the *safest* in all *modern Performances*; especially if an Author is, in any wise, addicted to Writing on *political Subjects*.[22]

The political print, sometimes styled as an emblem or device, shared with the emblem books not only a common nomenclature and much symbolism, but a rhetorical purpose as well. Though the latter was usually highminded and serious, and the former often jocular and mundane, both sought to move, to persuade their audiences in some way. A large proportion of satirical prints also share with the emblems a basic structure: a title (often in the form of epigram or pithy saying), a pictorial design, and supplemental verses.

Distinct from 'emblem' and the other synonyms, 'print' itself is a generic word, common to graphic art in general, to the process of reproduction of a design by transferring or 'printing' it. The print has been for centuries a medium of satire and propaganda, a medium especially suited to these subversive and critical purposes.

From the beginning of European printmaking in the fifteenth century until the present, the printmaker, in his work, has looked askance and

[20] Ibid., p. 180. [21] Ibid. [22] *Craftsman*, 9 Dec. 1727.

looked askew at all the powers that govern man, at Church and State, at science and art, at justice and war, at love itself.[23]

A market for polemical tracts, broadsides, and prints developed during the Reformation. Pictorial propaganda, mainly in the form of woodcuts, appeared in England at this time, but did not become important until the political and religious struggles of the seventeenth century.[24] The predominantly theological nature of this polemic shaped the character and substance of the symbolism. As a result of the prevailing tendency to choose a Manichean point of view, the Devil and his hellish legions appear frequently. There, too, are the flames of purgatory, pictorial metaphors such as the Mouth of Hell, and creatures of all sorts, including hell-hounds, dragons, and hydras. Arrayed against them are the forces of righteousness, usually represented by the personifications of Truth, Justice, and Religion.

The course of events in the second half of the seventeenth century brought the introduction of Dutch prints into England. First because of commercial rivalry and then because of political alliance, many prints published in the Netherlands dealt with English affairs. Numerically and qualitatively, Dutch satire predominated in the second half of the century, best represented by the extraordinary impact of Romeyne de Hooghe's graphic commemorations of the Glorious Revolution and his pillorying of Louis XIV.

Dutch graphic satire possessed certain characteristics which eventually influenced prints across the Channel. Many of the Dutch prints of the seventeenth century were commemorative in nature: graphic commentaries, in the spirit of historical paintings, on great events such as military victories, the signing of treaties, the death of kings, and major crises like the Glorious Revolution and the South Sea Bubble. Again, the subject-matter dictated the choice of symbols: statuesque, formal presentations, offering conventional allegorical figures.

The heavily symbolic character of this satire and propaganda was in keeping with the art of medallic illustration. Dutch medals, struck primarily for commemorative purposes, carried further the

[23] Frank and Dorothy Getlein, *The Bite of the Print* (New York, 1963), p. 6.
[24] See M. Dorothy George, *English Political Caricature: a Study of Opinion and Propaganda* (2 vols., Oxford, 1959), vol. i.

use of formal, conventional iconography and often adapted it to political satire.[25]

The symbolism thus carried in the prints and medals of the sixteenth and seventeenth centuries, particularly as it applied to certain standard subjects, provided a tradition for the political prints of the Georgian era. The medium, itself, had been established and partially developed. Earlier prints were perhaps the most intimate and immediate source of Georgian graphic satire. The inventors and draughtsmen of the eighteenth century borrowed, copied, and stole from a corpus of prints accumulating for over a century. Many throwbacks in imagery and motif occur. *Guy Vaux the 2.d* [BMC 3439, Plate 83], for example, a satire on Henry Fox, showing him approaching Parliament surreptitiously at night, with lantern in hand and the Eye of Providence above, is a variant of a theme incorporated into several prints of the seventeenth century, all having to do with Guy Fawkes's Gunpowder Plot.[26]

The reissuing of successful prints was a common practice in the eighteenth century. An accumulated stock of old plates and prints lying about the printshops provided inventors and draughtsmen with a source of ideas. One is struck by the curious repetition of imagery.[27] In addition, the original state of a print or a variant state will sometimes appear years after the publication of the original. *The Stature of a Great Man or the English Colossus* [BMC 2458, Plate 32], for example, which was a satire on Robert Walpole published in 1740, appeared again, over twenty years later, as a satire on Lord Bute; the same engraving was used, but with appropriate changes to the face.[28] This dependency and repetitiveness, together with the symbolism, confirm the

[25] The classic work on the subject of the Dutch medal is the catalogue of Gerard Van Loon, the French translation of which is *Histoire métallique des XVII Provinces des Pays-Bas, depuis l'abdication de Charles Quint jusqu'à la Paix de Bade en MDCCXVI* (5 vols., Hague, 1732–7).

[26] e.g. the frontispiece to *November the 5, 1605. The Quintessence of Cruelty, or Master-Peice* [sic] *of Treachery, the Popish Pouder-Plot* [sic] (London, 1641) [BMC 64].

[27] Plate 91 contains two designs which are almost exact reproductions of designs in a print published years before: *London's Conduct stands the Test, or Bristol & Nottingham weighed in the Balance & found Light: with a Sketch of a M–l Forge, and the Worcester Magician* [BMC 2577]. Plate 91 is a copy of a print without title, in the author's possession (not in the British Museum collection).

[28] *The Stature of a Great Man, or the Scotch Colossus* [BMC 4000].

impression of conventionality in the graphic satire of the period.[29]

Quite different in character was the other principal source of the eighteenth-century political print; a source which, too, is attached to the nomenclature of pictorial satire. This source—fresh, innovative—is 'caricature'. The emblematic tradition, drawn primarily from the various iconographic sources, served as the mainstay of graphic satire until the middle of the eighteenth century, when caricature, hitherto alien in name and technique, began to change the character of the print. Political caricature is, in truth, a flower and not a seed of eighteenth-century satire.

The word has several meanings. In its broadest sense, caricature has been, since Gillray, the name given to all forms of graphic satire.[30] Its more precise (and proper) definition limits caricature to an artistic technique which distorts the human image by exaggeration of individual characteristics (or deviations from some ideal norm).

The Sculptors of ancient Greece seem to have diligently observed the forms and proportions constituting the European ideas of beauty; and upon them to have formed their statues. These measures are to be met with in many drawing books; a slight deviation from them, by the predominancy of any feature, constitutes what is called *Character*, and serves to discriminate the owner thereof, and to fix the idea of identity. This deviation, or peculiarity, aggraved, forms *Caricature*.[31]

Caricature, therefore, seeks to 'perfect' or complete the deformity, or to abuse the 'real' image of an individual, mimicking

[29] Artists are, perhaps, by nature imitative. So much of the substance and style of art—at least of the Renaissance, Baroque, and Neoclassical periods—is in the nature of a commentary on previous art. This phenomenon frequently takes the form of allusion. It is not surprising that, in this respect, lowly satire catches a reflection of the sublime reaches of the grand style. Many of the draughtsmen and engravers of political prints were experienced in the graphic reproduction of the old masters. They carried over from the latter to the former not only iconography but basic principles of composition—symmetry, contrast, unity, balance—and stock elements of design such as decorative ornament, the architectonic framework, landscape background, and curtain-drapery framing. There is allusive commentary as well: some prints are clever imitations of old masterpieces.

[30] Thomas Wright's, *A History of Caricature & Grotesque in Literature and Art* (London, 1865) is typical of the way in which the word was misused. Many students of graphic satire assumed that Gillray, Rowlandson, and, later, Daumier 'established' such satire with their caricatures, and therefore they used the word generically.

[31] Francis Grose, *Rules for Drawing Caricatures: with an Essay on Comic Painting* (London, 1791), p. 6, in a footnote.

his own individuality by exaggerating it. The word comes from the Italian *caricare*: to charge or overload.

Hogarth objected to 'caricatura' because, as he understood it, the technique completely ignored 'character'.[32] In abbreviated, linear fashion it indulged in the fanciful changing of a person's appearance, striking outlandish parallels with the features of animals. Caricature was, to him, a game, a gimmick, a toy, but not respectable art. Such, perhaps, was the caricature in which Italian artists and English dilettantes indulged in Hogarth's day. But caricature in principle, and eventually in practice, included the 'character' that Hogarth believed so important. This principle of caricature accepts the assumption of physiognomy: that a man's inner being can somehow be reflected in his external appearance.[33] Caricature, though perhaps more extreme than character in technique, seeks in a succinct and composite image to capture the substantive character as well. It can be a powerful weapon of satire.

An avocation of Italian artists in the seventeenth century, 'caricatura' first became known in England in the early 1700s. Pier Leone Ghezzi's grotesque portrait-caricature of eminent personages in seventeenth-century Rome appeared in England in the early part of the eighteenth century. Arthur Pond was the first native artist to popularize caricature as a fashion.

The beginning of political caricature is difficult to date precisely. The word itself does not appear on prints until the 1750s.[34] By the early years of George III's reign 'caricature' was fashion-

[32] Henry Fielding is supposed to have expressed Hogarth's feelings about the subject when he wrote in the preface to *Joseph Andrews*: the excellence of Comic History Painting rests 'in the exactest Copying of Nature; insomuch that a judicious Eye instantly rejects anything *outré* . . . whereas in the Caricatura we allow all licence,—its aim is to exhibit Monsters, not Men; and all Distortions and Exaggerations whatever are within its proper Province. . . . what Caricature is in Painting, Burlesque is in Writing. . . .'' Henry Fielding, *Joseph Andrews*, ed. J. P. de Castro (London, 1929), p. 21.

[33] Man's ancient awareness of his affinity with the animals, observed by Aristotle, is one of the bases of physiognomy. At the end of the seventeenth century, Le Brun, the father of this pseudo-science, pointed out the close coincidences in the physical characteristics of man and beasts, and argued that these physical associations indicated similarities in character and behaviour as well. The theory contained the seed of caricature: the exaggeration of a slight resemblance into a clear parallel, thereby suggesting some other connection between the two sides of the parallel. A man who looks like a fox might, indeed, be 'foxy'. This form of caricature appears in many of the personal satires of the time. See below, chap. viii.

[34] Below, pp. 37, 53–7.

able; a good number of prints advertised in the London news-
papers were now described in this way. In 1762 Mary Darly, one
of the major printsellers, published a book, entitled *A Book of
Caricaturas, on Sixty Copper-Plates*,[35] a hastily and poorly pre-
pared work, in which are collected a few meagre impressions of
indifferent etchings. The book was probably intended for an easy
profit from what had become a popular fashion. The publisher
says of caricature:

Caricature is the burlesque of character, or an exaggeration of nature,
when not very pleasing, it's a manner of drawing that has & still is held
in great esteem both by the Italiens [*sic*] & French, some of our
Nobility & Gentry at this time do equal if not excel any thing of the
kind that has been done in any other country, tis the most diverting
species of designing & will certainly keep those that practise it out of the
hippo, or Vapours & that it may have such an effect on her friends is the
wish of M.ͬ Darly.[36]

The collection pretends to demonstrate the theory of caricature,
its impressions showing the various 'types' of profiles and features.
Several of the designs are taken from political prints published
earlier.

Theory and practice aside, the actual origins of caricature in the
political print are obscure. One should make a distinction between
caricature as a theoretical technique and caricature as a phe-
nomenon. The phenomenon predates both the fashion and the
theory. Phenomenological caricature is, in a sense, as old as the
taste for the grotesque in art.[37]

The bulk of political prints in the early and mid-Georgian era
show no indication of caricature in the theoretical sense. Many
offer unskilled and casual attempts at realistic likenesses. Some
are crude, especially the woodcuts. But a few prints suggest a

[35] *A Book of Caricaturas, on Sixty Copper-Plates. With the Principles of Designing,
in that Droll & pleasing Manner; by M. Darly with Sundry Ancient & Modern
Examples & several well known Caricaturas. Taken from the Tabernacles, Newmarket
Playhouses, &. &.* (London, 1762); an advertisement for this book appeared in the
Public Advertiser, 21 Dec. 1762: 'For the Use of Young Gentlemen and Ladies . . .
The Principles of Caricature on 60 Copper-plates, laid down in so easy a Manner
that a young Genius may soon attain to a Facility in Drawing any Droll Phiz, or
Carrick. . . .'

[36] Ibid., p. 2.

[37] Certainly as old as the interest in varieties and deviations in physiognomy. In
this sense, Leonardo's facial studies can be considered caricature, or 'proto-
caricature'.

playful changing of the portrait likeness, an interest in the grotesque, and an awareness on the part of the artist that the individual characteristics can be exaggerated for satiric effect. An example is the study of Lord Chancellor Hardwicke in *A Political Battle Royal, Design'd for Brougton's New Amphitheater* [BMC 2581, Plate 49].[38] The face is amusing: enough resemblance to the person, but an image transformed into a clown by the idiotic or inebriated expression. Another example is *The Anti-Crafts Man Unmask'd* [PML.ii.17ˇ61, Plate 47],[39] in which William Pulteney, the Opposition patriot-turned-courtier, displays a study in grotesqueness: a malevolent leer, a toothy grin—a face not as full as Pulteney's, but with his sharp, aquiline nose. In the same vein, but more lighthearted, is the study of Robert Walpole in *The late P–m–r M–n–r* [Plate 54]: not a good likeness of the minister, but a comic face that sticks in the mind.

Closer to actual caricature are many portrait studies with just enough exaggeration and recurrence in the prints to become humorous, fixed images of the individuals they portray. The profile study of George II in Plate 51 [40] is a characterization of the King which appears several times in the prints of the 1740s and which resembles the portrait in Plate 7.[41] It fixes the King in a characteristic image: stiff, erect, goggle-eyed; with a high prominent nose; an inscrutable smile on the thin, tight lips. In much the same way the image of the stout Tory M.P., Sir John Hynde Cotton, in *A very Extraordinary Motion* [BMC 2613, Plate 55], and which can be seen almost without alteration in other prints, makes a caricature of the large, bulky profile, especially the massive chest and paunch, large head, jutting chin, and cheery smile.

As frequent and naturally expressive as caricature may have

[38] Hardwicke is the figure standing in the background in the centre of the design.

[39] The figure in this particular print may be intended to represent Walpole, as a rejoinder to *The Craftsman Unmasked*, which is an attack on Pulteney [BMC 2557]; the images in both prints are the same.

[40] This print is probably the work of Bickham. Along with *The late P–m–r M–n–r*, also his, *A Political Battle Royal* and *The Court Fright* [BMC 2606, Plate 53] (possibly by the same artist, though their styles are, in certain respects, dissimilar), it demonstrates Bickham's abilities as a proto-caricaturist, adept in the study of the grotesque.

[41] Freeman O'Donoghue (ed.), *Catalogue of Engraved British Portraits Preserved in the Department of Prints and Drawings in the British Museum* (4 vols., London, 1908–14), i, No. 46.

been in the prints of the 1740s, not until a decade later, when the word itself begins to appear, does a distinctive style of caricature take form. This style is marked by greater simplicity in design and greater emphasis upon personal satire.[42]

The numerous outline-etchings and engravings produced in the late 1750s and early 1760s display the succinct qualities of this caricature. While many of these designs suggest a childish crudity, there often seems to be an intentional simplicity, a fanciful attempt to capture in a few lines the outstanding features of personality.[43] The Distressed Statesman [BMC 3594, Plate 95], for example, a satirical study of William Pitt, is caricature in the style of Ghezzi: a bare outline profile; stark simplicity with the absence of background.

Such designs differ as much from the grotesque proto-caricatures of the 1740s as they do from the fulsome images of Rowlandson and Gillray. All the styles, however, agree in their interest and aim. The gift of caricature is the imaginative appreciation of personality, an eye for the physical characteristics of the individual, and, to the extent that they can be captured in the work of pen, graver, and needle, the personality and also character.

The difference between the iconographic print and caricature is, in a theoretical sense, fundamental. The former satirizes a particular individual or concept by associating him (or it) with appropriate symbols and stereotypes; the latter concentrates on the individual himself and is of a more subjective, personal nature. Graphic satire employing conventional symbols tends to be impersonal. To the extent that it concerns itself with individuals it portrays them in a realistic way; it treats them as stereotypes and measures them by objective norms, embodied in a cluster of conventional symbols.[44] If ridicule is the objective, such

[42] See, among the large number of prints published in the mid-1750s attacking the Newcastle ministry, Plates 79, 81, and 82.

[43] Many of these prints have been attributed to George Townshend (see below, p. 51ff). They include some of the above-mentioned satires on the Newcastle ministry. The Recruiting Serjeantor Brittanniais Happy Prospect [BMC 3581, Plate 93], is a Townshend; it contains caricature portraits of several figures, including the 8th Earl of Winchilsea and George Bubb Dodington on the left. Compare this print with Plate 94, which is a reproduction of a drawing attributed to Hogarth in the Earl of Exeter's collection. The drawing is somewhat of a puzzle: if it is by Hogarth, did he provide Townshend with the two caricatures or, more likely, was he mimicking Townshend's caricature style? Below, p. 49.

[44] Consider Plates 10, 12, 33, 44, 62, and 71.

satire resorts to stock motifs of denigration, as in *Idol-Worship or The Way to Preferment* [BMC 2447, Plate 28], in which the victim is placed in a demeaning position. The image is impersonal; there is no individuality. Only with the context, date, and inscriptions, is it obvious that the subject is Robert Walpole.

Caricature, on the other hand, interests itself in the individual himself. It does not measure its victim by objective norms, but rather by his own individuality. In its pure sense caricature pretends to be valueless: it does not judge the individual, but reveals him for what he is, and lets the viewer judge on the basis of that revelation.

Analysis of these two forms of graphic satire draws sharp distinctions. A truer understanding of the prints requires that these distinctions not be pushed too far. The forms intermix. Many prints do not fall unequivocally into either category. Many prints, often turned out by second- and third-rate draughtsmen, especially in the burgeoning publication of the 1760s, are of indifferent artistic quality: whose sense and humour depend upon the inscriptions and setting of the design.

The emblematic tradition, carried in diverse receptacles, and caricature in budding form, are the distinct though converging artistic sources of the eighteenth-century political print. The print can claim association with a tradition of graphic satire and propaganda of ancient lineage. It possesses, nevertheless, an individual identity: a distinctive quality that stems from the print's eclectic character, drawing ideas and spirit from many sources. Much of its humour derives from jest-books and bawdy tales; its verses from street ballads and folksongs; the metaphors and motifs of many of its designs from children's games, chapbooks, and fables. The political print was nourished by, as well as being a part of, the wellsprings of popular culture. The development and growth of graphic satire in the eighteenth century was, moreover, a peculiarly English phenomenon.

2. The Publishers

The production of prints was a manifold process, requiring the work of draughtsman and engraver, printer, publisher, and seller. In theory each function was distinct, but in practice they were often jumbled together, sometimes involving only one or two individuals.

The publication line which often appears at the bottom of a print usually gives the name of the publisher, in the form of 'published by' or 'printed for' such-and-such a person, and in some cases followed by 'and to be had at the Printshops of London and Westminster'. Not all printsellers published; most publishers were printsellers. Sometimes the publisher bought plates from the artists who designed and engraved them. Sometimes he regularly hired the talents of artists who produced the plates that he would request. It was just as common, however, for independent draughtsmen and engravers to be their own publishers and sellers, and many of them ran their own shops.

The old regulations of the Stationers' Company clearly distinguished between printers and sellers; it closely restricted the number of printing presses in England. These restrictions had ceased to be applicable in the eighteenth century, as independent presses had flourished for some time. A few publishers probably took their work to one of the established printers in London, who would often employ their presses, when idle from the printing of books and tracts, in producing the trivia of the printing trade: shopcards, handbills, theatre tickets, and other engraved or etched material.[45] Other publishers operated their own presses; the printing from the copper-plate design was a relatively simple procedure.[46]

After printing, the publisher made the prints ready for sale, often with an advertisement in the newspapers and with the distribution of the prints among other printsellers. These sellers would, in some instances, purchase the material at a cut-rate price or exchange other prints for them. The growing market for prints made it advantageous for each printshop to have as wide a selection as possible. The exchange and sale of printed matter among the various shops was an important part of the business.[47]

Hogarth, as mentioned above, stated in 1735 that there were no more than twelve major printshops in the whole of London and Westminster. He charged in his pamphlet that a clique of printsellers monopolized the trade. He had especially in mind those

[45] See P. M. Handover, *Printing in London from 1476 to Modern Times: Competitive Practice and Technical Invention in the Trade of Book and Bible Printing, Periodical Production, Jobbing* (Cambridge, Mass., 1960), chap. vii.

[46] Save for plates where letter-press was added, the work of the compositor was not needed, since the engraver had prepared the plate.

[47] See below, chap. iii.

with large inventories, ideal locations, and established reputa-
tions, who did most of the publishing. These few men were,
according to Hogarth, not giving the artists a just proportion of
the profits from sales. And the artists were at the mercy of the
printsellers because

few of these Artists, in the present Condition of the Profession, have
Houses conveniently situated for exposing their Prints to Sale; and
Those, who have, have much more advantageous Ways of spending
their Time, than in Shewing their Prints to their Customers. The Shops
therefore are the only Places proper for this Purpose.[48]

The owners of the major shops acted in collusion to keep their
artists in line. Upon agreeing to publish a print they 'insist upon
a most unreasonable Share of the Profits for selling the Prints,
near double what a Bookseller ever demands for publishing a
Book'.[49] More than this, however, the printsellers, when they
find a popular print, arrange to have copies made for sale and none
of the profits from this sale go to the artist of the original. 'One
Artist's having it in his Power to copy the Designs of another is,
therefore, the true Source of all these Grievances.'[50] The conse-
quence was that the artist is 'kept Night and Day at Work at
miserable Prices, whilst the overgrown Shopkeeper has the main
profit of their Labour'.[51]

Hogarth concluded his argument with a request for a copyright
law to protect the original designers of plates. He argued that the
intrinsic value of talent should enjoy just extrinsic rewards; copy-
ing required little talent and therefore should have little re-
muneration. An act to protect the creativity of design would, he
said, promote the arts in England and benefit the printsellers as
well since it would 'increase the Number of those who bring
Prints to their Shops, and encourage those who purchase, by
improving the Prints, and lowering the Price. . . .'[52]

Hogarth asked the same privileges for the artist that had been
given to authors in the copyright act of 1709. The situations were
similar to an extent: creative talent was, without protection,
subject to exploitation and unrewarded effort. There were also
differences. The writer was and is largely removed in his work
from the business of printing and publishing; his talent had

[48] *The Case of Designers, Engravers, Etchers, &c. Stated*, p. 2.
[49] Ibid., p. 3. [50] Ibid. [51] Ibid. [52] Ibid., p. 6.

nothing to do with putting his work into printed form. Draughts-men, on the other hand, were very often engravers and/or etchers as well. They usually had no need of a compositor. The artist's talents could produce a copper-plate ready to be printed. All that was needed was a small press (or a willing printer) and the desire to sell their prints at their own residences.

None the less, in 1735 Parliament enacted a law to guarantee the rights for which Hogarth asked.[53] Although a public statute, it has been rightfully styled 'Hogarth's Act', since for all intents and purposes it was specifically designed to satisfy a grievance that had been almost solely his. The great popularity of his *A Harlot's Progress* encouraged pirated copies. Hogarth's aim was to secure for himself the rewards of his individual genius. The rest—the abusive cliques of printsellers, exploitation, the diffi-culties of the artist setting up his own business—he exaggerated from his own rather special circumstances into a general indict-ment of the trade.

The nature of the trade provided, as Hogarth's own career testifies, the draughtsman-engraver with a certain degree of independence. This independence was also possible in the pro-duction and sale of political prints, where skilled design and engraving were not at a premium. Hogarth's Act may have encouraged this independence but designers and engravers who had their own printshops existed before the act was passed. The act provided that

every Person who shall Invent and Design, Engrave, Etch, or Work in Mezzotinto, or Chiaro Oscuro, or from his own Works or Invention, shall Cause to be Designed and Engraved, Etched, or Worked in Mezzotinto or Chiaro Oscuro, any Historical or other Print or Prints, shall have the sole Right and Liberty of Printing and Reprinting the same, for the Term of Fourteen Years. . . .[54]

The act also specified that 'the Day of the first Publishing . . . shall be truly engraved with the Name of the Proprietor on each Plate, and Printed on every such Print or Prints. . . .'[55] All print-

[53] *An Act for the Encouragement of the Arts of Designing, Engraving, and Etching Historical and other Prints, by Vesting the Properties thereof in the Inventors and Engravers, during the Time therein mentioned.* A copy of the publication of the statute is in the British Museum, but without indication of date or publisher. Also, P.R.O., Parliament Rolls, 8 Geo. II (roll 5).

[54] Ibid., p. 2.　　[55] Ibid.

sellers were forbidden, within the period of the copyright, to copy or sell the print 'without the Consent of the Proprietor or Proprietors . . . obtained in Writing, signed by him or them respectively, in the Presence of Two or more credible Witnesses. . . .'[56]

The first visible effect of the act was to create a publication line on most prints, including political satires. This line followed a usual form with 'Published according to Act of Parliament' (sometimes abbreviated), followed by the date of publication and the name of the publisher. The shop and its location were frequently added, as free advertisement for the publisher. In most instances proprietorship belonged to the publisher or printseller, who were not necessarily the original designer and engraver.

The act did little to change the nature of printselling itself. The majority of publishers continued to be printsellers who commissioned artists to do their work. Many artists, as mentioned, were also engaged in printselling. Cheap as political prints were— requiring little time or special talent—the publishers did not always take care to secure the copyright. In fact, a loophole in the statute did not protect a publisher if he was not, as well, the inventor of the print. On many prints 'Publish'd according to Act' is not even mentioned. Copying and plagiarism continued, for the act was rarely enforced. The first conviction did not come until fifteen years later:

Tuesday 24. Was a tryal at the Court of *King's Bench* in *Guildhall* (being the first on the statute) between a printseller in *Fleet-street*, plaintiff, and a publisher on *London* bridge, defendant, for the latter's selling several base and spurious wood print copies of a graving, the plaintiff's property, contrary to an act of parliament made the 18th of his present majesty, inflicting a penalty of 5s. per print; a verdict was given for the plaintiff.[57]

Woodcut productions of more finely-done engravings were frequent, as were the generous borrowing and imitation of ideas and themes. The *European Race* series brought several imitations. *The Motion* was followed by a print of the same title and

[56] Ibid.
[57] *Gentleman's Magazine* (July 1750), xx.331. The '18th of his present majesty' should read the '8th'.

theme [BMC 2478]. The many book-collections of prints consisted of copies, sometimes reversed and reduced, of original prints. It is not likely that the copyright was respected in all these cases.

3. *The Artists*

Anonymity prevails over much of the invention and design of satirical prints. Little is known of the men who possessed the inventive wit, the necessary information of the happenings in the political and social worlds, and the ability to transpose both into graphic satire. The ideas for many prints, indeed the designs themselves, came as suggestions from people outside the trade. Prints did not, like cartoons today, provide instant commentary on the typical events of a changing political scene. A delay of weeks was not uncommon. No doubt much of the necessary information spread quickly through the newspapers and into the gossip of the coffee-houses. But often a good deal of time and labour would be required before this information was translated into graphic satire.[58]

Most of this work was done by the fraternity of draughtsmen and engravers then in London. During the century there developed a market for prints and graphic illustrations of all sorts. There was much in the way of reproductions of paintings, ornamental designs in bookplates and frontispieces that contemporary taste demanded. Engaged in satisfying this demand were a large

[58] Creation of the print began with the design, done in ink and wash to indicate line and shading. The task of reproducing the design on copper-plate was a slow process, especially if the design were complicated. The engraving had to be done in reverse of the final impression. Mistakes frequently appeared: a letter reproduced backwards, a sword and scabbard on the right hip instead of the left. The job of making inscriptions may have been left by the draughtsman and engraver to another person, an inscriber who worked for the publisher. Here, again, accidents occurred. The 'balloons' provided by the engraver were sometimes not ample enough to hold the inscriptions.

The majority of political prints of the period 1727–63 are engravings. Not all, however, are 'pure' engravings; it was not uncommon in the eighteenth century to combine the processes of engraving and etching. Etching, lending itself to the freer qualities of caricature, became the principal tool of satire in the second half of the century. Mezzotint, though its softer, tonal qualities made it effective in the reproduction of paintings, was not frequently used in political prints. It was not easily adapted to the inclusive nature of the satiric print, with the latter's small figures, balloons, and inscriptions.

number of artists. At their best, most seemed to have been merely competent:

industrious men, whose labours were chiefly confined to the embellish-
ment of books, plays, and pamphlets. It was a happy circumstance for the
artists of this class, that the taste of their employers was not more re-
fined, otherwise they would, without doubt, have considered the en-
gravings as a disgrace, rather than an ornament, to any creditable
publication.[59]

A nearly contemporary and rather spiteful view—and not es-
pecially fair. Some of their reproductive and original work is of
excellent quality. In the modest, but freer and mostly untried
element of political satire, some of these artists display great
invention as well as skill.

Vertue's list of copper-plate engravers working in London in
1744 numbers almost fifty.[60] Many were Frenchmen, or persons
of French origin. Their names include Daniel Fournier, John
Simon, Claude Dubosc, Bernard Baron, Paul Fourdrinier, Hubert
Francis Gravelot, Simon Ravenet (father and son), Gerard Scotin,
Pierre Charles Canot, Louis Boitard, Francois Vivares, Antoine
Benoist, and Charles Grignion. A few became permanently
established in London; some migrated back and forth between
England and the Continent.

The presence of these artists in London is not surprising.
French taste and fashion were a common—if much inveighed
against—fixture in English life. French artists had been for some
time masters of the graphic arts, especially skilled in ornamental
design. In William III's time and during the war of the Spanish
Succession artists from the Netherlands supplied the English
market. During and after the war a migration of French draughts-
men and engravers began.

The end of the war was one of the reasons for this migration.
There were others. Business was better in London than in Paris,

[59] Joseph Strutt, *A Biographical Dictionary; Containing an Historical Account of All
the Engravers, from the Earliest Period of the Art of Engraving to the Present Time;
and a Short List of Their Most Esteemed Works* (2 vols., London, 1785), i.304.

[60] 'Vertue Note Books, Volume VI', *The Thirtieth Volume of the Walpole Society*
(Oxford, 1955), pp. 197–8. Himself an engraver of some distinction, George
Vertue's antiquarian interests and wide travels enabled him to compile a mass of
notes, which now serve as valuable source-material for the study of English en-
graving in the eighteenth century.

because of the former's rapidly growing publication trade—books primarily, but also pamphlets and prints. The publishers needed artists that England could not then supply. So they encouraged or contracted with the French to come over.

Politics, or at least religious conviction, was another reason for this migration. The Huguenots, displaced by Louis XIV, enriched many areas of British life. One of the French artists, Fournier, was the son of French refugees. Some of the best anti-French prints were done by artists such as him. *The Glory of France* [BMC 2849, Plate 62] is Fournier's bitter testament to the nation of his origin.

The French nationality of the artist was the subject of controversy involving one pro-ministerial print published in 1730: *To the Glory of the R. Hon^{ble} S^r Robert Walpole* [BMC 1842, Plate 10]. Fourdrinier, whose name appears on many illustrations and frontispieces in the early and middle decades of the century,[61] engraved the print; two other Frenchmen named Dumouchel and Faget invented and designed it. The print is a graphic panegyric to the minister. Fourdrinier and the others may have been seeking patronage or favour. In any event, the subject of the print and the French background of the artists brought some twitting remarks in the Opposition *Craftsman*; a correspondent observed that 'a *curious print* hath been lately advertised in the News-Papers, and is now exhibited to Sale in the Print-Shops, entitled, *The Draught of a Print*, most humbly inscribed *to the Glory of the* Right Honourable Sir R–t W–le'.[62] The correspondent noticed that the authors of the print were 'three *loyal Frenchman*' and '*foreign* Patriots', who have created a '*fine, emblematical Panegyrick* (to the Honour and Glory of that *great Man*)'.[63] The writer then continued his ironic pose by giving a description of the print, offering interpretations, each with a *double entendre*.[64]

[61] Evidence suggests that there were two Fourdriniers working in London at this time (including Peter Fourdrinier, mentioned above, who kept a shop near Charing Cross).

[62] *Craftsman*, 20 June 1730. [63] Ibid.

[64] Plate 10 is one state of this print, without the artists' names and with the satiric rendering of the description added (which converted the print into an anti-Walpole satire). Shortly after the letter to the *Craftsman* an advertisement for the original print engraved by Fourdrinier appeared and warned that 'the Publick are desired to take Care not to be imposed on by very ordinary Copies of it, which are sold' (*Craftsman*, 11 July 1730). The print was reissued in 1740 with new letterpress.

Though many French artists had become established in London (and several had printshops there) and, in fact, had dominated the more serious engraving of the period, few made names for themselves with satiric studies. Most were primarily reproductive engravers. Gravelot, who was a designer of considerable ability and distinction, the draughtsman of innumerable illustrations for books and the like, only dabbled in satire. A print most likely inspired by *The Motion* series [BMC 2478], and *The Devil upon Two Sticks* [BMC 2439], an anti-Walpole print of 1741, are probably his.

Similarly, the names of Baron, Dubosc, Scotin, and Canot can be found on a scattering of prints, for the most part as engravers. Louis Boitard is an exception; he designed several satiric prints, including some anti-French pieces: *Britain's Rights maintained; or French Ambition dismantled* [BMC 3331] and *The Imports of Great Britain from France. Humbly addressed to the Laudable Associations of Anti-Gallicans* [BMC 3653],[65] two well-executed and complex satires.

There were other foreign artists in England at this time, primarily from the Low Countries. Dutch prints no longer flooded the English market, though attention was sometimes given to them:

Hague. Our *Pasquinading Painters* have resumed their antient Practice of turning the Affairs of *Europe* into *Ridicule*; having lately publish'd several *Droll Pieces* of this Kind . . . whilst our *French Artists*, in *London* are erecting *Monuments* and *Triumphal Arches* to the *Glory* of our *great Men*, these *Dutch Buffoons*, who are also our *Allies*, should have the Insolence to burlesque Them in such *infamous Parodies.*[66]

Especially popular prints would sometimes cross the Channel, the inscriptions of the plates changed to the proper language.[67]

Two prominent families of engravers, both with origins in the Low Countries, were living in England in the first half of the century, both in Bloomsbury Square: the two John Fabers (father and son) and the Vander Guchts, Michael the father, Gerard and

[65] This print, as well as *British Resentment, or the French fairly Coopt at Louisbourg* (as *Britain's Rights maintained*, a commentary on the early events of the Seven Years War), was published and sold by the Bowles family of printsellers.

[66] *Craftsman*, 25 July 1730; the allusion, of course, is to the Fourdrinier print.

[67] One such print is Charles Mosley's *The Invasion or Perkin's Triumph* on the Rebellion, which was also published in Holland with Dutch inscriptions [BMC 2637].

John, the two sons. Michael and John Vander Gucht worked as reproductive engravers, specializing in bookplates, anatomical and architectural studies.[68] Gerard was active for a span of some fifty years; he kept a shop at his residence in Bloomsbury.[69] He seems to have been more involved in political subjects. The government questioned him in connection with some designs he had presumably done for *A Philosophical Dissertation upon Death*.[70] He also engraved one of the few pro-Walpole prints ever to appear, the illustration to *The Patriot-Statesman* [BMC 2459, Plate 33], designed by Francis Hayman and published in 1740.

Hayman was a native draughtsman of some distinction. But for the English artists whose names are occasionally to be found on political prints—William Henry Toms, John June, Remigius and Nathaniel Parr, William Tringham, Henry Burgh, and Benjamin Cole—Strutt's assessment seems to apply: they were, as a rule, engravers with scarcely any genuine talent for the invention and design of satires.[71]

Significant, however, is the fact that the most prolific satirists of the period were English artists and printsellers, who designed, engraved, and sold their own prints. Bickham, Mosley, and the Darlys—who were the first to specialize in graphic satire—though overshadowed by the genius of Hogarth, established the English political print.

Hogarth, himself, has usually been placed apart from (and above) such men; it is a commonplace that Hogarth did not concern himself with politics. After the success of *A Harlot's Progress* and *A Rake's Progress*, legend has it that the artist was approached by members of the Opposition and asked to produce 'The Statesman's Progress' as a satire on Walpole.[72] Hogarth, the story goes, refused to prostitute his talents for the benefit of political factionalism.[73] Thirty years later, for reasons of loyalty and place (he

[68] John engraved the frontispieces to the fourth, fifth, and sixth volumes of the *Craftsman* (see below, chap. iii) and Plate 9. [69] Above, chap. i.

[70] S.P., Dom., Geo. II, Entry Book 32 (criminal warrants), not foliated. Gerard may have been the designer of *Aeneas in a Storm* [BMC 2326], a fine satire on George II and a print which has been attributed to Hogarth; see Ronald Paulson, *Hogarth's Graphic Works* (2 vols., New Haven, Conn., 1965), i.303–4.

[71] John June is an exception to the rule. He engraved, and most likely designed, several satires, including *The Comparison French Folly opposed to British Wisdom* [BMC 3546].

[72] Sir John Hawkins, *The Life of Samuel Johnson, LL.D.* (London, 1787), p. 500.

[73] A print with the same idea appeared anyway (see Plate 17, BMC 1938).

was then Sergeant Painter), hatred of his carping enemies in
Grub-street, financial losses, and a sense of justice and fair play,
Hogarth made a print in defence of Lord Bute's ministry, *The
Times Plate I* [BMC 3970, Plate 115].[74] The print caused a *furore*,
bringing the condemnation of the skilful and more numerous anti-
ministerial satirists down upon Hogarth's head. John Wilkes, in
the *North Briton*, acknowledged Hogarth's talents in calling him
'a very good moral satirist', but said he committed folly by sink-
ing to 'a level with the miserable tribe of party-etchers' and by
'entering into the poor politics of the faction of the day' instead
of remaining as he had, the instructor of the world 'by manly
moral satire'.[75]

Hogarth was more involved, however, in the political satire of
the day than these two incidents might suggest. He produced
other prints (or paintings after which prints were made) that
certainly belong to the corpus of political satire and propaganda.
The South Sea Scheme [BMC 1722] is one of the many prints on
that subject which marks the beginning of a new period in the
history of English graphic satire. *The Punishment Inflicted on
Lemuel Gulliver* [BMC 1797] and *Henry the Eighth and Anne
Boleyn*[76] are both in the spirit of the anti-court, anti-Walpole
propaganda expressed by the *Craftsman* in the late 1720s and
early 1730s; the former, a mock frontispiece to Swift's work,
employs the John Bull allegory to satirize Walpole. *The Gate of
Calais* [BMC 3050] and *The Invasion* series [BMC 3446–3461][77]
are in the tradition of the anti-French satires of the eighteenth
century.[78] The subject of Jacobitism is found in many of Hogarth's
prints. He designed a satirical headpiece for Henry Fielding's
Jacobite Journal, published in the aftermath of the Forty-five as a
rebuttal to the crypto-Jacobite ideas common in opposition
propaganda of the time.[79]

[74] The print is really more of an attack on Bute's enemies than a defence of the
minister.

[75] *North Briton*, 25 Sept. 1762. [76] Paulson, No. 116.

[77] The latter, published in the sombre year, 1756, is certainly a propaganda
effort. It employs the conventional device of contrast: French persecution, poverty,
and starvation as against English patriotism and plenty (in the same spirit, see
Plate 99).

[78] See below, chap. vi.

[79] Other prints have, at one time or another, been attributed to Hogarth. These
include *The Calf's Head Club* [BMC 2141] and *Aeneas in a Storm* (above, fn. 70).

So prolific was Hogarth's output and so wide-ranging his commentary on life in mid-Georgian England that political subjects found their way, directly or allusively, into other of his prints. This can be said, for instance, of *Masquerade Ticket* [BMC 1799], *The Stage Coach, or a Country Inn Yard* [BMC 2882], and *The March to Finchley* [BMC 2639]. *The Bench* [BMC 3662], a study of the Justices of the King's Bench (among them, Chief Justice Willes, passed over for the Lord Chancellorship in 1756) is a reaffirmation of Hogarth's distinction between character and caricature, a distinction he made some years before in *Characters and Caricatures* [BMC 2591]; it is also, incidentally, an attack on George Townshend whose card caricatures had become popular. Several of Hogarth's portraits, among them *Simon, Lord Lovat* [BMC 2801] and *John Wilkes* [BMC 4050], can be seen as satirical character studies. They are certainly political in substance.

Yet Wilkes was correct in saying that Hogarth had made a departure by involving himself in political factionalism. Hitherto he had maintained an Olympian detachment, refusing to take sides. About the time he designed the *Lemuel Gulliver* satire on Walpole, he also made an engraved salver for the Walpole family. The first two prints of his *Election* series were dedicated to Henry Fox and one of his political allies; the last of the series to George Hay, an ally of Fox's rival, Pitt. In one of his last prints, *The Times, Pl. 2* [BMC 3972], intended as a sequel, Hogarth returned to a non-partisan attitude; the satire (which he did not publish)—to the extent it has any clear meaning—is a general indictment of the political situation at the time.

Independence of mind, of course, does not preclude Hogarth's being a political satirist. A rugged independence distinguishes the work of James Gillray. Yet Hogarth differs from Gillray and other satirists who devoted their energies to political satire. The differences go beyond the distinction between character and caricature, or the fact that Hogarth was less interested in the study of individual personality than he was in the over-all scene. His allusive powers and grasp for topicality were all-searching, and so politics found its way into many of his prints. But it did so in many only to serve a more general purpose. The Oxfordshire election of 1754 inspired Hogarth's *Election* series, which contains many allusions of a topical nature to prominent figures and

events of the time. Yet the series is not about any particular election, nor is it, really, a political statement at all. Hogarth wanted to say something about the nature of man; the political context was incidental.

His prints, therefore, are not topical, but timeless.[80] This dissociates Hogarth from the main tradition of political prints. His work lacks that ephemeral, journalistic quality of such commentaries. And although Hogarth worked within many of the same conventions one sees in political satire—the spirit of 'O Tempora! O Mores!', the idealization of Old England and the unfavourable comparison of the present to the past[81]—he did so not for reasons of partisan indictment, nor even, so much, out of patriotic fervour, but rather as a genuine expression of a deeper and somewhat pessimistic feeling about the human condition.

Paul Sandby was Hogarth's *bête noire*, his most persistent and effective critic. He produced some of the most interesting satires of the period, mostly etchings, for the most part limited to two anti-Hogarthian flurries, the first in 1752–3, following the publication of *The Analysis of Beauty*; the second in 1762, inspired by Hogarth's sally into the political arena with *The Times Plate I*.

In the first series Sandby demonstrated definite satiric skills: the ability to turn many of Hogarth's ideas and images back upon their creator (and to mimic them), to incorporate into an integral design a wealth of allusions and variables, and a knack for caricature. The grotesque studies of Hogarth are savage.[82] The artist's animosity towards Hogarth derived in part from the

[80] Though it is certainly not the only example in the eighteenth century, the republishing of *The Punishment Inflicted on Lemuel Gulliver* in 1757 as *The Political Clyster* [BMC 3557], with hardly a change in the design, shows that Hogarth was not confined by topicality.

[81] As, for instance, his use of Britannia in the *Election* series or his feelings as expressed in *The Times. Pl. 2* and, his last work, *Tailpiece, or the Bathos* [BMC 4106].

[82] The prints include *Burlesque sur le Burlesque* [BMC 3240], *A New Dunciad done with a View of yᵉ fluctuating Ideas of Taste* [BMC 3241], *Puggs Graces Etched from his Original Daubing* [BMC 3242], *The Analyst Besh–n: in his own Taste* [BMC 3243], *The Author run Mad* [BMC 3244], *Montebank Painter* [BMC 3249], and, probably designed by Sandby, *Pug the Painter following the example of Messʳˢ Scumble Asphaltum & Varnish* [BMC 3277]. Another print, *Satire Representing the Burning of the Temple of Ephesus, &c.* [BMC 3245] is a departure from the other, more personal satires (though it contains allusions to Hogarth); this print illustrates Sandby's considerable ability as a landscape artist and his talent for chiaroscuro. Sandby, as with many other artists, preferred pseudonyms (often humorous) or anonymity in his satiric prints.

latter's opposition to the founding of the Academy (later, the Royal Academy) of which Sandby was a firm supporter.

The Times Plate I, which placed Hogarth in the difficult position of being the lone defender of an unpopular ministry, gave Sandby a splendid opportunity to renew the feud. He combined his attacks on Hogarth with some of the trenchant anti-Bute prints of the early 1760s. *The Butifyer. A Touch upon The Times* [BMC 3971, Plate 116] and *The Fire of Faction* [BMC 3955, Plate 114] are two of his prints. They display not only an obvious sophistication in design—in contrast to the meagre and often crude designs which appeared in many prints at this time—but show Sandby to be an artist of imagination and wit. The inventions and imagery in the designs are striking; in the case of *The Fire of Faction* perhaps so much so that the image overwhelms the sense of the print.[83]

Sandby lived for a time in Broad Street 'next door to the Fountain', where he sold in 1765 *Twelve London Cries done from the Life*, a collection of social caricatures. Thereafter Sandby's work in satire almost ceases. For many years he continued to pursue the work which had first brought him fame: landscapes.[84] A few caricatures in aquatint appear in the 1780s, but this is all. It was as Hogarth's nemesis that Sandby made his limited but admirable contribution to English graphic satire.[85]

Certainly the most atypical satirist of the period—and perhaps the most important—was George Townshend.[86] For Sandby satirical prints were secondary to the artist's major work; for Townshend, the proud aristocrat from one of the nation's premier families, they were a diversion. Townshend's place in the history of English graphic satire is obscured by the lack of compelling

[83] *A Poor Man Loaded with Mischief* [Plate 110] may be another of Sandby's prints; it was advertised, along with *The Butifyer* and *The Fire of Faction* in the *Public Advertiser*, 23 Sept. 1762, sold by Williams in Fleet Street. *John Bull's House sett in Flames* [Plate 108], *The Vision or M–n–st–l Monster* [Plate 117], and *Pug the snarling Cur chastised* [BMC 4083] might be Sandby's—the latter two in subject and style, the first in imagery, suggest so—but they came from different printshops.

[84] Known for his sketches of the Scottish Highlands (commissioned by the Duke of Cumberland), South Wales, and Windsor Castle and its environs. See A. F. Oppé (ed.), *The Drawings of Paul and Thomas Sandby in the Collection of His Majesty the King at Windsor Castle* (Oxford and London, 1947).

[85] Hogarth never saw fit, or never dared, to answer him.

[86] (1724–1807); he was the first Marquess, fourth Viscount Townshend.

evidence. Save for the witness of Horace Walpole, a tract or two, bits and snatches of contemporary correspondence, and some journalistic gossip, there is little to identify him with the many prints that appeared between 1756 and 1763, the time in which he is assumed to have been active. To prove that Townshend liked to draw caricatures is easy; to determine the prints for which he was responsible is difficult.[87]

George Townshend was the eldest son of the third Viscount Townshend and the grandson of 'Turnip Townshend', the statesman and agricultural reformer. His mother, the lively and scandalous Audrey, was one of the great wits and beauties of Georgian England. George's brother—the colourful and mischievous 'champagne Charley'—distinguished himself in a short, sometimes brilliant, but erratic political career. George entered politics through the army, receiving a captain's commission in 1744. He served with distinction under the Duke of Cumberland in Flanders and Scotland, and became the Duke's aide-de-camp in 1747. After promotions to lieutenant-colonel, Townshend retired from the army in 1750, largely as the result of a feud between him and Cumberland.[88] The latter's increased activity in domestic politics after the death of Frederick, Prince of Wales, his frustration of Townshend's desires for a second military career, and Charles Townshend's own political ambitions created the venom and wit that George Townshend was to display in so graphic a fashion.

George shared with his brother cleverness and a hard-drinking exuberance. Both frequented the bon-vivant world of clubs and coffee-houses. Like Charles, George was ambitious. He possessed geniality and good will, combined, however, with a quick and vindictive temper. Such attributes do not make for a steady course in public life. Townshend's career, first in the army and later as

[87] See C. Reginald Grundy, 'An XVIIIth Century Caricaturist: George, 1st Marquess Townshend', *The Connoisseur*, xciv.94–7; R. W. Ketton-Cremer, 'An Early Political Caricaturist', *Country Life*, 30 January 1964, pp. 214–16; much in the following pages is to be found in Herbert M. Atherton, 'George Townshend, Caricaturist', © 1971 by the Regents of the University of California. Reprinted from *Eighteenth-Century Studies*, volume 4, number 1, pp. 437–46, by permission of the Regents.

[88] Townshend was rumoured to have demeaned Cumberland, both in drawing and word, while serving under him. After his retirement, Townshend published a tract which was critical of the Duke and other British commanders in the War of the Austrian Succession.

Viceroy in Ireland, was troubled by controversy. He acquired many friends, but also a host of enemies.

The cleverness which Charles Townshend so aptly displayed in his speeches, George expressed with his pencil. He would draw rough sketches on tablecloths, scraps of paper, anything easy at hand. Throughout his active life he was eager for the latest political prints. When he was out of town, his friends would procure them for him. 'Dear Sir,' writes the Revd. Thomas Young in May 1763, 'I have not been able to purchase one of the caricaturas of Wilk[e]s—They are only at the Coffee houses—A Printseller has promis'd me two by to'morrow night. If he does not disappoint me, you shall receive them on Saturday. . . .'[89]

One of the first printed caricatures that has been attributed to Townshend is *The Pillars of the State* [BMC 3371, Plate 78],[90] published in 1756: a satire on the ministry of Newcastle and Fox. The print, which appears in the *Political and Satyrical History*, is a small one, possibly one of the many published at the time as illustrations on the backs of playing-cards. In the summer of 1756 Horace Walpole wrote to George Montagu, sending him some of these satirical cards which had come into fashion: 'There is nothing new, but what the pamphlet shops produce; however, it is pleasant, to have a new print or ballad every day—I never had an aversion to living in a Fronde. The enclosed cards are the freshest treason; the portraits by George Townshend are droll. . . .'[91] Most of the playing-cards to which Walpole probably refers offer portrait studies—caricatures of a sort. The same images of Newcastle and Fox appear repeatedly in this series of prints.

The British Museum contains two ink-drawings credited to Townshend.[92] The first is a crude but striking caricature of

[89] Historical Manuscripts Commission, *Eleventh Report, Appendix, Part IV* (London, 1887), p. 397.

[90] This print probably issued from the shop of Darly and Edwards, since the inscription at the bottom is similar in character to what appears on other prints of theirs. The original impression in the Peel Collection does not seem to carry a number and so may have been one of those published before appearing in book-form.

[91] Walpole to Montagu, 28 Aug. 1756. *The Yale Edition of Horace Walpole's Correspondence*, ed. W. S. Lewis (New Haven, Conn., 1937–), ix.195.

[92] Department of Prints and Drawings, in a large folio volume, entitled 'Honorary Engravers'. Almost identical drawings can also be found in Horace Walpole's copy of his *Description of Strawberry Hill* (1774), pp. 171–2; they are among a collection of drawings which Walpole pasted in the book (he wrote on one of the above: 'caricatures copied from Geo. Lord Townshend').

Newcastle: a bare outline sketch, profile left, full-length, slightly bent, wearing a physical wig,[93] and having features resembling (though not identical to) the figure in *Pillars*.

The second drawing (ink and colour wash) is autographed 'G.T. lusit'. It contains four caricatures: the image of Newcastle with reading glass, quite similar to the figure in the print; a profile of George Lyttelton (then Chancellor of the Exchequer), bearing a strong resemblance to the caricature representation appearing in several contemporary prints; a one-quarter profile of the Duke of Cumberland; a fourth figure, possibly Henry Fox, but without the usual fox's head.[94]

At the time the caricature cards were appearing both Charles and George had reason to be dissatisfied with the Newcastle–Fox ministry. Charles wanted a place. George desired an attractive commission. The brothers were neglected and in opposition. Both appreciated the value of political propaganda. Charles tried to establish an Opposition newspaper, the *Test*, but with little success. George had taken upon himself, with a characteristic fixity of purpose that was to prove disastrous for him in Ireland, the championing of the militia bill, which did not have ministerial support. Several prints in 1756, including *The 2 H,H,'s.* [BMC 3342], probably Townshend's, attack the hiring of German mercenaries, and the consequent neglect of a strong, native militia. Hogarth later alluded to Townshend's satirical efforts on behalf of the militia in *The Times Plate I* [Plate 115].

George harboured no special animosity for Newcastle, his uncle. In the Newcastle correspondence of 1757–8 are several letters from Townshend, cordial but showing frustration at having to ask the favour of a military appointment worthy of his station. George, like his brother, could not resist venting his wit on friend and foe alike. His natural talents and the foibles of the Duke made perfect companions for satire.

Townshend disliked Fox for his political association with Cumberland. His rancour towards Cumberland was bitter. The Duke, as Commander-in-Chief, opposed the idea of a militia. His considerable influence, exercised through Lord Barrington, Secretary at War, stood in the way of Townshend's army career.

[93] Below, chap. viii.

[94] The figure is identified as Fox in the drawing, but the profile bears a strong similarity to that of George II (as, for example, in Plate 7).

it is not the favour I ask of You to obtain from his Majesty; for whose service had I only a moderate inclination, I should not at this time think of Enjoying in it, after having been once drove out by the Dislike & Frowns of his HRH [sic] . . .[95]

Townshend's discontent expressed itself in a print which was published in 1757, entitled *The Recruiting Serjeant or Brittanniais Happy Prospect* [Plate 93],[96] published by Darly and signed 'Leonardo Da. Vinci Invt'.

Pamphlets, cards and prints swarm again: George Townshend has published one of the latter, which is so admirable in its kind, that I cannot help sending it to you. His genius for likeness in *caricatura* is astonishing.[97]

The print ridicules Fox's abortive attempts to form a government in April 1757. It is an etching, coloured, little more than an outline sketch; the over-all composition is shallow and reveals Townshend's limitations as an artist.

The print does contain, however, excellent portrait caricatures. In addition to the familiar image of Fox with the fox's head, there is a study of the Earl of Winchilsea, with paddle, from the rear (he was first Lord of the Admiralty); the Duke of Cumberland in a mock Temple of Fame at the right; the Earl of Sandwich with cricket bat; the inimitable George Bubb Dodington, perpetual place-hunter, in profile, with his enormous paunch. The prints espouses Townshend's beloved militia bill by taking issue with the importation of German mercenaries.

'As Townshend's parts lie entirely in his pencil, his pen has no share in them; the labels are very dull. This print which has so diverted the town, has produced today a most bitter pamphlet. . . .'[98] *An Essay on Political Lying*, probably written by a

[95] British Museum, Additional MSS. 32879, ff. 423–4.

[96] Sketches for this print are to be found in a volume of caricatures, belonging to the seventh Marquess Townshend of Raynham, Raynham Hall, Norfolk. The volume contains some two hundred and eighty-nine drawings and prints, which vary in style, subject, and quality. Most are the work of George Townshend, though a few are by his two sons, the 2nd Marquess and Lord John Townshend. The collection contains a number of distinctive caricature sketches of Newcastle, Lyttelton, Cumberland, and Pitt. A few of the sketches show the skill of a deft, linear caricature; others suggest only a crude, hastily executed attempt at realism. Some of the drawings are accompanied by witty inscriptions.

[97] Walpole to Horace Mann, 20 Apr. 1757. *Correspondence*, xxi.77.

[98] Ibid, p. 78.

hireling of Fox's, responded to Townshend's attack. After condemning the general abuse of freedom of the press, the writer made his counterattack specific:

But a certain *honourable* Person, the eldest Hope of a *Right Honourable Family*, hath given us a Species of Lying unknown to our Ancestors. He boldly paints his Lyes, and although all must allow the Dutch-like Genius of his Pictures, yet we must admire Boldness of his Pencil, and the Strength of his Colouring. This Man of Honour with all the likeness of Caricatura hath lately exhibited a Recruiting Serjeant, and humorously hung out of his Pocket a Label of £14,000 for Agencies. Did this *Man of Honour* really believe the lying Label he himself had written? [99]

The question alludes to a charge in the print that Fox was or would be receiving awards from the sale of offices and commissions. The pamphleteer also criticizes Townshend for supposedly unfair attacks on Cumberland: in particular, for the trite suggestion that His Royal Highness was partial to Hanoverian interests. Townshend, he said, displayed ingratitude by maligning his former patron. He even made caricatures of him while in the Duke's service. [100]

Other prints followed *The Recruiting Serjeant* in 1757 and 1758, having the same style and expressing the same themes: anti-Fox, anti-Cumberland, anti-Hanoverian, and pro-militia. Among them are *The Cato: of. 1757* [BMC 3584] [101] and *The Crab Tree or the Epilogue to the Recruiting Serjeant* [BMC 3592]. There is a good caricature of Cumberland in *The Triumph of Caesar* [BMC 3615] showing the usual profile, with pigtail wig, massive torso, short stubby legs, fat neck, and bulging cheekline.

William Pitt, a sometime political ally, also felt the sting of Townshend's wit. The brothers had quarrelled with Pitt during the protracted ministerial negotiations of early 1757, for not giving them due consideration. *The Distressed Statesman* [Plate 95], [102] probably published at the time of Pitt's resignation in April, is a superb caricature of the statesman: an amusing

[99] *An Essay on Political Lying, with Some Observations on a late famous Oration* (London, 1757), p. 8.

[100] Ibid., p. 9.

[101] BMC 3585 is an engraved reproduction in the *Political and Satyrical History* and is signed 'Leonardo da Vinci Invt. et Fecit'.

[102] The date '1761 vid. 1757' has been written in.

portrayal of his thin, gangly figure. The print was perhaps designed by Townshend for it is signed 'Leonardo de Vinci Invt.'[103]

In 1758 Townshend at last obtained a commission. He served the following year as one of General Wolfe's brigadiers in the expedition to Canada. There, Townshend made some interesting sketches of American Indians and the British military, which he sent to his friend and fellow advocate of a militia, William Windham of Felbrigg.[104]

Impudent remarks about Wolfe's generalship during the seige of Quebec (Townshend assumed command after Wolfe was killed and Monckton wounded) embroiled him in the controversy of another pamphlet-exchange.[105] His enemies assailed him as an arrogant, presumptuous glory-hunter, robbing the fame of his illustrious commander. Nevertheless, Townshend returned home a hero, was raised to the rank of major-general, and sworn in as a privy councillor.

Among the many prints that appeared in 1761 and 1762 against the Bute ministry are several that Stephens has attributed to Townshend.[106] All are crude in style—little more than rough sketches—with little caricature. Some are clever: their humour relying on obscene puns and allusions. Most stick to a single theme with variations: the Earl of Bute's supposed illicit relationship with the Dowager Princess of Wales.[107]

These prints (probably a majority of them) were published by Mary Darly in Cranbourne Alley. Some carry pseudonyms, typical of the prints designed by Townshend. 'D.Rhezzio', 'G.

[103] There are at least two caricature drawings of the elder Pitt in the volume at Raynham. One has some similarity to the figure in Plate 95.

[104] In a volume now part of the estate of the late Robert Wyndham Ketton-Cremer of Felbrigg Hall, Norfolk. The volume, though smaller than the collection at Raynham, has the same kind of material. The Lewis Walpole Library has photographic copies of the drawings in the Felbrigg volume. Townshend also sent sketches to Horace Walpole.

[105] Which in 1761 almost caused a duel between Townshend and the Earl of Albemarle.

[106] The editor of the British Museum *Catalogue* reaches this conclusion on the basis of hints provided in the Walpole and Grenville correspondence and newspaper articles, especially an anonymous one that appears in the *Public Advertiser*, 5 June 1765, perhaps written by Philip Francis—see Joseph Parkes (ed.), *Memoirs of Sir Philip Francis, K.C.B.* (2 vols.; London, 1867), i.148. Parkes believed Francis to have been the author of similar articles in the *Public Advertiser* of 1767.

[107] Below, chap. vii.

Oh! Garth', 'Sawney Heath of manchester', 'Sawney McAdam' are a few [see Plates 102, 103]. Darly was receiving designs and suggestions from an anonymous person who carried the pseudonym 'D. Rhezzio'.[108]

Were some of these prints invented or designed by Townshend? Possibly. The style does not compare with the striking portrait caricatures of earlier prints of his. The humour is, as remarked, blunt and sometimes obscene. Townshend did not have a reputation for especial grace. His years as Lord Lieutenant in Ireland were marred by clumsy and uncouth attempts at popularity, highlighted by drunkenness and buffoonery.

A political motive is not essential to establish Townshend's invention of the prints; his ridicule knew no permanent friends. Both Charles and George enjoyed political recognition after 1760. They were related to Bute by Charles's marriage. The latter was Secretary at War until November 1762. The sympathies of both, however, were with Pitt and Newcastle. Especially after the resignation of Pitt in 1761 their support of the ministry wavered. It is probable that Charles Townshend had misgivings about the peace settlement Bute was seeking. He resigned in November 1762, soon went into Opposition, and within a few months was talking to Newcastle about the necessity of a formed Opposition and the advisability of an Opposition newspaper.[109]

Bute wrote a letter to George Townshend on 2 November 1762 (at a time when some of the most outrageous anti-Bute prints were appearing) which suggests that friction may have existed between them as well:

I received your kind Letter on Friday and take the first opportunity of Answering it; for in this Critical Moment I wish to expose a few plain Facts to my Noble Friend, that he may not be misled by Errors wrote from hence. . . . Your favorable Opinion of the Peace I will make, does Me Honour, and yet I feel in a Work of this kind how impossible it is to pass without Censure. . . . I dislike too much a Ministerial Life, to wish by any Measure to settle Myself permanently in Office with the best of honestest Intentions; I have hardly met with any thing but cruel

[108] As has been said, the publishers of prints welcomed suggestions from outside sources. *Scotchmen be Modest: or, Albion's Ghost* (London, n.d.), No. 3 of a series contains a letter to the purchasers of the series, offering 'a few humorous Prints, now executing by an eminent Hand'. The anonymous contributor may have been Townshend.

[109] H.M.C., *Eleventh Report, Appendix, Part IV*, p. 399.

Abuse & base Ingratitude. . . . At the Minute I write, there exists the most factious Combination *Soi disant* great Men against the lawful Right and Liberty of the King that ever happened in this Country; The King's good Opinion of Me renders Me unfortunately the Object of Envy & Resentment. . . . I tempted to believe from the high Opinion I have of your Love & Affection to the King, had you been present you would have joined Me in the Measures Taken, if I mistake I shall be sorry for it; since Nothing can happen that will not make Me sensibly regret the smallest Diminution of Your Friendship. . . .[110]

It is not impossible to imagine Townshend as the creator of these abusive pictures. Few of them touch upon the Peace directly; most emphasize Bute's Scottish nationality and the nature of his position as a favourite. At least one, *The Triumvirate & the Maiden* [BMC 3908], deals kindly with the Duke of Cumberland.

What makes any connection between Townshend and these prints unlikely is his absence from the country throughout most of 1761 and 1762. He served with the allied forces in Germany during the summer of 1761. He was ordered to Portugal in the spring of 1762 where he remained until December. Most of the anti-Bute prints attributed to him were published in the autumn of 1762. While Townshend was in the habit of sending his sketches to relatives and friends, it is doubtful that he had time or opportunity to forward designs from the Portuguese interior to the printsellers in London.

Townshend became Viceroy of Ireland in 1767.[111] The Viceroyalty magnified the air of controversy that had harried Townshend's entire public life. His troubles began almost immediately. A rigid insistence upon needed reforms, combined with political ineptitude and rashness, alienated powerful interests in Ireland and at home.

While in Ireland Townshend continued to draw his caricatures, both for amusement and as a means of expressing his plight. 'He drew ridiculous pictures of himself in ignominious attitudes with his hands tied behind him; thus shunning opposition by meriting contempt.' [112]

[110] B.M. Add. MS. 38200, ff. 89–90.

[111] A last favour Charles secured for his brother before the former's death. The Earl of Charlemont believed that Townshend's service in Ireland was impaired because of his supposed connection with Bute. H.M.C., *Twelfth Report, Appendix, Part X* (London, 1891), p. 24.

[112] Horace Walpole, *Memoirs of the Reign of King George the Third*, ed. Sir Denis

Townshend resigned the Viceroyalty in 1772 and returned to England. Shortly after, he fought a duel with Lord Bellamont, the latter having taken offence at a supposed slight in the disposal of Irish patronage. Townshend returned to the comparatively sheltered post of Master-General of the Ordnance, which he held during the war in America. The remainder of his life he lived as a country squire. He continued to draw his sketches and executed amusing caricatures of Lord North and the younger Pitt.

Viewed as a whole, Townshend's drawings and prints show him to be a talented, if not accomplished, artist. Drawing and, more recently, *caricatura* had been popular avocations among the aristocracy. Townshend's work indicates the untrained and undisciplined hand of the dilettante.[113] Unlike the draughtsmen and engravers who made prints for a living, Townshend had no pecuniary motive. His sketches would probably not have gone beyond the dinner-table and drawing-room amusement, had not arrogance and ambition combined with his lively sense of humour to encourage publication. Townshend's nature was drawn to controversy. He shared with his brother an appreciation of the importance of propaganda. His prints, however, show more wit than artistic merit and, save perhaps for the militia bill, little of that serious attention to issues and conviction that makes a graphic satirist of the first rank. Still, Townshend was a colourful exception in a trade then characterized by many professional drudges. He represented a personal link between the world of politics and the world of the printshops.

le Marchant, Bart. (2 vols., Philadelphia, 1845), ii.64. Sir James Caldwell, sheriff of County Fermanagh, denied that Townshend was the creator of this satire: 'It was reported, but not truly, that Lord T. had drawn a *Caricature* of the *Ministry Hurrying Him on Board Ship* with his *Hands tied behind him.*' B.M. Add. MS. 24137, f. 64. Caldwell also mentions another satire and does not deny that Townshend drew it (f. 67). There are several Irish studies by Townshend in the volume at Raynham.

[113] Townshend may have been influenced by the work of Pier Leone Ghezzi, whose portrait caricatures had been circulating in England since the 1730s. The styles of linear, profile caricatures are much alike. Ghezzi was a master of outline caricature. *The Distressed Statesman* (Plate 95) is especially reminiscent of Ghezzi's style.

CHAPTER III

Prints and Opinion 'Without Doors'

'We are become a *Nation of Statesmen*. Our *Coffee-houses* and *Taverns* are full of them; nay we often find them cramp'd up behind *Counters*, or immur'd in *Stalls*, *Garrets* and *Night-Cellars*.' [1] The political world of the eighteenth century extended beyond the environs of St. James's Palace, Whitehall, and Westminster; beyond, too, the town- and country-houses of the governing class. Indeed, the political nation, always larger than the tight little arena of parliamentary politics, was growing throughout the century. Its dimensions are measured by the spread of pamphlets, books, ballads, and prints, first generated in large numbers by the political struggles of the seventeenth century. The demand for political literature of all sorts extended beyond London to the country at large; though London was the predominant market. This demand kept pace with the spread of literacy. But even the illiterate, as well as those who could read, participated in this larger political nation, if only as critical, loquacious observers. Coffee-house politicians abounded.[2]

'What attracts enormously in these coffee-houses are the gazettes and other public papers. All Englishmen are great newsmongers. Workmen habitually begin the day by going to coffee-rooms in order to read the latest news. I have often seen shoeblacks and other persons of that class club together to purchase a farthing paper. Nothing is more entertaining than hearing men of this class discussing politics and topics of interest concerning royalty. You often see an Englishman taking a treaty of peace more to heart than he does his own affairs.' [3]

The gossip of town and court, ship arrivals, the latest convictions at the Old Bailey and executions at Tyburn, country news, miraculous events, advertisements for panaceas, and occasional momentous happenings abroad filled the newspapers. The more informed and attentive readers perused tracts concerned with

[1] *Craftsman*, 4 Oct. 1729.
[2] And became a stereotype. See *The Grumbler 1748* [LWL, Plate 67].
[3] Saussure, *A Foreign View of England*, p. 162.

serious theological and political issues. Pamphlets in a lighter vein, prints, ballads, and broadsides were of a more amusing and passing interest. The coffee-house provided a nexus of political and social life; the latest prints were passed about or hung on the walls for all to see. They decorated the windows of the printshops nearby.

The satirical print was especially popular in England and had an appeal which foreign visitors noticed with puzzlement or contempt.

They have not better success in expressing the ramblings of fancy, than in copying the beauties of nature; which is proof how much every thing that comes within the province of taste, is foreign to the inhabitants of this isle: for even these compositions, however extravagant soever they may appear, are susceptible of it. The pleasantries of their pictures are like those of their writings, flat, heavy, and over-done: they are a sort of national pleasantries, which divert none but themselves. Those political prints, which appear daily against the ministry, are all of this stamp: they have not the least delicacy, and are remarkable only for the gross-ness of the satyr. And yet they assume a vanity from this mock talent, and believe that others are in fault, if they are not affected by it.[4]

In the foreign archives at the Quai d'Orsay in Paris are two volumes of documents, in which English satirical prints and news-papers from 1737 to 1744 have been carefully collected.[5] This material, with translation and explanation, was probably sent back to Versailles by the *chargés d'affaires* in London. 'On y trouve Le Genie anglais qui n'est un des plus delicat.'[6] Perhaps con-sidering freedom of the press in England a curious anomaly, the French representatives closely examined this political material as an index of informed public feeling with regard to foreign affairs and popularity of the ministry at home.

[4] Mons. L'Abbé le Blanc, *Letters on the English and French Nations* (2 vols., London, 1747), i.160.

[5] France. Ministère des Affaires Étrangères. Archives des Affairs Étrangères; Documents, Angleterre, 1737 à 1739 (Vol. xxxviii) and Documents, Angleterre, 1739 à 1744 (Vol. xxxix). Most of the prints in this collection are also in the British Museum (see bibliographical essay). The prints appear among copies and translation of the *Craftsman, Fog's, Common Sense* (Opposition newspapers), and commentary on parliamentary debates. Several hands probably did the translating, including Visines and Bussy, who were *chargés d'affaires* during the period. Cambis was the French ambassador in the late 1730s.

[6] Ibid. xxxviii, f. 344 (dated 21 May 1739).

1. *Circulation*

To assess 'public opinion' in the eighteenth century in any quantitative way is probably impossible, just as it is difficult to place any quantitative or qualitative measurement on the consumption of the political print. Not much is known about the circulation of newspapers and pamphlets in the early part of the century. One authority estimates that the *Spectator* had a circulation of about three thousand.[7] The editor of the *Craftsman* argued in 1731 that about one and a half thousand copies of each pro-Government newspaper and several thousand copies of pamphlets were being published against him.[8] Circulation of printed matter in the eighteenth century was, by modern standards, miniscule.

What few statistics there are on the sale of prints indicate that their circulation was even smaller. The printsellers examined by the Government in 1749[9] talked about the exchange of a half-dozen or so impressions of a given print. Darly, however, mentioned that he obtained 100 impressions of a print in exchange for a book of ornament for drawing.[10] Bispham Dickinson said that he bought almost five hundred copies of another print—and sold them all.[11]

Both pamphlets and prints sold cheap: almost invariably six pence, rarely fourpence, and sometimes a shilling if they were—in the case of pamphlets—long, or, with prints, coloured. Their price compared favourably with the cost of books. An ordinary octavo volume could cost five or six shillings; a duodecimo, about two or three. The political print was also cheaper than other engravings, etchings, and mezzotints, which could cost several shillings. Hogarth asked two guineas for the set of eight prints of *A Rake's Progress*.

The better-engraved satires shared with prints of a serious nature the quality of a curio. They were not, for the most part, intended for mass circulation, since the printshop itself did not

[7] P.M. Handover, p. 141.

[8] *Craftsman*, 31 July 1731. The *Craftsman*, itself, seems to have done even better, with an average circulation of about three thousand and on occasion rising to perhaps ten thousand. See J. H. Plumb, 'Political Man', in *Man versus Society in Eighteenth Century Britain*, ed. J. L. Clifford (Cambridge, 1968), p. 10.

[9] Below, pp. 78–80.

[10] P.R.O., S.P., Dom., Geo. II, General (Bundle 111), ff. 173–4.

[11] Ibid., ff. 167–8.

cater to a mass market. The printseller possessed a widely
diversified but limited stock of sundry and 'curious' items, in-
cluding maps, stationery, drawing books, pamphlets, prints of all
kinds and shapes, and sometimes decorative fans.[12]

The nature of the production of prints also limited their cir-
culation. The process, although not complicated, was tedious.
To make one impression from a copper-plate engraving the
printer had to lay ink over the plate, pressing it into the engraved
lines with a dabber, and then wiping away the excess. Damp
paper was then laid on the plate, impressed, and hung up to dry.
A great deal of pressure was required to 'draw' the ink out. This
process brought a steady deterioration in the quality of the plate,
until after a maximum of two or three thousand impressions its
quality was completely gone.[13] Only a few hundred good im-
pressions could be made before the plate had to be cut again.
Unusually popular prints sometimes had their plates re-cut for
more than one issue.

Largescale production was not characteristic of the trade.
Prints of some quality—even satires—were not looked at like a
newspaper and then cast away. They were, after all, 'art', and
therefore enjoyed some value as collectors' items, to be framed,
bound, or used as wallpaper.

Almost all prints were published in London and Westminster.
The legal and then customary monopoly of the metropolis still
existed, despite the growth of a provincial press and active
publication in Dublin and Edinburgh. London also provided the
market for their sale, though many no doubt circulated elsewhere.
Who were their consumers? The audience extended among all
classes: to anyone who could view the latest satires in the print-
shop windows. The number of buyers was, of course, more
limited, but not to any one class or station. Hogarth's prints
enjoyed a wide appeal, but especially among the upper class:
'They have made the graver's fortune who sells them; and the

[12] Though fans were usually sold by the fan-makers. '*This Day is Publish'd, Most
accurately delineated on a* Fan-mount. The Convention: or, Spanish Cruelty expos'd
and censur'd . . . the whole embellish'd in a beautiful Manner. Sold at Pinchbeck's
Fan-Warehouse, at the Fan and Crown in New Round Court in the Strand . . . Mr.
Delassalle's in the Abbey-Green, at Bath. N.B. At the above Place Ladies may have
their own Devices painted.' *Old Common Sense; or, The Englishman's Journal*, 12
May 1739.
[13] A. M. Hind, *A Short History of Engraving & Etching* (London, 1908), p. 15.

whole nation has been infected by them, as one of the most happy productions of the age. I have not seen a house of note without these moral prints.'[14] The appreciation of political prints varied with their quality and learning. A finely executed engraving with ornate embellishments, erudite allusions, and Latin (or even French) inscriptions, would hardly be intelligible to the semi-educated or illiterate [Plate 10]. A crude woodcut with a simple image and few inscriptions—perhaps with the jingling rhymes of a popular ballad—could reach a wider audience [Plate 16]. The phonetic puzzles of the hieroglyphics seemed to have provided a childish amusement [Plate 79].

Most prints that bear dates of publication appeared in the autumn or early spring of the year,[15] the times which mark the beginning and the end of London's 'season'. Printsellers, as with businessmen in other trades, sought the market provided by the worlds of politics and society, which migrated to London in October and November and made an exodus to the country from March until June.

2. *Propaganda*

As a polemical tool graphic satire enjoyed certain advantages. Though less simple than the modern newspaper cartoon, its visual nature commanded a wider appeal than the pamphlet or perhaps even the broadside.[16] Because of the relatively inexplicit quality of its imagery, the print was less susceptible to prosecution and retaliation than was the printed word.

The picture image possesses an instant attractiveness, lacking in all other elements of propaganda. The persuasive power of such imagery, because it is so vivid and concrete, can be great—and dangerous to the truth if improperly used. Symbols in visual proximation with one another can cause a connection to be inferred

[14] LeBlanc, i.162.

[15] The large number of prints published in the autumn of 1756 and 1762— periods of great ministerial unpopularity—affects the total but does not alter the basic conclusions it suggests. The country gentlemen coming to London for the parliamentary session were interested in seeing the latest satires; they probably took prints with them when they returned to the country at the close of the session.

[16] For a discussion of the use of pamphlets as propaganda, see Bernard Bailyn(ed.), *Pamphlets of the American Revolution, 1750–1776* (Cambridge, Mass., 1965–). Many of the conventional rhetorical devices used in the polemical tract—metaphor, allegory, parable, assertion, ethos—were also adapted to the political print. The wit of so many prints is found in their metaphorical inventions (e.g. Plate 63).

between the ideas or qualities they represent, which may not, by logic or reality, have any association. In one of the prints attacking the Jew Bill of 1753, *Vox Populi, Vox Dei, or the Jew Act Repealed* [BMC 3202, Plate 71], a cluster of symbols and expressions are jumbled together, few of which have anything to do with the actual issue. In several of the Rebellion prints of 1745 and 1746, attacking the Pretender's cause, the close proximity of the King of France, the Pope, and the Devil imply an all-too-simple causation and relationship.[17] The conjunction of diverse images with their innumerable connotations is a short-cut to and often a perversion of logic.

The most common device of propaganda in the prints, therefore, is that of simplification, and the distortion or suppression of facts. Truth is usually found in the nuance; these satirical studies make little allowance for the shade of difference. The complexities of an issue are sacrificed to the wit of invention and the limitations of graphic art. Simplicity facilitates persuasion, as it removes the responsibility of difficult decision from the viewer.[18] The prints that appeared in 1756 against the hiring of mercenary troops and in support of a militia bill (a much debated issue) make the point of contention and the proper course of action seem obvious and clear. *Forty Six and Fifty Six* [BMC 3477], published in September of 1756, uses a means of argument that is typical in the prints: the contrast of past glories with present degradation. In the left design George II and the Duke of Cumberland view a contingent of English volunteers; the soldiers make the appropriate exclamations ('Fortune, Life, and all is my King's'). In the right design, ten years later, a group of evil ministers review a force of German mercenaries, with long moustaches and suspicious accents ('So den as Ick heb to gelt Dat is als vat Ick vant'). 'Oh! Britain, didst thou e'er the Hostile foe Refuse?/ Inglorious Now, must these thy Chains Unloose.'

The prints argue by assertion, generality, platitude, appeals to authority (e.g. the 'Constitution') or to prejudice (as in the above example, hatred of foreigners). 'Britons Strike Home:

[17] *An Emblematical Print of Culloden* [BMC 2789] shows the Pretender, with the King of France, the Pope, and the Devil (in that order) behind him and prodding him on.

[18] The aim of propaganda, in short, 'is to make up the other man's mind for him'. Bernard F. Kamins, *Basic Propaganda* (Los Angeles, 1951), p. 90.

Revenge, Revenge Your Country's Wrongs', the words to a popular song, appearing in several prints, is typical of their exhortative rhetoric. The prints describe what is assumed to be true, instead of proving the truth itself; they portray what ought to be as if it must be. Phrases and symbols with conventional emotive connotations fill the prints and serve as shibboleths. Mosley's *The Invasion or Perkin's Triumph,* intended as a 'Protestant Print', brings to the viewer's mind all the usual associations of Stuart despotism: 'Hereditary Right', 'Arbitrary Power', 'Non Resistance', 'Passive Obedience'. They are joined by the symbols of Popish persecution: burning faggots, gallows, and wheels.

> Who views this Print with an Impartial Eye,
> May mark the dread Effects of Popery
>
>
>
> Gibbits [*sic*] and Faggots Swords and Wooden Shoes,
> With all Rome's dire invented Train of Woes.

The Rebellion Displayed [Plate 58] and Plate 59 show the use of the same tactics.

The prints' most powerful weapon as propaganda, however, is the derisive ridicule that permeates their character. It is this very characteristic, on the other hand, that often limits their effectiveness in persuasion. The appeal of this propaganda is negative: catering in a superficial way to mirth, cynicism, hate, perhaps even fear.

The humour and the contrived nature of the designs warn the viewer not to be too credulous or serious in his appreciation. The rhetorical bounds of graphic satire are limited to the cutting edge of disapproval and derision. Positive emotions of deeper feeling usually lie beyond its range. Its highest attainments can, perhaps, sear the conscience but it cannot caress the spirit.

Political prints were not used as propaganda in any definite and purposeful way. Most were probably not intended to persuade, though the matter of intent in their creation is difficult now to ascertain. Their effect, taken in the context of the contemporary moment, may have given them the value of propaganda, especially when the tempo of polemic quickened or national crises arose. Prints reflected as well as affected public opinion; to distinguish clearly the influence of each factor is not possible.

3. *Attitude of the Government*

The Government during the period 1727–63 did not, for the most part, regard the political print as a dangerous and effective weapon in the hands of the disaffected. The very humour and imagery of the print belied any pretensions, for it did not possess the mysterious aura of authority and veracity that had always been associated with the printed word and which had justified the regulation of the press for over two centuries.

Prints, unlike pamphlets, were not frequently used weapons of political strife. There probably was not a substantive link, either in material or literary support, between figures in public life and the publication of prints—as perhaps there would have been, had Hogarth agreed to produce satires on Walpole for the Opposition. No arrangement in graphic satire could compare with that which existed in the publication of the *Craftsman*, supported by Boling-broke and Pulteney; nothing comparable to the Government's support of Gillray during the French Revolution.

Townshend's career, of course, brought the two worlds together. He produced satiric designs just as Lyttelton and Chesterfield, among others, wrote pamphlets.[19] Townshend may not have been alone among men in public life in suggesting ideas and designs for the publishers. The prints which appeared in response to *The Motion* in 1741 may have had factional support [Plates 35 and 36].

Political prints, nevertheless, rarely caused trouble for the Government. No statute or policy had existed before 1735 to regulate their publication and sale. The nature of the print was ambivalent: part art, part journalism. Distinct and separate from the broadside, the independent satirical print hardly existed in England before the eighteenth century; it did not, therefore, become a problem for the legal machinery of licensing and regulation in force until 1695.

Discontinuance of the licensing system brought an end to direct censorship, but not to the belief that some form of government control of the press was necessary. Throughout most of the eighteenth century two indirect means of regulation were used: taxation and the law of seditious libel.[20]

[19] Politicians also produced some of the outstanding broadside ballads of the time.

[20] See Frederick S. Siebert, *Freedom of the Press in England, 1476–1776* (Urbana, Ill., 1952).

Acts of 1712 and 1724 imposed a stamp duty on newspapers and pamphlets of various sizes (certain loopholes in the first act made the second act necessary). Prints were not directly included though the duty on paper indirectly affected their publishers. Broadsides sometimes had to pay the tax of three shillings per edition that was imposed on pamphlets. *The Tale of the Robbin*, etc. [BMC 1839], a broadside with woodcut, was 'entred [*sic*] in the Stamp Office according to the late Act of Parliament', and carries on it the red stamp with thistle and rose. The hawkers who distributed most of these broadsides were, in theory at least, licensed by the Government.

More arbitrary and punitive was the law of seditious libel: 'after the fact' regulation, by which creators, printers, and publishers of material were held responsible for its contents. 'The Meaning of the Word *Libel* is, Sir, very estensive, nay, has no Bounds but what those in Power prescribe. . . . The most common Explication of the Word *Libel*, is that it is a false, scandalous, and seditious Writing, contriv'd to injure a Person's Reputation.' [21]

Scandalum magnatum, the making of defamatory statements about persons of high estate, was an old statutory crime, wide in its scope, but no longer in actual effect in the eighteenth century. If it had been, any sort of political satire would have been vulnerable. The law of seditious libel, developed in the courts of common law in the seventeenth century, held that it was a crime to publish anything that could bring subjects into disaffection from their rightful king and his government, and which subjected that government to hatred or contempt.[22]

In 1731 William Rayner was indicted by a grand jury of Middlesex for publishing a pamphlet entitled *Robin's Game, or Seven's the Main. Being an Explanation of Caleb D'Anvers' Seven Egyptian Hieroglyphicks prefix'd to the Seven Volumes of the Craftsman.* This pamphlet was one of several pieces of literature indicted, another being *Robin[s] Reign or Seven' the Main* [BMC

[21] *Old Common Sense*, 11 Nov. 1738. The writer adds, however, 'But, Sir, it should first be proved false, before those who are concern'd are punish'd.'

[22] To publish material that was likely to cause a breach of the peace constituted a criminal libel; high treason, the most serious charge, was rarely enforced against publishers after 1660: the criteria for treason were rigid, its proof difficult, its penalty excessively severe.

1822, Plate 9],[23] a print which appears separately and also in the tract.

The indictment makes clear the basis of the law of seditious libel: that proper respect and due veneration by the people for their magistrates is essential to good government and, in practical terms, for the security of the Succession; that without these, order and decency are subverted, anarchy and confusion introduced. The indictment condemns that 'presumptuous and unprecedented licence, which has been assumed by some State-Incendiaries, for the few years past, of inflaming, by false, seditious and scandalous libels, the minds of the common people with pretended grievances, and alarming them with imaginary dangers'.[24] These libels, the indictment maintains, have cast a bad light on His Majesty's government through censure and ridicule. It condemns the practice of 'impudent ridicule, attempting to beget in them [the people] a contempt for his sacred person. . . '.[25]

There is nothing treasonous in the pamphlet. Many of the themes for the illustrations were taken from essays in the *Craftsman* during the previous four years. Only one touches directly upon the King, and that is the first. In its explanation of this illustration the pamphlet suggests that the supporters of the ministry wished to substitute warrants, commitments, informations, and other weapons of prerogative for the liberties guaranteed in Magna Carta. The second, third, and seventh illustrations all concern liberty of the press. In the second, there is the suggestion that Walpole is employing illegal powers to persecute the press. The third illustration is a simple defence of the press's liberty, as is the seventh. The fourth and sixth designs attack Walpole's use of corruption and his personal ambition. The fifth touches the sensitive subject of foreign policy; its explanation insinuates that recent treaties have been foolish or evil steps to make England the tool of France.

None of the designs, in themselves, make a personal attack upon the King. In fact, most are cryptic enough, that without the verses and the explanations in the tract, they would be

[23] A warrant signed by Newcastle, 5 July 1731, orders the seizure of the authors, printers, and publishers of 'Robin's Reign', instead of 'Game', though the pamphlet was probably intended. P.R.O., S.P., Dom., Geo II, Entry Book 82 (criminal warrants). The folios are unnumbered.

[24] The indictment is printed in the *Gentleman's Magazine* (July 1731), i.286.

[25] Ibid.

innocuous. With the explanations they are suspect of seditious libel: casting aspersion on the King's government and his ministers; accusing them of subverting the Constitution with Jacobite principles; suggesting that they are, at the least, dupes of the nation's enemies.

Rayner was tried and convicted by commission of oyer and terminer at Hick's Hall. He was eventually fined forty pounds, sentenced to two years in prison, and ordered to give security for good behaviour for seven years. No action was apparently taken against the designers and engravers of the print.[26]

In a trial for seditious libel, until almost the end of the century, the court reserved the right to decide what was seditious and libellous. To the jury was left the right to determine the actual facts of publication and, on occasion, to interpret innuendoes. Innuendoes served as a screen for satirists to protect them from the rigours of the law. They regularly used abbreviations, nicknames, and pseudonyms for the objects of their satire. Ministerial writers condemned these elusive practices: 'the Weapons of their Warfare are *Allegories, Fables, Parables, Hieroglyphicks,* and *Parallel History.*'[27] Most common was the omission of certain letters of a person's name or an important word. Sometimes a print will show a name burnished out with only certain letters left, or a whole inscription changed because the engraver or the publisher thought the original too dangerous.[28]

Responsibility for the application of the law rested with the Secretaries of State, given the powers of search, seizure, arrest, examination, and commitment. They could issue warrants which were executed by messengers-in-ordinary, usually two in number.

Officers of the Crown sometimes relied on informers to keep a watchful eye out for the circulation of seditious material. In April 1733 a man named 'John Smith' wrote to the Duke of Newcastle, then Secretary of State for the Southern Department, about services of this nature which he had previously offered him:

May it please Your Grace,

Some Months ago I wrote to your Grace & offred [*sic*] to put you as

[26] Action, on other occasions, was taken against Richard Francklin, the printer and publisher of the *Craftsman* (above, chap. 1).

[27] *The London Journal*, 17 Feb. 1733.

[28] See Plate 117, where the engraver has tried, unsuccessfully, to replace 'Ministerial' with 'M–n–st–l' (of course, the opposite may have been true).

a Minister into a Method of destroying at least of Defeating the Herd
of Scriblers who from different views pester the Public with Libels.
Your Grace returned me a favourable Answer by Advertisement in the
Daily Journal & I in consequence thereof wrote Your Grace several
Letters which it seems were not thought worth an Answer. . . . The
Close of this Sessions will probably be attended with a Shower of these
Poison'd Arrows & it may not be useless if your Grace receive private
information from what Quarter they came & how they may be pre-
vented.[29]

The messengers, after seizure and arrest, brought the suspected
parties to Whitehall for examination, which usually produced
nothing more than evasive run-arounds and denials. The material
and information that were gathered were then turned over to the
Attorney-General, who decided whether or not prosecution should
follow. In some cases, Crown officials did not prosecute: the
terror of examination and confiscation of material being sufficient.

In June 1732 Charles Delafaye, Under-Secretary of State to
Newcastle, received a letter from an engraver and printseller
by the name of 'Eman! Bowen',[30] with regard to a plate and
prints that had been confiscated:

Sir:

I having lately seen Expos'd to publick sale, some of the same Prints
with the Inclos'd, which I bought, and have taken the liberty of laying
before you; presuming Sir, that you will remembr that this Print,
together with the Plate were formerly Seized by a Warrant from his
Late Majesties Principal Secretaries of State, and my Self, the Pro-
prietor and Publisher of it &c. were taken into Custody of Messengers,
and after 5 Days Confinement, was Examin'd before You, and oblig'd to
give Bail to Answer the process intended to be Commenced against me;
but after much Expence of Time & Money, was at last discharg'd from
my Recognizance.[31]

The print was a three-quarter-length portrait of Francis Atter-
bury, Bishop of Rochester, a Jacobite, who had been involved in
several plots since the Succession and who, after the latest one in
1722–3, was banished from the realm.

The reason assign'd for the Suppressing of this Print was, that the
Exposing of it to publick Sale would stir up the minds of the Vulgar to

[29] P.R.O., S.P., Dom., Geo. II, General, Vol. 29, ff. 156–7.
[30] The name, which is almost illegible, might, in fact, be 'Bouen'.
[31] P.R.O., S.P., Dom., Geo. II, General, Vol. 27, f. 44.

Disaffection against the Government, which was the farthest thing in the World from my Intention: my View being only to get a Penny in the way of my Business, my Loyalty to his Late & present Majesty and our happy Establishment having never been disputed or suspected.[32]

The printseller then lodged his complaint against the government:

These Prints now Expos'd to Sale as aforesaid, must necessarily come from the Secretaries Office, where the whole Number Printed off being Seized before any could be distributed about the Town for Sale, was carry'd together wth the Plate, and therefore not one could be Sold Since, unless, as I suppose, secretly and clandestinely by Some of the Servants of the Office.

But now the Late Bishop of Rochester being dead, the reviving of these Prints, It may be thought, won't produce the like Ill Effect, and therefore they may be Sold wth Safety. If so Sir, hope you'll easily infer from the premises that the Plate & Prints are Inviolably my Right & Property & to give 'em away to any other person whatsoever, is doing a Manifest Injustice to me and my family; beg therefore if the Selling of these Prints is Authoriz'd by the Secretaries of State . . . you'll Interpose . . . to have them restored to me. But if they are Sold Clandestinely, I would not, notwithstanding the Liberties other People take, Grave another Plate thô I could get 50 £. as I was once offer'd for doing of it; nor upon any other account would I Incurr the displeasure of the Government. . . .[33]

The print, which Bowen enclosed,[34] is a clipped impression of an engraving, bought at a pamphletshop in Holborn. Records in the State Papers do not indicate whether or not the complaint and request were ever answered.

If prosecution was undertaken, trial followed in either the Court of King's Bench at Westminster or by commission on the Middlesex circuit. Punishment of the convicted could be severe, but usually was mild. Imprisonment and fine were the severest penalties. The Government sometimes demanded a recognizance or security for good behaviour. The pillory, at the Royal Exchange and at Charing Cross, was the common fate for guilty publishers and printers—only painful if they were zealously pelted by the mob. Hawkers and balladsingers, if unlicensed or caught selling seditious material, were sentenced to Bridewell. Curious was the

[32] P.R.O., S.P., Dom., Geo., General, Vol. 27, f. 44.
[33] Ibid. [34] Ibid., f. 45.

sentence given to Joseph Carter, an apprentice of the 'high flying' printer, Nathaniel Mist; he was made to walk 'around the Four Courts in Westminster-Hall, with a Paper fixed on his Forehead, denoting his Offence. . . '.[35]

Government action, though sometimes terrifying and severe, was more often a nuisance to the recalcitrant printers and publishers in the trade. And, as a contemporary observer noted in jest, the attention of the Government could have its benefits:

The *Pillory* is an Estate certain to any one, who will accept of the *Post*; for the Sale of a Libel always rises in proportion with the Sufferings of its Author.

I knew of a Printer who obtain'd a pretty tolerable Fortune, by only procuring a State Messenger to call and take a Dinner with him, two or three times a Month, at his House in the City; and another, who was every Day expected to be sent to Gaol for Debt, that luckily chanc'd to be sent for to *Whitehall*, to receive a Reprimand. The Thing proved the making of the Man, for he soon retrieved his Affairs, and now lives in extraordinary good circumstances. But now, alas, these *Golden Days* are over; the *Ministry* seemed determined to take no notice of the Libels daily propagated, and by this Neglect to starve both Authors and Printers.[36]

Both Houses of Parliament claimed the right to act against all criticisms and accounts of their activities. If it wished to do so, each House could examine the authors, printers, and publishers, and order a publication to be burned by the common hangman. Prosecution it would usually leave to the Crown, through the normal channels.

Because of fear of prosecution or because of ignorance concerning the day-to-day activities of Parliament, the creators of political prints avoided that subject. Though political corruption was a favourite topic, it was rarely connected in a specific way with the House of Commons. There were a few exceptions. One is the 'November' scene in *The Political Kalender for the Year. 1740* [Plate 27], in which Walpole is shown being attacked. A second example is *From One House to An Other* [Plate 42], commenting on Walpole's elevation to the peerage. Another is

[35] *Craftsman*, 28 June 1729.

[36] Ralph Straus (ed.), *Eighteenth Century Diversions: Tricks of the Town, Being Reprints of Three Eighteenth Century Tracts* (London, 1927), p. 246.

The Screen. A Simile [BMC 2540, Plate 46], in which the House of Commons is shown at the bottom of the design.

In the period 1727–63 the several ministries, rather than Parliament, were most active in the attempted suppression of obnoxious literature. This activity was especially great in the late 1720s and 1730s, much less in the decades thereafter. The action against Rayner and *Robin's Game* represented only one skirmish in a struggle that had already been going on for several years and that culminated in the summer of 1731 in the successful prosecution of Francklin, for the publication of the two hundred and thirty-fifth edition of the *Craftsman*. During this year polemic in newspapers and tracts, concerning the proper limits of freedom of the press, became very intense. The victories of the Government's prosecution did not, however, cut off the publication of annoying attacks. In the years immediately following, printers, publishers, and pamphlet sellers were continually harassed.

An unsigned note in the State Papers, probably written in 1738 or 1739, calls attention to the problem:

Ballads and other nonsensical papers are publish[t] tending to feed the distempered humour of many of the Mobb against the Government; such as that which is here annex[t]

The Authors, Printers and Publishers of those Papers are generally . . . persons not worth the Notice of the Government or the Expence and Trouble of a Prosecution in the usual Forms, yet as their Practice is very mischievous it would be very much for the publick Service that some Method of Punishment should be thought of to deterr them from it.[37]

The writer suggests that statutory authority might allow the Government to consign some of these individuals to houses of correction, as loose, idle, and disorderly persons; the Government could also fine hawkers who did not have licences and send them to the same houses. With the memorandum are several publications, including the broadside, *The Negotiators. Or, Don Diego Brought to Reason*.[38]

The fall of Walpole lessened the activity of ministerial suppression. During the early 1740s the printers and publishers of *Common Sense*, the *Champion*, and *Old England, or The Constitu-*

[37] P.R.O., S.P., Dom., Geo. II, General, Vol. 46, ff. 341–2.
[38] *The Negotiators. Or, Don Diego Brought to Reason. An Excellent New Ballad. Tune of Packington's Hound* (London, 1738).

tional Journal were bothered, especially at the time of the contro-
versy about the hiring of Hanoverian troops. Political prints
dealing with this and other issues, however, seem to have been
immune.

The Forty-five increased the sensitivity of the Government to
any form of criticism. Prints complimenting the Duke of Cumber-
land and attacking the Pretender circulated freely at this time
[see Plate 60]. Prints favourable to the Young Pretender were also
circulated: one of them a portrait of Prince Charles,[39] which
came to the attention of Newcastle:

Whereas I have receiv'd Information, that several Prints have lately
been imported into this Kingdom purporting to be Prints of the Eldest
Son of the Pretender to His Majesty's Crown, in order to be dispersed
here, for treasonable & seditious Purposes: These are, in His Majesty's
Name, to Authorize & require you, taking a Constable to your Assis-
tance, to make strict & diligent Search in such Places, whereof you shall
have Notice, for the said Prints, & then having found, to seize & secure,
& also to apprehend the Person or Persons in whose Custody the same
shall be found, for treasonable & seditious Practices. . . .[40]

The concern about subversion, following in the wake of the
Rebellion, was the cause of an action taken against several print-
sellers four years later.

In the summer and early autumn of 1749 four prints appeared,
entitled *The Cropper* [BMC 3034], *John of Gant in Love, or Mars
on his knees* [BMC 3037, Plate 68], *Solomons Glory or the Rival
Mistresses* [BMC 3040], and *The agreeable Contrast between the
formidable John of Gant and Don Carlos of Southern Extraction*
[Plate 69]. The principal subject of these prints is the Duke of
Cumberland and his supposed relationship with a Savoyard
girl.[41] *John of Gant in Love* shows Cumberland on his knees in
supplication to the girl; a sign in the print reads: 'the Great Fat
Hog to be seen alive'. In *The agreeable Contrast* the Young
Pretender is seated in his library with Britannia beside him; he is
studiously reading Magna Carta, the writings of Locke, and other
treatises. On the floor is a copy of *John of Gant in Love*. Below is

[39] Possibly BMC 2674, a mezzotint.

[40] P.R.O., S.P., Dom., Geo. II, Entry Book 84 (warrants), not foliated.

[41] A frustrated amour; the Duke attempted, unsuccessfully, to make the girl
his mistress. Cumberland's obesity prompted much ridicule.

the verse: 'Here hapless Britain tells her mournful Tales,/ And may, and may again, till *One* prevails.'[42]

On 28 September 1749 Newcastle issued a warrant for the apprehension of the author, engraver, printers, and publishers of these 'seditious & treasonable Prints. . . .'[43] The reasons for this action were no doubt the apparent Jacobite sympathies of at least one of the prints and the scandalous attack on a member of the royal family in all of them. There was, however, another reason, as suggested in the *Penny London Post*:

On Friday last a Printseller near the Crown Tavern, on Ludgate Hill, was taken into Custody by his Majesty's Messengers for selling Prints reflecting on a very great Personage.

The same Day several others of the same Profession were seiz'd for selling the said Prints; and we hear that Informations are lodged against divers Printsellers for selling and exposing to Sale privately very obscene Prints and Pictures, which greatly tend to the corrupting the Morals of Youth.—This vile Practice has been a growing Evil for some considerable Time, and it is hoped that the Aggressors will be severely punished.[44]

The complaint was not a new one, though perhaps it was to become more earnest with the 'improvement of manners'. A writer to *Old England, or The Constitutional Journal* (who signed his name 'Britannicus') commented in 1744:

As the principal Improvement in polite and common regular Education, is received from Books, from the same Source it is that our Morals are corrupted; and it is the most shameful Odium which can be possibly thrown on a Nation, that it abounds with Writings calculated to serve the Cause of Vice, and depreciate every Virtue which would recommend it to the Care of Providence! To so vast a Height hath this Abomination gained Ground in our great Metropolis, that, at every Corner, and in every bye Alley . . . we see exposed to Sale, on Windows and Stalls, Pamphlets with the most immodest Titles and Impure Pictures, which a *Messalina* would blush to meet with. . . . At the Entrance of every public Place of Resort, Agents of Iniquity post themselves with these devilish Instruments of Temptation . . . every Coffee-house gives Admission to this sort of People, who impudently select, in those public

[42] Beneath Prince Charles' chair is the anchor of hope.
[43] P.R.O., S.P., Dom., Geo. II, Entry Book 84 (warrants).
[44] *Penny London Post; or The Morning Advertiser*, 29 Sept.–2 Oct. 1749.

Assemblies, such Pieces and Prints . . . our Daily Papers are become the Vehicles for dispersing Intelligence of them![45]

Obscenity, as well as sedition and treason, was cause for government prosecution. In April 1745 the Government sought out the authors, printers, and publishers of 'a most obscene & infamous Book of Prints, entitled 'A Compleat Set of Charts of the Coasts of Merryland','[46] as well as other obscene material. George Bickham was questioned as the suspected author and publisher of a treasonable map and pamphlet; a search of his house discovered a large collection of obscene prints and a rolling press.[47]

Six printsellers were examined in connection with the publication and sale of *The Cropper* and the other prints: James Verhuyck, Bispham Dickinson, Robert Sayer, Charles Mosley, Matthew Darly, and George Bickham. The examinations were conducted before Lord Stanhope. Verhuyck stated

that about Three Weeks ago, he bought two or three of the Print now shewn to him called '*the agreable Contrast*' of Robert Sayer Printseller in Fleetstreet, but does not know who is the Author, Ingraver or printer . . . Says that he bought about Six of a print now shewn him called 'The *prodigal Son, or, the Brute amonst the Beasts; to feed Swine*' of Bickham of Mays Buildings Says that the Print called the Cropper was brought to his shop by a Hawker & the Examt bought 3 or 4 of them & pd the person who brought them 4d for each.

Says that he bought several of the prints now shewn to him called John of Gant in Love or Mars on his Knees, of Dickinson a Printseller

[45] *Old England: or, The Constitutional Journal*, 30 Mar. 1745. Sixty years later the author of *A Satirical View of London at the Commencement of the Nineteenth Century. By an Observer* (London, 1801) was equally severe in condemning prints and printshops: 'The caricature and printshops, which are so gratifying to the fancy of the idle and licentious, must necessarily have a powerful influence on the morals and industry of the people . . . the greater part of such caricatures, prints, and paintings, as appear in the windows of our printsellers, are injurious to virtue. This humourous mode of satirising folly is very prejudicial to the multitude in many repects; in the loss of time to those who stop to contemplate . . . the opportunities given to pickpockets to exercise their art; and that incitement to licentiousness occasioned by the sight of voluptuous paintings.' p. 148.

[46] P.R.O., S.P., Dom., Geo. II, Entry Book 83 (warrants), f. 461.

[47] 'About 150 Obscene books with all Sorts of Obscene Postures Seized out of Mr. Bickhams Escrutore.' Ibid., General Vol. 146 (unclassified), ff. 359–60; the document is a note signed by one of the messengers, named Carrington. It is dated 29 Jan, but the year is not given; the placement of the note in this bundle suggests that it might have been written in the early 1740s. On Bickham, see above, chap. ii.

on Ludgate Hill but does not know the Author, Ingraver or printer thereof.[48]

Verhuyck claimed the usual plea of ignorance and told his examiners nothing but where he had obtained the prints in question. Dickinson, on being shown *Solomons Glory, John of Gant mounted or Mars on his Journey*,[49] and *John of Gant in Love*, denied knowing the author, engraver, or printer of the first two, but 'says that the other called John of Gant in Love or Mars on his Knees, was printed & published by—Lewis Copperplate printer in a Court in York Buildings of whom he bought Five Hundred which the Exam.[t] has sold'.[50]

Being shewn another print of a Woman almost naked & asked what he knows of that, he says that he bought five or six of the said prints of one Mosley Ingraver & printseller in Round Court in the Strand, some time last Week & says he thinks he has sold some of them.[51]

Sayer claimed that he bought *Solomons Glory* from Dickinson, *The agreeable Contrast* from 'Darley of Dukes Court near St. Martin's Church',[52] of which he sold about twenty. *The Cropper* he bought from a hawker whose name he did not know. Sayer also denied knowing the names of the author, engraver, printer, and publisher of each of the prints in question.

In the case of Charles Mosley:

being shewn several prints w.[ch] were taken out of his Shop by his Majesty's Messengers; He denys that he is the Author or Ingraver of any of them, nor does he know who is.

The Exam.[t] pretends that his Business of Print sellings is carried on by his Serv.[t] Maid & that he does not concern himself therein.

Being asked whether his Maid Servant buys & sells the obscene prints which were taken out of his Shop or how he came by them, he says that they might be left at his Shop in exchange for other prints for what he knows to the contrary; which is all he chooses to say about them; but says that he is very much ashamed that he has been concerned in such sort of prints & will not do so for the Future, intending to leave of the Business of Printselling.[53]

[48] Ibid. (Bundle 111), ff. 165–6. *The Prodigal Son*, etc. is BMC 3014.
[49] Possibly *Mars on His Journey* [BMC 3041].
[50] P.R.O., S.P., Dom., Geo II, General (Bundle 111), ff. 167–8.
[51] Ibid. [52] Ibid., ff. 169–70. [53] Ibid., ff. 171–2.

Darly was shown *The agreeable Contrast* and denied knowing who had produced it. He added that 'a person whose name he says he does not know, left about an Hundred of the sd Prints, at his shop in Exchange for a Book of Ornament for Drawing.'[54] He exchanged twenty-five of these prints for twenty-five impressions of *The Cropper*, with Sayer, and said that 'his Wife has sold several of the sd first mentioned prints, but does not know how many'.[55]

George Bickham pretended complete ignorance and denied knowing anything about the publication of the prints. He argued that 'the Business of his Shop is carried on by his Wife & that he never concerns himself therein.'[56] He believed that *The Cropper* and *John of Gant in Love* were acquired from Sayer, *John of Gant mounted* from Dickinson.

The records indicate that the examinations were made between 18 November and 20 November. The Government had decided a month earlier to prosecute four other individuals, not mentioned in these examinations, for the publication of *The agreeable Contrast*:

May it please your Grace,

In humble Obedience to his Majesty's Commands signified to me by your Grace's letter of the 13th Instant inclosing the Examinations of the Authors, Printer, and Publisher, the Engraver, and others concerned in a Print that was lately seized, and also one of the said Prints. . . . I have perused & considered the Examinations and Print (all of which are herewith returned) And am humbly of Opinion, the Print is a Libel upon his Majesty and his Governmt and particularly on his Royal Highness the Duke, and that the Author, printer and publishers are liable to be punished by Information in the King's Bench.

The persons who seem from the papers to be principally concerned and most guilty are *George Foster* the Seller and *John Seagrove* who were the Original contrivers of it and carried it through, *Thomas Gardner* the Engraver and *Henry Lewis* the Copper Plate printer and therefore I humbly conceive will be proper to be prosecuted. As to Nathaniel Parr who Engraved part only as he says in his Examination and refused to be concerned further when some of the offensive part was proposed and the other persons concerned as Servants in part of the work it may probably

[54] P.R.O., S.P., Dom., Geo II, General (Bundle 111), ff. 173–4.
[55] Ibid. [56] Ibid., ff. 175–6.

be more proper to make use of them as Witnesses. But this may depend on what may come out upon further Inquiry.[57]

The Attorney-General commenced preparations for prosecution on 14 November 1749. Recognizances were paid by Foster, Parr, Lewis, as well as Dickinson, Sayer, and Darly, to appear in the Court of King's Bench. The examinations made on 18–20 November were intended either to gather additional information for prosecution of Foster and the others or to prepare another case against the creators of the other prints. The publication of satirical prints had grown enormously in the 1740s. For several reasons, perhaps one of them being the Government's action, publication lessened considerably in the ensuing three or four years. They did not become numerous again until the controversy concerning the Jew Bill and then the beginnings of the Seven Years' War. Mosley, Bickham, Dickinson, and Foster ceased or almost ceased to be active as printsellers. Darly did not begin to publish political prints in great number until seven years later.

The large number of prints appearing between 1756 and 1763, many of them very critical of ministries and scandalously impudent with regard to the King and royal family, brought no significant response from the Government. Until the Wilkes affair there was little suppression. The instances are few. John Shebbeare, for his *Letter to the People of England*, was continually harassed. An occasional edition of a newspaper and a treasonable toast or two came to the attention of the authorities. In August 1756 a warrant was issued for the arrest of John Biswick,

for Sticking up a most Scandalous and treasonable Paper, on St. Margaret's Hill in Southwark, containing as follows: 'Now selling by Auction, by order of Thomas Holles Newcastle, Great Britain, and the Dominions belonging thereunto; Gibraltar and Portmahon were disposed of the first Day, and the Latter already delivered; Tomorrow comes on the Sale of the King, and Royal Family, Andrew Bung Broker and Auctioneer. . . .'[58]

[57] Ibid., ff. 117–18; the letter is from an official in the Attorney-General's office and is dated 16 Oct. The State Papers contain no records of examinations of Foster, Seagrove, and the others. Foster was, no doubt, the printseller mentioned in the *Penny London Post*, 'near Crown Tavern, on Ludgate Hill'. For Parr, see above, chap. ii.

[58] Ibid., Entry Book 84 (warrants), unfoliated. The theme is similar to that in *The Auction* [Plate 85], in which it is announced: 'Now selling by Auction at the Ass in the Lions skin in Little Britain all the Valuable Effects of John Bull.'

Scandalous, abusive, and libellous material in great quantity
poured from the press in the first years of the reign of George III:
newspapers and prints, attacking the King's ministers, his mother,
and even himself. Despite complaints, most of the prints went
untouched. A few brought Government action.

Friday 15. . . . A bill of indictment was found by the grand jury at the
general quarter sessions held at *Westminster*, against a famous print-
seller, for vending in his shop divers wicked and obscene pictures,
tending to the corruption of youth, and the common nuisance.—There
has of late been such a licentious use made of these wretched exhibitions,
as must in the end prove detrimental to the printseller's trade, of which
the offenders do not sufficiently seem apprized. Many of the represen-
tations that have lately appeared in the shops, are not only reproachful
to government, but offensive to common sense; they discover a ten-
dency to inflame without a spark of fire to light their own combustibles.[59]

In May of 1763 another print, *Mass-Aniello or the Neapolitan
Insurrection* [BMC 4014], an attack on the Government's new
excise scheme, came to the attention of the authorities.[60] The
allusion in the print is to an uprising in Naples in 1647, occasioned
by the oppressive taxation by the alien Spaniard.

Despite the instances of Government notice and action, the
great number of libellous and seditious prints that went untouched
suggest that pictorial satire continued to enjoy more tolerance
than the printed word. In law the position of both remained pre-
carious. In the entire period, 1727–63, Government suppression,
though capricious, was sporadic and inefficient. The Government
never followed a clear policy. Many a libellous picture went un-
noticed. There was too much material in the way of prints,
broadsides, and pamphlets for it to be suppressed effectually. The
authorities often found prosecutions not worth the expence or
effort.

The absence of many pro-ministerial prints suggests that the
Government did not believe graphic satire to be an important tool
of political propaganda. The production and sale of prints reflect,
instead, nothing very different from the temper of Grub Street in
the eighteenth century: a strong dose of entrepreneurship; a keen
sense of public taste and demand, salted occasionally with political

[59] *Gentleman's Magazine* (Oct. 1762), xxxii.501.
[60] P.R.O., S.P., Dom., Geo. III, General (Bundle 2), f. 64.

or personal animus, and useful enough on occasion to make prints important weapons in the arena of political strife.

Graphic satire, with its impudent disregard for the veneration and respect due to constituted authority, lived and grew—partially because of the seeming innocuousness of the tools which it used, partially because of its very size. The existence and development of the political print was one milestone in the winning of freedom of the press.

CHAPTER IV

The Allegory of Patriotism

One of the most striking developments in the mood and thought of the Georgian era is the exuberant nationalism which appears in the middle decades of the eighteenth century. At a time when Bolingbroke was trying to revive the ethos of patriotism—which had been for almost a century part of the vocabulary of political rhetoric, only to fall victim to hypocrisy and abuse—into an apologia for opposition, nationalist fervour was evidencing itself in the nation at large, in a way never seen before.

Its manifestations appear everywhere. A lasting expression can be found in the histories of Bolingbroke, Smollett, and Hume. Though partisan in character, they represent a great stride forward in the written story of the nation's past: testimony to the popularity of national history and the study of the development of its institutions.

A major stimulant for this surge of nationalism was the presence of war during the latter half of George II's reign. Pride in country was engendered with a new militancy, in commercial and maritime aggressiveness combined with a disdain for and inveterate hatred of Britain's ancient enemies. The year 1745 saw the birth of the two great patriotic songs: 'Rule, Britannia!' and 'God Save the King!'[1] The latter, first introduced during the crisis of the Forty-five, became instantly popular on the London and provincial stage, was published in magazines and broadsheets, and soon became a favourite street song and the world's first national anthem. Such pieces, along with traditional ballads and songs, were heady wine for a nation at war, a country delirious with victory at the close of the reign. The joy of national glory and spreading empire is well expressed in two prints which greeted the accession of George III: *Long Live His most Excellent Britannic Majesty King George the Third* [BMC 3732, Plate 100] and *King George* [PML iii.50.174, Plate 101].

The birth of modern nationalism, with its dependence upon a

[1] Though both songs were actually composed a short time before. See Percy A. Scholes, '*God Save the King!' Its History and Its Romance* (London, 1942).

broadly-based popular culture and the development of a popular journalism, can be traced to the graphic satire of the period. The political print, in fact, served as an agent of its growth. The two most famous visual images of British nationalism, Britannia and John Bull, were nurtured by the draughtsman's needle. Joining the traditional iconographical figures—Justice, Liberty, Fortune, Time, the Devil, Furies, Fame and the rest of their panoply— Britannia and John Bull led a small band of more contemporary images in presenting an allegory of patriotism.

1. *National Stereotypes*

The roots of mid-eighteenth-century nationalism are to be found in the seventeenth century, if not earlier. The taproot was that most basic of English prejudices: xenophobia. Hatred of the foreigner (if so many alien observers are to be believed) was a most characteristic expression of the Englishman's haughty nativism and insularity.

There began to develop in the seventeenth century, and become fairly settled in the eighteenth, certain national stereotypes: the Englishman's understanding of, for example, a Frenchman, a Spaniard, or a Scot. They became, in a negative way, expressions of his own sense of 'Englishness'. Developed from the impressions and prejudices of the past, these stereotypes gradually acquired a fixity of their own. In the prints their repeated use made them allegorical figures in their own right, companions to Britannia and John Bull.

The attitude of the middling and lower classes—in contrast to that of the aristocracy—towards the French was one of unqualified prejudice and dislike. The Frenchman was a vain, over-civilized, pretentious dandy, given to excess in fashion, food, and manners; a fawning rascal, who delighted in the intrigues of love and politics.[2]

His appearance in the prints corresponds with this general impression. He is almost always 'over-dressed' in the latest fashions. In *Old England: Or, The Constitutional Journal. Extraordinary* [Plate 50], the Frenchman standing beneath the kite wears a lace-bordered and feather-fringed cocked hat, and a large bag-wig, which was becoming fashionable in England about the

[2] Already a fixed impression in the seventeenth century; see *A Satyr against the French* (London, 1691).

middle of the century.[3] The bag-wig usually marks the Frenchman in the prints. He frequently appears, as well, in a finely trimmed, patterned coat and waistcoat, sometimes wearing the feathered hat, and often a solitaire.[4] The figure at the right in *Tempora mutantur, et Nos mutamur in illis* [BMC 3015, Plate 65] is a good example. In *The Grand Monarque in a Fright* [BMC 3284, Plate 76] a fop courtier, half-bowing, wearing a solitaire and bag-wig, stands next to the French king. 'Ribbands and Lace are the Things without which the *French* cannot live, and tho' they are a People of the least Reflection in the World, are prodigious fond [*sic*] of Looking Glasses.'[5] The English, in contrast, appear in the prints in 'undress': the clothes of everyday wear.

The Frenchman in *The Grand Monarque in a Fright* has what is intended to be a 'French' face: long and emaciated, bony, with heavy brows. Englishmen saw the French as by nature thin, awkward and knock-kneed in their affectation, with sharp aquiline noses, jutting chins, and raspy mouths. The representation in *The Contrast* [LWL, Plate 99] is typical.

The English were also fond of picturing the French as apes or monkeys. This particular comparison was of long-standing and probably originated from the observation of the oddity of French affectation:

> Their Modes so strangely alter humane Shape,
> What Nature made a Man, they make an Ape.
> The Faults of hers which they pretend to Cure,
> Burlesque God's Images with their Garniture.[6]

In many prints the Frenchman takes on the simian features of the ape, and in some prints he is obviously intended to be one. *The C–rd–n–l Dancing-Master, or, Pl–ce–m–n in Leading-Strings* [BMC 2530, Plate 40] shows two Frenchmen playing a fiddle and a French horn respectively; both resemble apes, with their dwarfish, hunched postures, their legs, and prognathous faces. One has a tail. Another example can be found in *A Poor Man*

[3] See C. Willett and Phillis Cunnington, *Handbook of English Costume in the Eighteenth Century* (London, 1964), p. 94.

[4] A black tie worn about the neck.

[5] *Letters on the French Nation: By a Sicilian Gentleman, residing at Paris, to his Friend in his own Country* (London, 1749), p. 37.

[6] *Satyr against the French*, p. 3.

Loaded with Mischief [Plate 110], in which the Duke of Nivernois is pictured as a monkey or ape.[7]

The Spaniard in the prints, in contrast to the French 'à la mode', wears the strangely antiquated dress of the seventeenth century: the image of an old but no longer especially important enemy. The essentials of this dress are the tightfitting doublet with jerkin; pantaloons (gradually replaced by breeches); cape; a high-crowned, narrow-brimmed hat, eventually giving way to the broader slouch hat with panache; and the large collar, either stiff, high and folded, or in the flat Walloon style. Boots are common. The hair is worn long. Beard and moustache remained popular throughout the seventeenth and into the eighteenth century. Typically Spanish, as well, are the slashed quarter-arms and trunks.[8]

The Naked Truth [BMC 2417][9] suggests what the Spaniard looked like during the Commonwealth; the figure is characterized by a high-crowned hat. The image changes little in the prints of the eighteenth century. In *Slavery* [BMC 2355, Plate 24] of 1738 the Spaniard driving the captured English seamen wears a crowned hat with panache, jacket, cape, breeches, and natural hair. The figure in *The Lyon in Love* [Plate 22] provides a good example of the broad-brimmed hat, decorated with a flower; his dress also has slashed quarter-sleeves. The moustache is common, as

[7] The Duke of Nivernois—Duc de Nivernais—was French plenipotentiary in England during the peace negotiations of 1762. A similar figure (perhaps Nivernois) appears in Plate 112. The comparison of men to apes or monkeys is immemorial. To 'ape', of course, suggests mimicry, imitation of something superior to one's nature—as the anthropoid 'apes' human behaviour. So, too, the Frenchman apes in his pretentiousness and artificiality, denying human nature. Apelike qualities could also suggest something bestial and sub-human. The Devil was often visualized as a small imp or monkey. Physiognomy associated simian features with bestiality and viciousness. Gillray, probably with this idea in mind, sometimes caricatured the French Jacobins as men with simian faces. Evolutionary ideas in the nineteenth century strengthened the association and made possible racist vilification. The apelike countenance became part of the Irish stereotype in Victorian graphic satire. See an interesting study of this subject in L. Perry Curtis, jun., *Apes and Angels, The Irishman in Victorian Caricature* (Washington, D.C., 1971). The Irishman did not become a familiar stereotype in the iconography of humour and propaganda until the nineteenth century. Like Ireland he is generally ignored in the eighteenth century.

[8] See Brian Reade, *The Dominance of Spain, 1550–1660*, part 4 of *Costume of the Western World*, ed. James Laver (6 vols. London, 1951).

[9] The design is a device copied from a Dutch medal of the seventeenth century: a satire on Cromwell's enemies.

in *The Consultation of Physicians, on the Case of the Queen of Hungary* [Plate 39], in which there is a Spaniard, wearing a small, flat hat with panache; he sports a thin, turned-up moustache.

With the growing commercial conflict between the two countries in the 1730s, the proud, arrogant Spaniard became a familiar image. His strange dress and appearance provided him with an aura of mystery.

Less like the Spanish and more like the French, the Dutch stereotype is a subject of ridicule. Beside the mawkish Frenchman and exotic Spaniard, the Dutchman stands out as a portly, robust fellow, carefree and indolent, with a smile on his face. 'A Dutch Man is a Lusty, Fat, two Legged Cheese Worm: A Creature that is so addicted to Eating Butter, Drinking fat Drink, and Sliding, that all the World knows him for a slippery Fellow.'[10] He is 'clownish and blunt to men, respecting neither person, nor Apparel'.[11] His dress is 'plaine and manlike, alwayes of one fashion. . . .'[12]

The Dutchman in the prints seems oafish. He usually wears a jacket, trousers or baggy breeches, a kerchief, and a stocking cap (though often it is a slouch hat). The figure in *The European Race* [BMC 2334, Plate 20] and *The European State Jockies* [BMC 2449, Plate 29] are typical. The face is most often that of a well-fed burgher: full, applecheeked, sometimes with a bulbous nose [see Plate 39].

The stereotype plays the part of the inevitable bystander in European affairs; he is lazy, cautious, with a sharp eye for his own interests. A reluctant ally, the Dutchman prefers to sit back and smoke his pipe. The English also faulted the Dutch for their greedy, mercantile spirit. The hog on which the Dutchman rides in *The European State Jockies* is laden with barrels and money.[13]

[10] *The Dutch Boare Dissected, or a Description of Hogg-Land* (London, 1691). A broadside.

[11] *The Dutch Drawn to the Life, in I. An Exact Description and Character of the several Provinces of the Netherlands. II. An Account of their Trade and Industry* (London, 1664), p. 69. [12] Ibid., p. 57.

[13] An unusual personification of the Netherlands appears in *The Parcae: or, The European Fates* [PML ii.46.153]. The image is that of a headless figure with seven hands, each with a purse of money; the figure is meant to suggest the political instability and disunity of the United Provinces as well as the Dutchman's grasping materialism: 'Tho headless Holland, with his seven Hands./ To make the most of all Things, neutral Stands.'

Prussians, Turks, and Russians occasionally appear in the prints, but their images are not well developed. An unsympathetic stereotype of the Scot was well fixed in the minds of eighteenth-century Englishmen and becomes important in the prints of the 1760s.[14]

The American colonist does not begin to appear in the prints until the middle of the century; the image becomes especially familiar in the prints of the 1760s and 1770s. The Red Indian is sometimes adopted as a personification.[15] In *The American Moose-Deer, or away to the River Ohio* [BMC 3280], a colonist appears in an Indian feather-bonnet, ragged coat, and breeches. The Indian, or the man in Indian dress, was to remain the personification of America until the birth of Uncle Sam in the nineteenth century.

2. *Britannia*

The Romans gave the provinces that fell under their sway lovely feminine names, and so Britannia appears in the reign of the Emperor Claudius—though Julius Caesar had known her a century before. As a lady in the Roman pantheon of allegorical figures, she does not make her appearance until the reign of Hadrian, when she has her début on the reverse of a Roman coin.[16] She sits facing the viewer, her right foot resting on rocks, her head inclined on her right hand. She holds a sceptre in her left hand and a large round shield at her left thigh. Later, in the reign of Antoninus Pius, Britannia takes on the image that is to remain with her until and including the British coins of the modern era: a classically draped figure, seated three-quarters left; a spear held out in her right hand; her left forearm resting on her shield; her feet against the rocks; her head adorned with a plumed helmet.[17]

Britannia disappears with Roman Britain and probably does not return until the early seventeenth century, when she stirs only faintly, as a decorative item on a few frontispieces. The earliest of these is William Camden's *Britain, or a Chorographicall Description of the Most flourishing Kingdomes, England, Scotland,*

[14] See below, chap. vii.

[15] Taken from the traditional allegorical representations of the four continents, which can be seen in Plates 20 and 29.

[16] See Gilbert Askew, *The Coinage of Roman Britain* (London, 1951).

[17] Though on many of the coins of Antoninus Pius she is bareheaded.

and Ireland (London, 1610), in which Britannia takes the same appearance as in the later Roman coins: seated three-quarters left, with the English Channel behind her. At the same time the emblem book, Peachum's *Minerva Britanna*, was published.[18] One of its emblems is entitled 'Ad Britanniam', showing much the same figure, but standing on the shore, repelling a ship with her right foot.

> With haire dishevel'd, and in mournefull wise,
> Who spurns a shippe, with Scepter in her hand:
> Thus *Britaine's* drawen in old Antiquities,
> What time the *Romanes*, overran her land:
> Who first devis'd her, sitting in this plight,
> As then their captive, and abandon'd quite.
>
>
>
> Thrice-famous *Ile*, whom erst thou didst obey,
> Usurping *Roome*, stands now in awe of thee:
> And trembles more, to heare thy Soveraines name,
> Then thou her Drummes, when valiant *Caesar* came.[19]

Why did Britannia return during the reign of James I? Perhaps because of the classicism of the Renaissance, combined with a new love of antiquarian studies.[20] Or it might have been the result of the first step towards union of the two kingdoms of England and Scotland, which the succession of the Stuarts brought about and which was imperfectly embodied in the first Union Jack.[21] Perhaps the exuberance and pride generated by the defeat of the Armada encouraged it: a quickened sense of Britain's insularity and favoured position. 'For should our Swaines divulge what sweets there be/ Within the Sea-clipt bounds of *Britanie*,/ We should not from invasions be exempted.'[22]

The medallic history of Britannia begins with a Dutch satiric piece of 1655—from which *The Naked Truth* came—showing Cromwell kneeling before Britannia, his head in her lap, and his

[18] Henry Peachum, *Minerva Britanna or a Garden of Heroical Devises*. Above, chap. ii.

[19] Ibid., emblem 108.

[20] Surveys such as Camden's became popular in the seventeenth century; his book includes a history of coinage dealing with Britain.

[21] The first Union Jack appeared in 1606. In the precise and original sense of the word, 'Britannia' referred only to Roman Britain, which did not include Scotland, but only the province of the Empire.

[22] William Browne, *Britannia's Pastorals, The second Booke* (London, 1616), p. 125.

arse exposed for a Frenchman and Spaniard to kiss. A year earlier a medal, celebrating the peace with the Netherlands, appeared; in it a female figure represents each of the two countries, but it is not certain that one is intended to be Britannia. After 1655 she continues to be seen on the medals by John Roettier, celebrating the Restoration, and thereafter remains a standard allegorical figure in Dutch and English medals.

The same Roettier executed a medal in 1667 for the Peace of Breda. Britannia appears on the reverse, in the old manner: seated by the seashore, her feet resting on rocks; her hands holding spear and shield, as she looks upon her navies. Legend has it that Roettier used Frances, Lady Stuart, of Charles II's court, as his model.[23]

Five years later the first English coinage to include Britannia was minted, also designed by Roettier. On the reverse of farthings and half-penny pieces she can be seen, seated, a spear in her right hand, olive twig in her left, and a shield under the left forearm. On all coins of this period the lance, shield, and olive twig remain Britannia's standard attributes.[24] Her image on the reverse of the copper coinage of George II's reign does not change. Not until the reign of George IV and Victoria were the trident, plumed helmet, and lighthouse added.

Britannia is not a familiar figure in the prints of Restoration England. She does not become established until the middle decades of the eighteenth century, when, in a time of aggressive nationalism and empire, she lent herself to a patriotic song and a quickened sense of national destiny.

The prints give the impression of simplicity in what Britannia is and what she represents. As with many of the traditional allegorical figures such as Truth or Justice, her appearance is a simple, maiden beauty: a young female with soft features, in classical tunic or simple dress; bareheaded, with a tress of hair falling down her neck. The shield and lance are her principal attributes. The shield has either a simple oval shape, or is a more elaborate escutcheon with ornate borders (cartouches, as in Plates 86 and 113).

[23] Henry B. Wheatley, *The Diary of Samuel Pepys for the Year A.D. 1667* (New York, 1942), p. 76.

[24] Though a coin of 1713 shows Britannia holding the rose and thistle, confirming her representation of the United Kingdom.

Britannia represents the nation; whether that nation is England or Great Britain varies with the subjects and intent of the prints. As a rule, the cross of St. George and saltire of St. Andrew decorate her shield, though on a rare occasion it displays the royal coat-of-arms. She is, in many prints, explicitly intended to represent Britain, as in *King George* [Plate 101], dedicated to the accession of George III. Britannia was, of course, occasionally an expression of the Englishman's gratuitous confusion of England and Great Britain.[25] A few prints clearly distinguish between Britannia and Scotland. In *The Scheme Disappointed A Fruitless Sacrifice* [BMC 1928, Plate 15], the latter is personified in another goddess, 'Scotia', with helmet and tunic, and a thistle on her shield. Many prints on the Forty-five and a few of the anti-Bute prints of a later time deliberately isolated Britannia from her delinquent northern children, by leaving the saltire of St. Andrew off her shield. Such, for example, is the case in *Tempora Mutantur* [BMC 3886, Plate 107] of 1762.

However the limits of her province might be construed, she is the Minerva, the Pallas Athene of Britain. Britannia's affinity with the Greek and Roman patron goddess is iconographical; there is a similarity in appearance and attributes, as well as in the qualities she represents. In the English edition of Ripa's *Iconologia*, 'Potesta', or the 'Government of a Commonwealth', is represented by a

Lady resembling Minerva; an olive branch in one Hand, and a Shield; in the other a Javelin; with a Helmet on her Head. Her Deportment, like Minerva, shows that Wisdom is the Principle of good Government. The Helmet, that the Republic ought to be well fortified and secur'd from foreign Force. The Olive and Dart, that Peace and War are both beneficial to the Commonwealth: for War because by Experience Valour is attain'd; Peace, because Leisure to acquire Prudence to govern.[26]

In the illustration accompanying this description the artist has taken Britannia as his model: a figure seated three-quarters left, by the seashore; in classical drapery with plumed helmet and breastplate; a lance and olive twig held in her hands; the cross of St. George and saltire of St. Andrew decorating her shield; ships in the background.

[25] See, for example, Plate 70.
[26] Tempest, *Iconologia*, p. 80.

Britannia becomes, in the role of a youthful matriarch, the satirist's and propagandist's voice of patriotic exhortation. She is the apotheosis and idealization of the values which the nation holds dear. In a pamphlet of 1742, entitled *Britannia in Mourning*, the reader encounters a political jeremiad in the form of a dialogue between two characters. One, an embittered patriot, yearns for the Britannia of old:

Here, my worthy Friend, see the fair *Britannia*, the bright *Idol* I adore; see her, in one Part of this finish'd Piece, cloathed in a Milk-white Robe, blooming as *May*, chearful as the Summer's Dawn, rais'd high on a Pedestal ornamented with Ensigns of *Victory*, *Power*, *Peace*, and *Plenty*: See how the Nations of the Earth bow down to her: See the Riches of the World landed at her Feet: See *Liberty* supported by her on one Side, and the Gorgon *Tyranny* trampled upon on the other. See the *Great States* of *Europe* differently represented, courting her Smiles, and suing for her Alliance or Protection.[27]

It was natural for artists to make Britannia the frequent companion of Liberty, Justice, Religion, Plenty, and the other allegorical representations of the public weal.[28] Her association with Liberty was close throughout the eighteenth century.

> Not, as of old,
> Extended in her hand the cap, and rod,
> Whose slave-enlarging touch gave double life:
> But her bright temples bound with *British* oak,
> And naval honours nodded on her brow.
> Sublime of port: loose o'er her shoulder flow'd
> Her sea-green robe, with constellations gay.
> An island-goddess now; and her high care
> The Queen of Isles, the mistress of the main.[29]

from a poem in which the associations of Britannia and Liberty are conjoined.

A close iconographic sister to Britannia, Liberty herself occupies an important place in the political prints. She represents the highest political ideal, the aegis of all true patriots. As with Britannia, her appearance is simple: a comely young woman in

[27] *Britannia in Mourning: Or, a Review of the Politicks and Conduct of the Court of Great Britain* (London, 1742), p. 7.

[28] As, for example, in Plate 59.

[29] Thomson's 'Liberty': Patrick Murdock (ed.), *The Works of James Thomson* (3 vols.; London, 1788), ii.18.

white drapery or modest dress. Her attributes are few. Sometimes identified by broken fetters at her feet,[30] she is usually recognized by the Cap of Liberty on a pole. Dutch medallists popularized this emblem in the sixteenth century.[31] Its symbolism derived from the ancient Roman custom of manumission, whereby a slave wore such a cap as a sign of his newly-won freedom.[32] The cap appears as an emblem on Roman medals. The Dutch adapted it as a symbol of their struggle for independence from Spain. The Cap of Liberty was a familiar image in England during the eighteenth century, before the French Revolution, using the Phrygian bonnet, gave it a new life as an emblem. Usually bell-like or flat and broad-brimmed in shape, the emblem appears frequently in the prints.

Britannia, who herself carries the Cap of Liberty in Plate 50, is closely associated with Liberty in the prints. They often appear together. Britannia is the guarantor of Englishmen's rights and liberties, as in *The Scheme Disappointed* where 'Magna Charta' rests on her lap. *The Fall and Rise of the British Liberty* [Plate 44], subtitled 'Britannia's Critical Year 1742', takes Britannia as its subject—though it could have just as well been Liberty—and depicts her plight and eventual triumph over the figures and symbols of foreign tyranny.

Britannia also embodied Virtue, especially those virtues relevant to national and public life: love of country, dedication, honesty, selflessness, discipline, simplicity. Assuming the responsibilities of a motherly charge, she exhorts her sons and daughters of all classes: 'Ye Offspring of my favour'd Isle attend, Hear, in my Voice the Parent, & the Friend. . . . Let Prince, Priest, People, ev'ry Rank and Age,/ In the same humble, awful Work engage.'[33]

The prints show her as the avowed enemy of corruption, as Liberty was to Tyranny.

[30] See *Robin⁸ Reign or Seven⁸ the Main*, Plate 9.

[31] The emblem probably first appeared on a medal in 1574, and thereafter figured prominently: Van Loon, *Histoire métallique*, i.179.

[32] Van Loon gives two interpretations of the custom: 'Formerly in Roman houses slaves freed by the will of their owner covered their heads in the funeral ceremony of their patron . . . or when a master freed a slave, he made him raise his head and had him cover his head with a hat; from which came the expression among the Latins: "appeller quelqu'un au chapeau", that is to say, "to destine him liberty." Ibid., p. 201.

[33] *The Acceptable Fast: Or, Britannia's Maternal Call* [BMC 3341].

... where we find a spark
Of public virtue, blow it into flame
Lo! now my sons, the sons of freedom! meet
In awful senate; thither let us fly;
Burn in the patriot's thought, flow from his tongue
In fearless truth; myself, transform'd, preside,
And shed the spirit of *Brittania* round.[34]

Britannia's virtuous charge sides her with the Opposition. The national goddess is the exalted patroness and guardian of true patriots. She weeps with Pitt and his patriot Opposition at the sad state of the country's affairs in *Tempora Mutantur*.

Satirists and propagandists tried to convey in Britannia the idea of virtuous innocence. Again and again the prints show her as an innocent, abused, insulted, cozened. Conjoining chivalry with patriotism, the prints expressed this theme as a means of lambasting the evil of the age, whether represented in politicians or the nation at large.

The decline and impending fall of Britannia is a common lament:

As on the sea-beat shore Britannia sat,
Of her degenerate sons the faded fame,
Deep in her anxious heart, revolving sad:
Bare was her throbbing bosom to the gale,
That hoarse, and hollow, from the bleak surge blew.[35]

The patriot 'Earnest' in *Britannia in Mourning* is filled with morose visions of Britannia's deteriorated state, and in the beginning of the dialogue looks at a picture of her, naked and disgraced.

This theme was graphically expressed with innumerable variations. Many prints, in their criticisms of the government or the nation, show Britannia distraught, weakened, or defeated. *The Court Fright* [Plate 53] is an example. Here Britannia, a victim of an incompetently conducted war and a betrayal of national interests, faints beside the King. A weeping Britannia is an image which frequently appears.

In the enactment of the theme her sadness and weakened condition are shown to be the result of persecution, abuse, and

[34] Thomson's 'Britannia. A Poem.' *Works*, ii.10.
[35] Ibid., ii.1.

liberties taken. The adaptations are many. One of the illustrations to *A List of Foreign Soldiers in Daily Pay for England* [Plate 52], an anti-Hanoverian satire of 1743, shows Britannia as a baby, in the lap of a German nurse who mistreats and underfeeds her. Occasionally the theme takes a more savage tone. *The Whipping Post* [BMC 3945, Plate 113] of 1762 shows Bute thrashing Britannia with a thistle, as she stands stripped naked and tied to a post—punished like a common harlot or other miscreant.

Sometimes Britannia's fate is martyrdom. The grotesque and striking *The Conduct, of the Two B*****rs* [BMC 3069, Plate 70], an imitation of Nicholas Poussin's *The Martyrdom of Saint Erasmus* at the Vatican, shows Britannia lying desecrated on a table, as two ministers (the Pelhams), malevolent and satanic expressions on their faces, disembowel and dismember her: 'O England, how revolving is thy State!/ How few thy Blessing! [*sic*] how severe thy Fate.' In the same vein is an etching of 1757, entitled *A View of the Assassination of the Lady of John Bull Esq^r Who was barbarously Butcher'd Anno 1756 & 57 &c.* [BMC 3548]. In Gulliverian fashion, Britannia appears tied down, half-naked, on a beach, and dismembered by invading Frenchmen of Lilliputian size.

Somewhere in the dire lamentations of this theme can usually be found the idea of 'Britannia *redux*', that she will return. *The Temple and Pitt* [BMC 3652, Plate 98] of 1757 shows an apparently defunct Britannia laid to rest, but with the promise: 'She is not dead but sleepeth.'

For Britannia is as much an expression of martial strength as she is persecuted innocence. A measure of the patriotism that enveloped her as an aura took the form of an aggressive nationalism: idealized in her being and approximating to the French *la gloire*. Her principal attributes, lance and shield, suggest military prowess. But she rarely uses them. While a militant Britannia occasionally can be seen—as in *The Rebellion Displayed* [Plate 58] during the crisis of the Forty-five—her femininity and goddess-like presence required that others be her agents. She is the inspirer, the guardian of a rampant patriotism. Her role is exhortative. True martial valour is represented by the British lion, of which Britannia sometimes has charge.[36]

Close, too, is Britannia's association with maritime or naval

[36] See below, p. 102.

glory. 'Rule, Britannia!', along with the prints and medals of the time, demonstrates her connection with the nation's seapower. Pictorially, Britannia always associated herself with the sea, even in the earliest coins and medals. 'Hail, happy Land, whose fertile Grounds/ The liquid Fence of *Neptune* bounds . . . Who is't prescribes the Ocean Law?'[37] Rarely does Neptune's attribute, the trident, replace the lance in the prints, though Neptune, himself, sometimes can be seen in the company of Britannia. In a broadside with woodcut illustration, *The Assembly of the Gods* [PML iii.38.127], of 1756, he chooses Britannia's side against France and pleads the British case:

> That they alone reign'd Monarch of the Deep.
> And now as shee full Royal o'er her rides
> All Powers to her their waving Pendants strike,
> And with Submission their due Homage pay . . .

As the embodiment of triumphant national self-esteem and as the martyr of the satirical jeremiad, then, Britannia plays an important role in the graphic satire and propaganda of the mid-Georgian era. This is the first medium in which she is used frequently and imaginatively. However trite and shallow her symbolic import may now seem to be, her presence and varied use attest to the strong pulse of nationalism in the middle decades of the eighteenth century.

3. *John Bull*

If Britannia was the embodiment of national aspirations and ideals, John Bull came to be the embodiment of national character. Originally a literary creation, conceived by John Arbuthnot in a series of tracts published during the War of the Spanish Succession,[38] by the end of the eighteenth century John Bull had developed as an ideal-type Englishman.

James Gillray and John Tenniel have both been credited with the invention of John Bull as he is known today: a burly, almost oafish English squire, of simple manners and hearty living.

[37] *King George* [Plate 101].
[38] Five pamphlets published in 1712. The title of the first is: *Law is a Bottomless-Pitt. Exemplify'd in the Case of The Lord Strutt, John Bull, Nicholas Frog, and Lewis Baboon. Who spent all they had in a Law-Suit. Printed from a Manuscript found in the Cabinet of the famous Sir Humphrey Polesworth* (London, 1712).

Gillray's caricatures during the French Revolution and, later, Tenniel's illustrations for *Punch* did make John Bull famous. But credit for launching him on his artistic career is also due to the political prints of an earlier period.

The birth of a pictorial character was a laboured one. John Bull did not, in fact, appear in a political print until almost half a century after Arbuthnot's original creation. Despite the immediate popularity of the tracts, the particularity of their subject-matter and the obscurity surrounding their authorship[39] discouraged their becoming an influential classic. They did reappear or were imitated now and then in the first half of the century. French and German translations were made. Renewed Anglo-Scottish animosities inspired a variation of the old story in the 1760s: *The History of the Proceedings in the Case of Margaret, Commonly called Peg, only lawful Sister to John Bull, Esq.*, a pamphlet of 1761 by Adam Ferguson, provides an example.

The motif of Arbuthnot's political allegory was a popular one: that in which countries become landed estates, with their interests and concerns translated into domestic properties and lawsuits, their kings and ministers into landlords and stewards. A continuation of the original allegory was published in 1744, with John Bull as the king. In *The Night-Visit, or the Relapse: With the Pranks of Bob Fox the Jugler, while Steward to Lady Brit, display'd on a Screen* [Plate 48], Britannia replaces John Bull as the head of the estate. Surrogate John Bulls are found in the fictitious names, adopted by editors and correspondents of the many newspapers of the period: such names as 'Sir John English' and 'Jeffrey Broadbottom'.[40]

[39] Swift has received credit for the tracts. The consensus among modern scholars, however, attributes them to Arbuthnot. See L. M. Beattie, *John Arbuthnot, Mathematician and Satirist* (Cambridge, Mass., 1935).

[40] In fact, there are many varieties of the John Bull image in literature and art. The Sir Roger de Coverleys, Squire Westerns—the general stereotype of the honest, blunt, trueborn Englishman—are embodiments of the simple, unpretentious, and durable virtues of country life. The rustic, fox-hunting squire is a familiar character in the political prints (see below, chap. v).

John Bull himself appears in an advertisement in the *Craftsman*, 10 Jan. 1729–30: 'Whereas a Scandalous and most insolent *Libel* was this Day published and dispersed through all Parts of this Town, highly reflecting on *Me* and *My Conduct*, in order to render me ridiculous and contemptible to the World, and, as it is supposed, to exasperate well-meaning People against the *Liberty of the Press*, at the Meeting of the *Parliament:* This is to give Notice that if any Person will discover the *Author* or *Projector* of the said *Libel*, so that he may be legally convicted thereof and

Law is a Bottomless-Pit [BMC 1990], a satirical piece on the law published sometime in the 1730s or 1740s,[41] contains part of the title of Arbuthnot's original tract: a phrase which he coined. Suddenly, in the prints of the 1750s and early 1760s, both the name and motif began to appear. *The Auction* [Plate 85], a print of 1756 attacking the sell-out of the nation by the Newcastle ministry, displays a 'selling by Auction at the Ass in the Lions skin in Little Britain all the Valuable Effects of John Bull Me[rchant?] and Chap[man?] leaving of Trade. By A. Lapis Broker'.[42] John Bull himself is not present, but 'Mons^r Baboon' (Louis XV?) and 'Madam South' (probably the Queen of Hungary) are.[43]

A View of the Assassination of the Lady of John Bull shows Britannia, but not John Bull. In the original tracts, his 'wives' were the political parties, whichever one was in office at a given time. In *John Bull's House sett in Flames* [Plate 108] of 1762 John Bull again does not appear. The print implies that he is George III styled as a squire, for his 'house' is St. James's Palace.

John Bull finally makes his debut in *A Poor Man Loaded with Mischief. Or John Bull and his Sister Peg* [Plate 110],[44] published in September 1762. Intended to demonstrate England's subservience

brought to *condign Punishment:* he shall receive of me *John Bull,* at my House in *Westminster,* a suitable Reward, and all possible Encouragement owed to such a Seasonable service. Witness my Hand *John Bull.*' The letter, a satirical piece, probably alludes to the just published Treaty of Seville and anticipated parliamentary opposition to it. John Bull, in a sense, represents Parliament; the 'Projector' is presumably Walpole.

[41] It is difficult to determine the date, because of the lack of publication line and the general nature of the subject. The style of dress, however, appears to be that of the 1730s and 1740s.

[42] 'A. Lapis' is Andrew Stone, the Duke of Newcastle's secretary. See above, p. 81, and below, chap. viii.

[43] The reclining figure in shadow at the lower right of the design is the Dutchman, 'Mynheer Nick Frog', who, bankrupt, is selling John Bull's estates.

[44] Though the design of this print bears a striking resemblance to a popular emblem ('Amicitia' in Alciati's *Emblemata*), in which a blind man carries a lame man on his back, the latter directing the former; and a still older fable, 'A Lame Man and a Blind', L'Estrange, *Fables and Storyes Moralized. Being a Second Part of the Fables of Aesop and Other Eminent Mythologists* (London, 1699), p. 90, the inspiration for the print was a public-house sign in Oxford Street, 'The Man Laden with Mischief', said to have been painted by Hogarth. The sign shows a man carrying a woman and other impedimenta on his back. See Revd. E. Cobham Brewer, *A Dictionary of Phrase and Fable* (London, n.d.), p. 118.

to Scottish influence, the print shows John Bull, a blind and perhaps lame man, walking along a road, led by a fox (Henry Fox) and burdened with his termagant sister, Peg, with her shrew's face and tartan dress.

Arbuthnot provides little description of John Bull, saying only that he was 'ruddy and plump, with a pair of Cheeks like a Trumpeter'.[45] His character was that of 'an honest, plain-dealing Fellow, Cholerick, Bold, and of a very unconstant Temper. . . careless . . . a Boon-Companion . . . plain and fair dealing. . . .'[46] The sparse physical description does, at least, suggest the image created by Gillray, though the artist took his caricature to the extreme in making John Bull a fulsome, lumpish buffoon.[47]

In *A Poor Man Loaded with Mischief* he seems rather ordinary, neither especially fat nor thin, plainly dressed in shirt, waistcoat, and breeches. The face is not appealing, nor, despite the cuckold horns, is it particularly amusing. Much the same can be said for the John Bull in *Jack Afterthought or the Englishman Display'd* [BMC 4020, Plate 119], who presented a very ordinary, rustic image in riding attire, with jockey cap, simple coat, breeches, and jackboots: the picture of the plain country gentleman.

In these prints of the middle of the century, then, there is little significant development of the character of John Bull beyond his introduction into graphic satire. He was a convenient figure for satirists to use in the early 1760s, in depicting the strong anti-Scottish feeling then occurring in England.[48] John Bull had not yet completely freed himself from the story which gave him birth. But from the very beginning there was that suggestion of his down-to-earth Englishness from which he was to develop into an independent, full-blown embodiment of national character.

[45] [John Arbuthnot] *John Bull Still In His Senses: Being the Third Part of Law is a Bottomless-Pit* (London, 1712), p. 9.

[46] Arbuthnot, *Law is a Bottomless-Pit*, p. 10.

[47] The essential character of Arbuthnot's original description continued to hold true, as this adaptation of 'God Save the King' in 1809 testifies: 'God save great Johney Bull/ Long live our noble Bull,/ God Save John Bull!/ Send him victorious,/ Loud and uproarious/ With lungs like Boreas,/ God save John Bull.' Scholes, p. 36.

[48] The nature of Arbuthnot's John Bull was that of a well-meaning, exploited innocent. This may account for the fact that in a few prints of the 1760s he was intended to be George III (a young king, duped by his mother and Lord Bute—see below, chap. vii). George III's extraordinary popularity at a later time has usually been explained by the fact that he, in his character, prejudices, and tastes, expressed those very 'English' qualities embodied in John Bull.

4. *A Menagerie of Nations*

The use of animals as symbols is very old. Classical fables and the bestiaries which enjoyed great popularity during the Middle Ages contributed much to the body of conventional iconography. Animal symbolism is a distinctive element in the political print. An ample representation of familiar beasts, with their time-honoured associations, can be found: the serpent of wisdom and prudence, guile and sin; the goat of lust; the ass of stupidity or subservience; the ape of vanity and folly. So, too, some of those fanciful and exotic creatures crowded by man's imagination into the bestiaries: the dragon with its spiked nose, fangs, and leathern wings; the terrible hydra with its many heads, a symbol of multifarious evil.[49] Animals were especially important in depicting a common and presumably popular subject of the political print: foreign affairs. Collectively, the prints offer a veritable menagerie of nations.

Artists stocked their menagerie from two principal sources: fables and heraldry. The old fables, especially the fables of Aesop, enjoyed a great vogue in the late seventeenth and early eighteenth centuries. They provided a source of ideas for the emblem books. L'Estrange's *Fables of Aesop and Other Eminent Mythologists* became a classic. Many editions of Aesop appeared in the first half of the eighteenth century. Fables were incorporated into the literature of political allegory. Not surprisingly, some of these tales found their way into the prints. *The Lyon in Love* [Plate 22][50] takes its title and theme from one of them. *The Whole State of Europe* [BMC 2502, Plate 38][51] adopts another fable of Aesop.

Heraldry provided another rich source of material and was a natural preserve for the actions and interrelations of the European states. The lion of the menagerie—a proverbial king whose domain extends to the prints as well—comes from heraldry. In

[49] See John Vinycomb, *Fictitious & Symbolic Creatures in Art with Special Reference to Their Use in British Heraldry* (London, 1906). On the subject of bestiaries, T. H. White, *The Bestiary: A Book of Beasts* (New York, 1954), is informative and enjoyable.

[50] L'Estrange, fable cxxi.

[51] *The Whole State of Europe. Or an Hieroglyphick for ye Election of an Emperor of Germany. Being an Explanation of those Three curious Emblematik Capital Paintings of Sr. R–t W–l's at his House in Chelsea. N.B. The Beasts represent Certain Monarchs, and the Birds Certain Kingdoms, the Eagle in Particular Germany with her Nine Electors.* L'Estrange fable cxvi.

their seventeenth-century prints and medals the Dutch used the unicorn to represent Britain and reserved the lion for themselves. The lion with seven arrows in its paw and surrounded by a fence of security was a popular device in the Netherlands' struggle for independence in the sixteenth century.[52] The lion only occasionally represents the Netherlands in the English prints of the eighteenth century, for England had borrowed from its own coat-of-arms and adopted the lion as its national symbol. A common figure in heraldry, the lion since ancient times was associated with courage, fortitude, and force in the cause of virtue and justice.[53] It proved a fitting companion to Britannia.

The British lion plays two roles in the prints: the symbol of militant patriotism and the person of the king himself.[54] In the former role the lion confronts the eternal menace of Britain's enemies. 'Whelp'd in the Tower of London' [Plate 20],[55] the lion is, if fairly met, invincible. 'The Sacred Lion conquers every Foe,/ And tears in Pieces all devouring Beasts' [BMC 2789]. Print after print shows him subduing his natural enemies, trampling on their shields, terrifying them with his ferocious-looking teeth and claws.[56]

In accordance with the critical nature of this satire and propaganda—and the theme of the martyred Britannia—the prints more frequently show the lion deceived, betrayed, and unjustly restrained. He becomes a symbol of national honour, aroused and enraged by his disgrace. The lion asleep in the face of some imminent peril is a recurring image; so is the lion chained.[57] The Spaniard in *The Lyon in Love* deprives the beast of his claws with the acquiescence of Walpole. One of the panel designs of *The Scheme Disappointed*, etc. [Plate 15] shows a captive lion, 'hung up by the heels struggling to get loose', while in the next design is Britannia, in chains, her lance broken, weeping. The negotiators of the unjust Peace of Aix-la-Chapelle in 1748 have betrayed the British lion in *Tempora mutantur* [Plate 65], etc. as he lies prostrate, stabbed, with a look of anguish and suffering on his face.

[52] Van Loon, vol. i.
[53] Guy De Tervarent, *Attributs et symboles dans l'art profane, 1450–1600: Dictionnaire d'un langage perdue* (2 vols., Genève, 1958–9), ii.242ff.
[54] For the lion as king, see below, chap. v.
[55] An allusion, of course, to the menagerie there.
[56] See Plates 24, 29, and 76.
[57] See Plates 44, 66, 90, and 107.

Occasionally replacing the lion as a symbol of patriotic militance is another animal whose associations with England are closer than those of the conventions of heraldry: the mastiff or bulldog. The renown of the 'true breed' dates from Roman days; British dogs were famous even then for their fighting ability in sport and war. A correspondent to the *Craftsman* observed:

As I am a constant Reader of your *Journal*, I find in one of them, lately publish'd, a Description of a Piece of *Dutch Drollery*, express'd by a *Picture*; wherein is pourtray'd a generous *English Bull-Dog* thrown upon his Back; unfairly held down; depriv'd of all Self-Defence; and exposed to the Insults and unmerciful Drubbings of a *sniveling Hero*, in a *short Cloak* and *sable Whiskers*. . . . Our Forefathers not only reposed an intire Confidence in the Fidelity of these Creatures, as *domestick Guardians*, but took them likewise as a Sort of *Companions* Abroad, to participate with them in their Sports and rural Diversions. . . . an Attempt hath been lately made to reduce *these Animals* from their *glorious Immunity* into a State of the most *abject Slavery*. . . . that antient genuine Race of *true-bred English Bull-Dogs* . . . excelling in Fight; victorious over their Enemies; undaunted in Death. . . . But much I fear that few of *that Race* are now surviving . . .[58]

Dogs were also popular devices in heraldry, symbolizing fidelity, obedience, courage, watchfulness, and resolution.[59] The English dog, straining at the leash, is a familiar image in the prints and can be seen in *The Gallic Cock and English Lyon or A Touch of the Times* [BMC 2437, Plate 26] and with Britannia in *The Whipping Post* [Plate 113].

Another traditional symbol of vigilance, the cock, probably became associated with France in the sixteenth century; the association may have originated in a pun: *gallus, Gallia*. This pun appears in *The Pillars of the State* [Plate 78], in which Henry Fox and the Duke of Newcastle face each other beneath two gallows, between which is a cock, atop an overturned ship with the inscription: 'Gallus—So Near'. An additional meaning, of course, has been added.

Lion and cock figured together in many of the old fables. They appear together in the prints, portraying Anglo-French rivalries. *The Gallic Cock and English Lyon* shows the former attacking the latter. The triumphant cock, with a fleur-de-lis on its wing, crows

[58] *Craftsman*, 13 Sept. 1729. The '*sniveling Hero*' is the Spaniard.
[59] William Berry, *Encyclopoedia Heraldica, or Complete Dictionary of Heraldry* (3 vols., London, n.d.), n.p.

outside the stockade in *Tempora mutantur*, etc. Sometimes the tables turn, however, as in *British Resentment, or the French fairly Coopt at Louisbourg*, in which an 'English Saylor encouraged by a Soldier, Squeezes the Gallic Cock by the throat, & makes him disgorge the French usurpations in America'.

The fox—the Reynard of the old fables—is an occasional representative of France. This is especially true of prints published when the guileful hands of Cardinal Fleury and—subsequently and to a lesser extent—those of Cardinal Tencin directed French affairs. Craft and treachery were, to the English mind, the heart of French diplomacy. The fox seemed an appropriate symbol [Plate 53].

The cock and fox represented the ancient and natural enemy of the British lion. The white horse of Hanover became an inveterate foe only in the eighteenth century. A heraldric device on the arms of Hanover, the horse was added to the British royal coat-of-arms with the succession of George I. Graphic satire adopted the symbol, especially in the 1740s, to express the strong anti-Hanoverian feeling of the time. The horse became a bloodthirsty, aggressive creature, a parasite ravaging Britannia or the British lion. It licks up the blood of the martyred Britannia in *The Conduct of the Two B******rs* and the blood of the lion in *Tempora mutantur*.[60] *The Court Fright* [Plate 53] shows the horse of Hanover, with a map of England as its saddle, trampling on the body of a bankrupt Englishman.

The other creatures in the menagerie—the Russian bear, the Turkish elephant, the Imperial eagle, the Spanish wolf or griffin[61]—can be seen in *The European Race, The European State Jockies*, and *The Whole State of Europe* [Plates 20, 29 and 38]. Much of the animal symbolism in the last-mentioned print is fanciful: there is no strict adherence to national coats-of-arms. A dolphin, for instance, represents Venice simply because of that city's close association with the sea, and not because of any heraldic connection.[62]

English satirists in the eighteenth century liked to symbolize

[60] See, also, Plate 98.
[61] The wolf was used perhaps to suggest the voracious ambition of Elizabeth Farnese, a 'she-wolf' in her time. In the fables the wolf, like the fox, suggested predatory cunning.
[62] The dolphin was considered the supreme beast of the sea; in heraldry it was a device—because of a pun—of the dauphin of France.

the Netherlands with a boar. A Dutchman rides such an animal in *The European Race* series. A Dutch boar sits at the table smoking a pipe in *The Congress of the Brutes* [BMC 3009, Plate 64]. The association originated in the seventeenth century. '*An Hollander* is not a *High-lander*, but a *Low-lander*; for he loves to be down in the Dirt, and *Boar*-like, to Wallow therein.'[63]

The boar was not an especially generous tribute to a nation that had been England's traditional ally in the cause of Protestantism and European freedom; a nation that, over a century before, had added to the iconography of satire and propaganda the lion of courage and might, the ideal of Liberty, as symbols in the struggle for independence. The boar, along with 'Nick Frog' of the John Bull allegory and the fat, lazy burgher of the prints, reflects the suspicion and dislike of commercial rivalry that underlay the venerable alliance of the two countries.

The Englishmen's appropriation of these time-honoured trademarks of national pride—the lion and Liberty—combined with the development of Britannia and John Bull (whom they could properly call their own) signalled both the newly-won independence of English graphic satire and the growth of British nationalism. In the broadest sense, this symbolism is a product of the rejuvenated national pride and sense of exclusiveness that characterize the epoch following the Glorious Revolution. Specifically, it measures the pulse of aggressive patriotism that ruffled the *quieta non movere* of the Walpole era, brightened the rising star of William Pitt, impelled the surge of imperialist expansion, and —taken together—gave a new tone to the politics of the middle decades of the eighteenth century.

[63] *The Dutch Boare Dissected, or a Description of Hogg-Land.*

CHAPTER V

The Country-Party Interest

'Like the Muses, when Satire has no great work in hand, she will generously busy herself with providing entertainments for men, and inspire artists in the creation of burlesques and caricatures, and that adorable nonsense which, if it were carried a little farther, would spill over into sense and become biting criticism.'[1] While the Tory poets in literature concerned themselves with folly and knavery in Walpole's England, and produced some great satire by their labours, the same preoccupation at a less exalted level gave inspiration to the prints, ballads, and squibs of the day.

There were, however, few great political issues which satire in any form could take in hand. The Excise and Jew Bills, the Forty-five, the loss of Minorca, and the Peace Settlement of 1763 were scarcely more than ripples on a languid surface: though stirred by the breezes of the new patriotism, in domestic politics the decades before the American Revolution were an age of quietude, satisfied with the largely shallow issues of political corruption, Governmental oppression of liberties and trade, and ministerial sell-outs to foreign powers. Political satire was, by and large, confined to the ephemeral and superficial, and to moral concerns for which the incidental happenings of the day provided the exempla of argument.

None the less, as political propaganda the prints served as a channel for the expression of certain ideas, consistent enough to be considered an ideology: a cluster of attitudes, policies, and dicta that, in part, represents the 'country-party' interest or programme. The tenets of the country-party programme were pervasive and proverbial in eighteenth-century political thought, especially in the apologias of political opposition. With the support of the City interest, discussed in the next chapter, country-party ideas formed the theoretical justification of the 'patriot' cause.

'We are for the *old Country Interest*, against Bribery and Corruption, Placemen, Standing Armies, Taxes, and the like

[1] Gilbert Cannan, *Satire* (London, n.d. [1914]), p. 52.

Plagues of the Nation.'[2] The prejudices of this interest combined a dislike of courtiers, professional politicians, stockjobbers, and placemen—the products of court politics—with an emotional reverence for the institution of monarchy; an insular patriotism that was both militant and isolationist; a distrust of continental entanglements and a desire to promote the nation's honour and interests through seapower; and a parochial nativism which held foreigners in contempt and which despised foreign influence. Its programme, under whose banners the changing corps of Opposition marched, was more negative than positive. Its advocacy of reform rested on a base of reactionary discontent.

1. *Anti-Court Satire*

Fundamental to country-party ideas—the foundation on which it rests—is an anti-court bias. This bias afforded the literature of political opposition with a point of view for its pretensions to a satiric ethic.[3] In the guise of satire an outlet was found for the prejudices associated with the country-party interest.

A writer to the *Craftsman* in 1729 observed that 'the business of your Paper hath been to prove the World *mad*; that is, according to the Principles of *Stoicism*, governed by a strange Medley of Ambition, Ignorance, Luxury and Corruption.'[4] The *Craftsman* assumed the posture of the highminded satirist, a patient and sardonic Jeremiah, at war with an evil age, with a Britain that had grown soft and corrupt, bereft of the simple, manly virtues that had ennobled her in glorious days past. *O tempora, O mores!*

The affectation of moral earnestness is mixed with a lighthearted humour in the political print.[5] Its expression is mainly verbal, in verses or inscriptions, since few of the images lend themselves to any sublimity.

> Britons brave are true and unconfin'd
> To lash the Coxcombs of the Age, design'd,
> Fixt to no Party, censure all alike
> And the distinguish'd Villain sure to Strike.[6]

[2] *The Old Interest Display'd; a Dialogue Between an Alderman and Cobler. Address'd to the Freeholders of Oxfordshire* (London, n.d. [1754?]), p. 4.

[3] An idea which has recently been explored thoroughly and well by Maynard Mack, *The Garden and the City: Retirement and Politics in the Later Poetry of Pope, 1731–1743* (Toronto, 1969). [4] *Craftsman*, 27 Dec. 1729.

[5] See Plates 61, 86, and 111. It is interesting, perhaps, that the prints themselves were cited by some contemporary observers as evidence of the nation's moral decay.

[6] *Jaco-Independo-Rebello-Plaido* [BMC 2856].

Pure malevolence, not softened by any humour, is rare in the prints. Personal vilification, though often cruel and shortsighted, usually hid itself in amusing banter: knocking about the high and mighty, consigning them to Hell [Plates 80 and 120], or perhaps contriving a more vivid and original form of punishment [Plate 86]. There is the occasional print that rises above this kind of delightful sadism, to a level of scorn and righteousness in attacking greater evils. Some prints are didactic; similar in form to the material in emblem books, their designs offer examples of some moral or truism. *The Scotch Hurdy Gurdy or the Musical Boot* [BMC 3847], a satire on the all-powerful favourite, Lord Bute, offers this earnest reflection:

> What is Ambition, but desire of Greatness?
> And what is Greatness, but extent of Power?
> But lust of Power's a dropsy of the mind,
> Whose thirst, encreases, while all drink to quench it;
> Till, swol'n, and stretch'd by the repeated draught,
> We burst and perish. . . .

Satire closely scrutinizes human nature; its aim, the exposure of man's foibles and sins. One of its operative ideas, especially in the eighteenth century, was that though the manifestations of human frailty were many, they could be reduced to categories. A culture that was buttressed by latitudinarian religion and classical, humanistic values believed that selfishness and folly were the most basic of human sins, as expressed in hypocrisy, greed, affectation, duplicity and other guises. The aim of satire was to see through the seeming.

The objects of satire, quite naturally, belong to stereotypes. The subjects of political satire filled well-used moulds. Here certain moral constants take their measure of a changing political scene, where ministers and patriots come and go, and change their colours.

The norms of political satire display a definite anti-court, anti-ministerial character. Government was the focus of all political activity. Because it meant wealth, power, and responsibility, government appeared to the cynical eye the prime mover of evil in the political world: a corrupting influence by which the private vices inherent in men were caught in a snare and became public ones. Authority was mocked, power distrusted. Because the 'Ins'

were more vulnerable than the 'Outs', political satire—certainly in the prints—usually sided with the Opposition. It championed the cause of the patriots.

A qualification, however, is necessary. There is also evidence of a more critical, independent spirit which could censure 'mock Patriots' as well as 'treacherous Ministers'. Patriot-turned-courtier is a familiar stereotype in the pamphlet literature, and also present in the prints. *The Anti-Crafts Man Unmask'd* [Plate 47], a satire on the sometime leader of the Opposition, William Pulteney, is an example. *The Wheel of Fortune*, etc. [Plate 43], remains aloof from any factional bias as it depicts the changing fortunes of patriots and place-holders. Its Horatian mirth suggests that, at bottom, all politicians, in or out, are the same. *Next Sculls at the Adm***ty* [BMC 2614], a print of 1744 concerning the change of Admiralty Boards that year, expresses doubt that one set of political opportunists will improve upon another:

> Huzza, Boys! a Fare: Who can first get to Port?
> Cry the Outs.—It is ours, say the Ins of the Court,
> Quoth the First, you already all Parties have tir'd,
> You ply not at all,—then for what are you hir'd?
> And will you do better? the Ins made Reply,
> Do better? aye, surely? or give Reasons Why.

Ins are victims more often than Outs because the former are more noticeable and, bearing responsibility, usually more vulnerable.

Bias and values, however, remain the same, for they run deeper than the mere accidents of public life. The hypocrisy of Opposition pseudo-patriots is as much a part of the whirlpool of court evil as the factors of power themselves.

Anti-court satire belongs to a tradition going back to the reign of Charles II. Court life and politics prompted volumes of satirical verses and vulgar lampoons during the Restoration. The tradition did not die in the eighteenth century. One excellent expression of this prejudice is *Britannia in Distress under a Tott'ring Fabrick with a Cumberous Load* [BMC 3524, Plate 89]. The print reflects, in part, the prejudices of the middling and lower classes of society towards the licence of the upper class; in part, a more general 'country' distaste for the world of court and fashion in which the aristocracy moved. The 'S–e', whose major supports are 'Trade' and 'Publick Credit', is in danger of

collapse. The design shows in graphic form how extravagance, folly, and irreligion have brought about this peril. The corruption of places and pensions, the waste and vice of masquerades, and the pernicious fashion of atheistic or deistic literature ('Hobbs' and 'Bolingbroke') are the sins shared by this world.

The courts of the first three Georgian kings were not as venal as that of Charles II. Lacking the aura of sanctity of the seventeenth-century monarchy, they remained, however, rather dreary and mundane. The family quarrels and occasional scandal of the House of Brunswick encouraged many anti-court satires. George II's feud with the Prince of Wales and his relationship with Lady Wallmoden exposed the monarchy to public ridicule. One of the satires on the latter subject is *The C–t Shittle Cock* [BMC 2451], a print of 1740 concerned, in part, with the resignation of the Duke of Argyll in that year. But of greater interest are the obscene puns. The design shows George II and Walpole playing shuttle cock (Argyll as the cock). Lady Wallmoden (now Countess of Yarmouth) observes the game and says to the King: 'Your Cock my Love mounts rarely in Yarmouth.' Another excellent anti-court satire, a comment on the King's notorious temper, is *The Festival of the Golden Rump* [BMC 2327, Plate 19].[7]

Scandal within the royal family exposed George II to public abuse in the 1730s. The sovereign, however, was not often the object of attack. The designers of the prints acknowledged the legal fiction and tactic of respectable Opposition: mistakes of the Crown must rest with the king's ministers and not with himself.

The world of the court, on the other hand, as a major arena of political activity, was adequately appreciated in graphic satire. *The Screen* [BMC 2539, Plate 45] reveals a keen understanding of the byzantine politics of the royal household. The crown in the

[7] The design shows the King on a pedestal, kicking up his leg as he would do in kicking his hat. The print is a satire on the supposed court triumvirate of George, Queen Caroline, and Walpole. Published in 1737, it was one of the most celebrated of such satires. A detailed description of the meaning of the print appeared in *Common Sense*, 19 Mar. of the same year. The description, adopting the common satirical artifice of a vision or dream, interprets the design as an expression of pagan idolatry. Walpole is the 'Chief Magician', Caroline the 'High Priestess', and George the 'Pagod', whose 'Golden Rump' is being worshipped. The print is discussed in Mack, *The Garden and the City*, pp. 143–9; John Loftis, *The Politics of Drama in Augustan England* (Oxford, 1963), pp. 139ff., examines the political consequences of the print—and a supposed play using the same idea—which led to the Licensing Act, imposing censorship on the theatre.

design is a composite symbol of the structure of the monarchy, with the important positions in state and household—including the 'Page of the Backstairs', an all-important position in the comings and goings of court intrigue. The screen to which the crown is attached implies the secret influence and manoeuvring behind the façade of public affairs. The bags of money on the table on the right illustrate the corrupting power of the Crown, as employed by evil ministers.

The power of the Crown, improperly used, was a corrupting agent that could turn righteous patriots into unscrupulous ministers. The race for the spoils of office was capable of corrupting all. *Locusts* [BMC 3018], a print of the late 1740s, shows a host of insects moving down Whitehall, carrying the attributes of public office (mitres, keys, batons, seals, etc.). '*Unjust Stewards, Embezzlers,* or *Squanderers* of publick Money . . . *Stock-jobbers, Plunderers* and *Engrossers . . . State Harpies* and *political Blunderers'*,[8] they were a plague upon the land. The satirist was cyncial about human nature, but he distrusted the office more than the man—or rather the man because of the office. This point of view is a steady one in the political satire of the period. It was in sympathy with the prejudices of the political grumblers who filled the coffee-houses of the nation.[9]

2. *The 'Country Party'*

The origins of the 'country party' are found in the reign of Charles II. It began as a negation: a collection of political groups, defined primarily along religious lines, who in the 1670s united to oppose court policies, first of the Cabal and then of Lord Danby.[10] Opposition to the court and court politics was the country party's first constant attribute. The antithesis of court and country meant a distinction in attitude, prejudice, and way of life.[11]

The first doctrines of the nascent party were 'Whig', or what

[8] *Craftsman,* 3–7 Feb. 1727.
[9] See the stereotype of the grumbletonian in Plate 67.
[10] David Ogg, *England in the Reign of Charles II* (2 vols., Oxford, 1963), ii.477, 526–7.
[11] And, in this sense, there was a country party long before the name, itself, came into use. Indeed, its existence may be considered as old as the confrontation of court and country, who formed the two rival orbits of power within the political nation, particularly when they met on the common ground of Parliament.

were soon to be called Whig: the guarantee of the subject's liberties, including a degree of religious toleration, and security of property. Its constitutional position opposed the abuse of the prerogative to increase the power of the Crown, and *sub rosa* attempts to gain similar objectives by court influence and patronage.

The development of the Whig and Tory parties did not eliminate the older antithesis of country and court which had first produced them. The country party as a political interest continued. It was elastic, including men attached to both political labels.[12] But by the turn of the century the country party, originally Whiggish in character, had begun to take on a Tory stripe.[13] The Hanoverian Succession and subsequent exclusion of the Tories from national office sometimes made 'Tory' and 'country party' synonymous after 1714. Men professing themselves Whigs, however, continued to be counted in its ranks.

In the morphology of Georgian parliamentary politics, with party distinctions fractionalized and confused, the country party revealed itself as no real party at all. It claimed different meanings. In terms of men, the phrase sometimes suggested a 'residual' interest: M.P.s who could not be identified with any other political group, men without connection or alliance. In the reign of George I much of this interest could be labelled as 'Tory'. By the time of the American Revolution the more homogenous designation of 'country gentlemen'[14] had become common. This group could be powerful in loose association, especially when an issue arose that was important enough to garner even those backbench independents who normally supported the Government.[15] But the

[12] Robert Walcott, in his 'English Party Politics (1688–1714)', *Essays in Modern English History in honor of Wilbur Cortez Abbott* (Cambridge, Mass., 1941), pp. 81–131, distinguishes court Tories, court Whigs, country Tories, and country Whigs. The alignment of these groups in Parliament would depend on the issue: to what axis it belonged, court–country, Tory–Whig.

[13] See Geoffrey Holmes, *British Politics in the Age of Anne* (London, 1967), pp. 116–47.

[14] Sir Lewis Namier, 'Country Gentlemen in Parliament 1750–84', *Personalities and Powers* (New York, 1965), pp. 59–77.

[15] As, for example, happened in the fall of Lord North's ministry in 1782. The backbench independents are often reckoned to have comprised half the eighteenth-century House of Commons (even more, if 'independent' was taken to mean anyone unattached, including those M.P.s without desire for office or reward, but who inclined to Government or Opposition as a matter of principle). In a narrower sense, independent meant the 'swing vote' of backbenchers whose behaviour in divisions

phrase was usually associated with the Opposition factions in Parliament, who adopted it in preference to the then more opprobrious names of 'Opposition' or 'Tory'. Claiming the name of 'country party', the forces of Opposition evoked an ideal which, though it rarely materialized, appealed to a proud and wholly respectable heritage.

It is not the 'country party' *qua* party, therefore, that is most important in eighteenth-century politics. It is rather the 'country party' as a political ideal or conglomerate of issues with some claim to be a programme.[16] Rustic virtue and disinterestedness reflected a social and political ideal that could be affected by anybody. But it was borne most naturally by, and perhaps embodied in, the backbench country squires. The social basis of the country party remained the land: 'The Gentlemen, Clergy, Freeholders, Farmers, and Occupiers of Land who have long been the independent Part of this Kingdom, have supported its Constitution, and have many a Minister uneasy. . . .'[17] To call this the 'landed interest' is, in a narrow sense, correct. Opposition to the land tax was a cardinal doctrine, prominent in the satires where the burden of taxation is censured. The country-party programme, however, had an appeal wider than the support of squire and freeholder. Refined and added to in the development of a parliamentary Opposition as an institution, the programme was a link between the politics of Restoration England and the new spirit of patriotism which transformed British (and Irish) politics in the middle of the eighteenth century; and eventually a link, as well, with the urban radicalism born of the Wilkite movement.

A series of acts and bills pushed forward to help secure the Hanoverian Succession—the Riot, Septennial, and Mutiny Acts,

was unpredictable. When this vote combined with the independents inclined to Opposition, a 'country party' could make itself felt. A considerable literature has examined the nature of party and parliamentary groupings in the Georgian House of Commons. See, for example, John Owen, *The Rise of the Pelhams* (London, 1957), pp. 41–86; John Brooke, 'Party in the Eighteenth Century', *Silver Renaissance*, ed. A. Natan (London and New York, 1961), pp. 20–33.

[16] Professor Holmes, who argues that the country party of the seventeenth century had become moribund by the reign of Queen Anne, believes it more proper to refer to a country 'tradition', or ideal, in Georgian politics. In this study 'country party' and 'country interest' are used. The former remained common (albeit anachronistic) parlance in the eighteenth century.

[17] *An Address to Such of the Electors of Great-Britain, as are not Makers of Cyder and Perry. By the Representatives of a Cyder-County* (London, 1763), p. 32.

and the Peerage Bill—were hotly contested by independent Whigs and Tories alike, and intensified the strain of constitutionalism in the country-party programme. The Revolution Settlement, construed in literal fashion, became its lodestar.

We have heard them [the country gentlemen] question the Validity of the *Act* for *Septennial* Parliaments. We have known them call the Riot Act, an intolerable *Yoke* on the Neck of a *Free People*. *Excises* have been branded, as the *Badges* of *Slavery*; and *Taxes* in general, treated as so many *Branches* of *Oppression* at the same time that all these *continue* to be *known Laws* of the *Land*.[18]

A contemporary associated the first stirring of an opposition to Walpole with what he considered to be a 'country party', in the events following the South Sea Bubble. 'After the Affair of the South-Sea, abundance of Country Gentlemen who had no other *Business* in Parliament than to *serve* their *Constituents*, began to have their Heads full of melancholy Apprehensions, when they saw what a *Turn* that Affair took, and how the *Justice* of the *Nation* was elluded.'[19] They raised particular objection to the 'screening' process, whereby that part of the Opposition which had come into office shielded their guilty predecessors from examination and prosecution. Graphic satire soon picked up the 'screen' as a pictorial conceit. The metaphor appealed to country gentlemen suspicious of court intrigue, convinced that most politicians, whatever their pretensions, were colluding scoundrels at heart.[20]

With pride in his independent conviction, the country gentleman took upon himself the role of watchdog of the Constitution. According to the credo of the independent Whig he adhered 'to his Principles, and has no Pretensions to a Place. . . . He claims a Right of examining all publick Measures, and, if they deserve it, of censuring them.'[21] Writing to their representatives in Parliament, the electors of the County Palatine of Lancaster expressed

[18] *The Crafts of the Craftsman; or, a Detection of the Designs of the Coalition, Containing Memoirs of the History of False Patriotism for the Year 1735* (London, 1736), p. 37.

[19] [John Campbell], *The Case of the Opposition Impartially Stated. By a Gentleman of the Inner Temple* (London, [1742]), p. 9.

[20] The screen, in fact, became a stock symbol of court duplicity and corruption. See Plates 45 and 46. As a polemical expression the term came again into fashion after the resignation of Walpole in 1742, when his successors did not act against him.

[21] *The Character of an Independent Whig* (London, 1719), p. 3.

their pleasure in knowing that they were 'represented by Gentle-men, who, in a degenerate Age, have had the Courage and Integrity, both in your publick and private Characters, to resist that Flood of Corruption and Court Influence, which for many Years has prevail'd, and almost overspread the Land'.[22]

The independence that informed the country party was its greatest flaw, rendering it ineffective as a force of political opposition that could carry its measures. Bolingbroke, who tried to distil the country-party sentiment into a coherent political doctrine, desired a country party that would be truly national, an organized patriot opposition with strength to prevail:

A country party must be authorized by the voice of the country. It must be formed on principles of common interest. It cannot be united and maintained on the particular prejudices or . . . directed to the particular interests of any set of men. . . .[23]

This party remained, however, amorphous and disorganized. The *Craftsman*, which worked for the strengthening of the patriot cause, lamented the country interest's inability to act:

I have, in *former Parliaments*, known some of the *Rural Esquires* the oddest and most unaccountable Creatures breathing. They will sit at *Home*, or in their Country *Coffee-houses*, railing at *Courtiers*, complaining of the Severity of *Taxes*, exclaiming against the Oppression of so large an *Army*, and the giving away *Money without Account*; in short, up-braiding the *Government, and the general Administration of Public Affairs* in all its Parts; and yet would they not stir one Step, nor say one *Syllable* (nothing but a *Monosyllable* being expected from them) to remedy any of the Mischiefs they so loudly complain'd of; nor will they give their Attendance to help and assist *others* that would attempt it.[24]

It is not surprising that the country interest is not easily found in the prints, though obscure recognitions of such a party do exist. The archetypal country gentleman appears frequently as an object of amusement. In fact, he is in a sense a prototype of John Bull, an embodiment of national character itself grounded in the attitudes and prejudices of the country interest.

A critic of the *Craftsman* attacked its editor for wishing 'an

[22] *Great Britain's Memorial. Containing a Collection of the Instructions, Representa-tions, &c., &c., Of the Freeholders and other Electors of Great Britain, to their Repre-sentatives in Parliament for these Two Years past* (London, 1741), p. 29.

[23] 'A Dissertation upon Parties', *The Works of the Late Right Honourable Henry St. John, Lord Viscount Bolingbroke* (8 vols., London, 1809), iii.82.

[24] *Craftsman*, 29 Nov. 1729.

Assembly of *Foxhunters'* as a panacea for the nation's ills; a defender of the journal, who signed himself 'John English', replied that 'a *Foxhunting Parliament* and a *Foxhunting Administration*'[25] would go very well together. Country squires did, in fact, constitute a large proportion of the House of Commons in the eighteenth century. In terms of visual imagery they were representative of the Commons itself. A colourful class of men, despising the foppery and effete luxury of London society, they came to the parliamentary sessions proudly wearing their rustic habits, often walking in with their jackboots and spurs, and even carrying their whips into St. Stephen's.[26] In *From One House to An Other* [Plate 42], a print concerned with Walpole's elevation to the peerage, a few of the M.P.s on the left are attired in the riding attire of country dress, in contrast to the dress attire of the peers at the right. The apparel of the foxhunter—jockey cap, riding habit, and jackboots—mark them. Such a figure, holding a riding crop in his hand, can also be seen in *A Political Battle Royal* [Plate 49].

The M.P.s pictured in this way do not necessarily represent the country party or Opposition. Walpole sought and often gained the support of the landed interest in Parliament. He sometimes hoodwinked the country squires with his carefully polished image of a gentleman farmer, his cultivated rustic manners, and his attempts to lower the land tax. *The Grounds* [BMC 2484, Plate 35] exposed Walpole's beguilement and corruption of the House of Commons, by showing a line of six M.P.s, in hunting dress, pulling the minister's oppressive government machine. Yokes about their necks are symbols of their servitude and folly, as the backbenchers who filled out the minister's parliamentary majorities.

Sometimes a collection of foxhunters do represent the permanent 'Outs' in the Commons. In *The Motion* [Plate 34] they become the corps of Pulteney's supporters in the ill-ventured attempt to overthrow Walpole: the lobby-fodder of parliamentary Opposition. In the print several M.P.s in riding dress walk along the foreground.

[25] Ibid., 6 Mar. 1731.
[26] John Pine's *A View of the House of Commons in Session, 1741–42* (in the Lewis Walpole Library) shows in great detail a view of a crowded session as seen from the bar of the House. A riding whip or two can be detected among the many faces.

The imagined simplicity and rugged virtue of provincial life were easily identified with the qualities of patriotism. The English bulldog, as a national symbol, takes upon itself a rustic flavour. In *The Fox & Goose or the true Breed in full Cry* [BMC 3469],[27] a print of 1756 attacking the Newcastle ministry, 'Pub. by the old Fox hunter, Tom Steady at the sign of the heart of Oak in Antigallican Square', shows a fox carrying a goose on its back (Henry Fox and Newcastle), chased by a pack of dogs, representing old British virtues, barking: 'pro Patria non sibi', 'No French Chicanery', and 'No foreign Intrusion'.

Government pamphleteers tended to equate the country party with unregenerate opposition. A favourite device was to impugn the country interest not only with the charge of Toryism, but even worse, with Jacobite treason: 'a Man cannot act the part of a *Patriot* or a *Country Gentleman*, without being in danger of drawing upon himself the Imputation of *Jacobitism*. . . .'[28] Though the equation of the country party with Toryism was at least half true, the charge of Jacobitism was unfair.

Overt Jacobitism is rarely espoused in the prints. Extant Jacobite satires are few.[29] It is not always possible to distinguish Tory-minded satire, though Tories belonged to the disaffected, for whom the anti-Government bias and the country-party programme had great appeal. As the identification of Tory with 'country party' is not unusual,[30] and the two are often associated in the prints.

One such print is the *Kentish Election* [BMC 2017, Plate 18]. The design shows a village green with the hustings in the centre. Two processions meet in front of it, each in support of rival candidates. From the right comes the 'Protest Interest', led by a clergyman and here made synonymous with the court party.

[27] The metaphor in the print derives, of course, from the children's game, 'Fox and Geese'. The 'true Breed', in this case, would not be bulldogs but, presumably, a pack of hounds.

[28] *Craftsman*, 4 Nov. 1727. [29] Above, chap. iii.

[30] See 'Mr. Smith's touch-stone, to distinguish Tories from Whigs', LeBlanc, *Letters on the English and French Nations*, i.267–79. This humorous piece, by 'Nathaniel Smith of Leicester', contrasts the two stereotypes of Whig and Tory, identifying the latter with simple, 'country' virtues: the Tory is of stronger, more virile constitution (the Whig: short and effeminate), eats better food (beef and pudding vs. the Whig's French cooking), and imbibes heartier drink (port, not champagne or burgundy). He is open, honest, friendly; his counterpart, a silly, affected courtier. The Tory is, in fact, the very likeness of John Bull.

Exciseman are found among its supporters, most of whom wear cocked hats and cockades. From the left comes the 'Country Interest', in support of 'Vane & Dering', their candidates. The attire of this group is less assuming. Oak-leaves appear on several hats.[31] Riding habits, however, are found in both groups. This print suggests the continued existence of two-party rivalries in local politics, sustained in part by the vestiges of the old religious controversies.

Another example of the identification of Toryism with the country party is *The Claims of the Broad Bottom* [BMC 2579], a satire on the Opposition in 1744. A group of figures is shown seated at and standing around a table. The designs of Dodington, Wynne, and Chesterfield for place are attacked, as are their jealousies of Argyll and Carteret. Pitt and Lyttelton, representing the Cobhamites, are also present and they reflect on the improbability of their gaining place. Newcastle and Pelham stand in the background. On the left is the distinctive profile of Sir John Hynde Cotton, representing the Tory contingent. He holds a piece of paper containing a request for office in one hand; and another paper, giving assurances to his supporters, behind his back: 'Fear me not boys I will still be true to the good old Cause and to my K–g in or out of Place—Hold fast you shall carry the broad Bottom—And if there be not Places enough for us all we will make more.' Behind Cotton at the far left stands a group of foxhunters, in jockey caps and jackboots, with twigs of oak-leaves sticking in their caps. On the ground is 'A List of Patriot Toasts', with a mixture of Tory, Jacobite, and country-party sentiments: '1. The broad Bottom'; '2. Dux et Redux'; '3. The Englishman at Rome'; '4. Expulsion of all National Grievances'; '5. Confusion to the Ha–ans'; '6. The King and the Church &c. &c. &c.'

The Tory squires' lukewarm acceptance of the new dynasty tempered their respect for the monarchy; they revered the institution and laughed at the foibles of their kings—a paradox that is common in the prints. Anti-Hanoverian feeling joined nicely

[31] 'On the 3rd of September numbers of people wear oak leaves in their hats, some of these leaves being silver-gilt. This custom is in memory of Charles II. hiding in a hollow oak after his defeat at Worcester on September 3rd, 1651.' Saussure, *A Foreign View of England*, p. 298. John Doran, however, in his *London in Jacobite Times* (2 vols., London, 1877), ii.412, says the mounting of oak-leaves on 29 May was an old Jacobite custom to celebrate the Restoration of Charles II.

with a distrust of continental entanglements and the costly wars that such entanglements produced.

One sure appeal, part of that strain of nativism which foreign observers considered endemic to English character, especially in untutored and provincial souls, was the myth of 'Old England'. The phrase is continually used in eighteenth-century polemic. It was an evocative phrase with many connotations. During the Restoration it called to mind, particularly among the gentry, a desire for the nation to return to the good old days, before the disruptions of civil war and commonwealth, to the tranquillity, harmony, and respect for proper degree and station.[32]

In the eighteenth century the phrase also evoked the image of a golden age, since past. As the Tories saw it, that age ended with the Succession. *The Glory of old England* [BMC 2331], a print published in 1738, brought to mind the England of 'Queen Anne's glorious days'. In the centre of the design is a statue of the Queen, similar to the one at Blenheim Palace (which appears in the background). On the pedestal is an inscription with a 'character' of Queen Anne, written by the Dowager Duchess of Marlborough:

Queen Anne was very Graceful & Majestic in her Person. Religious without *Affectation*, she always meant well. She had no *false Ambition*. . . . Upon her Accession to the Throne, the Civil List was not increased. . . . She paid out of her Civil List many Pensions granted in former Reigns which have since been *thrown upon the Publick*. . . . She was extremely well bred . . . her behaviour to all that approached Her was decent & full of Dignity, and shew'd *Condescention*, without *Art* or *Meanness*. . . .

The intended comparison with the undistinguished and dreary temper of Hanoverian England is obvious. This habit of comparing unfavourably the present to a glorious past came naturally to the discontented who complained about the disgraceful actions of German kings and who saw a nation bereft of glory and courage: 'free born Subjects of *Old England*, once the Dread, the Envy, and the Admiration of *Europe*',[33] now stigmatized and held contemptuous by other nations. Country gentlemen complained about Hanoverian connections. The editors of *Old England: or, The*

[32] 'For all that I have yet seen, give me old England.'—Lord Clarendon; quoted in Arthur Bryant, *King Charles II* (London, 1934), p. 87.
[33] *Four Letters Publish'd in Old England: or, The Constitutional Journal* (London, 1743), p. 18.

Constitutional Journal wrote in 1744: 'As *Englishmen*, the Authors of it esteem'd themselves *authoris'd* to assert and defend the Liberty and Property, the Glory and Independency of *Old England*. . . . [and to condemn] *British* Wealth made the Property of *Foreigners*. . . .'[34]

The prints concerned with the Hanoverian troop question in the 1740s employed the phrase 'Old England' several times.[35] The phrase appears again in the prints attacking the Jew Bill and in the anti-Scottish prints of the early 1760s. Any feeling against foreigners evoked it. Britannia often served as its symbol. *The Evacuations, or An Emetic for Old England Glorys* [Plate 112] shows Britannia as Old England, in the hands of treacherous sons and inveterate enemies:

> Our Country Old England appears very ill
> O Sick, Sick, at heart. Since she took a Scotch Pill
> Behold her Blindfolded, the Quack is upon her
> And Administers, what makes her give up her honour.

Graphic satire and propaganda—as expressions of popular dissent employing country-party material—cannot, therefore, be classified by party lines, particularly the traditional divisions of Whig and Tory. 'Party' is almost never mentioned in the period 1727–63, not even during the first years of George III's reign, when anti-Government propagandists saw a revival of Tory principles. The names 'Whig' and 'Tory' remain almost completely absent.

One exception is an etching of undistinguished quality, perhaps published in 1756 [BMC 3436, without title],[36] which shows a London street scene, a large Gothic edifice at the end of the street

[34] *Old England: or, The Constitutional Journal. By Jeffrey Broadbottom, of Covent-Garden, Esq.*, 11 Feb. 1744.

[35] See Plates 50 and 52 (in the latter print, on a label held by a figure on the left).

[36] Dating the print is a problem. Edward Hawkins, collector of the prints in the British Museum, has written in 'Change of Ministry, 1756', thinking perhaps of Guy Fawkes Day and the fall of the Newcastle ministry about that time. Mention of Hessian and Hanoverian troops in the inscription dates the print no earlier than 1756, but reference to Tory and motley administrations should place it later, perhaps 1757 after several months of ministerial instability. Pitt withdrew the mercenary troops at the end of 1756—see Julian S. Corbett, *England in the Seven Years' War* (2 vols., London, 1907), i.151, on the Speech from the Throne in December. Pitt subsidized German troops at great cost, however, in subsequent years.

in the background (perhaps Guildhall), and an intersecting street running across the foreground. A procession moves along the street, carrying the straw effigy of a minister on a horse. Behind the effigy two men carry faggots and a gibbet. Below are these verses: 'Were you in Effigy to burn,/ Each treacherous Statesman in his turn;/ What better would Britannia be,/ Whilst the proud Knaves themselves are free?' Beneath the design is a long inscription:

Who can call to remembrance without abhorrence the behaviour of a Wh–g–sh Ministry, who neglecting every thing else but *the business of Bribery & Corruption*, reduced the Credit of the Nation, & themselves to so low an ebb, that at length they were obliged to import H–ss–n & H–n–v–r–n Troops to support an *immense unconstitutional Standing Army*. . . . Now it wou'd be well for England if the several *Tory* or motley Adm–n–str–ns since that time could demonstrate that they have spent less time & treasure in the same destructive employment.

Satire and caricature grasp the individual more easily than the group. This, in part, explains why the prints of the era concentrated their attention on individuals—not parties, not factions, not coalitions. The phenomenon also reflects an historical truth: the politics of the mid-eighteenth century had reached a marked degree of atomization.

Though the prints expressed 'Opposition' ideas from the 1720s onward, in the large number of anti-Walpole satires little attention was given to the Opposition. Only on the eve of Walpole's fall—and certainly after it—was the penumbra of the great minister's shadow removed and the motley of Opposition groups exposed to close scrutiny. The *Motion* series produced a critical study of the Opposition. *The Motion* itself provides an abstract of the Opposition. The design depicts its leading members proceeding along Whitehall to Westminster, in a precipitate quest for office.[37] The Duke of Argyll and his lap-dog, Bubb Dodington,

[37] The metaphor in the print and the prints which followed it was not new. *Like Coachman, Like Cause* [BMC 1497], a print *c.* 1709 attacking the low church policies of the Whigs, shows a street scene in front of Whitehall with Holbein's Gate in the background. A coach labelled 'Common Wealth', with the Devil driving, moves down the street, rolling over 'Magna Carta' and 'Liberty of the Subject' (compare with BMC 2490, 2491, and with Plate 35). In 1741 T. Cooper, the publisher of *The Motion*, published *The Opposition. A Vision*, a clever satirical allegory, in which the Opposition is described as a motley group of individuals,

represent the recently disaffected court Whigs. Argyll (the darling of the 'broadbottoms', whose strategy was to 'storm the closet'), waving the sword of Damocles, directs the coach. The broadbottoms are also represented by Chesterfield and Lyttelton; the latter, one of Cobham's 'patriot boys', makes a comic Don Quixote, riding on the horse at the rear of the train. Carteret, attempting to leave the coach, and Pulteney, leading the procession of figures in the foreground, represent the old block of malcontent Whigs. The country members who follow represent their basic parliamentary following.

Criticism of the Opposition in the prints (there is little) followed the same line of attack traced by government pamphleteers. Opposition meant faction, and faction meant discord. Prints would conjure the spectres of Faction and Discord, the memory of Wat Tyler and Jack Cade.[38]

The fall of Walpole and the move towards a 'broadbottom' government under the Pelhams' sway blurred the lines of party and interest, and erased for some time the stable distinctions of Government and Opposition. The prints, especially in the early and middle 1740s, examine the contentious politicians' quest for office; at the expense of King and backbench independent alike, seemingly betraying both their principles and their followers. *A Political Battle Royal, A very Extraordinary Motion* [Plates 49 and 55], and *Broad-bottoms* [BMC 2621, Plate 56] are among them.

The theme of patriot-turned-courtier became popular in print and pamphlet, to the delight of the country interest and remnant Tories ('the dupes of many oppositions') who felt they had been betrayed.[39] The satires show members of the old corps and erstwhile patriots contesting for office; country-party principles are espoused, but few patriots appear to champion them.

A strong and popular Opposition does not again come forth until the middle 1750s when, in the wake of violent attacks on the Newcastle ministry, the patriot cause takes form again under Pitt and Temple. The sharp antithesis of minister and patriot

crowded in a wagon, pulled by a team of unruly asses. The author of the tract was Henry Fielding. The coach or wagon metaphor is found in several of the prints of the *Motion* series.

[38] Plate 33 and *The Funeral of Faction* [Plate 36].

[39] See *An Address of Thanks to the Broad-Bottoms*. This tract adopts the John Bull allegory. Plate 56 is its frontispiece.

once more appears in the prints. The conflict, however, remains one of individuals and issues. The parliamentary struggle and backstairs politics are absent.

The year 1760 is still, to a certain extent, a watershed, if not in terms of political structure or the normal patterns of political behaviour, at least as regards issues. In pamphlet and newspaper there was a revival of old party distinctions. Opposition literature accused Bute's ministry of renovating Tory principles, witnessed by 'an open and declared profession of increasing the power of the Crown, by creating influence and dependencies upon it, in both Houses of Parliament'.[40] Ministerial apologists countered by denouncing the Opposition as a group of disappointed Whig magnates, denied their presumed monopoly of office. Much of this polemic is missed in the prints, which stuck rather closely to the old motifs—and what is more important, did not bother to give them new or party names—with an increased emphasis on court scandals and anti-Scottish prejudice. The substance changed very little.

The cant of 'faction' is raised in a few of the anti-Bute prints, including *John Bull's House sett in Flames* [Plate 108] and *The Fire of Faction* [Plate 114]. The meaning of the charge is vague. In the former print Bute is accused of creating, by secret and illicit influence, a court and Scottish party, against the national will as voiced through the Opposition. The latter print is an attack on Hogarth, for his support of Bute's cause (i.e. fanning the flames of political discord).

In a sense, the graphic satirists agreed with Bolingbroke's argument in the 'Dissertation upon Parties', wherein he maintained that the genuine distinctions of Whig and Tory ceased to have any meaning after the Revolution; illusory distinctions were kept alive by misunderstanding and the devices of evil ministers who played the game of faction. The idealized axis, where principle and issues claimed some relevance, was that of corrupt ministers and national patriots: the old axis of court and country.

3. *Constitutionalism*

Advocates of the country-party programme were political purists, believing that the King's government should return to

[40] [John Butler], *Serious Considerations on the Measures of the Present Administration* (London, 1763), p. 4.

first principles and adhere to the constitution as established. They believed that the Revolution had dissipated the cloud of mystery and disagreement that enveloped the constitution in the seventeenth century. After 1689 the powers of Crown, Parliament, and the courts were clearly delineated; the rights of the subject secured. These constitutional 'puritans' who inveighed, therefore, against the influence of the Crown, prime ministers, cabinets, and cabinet councils—which the law and the constitution did not know— could not see them as necessary products of expediency, conveniently allowed by the absence of law or vagueness in the letter of the law.[41] Government, to them, was fundamentally misordered, and from it came such unconstitutional[42] measures as the Riot Act, standing armies, Sinking Fund, and Hanoverian ties.

Constitutional theory, much debated in the pamphlet literature, is only superficially expressed in the prints. There are few prints in which abstractions of the constitution or state take visual form. The comparison of the two to a building or structure of some sort is a common conceit.[43] Architectural metaphors abound in Georgian literature and art, being especially apropos in depicting the eighteenth-century idea of the constitution, suggesting as they did a mechanistic contrivance, the product of human invention.[44]

The 'Palladium of the Constitution' is an oft-used phrase in the eighteenth century: a holy of holies on which the safety of the nation depended. In *The Quere? which will give the best heat to a British Constitution Pitt: Newcastle or Scotch Coal* [BMC 3735] three altars are seen, perhaps intended to represent the constitution, or the proper means of worship before it. Pitt's is made to appear the best: 'this Alter is built of Freestone & is Furnish'd with Pit coal dug out of the bowels of Liberty by a West Country

[41] This attitude reflects 'the genuine bewilderment of a generation which saw its constitutional practice apparently undermining the purpose of its most cherished constitutional forms'. H. N. Fieldhouse, 'Bolingbroke and the Idea of Non-Party Government', *History*, n.s.xxiii.56.

[42] 'Constitutionalism' was not yet a commonly used word, nor the word 'unconstitutional' (though it does appear in BMC 3436). Writers sometimes adopted the stronger term 'anti-constitutional'.

[43] Proximate to this conceit is the great temple of Liberty into which Liberty leads her sisters in *Rebellion Displayed* [Plate 58]: 'Templum Libertatis ab Aera Anglicanae Salutis MDCCXV In Brunswicensis Lunenburgensis Domo potentissimo semper floruit.'

[44] As an organic metaphor would be appropriate to nineteenth-century ideas of the constitution.

Miner, & is reckon'd the best vein that ever was in Great Britain, it makes a glowing heat, with a steady clear Flame not easily to [*sic*] Extinguish'd, emitting a genial heat to all around it.'

Less exalted, but with more of a rustic flavour, is the comparison of the constitution to a country house in the allegory of *The Night-Visit*, etc. [Plate 48]. Two scenes on the screen show the 'mansion house' of Lady Brit's estate and Walpole's 'Houghton Hall'. The first house is styled as the 'Constitution' and is, in contrast with Walpole's pile, dilapidated:

He [Walpole] lets the Mansion-House then much decayed, run to Ruin for Want of Repair; pulls down some of the main Beams that supported it, with great Part of the Foundation Wall; takes away the Partitions of the Middle Floor, and throws the Whole into one.—At the same time he builds a splendid House like a Palace for himself, with Part of the Spoils of his Lady's.

The designer, unfortunately, has not carried the metaphor far enough; the image of the 'Constitution' is too small to show any component parts.[45]

Ideographic representation of the 'State' is also sometimes attempted. In *Britannia in Distress*, etc. [Plate 89], the 'Fabrick' which is tottering is 'The S-e', represented by a portico of the Corinthian order, buttressed by its two major pillars (caryatids), 'Trade' and 'Publick Credit'.

A common metaphor is the 'ship of state', an image which appealed to the patriots who championed British maritime supremacy. A supporter of the Opposition wrote a letter to *Old England: or, The Constitutional Journal* in 1743, complaining of the 'Hanoverian rudder' in the 'vessel of Great Britain'.[46] *The*

[45] One of the best visualizations of the constitution is in a print published in 1770 (an illustration in *The London Museum*, Mar. 1770), entitled *The Constitution* [BMC 4430]. The engraving shows a tripod, with its three legs marked 'King', 'Lords', and 'Commons', joined at the top by a ring which is marked 'Tria junto in uno'. The device suggests the supremacy of Parliament. The tripod supports a balance; on one scale rests the 'Bill of Rights', 'Magna Charta', 'Freedom of Election', and 'Freedom of the Press'—the fundamentals of the constitution which, if in a balance that is impartially secured by Parliament, should outweigh (but don't) the other scale, weighted down by a hand protruding from a cloud at left (Prerogative or Crown influence), and applied to the scale by Lord Bute, who stands in the middle. In the background is a dilapidated edifice, perhaps also suggesting the constitution. The print is a product of the Wilkes controversy.

[46] *Four Letters*, p. 25.

Triumph of Neptune in the Caracatura Stile Anno 1757 [BMC 3572], a satire on Lord Winchilsea's incompetence as First Lord of the Admiralty, shows a ship in the left half of the design, labelled 'The Old England', in a state of deterioration. *A View of the Old England just arrived from a Cruise round the Globe* [BMC 3920] has a large ship filling its design; the 'Captain' is the King, the 'Pilot' is the Earl of Bute. Pitt (as a former pilot), Cumberland, and the rest of the crew complain about how England has been forced to relinquish many of her conquests and prizes in the peace settlement.

The undermining of the state and the violation of the constitution are stock anti-ministerial indictments. Newcastle, in *The Devils Dance Set to French Music by Doctor Lucifer of Paris* [BMC 3373], is shown standing with a copy of 'Magna Char[ta]', in an imitation of medieval script, in one hand, and a piece of paper which reads '[Con]stitution as . . . Established—so help me g[od]' in the other. The satire implies that the Duke has violated both the Charter and his oath in his conduct as minister. In *A Cheap and Easy Method*, etc. [Plate 51], the Pelhams have sacrificed 'Habeas Corpus', 'Bill of Rights', and 'Mag[na] Char[t]er' (which serves as fuel in the smoking house at right) to their dealings in corruption.

Among the cardinal principles of the Constitution was the doctrine of separation of powers. Advocates of the country-party programme argued that the influence of the Crown and the statecraft of evil ministers had erased this separation by destroying the independence of Parliament. Corruption is a major theme in the prints.[47]

The country interest saw another of the first principles embodied in the Act of Settlement, which supposedly guaranteed British sovereignty and independence with an alien dynasty on the throne. Anti-Hanoverian feeling ran strong. One of the many prints on the subject, *The H–r Bubble. Old E–l–d's *T.*Totum, being the H–r Bubble or our all to Nothing* [BMC 2589], shows a lion, couchant, on a patio; the lion's body rests on a large scroll, 'The Act of Settlement'. On the lion's back are piled several smaller scrolls, inscribed: 'Dains', 'Austrians', 'Hessians', 'H–r–v–ns', 'Vots of Ct', 'Sinking F–d'. The horse of Hanover

[47] See below, p. 130ff.

rests its front legs atop this pile and proudly rears its mane.[48]

The most important of the first principles, understandable in these anti-authoritarian studies, was Magna Carta, as the original guarantee of the nation's liberties. In the more pedestrian examples of eighteenth-century political thought the Great Charter, and not the Petition of Right or even the Bill of Rights, was the fountain of British constitutionalism.[49]

The creators of Opposition prints and pamphlets concerned themselves with the issue of individual liberty, especially the liberty of the press. Liberty was the highest of political ideals: Britannia's sister and companion, championed, as her enemy, Tyranny, was condemned.

Magna Carta, itself, served as a symbol of the legitimate authority that provided for the rule of law and secured fundamental liberties. In the first design of *Robin's Reign* [Plate 9] an apotheosis of the Charter takes place, and a contrast between the rule of law and illegal prerogative is implied: 'Britons behold your Constitution here!/ Obedience to your Laws; even Princes Swear!' Britannia, the guardian of the Constitution, sits with Magna Carta on her lap in *The Quere? which will give the best heat to a British Constitution*, as she also does in *The Scheme Disappointed* [Plate 15].

As with her champions, Liberty and Britannia, the Great Charter suffers from abuse and impending destruction. 'Magna f–ta' appears frequently in the prints, as if to imply what the Charter was worth in contemporary England.

Not surprisingly, the anti-Jacobite prints of the Forty-five show Magna Carta either triumphant over Stuart principles [see Plate 59] or discarded as it would be if the Pretender's cause prevailed [Plate 57]. More than a revival of 'Tory' principles,

[48] The Opposition charged that the 'Sinking Fund' and other special appropriations were being used for foreign subsidies, as well as parliamentary corruption.

[49] In the tradition of seventeenth-century political thought eighteenth-century thinkers continued to seek the origins of the constitution in pre-Norman England. W. H. Dunham, in 'Magna Carta and British Constitutionalism', *The Great Charter: Four Essays on the Magna Carta and the History of Our Liberty* (New York, 1965), pp. 20–47, argues that Magna Carta ceased to be the most important source of British constitutionalism in the seventeenth century when first the Petition of Right, and then the Revolution Settlement replaced it. In popular thought and lore, however, the Charter remained a symbol of the nation's entailed inheritance of liberties.

the Englishman's hatred of the Scotsman and his belief in the latter's ignorance of English political institutions explain the rare appearance of constitutional issues in the anti-Bute satires. The beast in *The Vision or M-n-st-l Monster; address'd to the Friends of Old England* [Plate 117][50] tramples on the emblem of Liberty, a torn Magna Carta, and a martyred Britannia; the monster also consumes the right of 'Habeas Corpus': 'the *sole Fence* of the Subject against the Power of the Crown'.[51]

Destruction of parliamentary independence, subservience to foreign interests, and violation of guaranteed rights all expressed the ready fear that government was being turned into a 'state engine' for the enslavement and impoverishment of the nation. The vehicle on which Walpole rides in *The Grounds* [Plate 35] is such an engine. It is a wagon, designated 'The Money Press'. The wheels are decorated with 'Penal Laws', 'Gin Act', 'Civil List', 'Taxes', 'Debts', 'Expence of Law'. Walpole's secret disbursements mark the side panels of the wagon (e.g. 'For Secret Services'). Pennants indicating oppressive taxes fly above the wagon: 'Land Tax', 'Candles', 'Tobacco Wine', 'Malt Aid', and 'Stamps'. Beneath the wheels four figures are crushed, including Honesty and Liberty.[52]

Oppression by government is an old theme in English polemical literature. It gave the spark to Whig ideals three-quarters of a century before the reign of George II and to the opposition of the gentry to Charles I a generation before that. The fear of oppression infused the country-party programme in the eighteenth century; the country interest saw in the Hanoverian governments the ghost of Stuart tyranny—in a different guise. The dread of excise and standing armies was not new: a legacy of the seventeenth century. The furtive designs of a corrupt Parliament, however, replaced the open and proud presumption of Stuart

[50] An interesting print, it shows how graphic satire can, with a minimum of inscription and maximum use of the expressive power of imagery, say a great deal in a single illustration. The single image of the design—the monster, Lord Bute, and his minions—is a composite one, with an ideographic meaning that is efficiently expressed. The lengthy passage beneath it, a parody of chapter thirteen and other parts of Revelation, converts the print into a rhetorical piece.

[51] *Old England: or, The Constitutional Journal*, 25 Feb. 1744.

[52] Another 'state engine' is found in *The Motive, or Reason for His Honour's Triumph* [BMC 2485], one of the *Motion* series, in which Walpole rides on a 'Commonwealth' coach, pulled by asses and horses; the traces are marked: 'Merchandize, Manufacture, sinking Fund, Husbandry, goaded on by Bob'.

prerogative. The Septennial Act, Riot Act, and Sinking Fund took the place of suspensatory power, summary justice, and ship money. To men who continued to think in terms of the past and who could not adjust to new realities the danger was real enough: '. . . our ancient Liberties, Rights and Privileges, as *Englishmen*, will be taken away and destroy'd, and our boasted Constitution totally demolish'd, if some effectual Methods be not taken to cure the vile Corruption and slavish Principles of the present Times.'[53]

The appeal to the country interest was consistent, if not imaginative, in expressing a bias against authority. *A M–n–l Forge* [see Plate 91] depicts the usual products of ministerial tyranny. The scene is a foundry, with a forge on the left, anvil and other tools in the middle. To the right are shelves where the finished products are placed. Two ministers are at work (animal caricatures, one—a fox—is certainly intended to be Henry Fox, the other—a badger or weasel—probably Newcastle). They produce 'Tax Skewrs', 'Debt Bridles', 'S–te Fork', 'Party Bars', 'Law Pincers', and 'Lies of the Day'.

A part of ministerial oppression was the financial burden of high taxes and a growing national debt. Both provoked the frequent complaint of London merchants as well as country gentlemen. The country interest, however, associated fiscal irresponsibility with the financial and trading interests. 'The *old Country Interest*', the *Craftsman* charged, has been 'almost swallow'd up by *Stockjobbers* and *Monied-Upstarts*'.[54]

Broad-bottoms [Plate 56] is typical of country-party sentiment: 'Believing, we lifted ye up among the Mighty;/ Yet our Drivers have ye join'd, increasing our Loads.' The asses, representing the foolhardy nation, are burdened with various taxes, including the 'Land Tax' in the centre foreground. The Opposition asserted that there was a mismanagement of public funds; moneys which ought to be open to public appropriation and account were being turned into salaries, bribes, and pensions of a minister's corrupt machine. Walpole has created such a beast in *Merlin, Or the British Enchanter* [Plate 37][55]: 'His Honour's Pack Ass', laden

[53] *Great Britain's Memorial. Containing a Collection of the Instructions, Representations*, etc., p. 30.

[54] *Craftsman*, 24 May 1729.

[55] This print was probably intended to preface the election of 1741 (see below, chap. vi).

with the revenue from customs and the land tax, from which the tree of Government corruption and influence has grown. Its major branch is 'Excise', its smaller branches are the officers and commissioners that excise has produced.

The growth of government's fiscal bases was, if not an unconstitutional tendency, a development which the country interest understood the least—and perhaps feared the most.[56] In stockjobbing, funding, and other projecting schemes it saw not only the greed and rapacity of City and Court but also the source of that forbidding miscreation, known as political corruption.

4. *Corruption*

'In this Country, the children in all conditions of life suck the spirit of party with their milk. They have scarcely learned to speak, when they are taught the terms of *corruption* and *opposition*, by which they now denote the different parties, which were not long since characterized by the odious names of whig and tory.'[57] Corruption was what apologists of the Opposition talked about most in their attacks on the Government. For the country-party programme corruption was the *bête noire*, the first cause of the anti-constitutional ills in the body politic. Once eradicated, the nation could return to the reign of virtue.

Political corruption meant, in particular, the perversion of parliamentary independence through the influence of the Crown. This influence was employed in the pernicious designs of ministers who could not retain their places without such jobbery. The Commons had fallen into an 'anti-constitutional dependency',[58] a mere rubber-stamp to ministerial policy. The separation of powers, vital to a mechanistic interpretation of the constitution, was thereby destroyed.

Opposition polemic also displayed a gloomy foreboding that corruption had no longer confined itself to politics, but had infected the moral fibre of the nation. '*Corruption* is a poison which will soon spread itself thro' all Ranks and Orders of Men,

[56] An idea which Isaac Kramnick has explored in considerable detail in *Bolingbroke and His Circle: The Politics of Nostalgia in the Age of Walpole* (Cambridge, Mass., 1968). It is Mr. Kramnick's argument that much of the Opposition's ideology, and in particular Bolingbroke's political thought, was a genuine reaction to the financial revolution of the late seventeenth and early eighteenth centuries.

[57] Le Blanc, *Letters on the English and French Nations*, i.196.

[58] 'A Dissertation upon Parties', *Works*, iii.291.

especially when it begins at the *Fountain-head*. A spirit of baseness, prostitution and venality will universally prevail; Luxury and Extravagancy will introduce Want and Servility of Mind. . . .'[59] Bolingbroke expressed a fear that 'the *same Depravity and Corruption* [would] soon find their Way from a Court to a Cottage . . . so that in a short Time the very Name of Virtue may come to be lost in such a Kingdom'.[60]

The corruptibility of man by greed and susceptibility to the temptations of the world was not a new belief nor subject for satire. 'I Look upon the *Love of Money* to be one of the *Earliest Passions* that declares itself in the *Mind of Man*; before we are activated by any of the others, *This is Predominant* in us.'[61] Selfishness and avarice are old antagonists of human virtue. Money is a traditional symbol of worldliness and man's covetous nature. Money is an attribute of the Devil, who, in the sense of the Faustian myth, gains the souls of men in the next life with the promise of riches in this one.[62]

The pursuit of money and riches, therefore, usually possessed a connotation of dirt. A common synonym for money in the eighteenth century was 'cole', or coal. In *The Cole Heavers* [BMC 3423], a print of 1756, the principal members of the Newcastle ministry stand in a coal-lighter docked at Westminster quay. Each of the ministers is plundering the coal bin. Newcastle observes: 'Brothers, this is very Dirty Work.' At far left is the Devil who points to the group and says: 'Eternal Darkness they shall find,/ And them eternal Chains shall bind/ To infinite Pain of Sence [*sic*] & Mind.'

The love of money was degrading; it demeaned the status of man and caused him to share affinities with creatures beneath him. *A Cheap and Easy Method* compares the placeman's greed for office to the behaviour in a pigsty, where the placeseekers become swine. Newcastle, Pelham, Carteret, and George II are the swineherds, sacrificing a high-minded concern for constitutional

[59] *Craftsman*, 29 July 1727.

[60] 'On Bribery and Corruption', *A Collection of Political Tracts* (London, 1748), p. 281.

[61] *The Political Foundling. The Bon-Fire Contest: or, Bob Cashier'd. To Which is Added, An Epistle from Walpole the Jesuit in the Infernal Shades, to a M— of S— in the Land of Nod* (London, 1733), p. 5.

[62] Money was an attribute of the Infernal Trinity in Renaissance iconography: the World, the Flesh, and the Devil. See Chew, *Pilgrimage of Life*, pp. 70ff.

principles to their designs of corruption. In *The Devil upon Two Sticks*, a print of 1741 concerning the general election, the design takes a rural setting. A village appears in the background on the left; across most of the foreground is a horsepond, in which piglets and other creatures can be seen. The image symbolizes corruption. Carried through the pond on the backs of two M.P.s is Walpole. Several of his followers have already walked through and are trying to clean themselves. Another is holding his nose.

The self-righteousness displayed by graphic satire knew no middle ground between incorruptible virtue and degradation. Public figures either lived up to the most exalted standards of disinterested idealism or they were essentially bad. Though ministers and most politicians fall into the latter category, there was an assumption that in the final test virtue and right would prevail. In *Magna est Veritas et Praevalebit* [BMC 3390] a balance in which virtue and vice are measured is held by a hand issuing from the clouds. In the left scale sit the members of the Newcastle ministry with bags of money as their attributes; in the right scale is Pitt with a laurel wreath: 'an honest and good Minister, whose single Virtue we find is capable of doing more than all the others put together'.[63]

The critics who inveighed against corruption agreed that its source lay in the political arena and at the national level. The writer of a Tory broadside (probably published in 1756) condemned 'the present pernicious system . . . the Augean stable of filth which hath been accumulating for these forty years past. . . .'[64] Political corruption, however, was an old issue and an even older reality. Complaints and controversy about the engrossment of public favours, the sale of offices, bribery of Crown servants, and the use of patronage to sway impartial deliberation are found in the sixteenth century and were certainly common in the reigns of James I and Charles I.

In the eighteenth century it was believed that the corruption of Parliament by the Crown began in earnest during Charles II's reign.[65] This surreptitious design then failed, however, because

[63] *Political and Satyrical History of the Years 1756 and 1757*, p. 8.

[64] *General B–y's Account to His Majesty, Concerning the Loss of Minorca*. The broadside is without publication line.

[65] Though the phrase 'standing Parliaments' (the companion of standing armies) can be traced back to the Reformation.

the Crown lacked sufficient revenue and patronage. As a lively issue corruption does not appear in the political prints until after the Succession; in fact, it is not a major issue before the reign of George II. The noise of religious controversy and foreign affairs had, until that time, drowned out murmurings about Crown influence and placemen in Commons.

It is true, indeed, that bribery and corruption had taken pretty deep root long before Sir Robert Walpole was made chief minister; yet he is peculiarly entitled to the honour of having been the first who reduced this practice, as it were, into a regular system.[66]

The *Craftsman* and other journals and pamphlets in support of the Opposition after 1726 made corruption the major issue in their campaign against Walpole. The designers of the political prints followed their lead.

Bolingbroke argued that corruption of Parliament occurred in two ways: undue influence and bribery in the election of Members; corruption of M.P.s after they were elected.[67] The country interest was always alarmed about the influence of central authority in local politics—which the country gentlemen considered their own domain. The country-party programme argued that the election to Parliament ought to be free, that the Bill of Rights guaranteed this freedom. Behind the argument, of course, was the belief that the independent gentry of England, and not Crown servants, should constitute the House of Commons.

I think it would be no difficult matter to draw a pretty ridiculous representation of a first minister, issuing his orders to the numerous standing army of placemen, and making out a list of members for a new parliament: and I would recommend it to Mr. Hogarth, to try his fertile imagination, in a drawing for a *political print* on this subject. I would have the *great man*, surrounded by all his trusty dependents and clerks, drawn, seated at a table, on which should be placed, variety of books and papers, distinguish'd each by its proper label. Here we might read, *lists of voters* under the *excise*, the *customs*, the *war office, &c. &c. lists* of sheriffs and returning officers; and exact accounts of the state of *admiralty* boroughs. . . . Before the *great undertaker* should lie open

[66] *An Impartial Examination of the Conduct of the Whigs and Tories, from the Revolution down to the Present Times. Together with Consideration upon the State of the Present Political Disputes* (London, 1763), p. 63.

[67] 'A Dissertation upon Parties', *Works*, iii.173.

a list of the members last chosen, which he is to alter and amend as he thinks proper. . . .[68]

In this imagined print the minister's creatures bear the marks 'M.M.', 'K.M.' (the King's men), and 'I.M.' (independent members). The last group is described as a 'strange set of old-fashioned rustics, who bring notions of public spirit, œconomy, and inquiry, with them to parliament'.[69] Every seven years, before a general election, pamphlets such as the above would appear, urging the return of a free and honest Commons which would bring the country back from the brink of financial ruin and constitutional disaster.

The political prints display little interest in or knowledge of local politics. Produced in the city, near to the political centres of St. James's and Westminster, the prints were drawn to national politics, which provided most of their incidental and theoretical material. The satirists, for the most part, seemed uninterested in the parochial world of borough and county, where territorial interests and the cordial exchange of favours turned the political wheel. In simplistic fashion they accepted the older view that corruption was a 'showerbath from above' instead of a 'wellspring from below'. *The Devil upon Two Sticks* is a typical expression of this assumption. In the left part of the design two candidates contest for the support of a voter. One, holding the emblem of Liberty, goes unrequited; the other, a court candidate in lavish dress, offers a bribe which he has taken from the pocket of Britannia.

Though not arguing any party point of view, the frontispiece to *The Humours of a Country Election*[70] turns a sardonic eye on the humour of two courtly candidates making their campaign progress to a village in some rural backwater. The first scene shows the local inhabitants out to greet the candidates on their arrival. The second scene takes the candidates to the local tavern where they seek votes through bribery and charm. The final scene displays the chairing of the victorious two, dressed in their finest.

Graphic satire tended to accept the simplistic assumption that

[68] [John Douglas] *Seasonable Hints from an Honest Man on the Present Important Crisis of a New Reign and a New Parliament* (London, 1761), p. 40.

[69] Ibid., p. 41.

[70] *The Humours of a Country Election* (London, 1734). The frontispiece is BMC 2030.

elections were fundamentally a contest of honesty and dis-
honesty, the appeal to virtue and reason versus the use of bribery
and cajolery. *Ready Mony the prevailing Candidate* [Plate 8],
which reveals the hypocrisy of candidate and voter, employs the
contrast. The scene is the street of a village or small town, with
buildings on both sides falling away into the background. On the
left side of the street is a statue of Justice, on the opposite side, a
statue of Folly. Beneath the latter is a candidate praying and
burning incense: 'Help me Folly or my Cause is lost.' In the
middle of the street two candidates solicit a voter. The virtuous
candidate on the right admonishes: 'Sell not your Country.' His
rival places money in the pockets of the voter who proclaims:
'No Bribery but Pockets are free.' In the background a crowd
watches a 'prevailing candidate', fancily dressed, chaired in
triumph. He distributes gold with these words: 'For my Coun-
try's Service'. Money is the prevailing interest, though the
tavernkeeper at right offers an equally undistinguished reason for
his vote: 'He Kist my Wife, he has my Vote.' As the verses below
explain, folly as well as greed prevails.

Hogarth's *Four Prints of an Election* [BMC 3285–3327],
inspired by the Oxfordshire contest of 1754, is the best satirical
study of local politics during the period. Crowded, in the usual
Hogarthian fashion, with tumultuous activity of every kind, the
four designs adhere to the themes of bribery, treating, and the
unctuous solicitation of votes. Always behind the scenes is the
sinister presence of impending chaos and mob rule. These prints
show a maturer understanding and portrayal of the political
animal than that which is usually found in stock Opposition
propaganda.

The panacea for corrupt elections, according to the country-
party programme, were acts to prohibit bribery—one of which
was passed in 1729. The act [71] was so ineffectual that even suppor-
ters of the Government voted in its favour.

More dangerous than the interference in elections, however, was
corruption at the centre of power. Here government could
directly and more efficiently gain the prostituted loyalty of M.P.s.
Independent virtue lured by court influence is a common theme.
In the *Dissection of a dead Member* [BMC 3271, Plate 75] [72] is told

[71] From Sir Watkin Wynne's bill of 1729.
[72] Perhaps suggested by Hogarth's *The Reward of Cruelty*.

the tragedy of a country member, corrupted by the jobbery of Westminster. In the scene physicians are examining the body of the dead M.P. One observes: 'Ay, Ay, He knock'd his head too hard against Politics & Bruisefy'd his Pericranium He was bred a Fox hunter.' The bespectacled surgeon behind the table studies the corpse and reflects: 'The Vena Cava of the Thorax makes a Noise & sounds as if one shou'd say—My Country be dam'd & his Intestines have got I think tis Bribery wrote on them—not a drop of good blood in his heart.' Another physician notices 'a most potent Foeter exhale as if the Whole Body was Corrupted. ...'

The means of corruption, as expressed in the prints, are few: outright bribes, pensions, and places. In *The Grounds* there is a female personification of 'Bribery & Corruption': an alluring strumpet with a domed hoop skirt and low-hanging bodice. She distributes places and patents. At her feet are purses of money and pieces of paper marked 'Benefice 700', 'Pension 500', 'Place 1500 a year', 'Bank Bill 500¹'. The satirists accepted the myth that the direct bribe was an effective (and used) method of corruption. In *Bribery* [see Plate 91], one of the card-caricatures, a minister holding a wand in his left hand offers a bag of money to a member on his left: 'In the name of Corruption Split.' The M.P. obliges by splitting in two ('I obey your Wand').

Only a degree more subtle than the handout was the giving of pensions: a long established prerogative of the 'King's bounty'. The country interest complained about pensions as another pernicious extension of Crown influence and the national debt. These critics accepted the facile notion that there was a sure connection between the royal charity and political loyalty. They also assumed that these allowances were widely disbursed among Members of Parliament.

On a table in the right of the design of *The Screen* [Plate 45] are various bags of money, indicating the specific allotments; 'King's Serv't's Money' and the sinister 'Secret service mony' are two of them. The latter was believed to be the major fund of corruption, as an outlay of money for elections and pensions.

Among the devices that Walpole must give up in *The Political Vomit for the Ease of Britain* [BMC 2531, Plate 41][73] are

[73] A satire on the recently fallen Walpole, using the body function to show how he was forced to rid himself of the powers and schemes he had devised during his years in office; the new ministry scrambles for the spoils.

'Private P–ns–ns'. In *A Court Conversation* [BMC 3492], con-
cerning the impending fall of Newcastle's Government in 1756,
several ministers are seated in a room, about to fall off their
chairs. Packets indicate disbursements for German mercenary
troops (and a dog is tearing up the 'Act of Settlement'). In a
collection of ministerial records in the left foreground is one
volume which reads: 'Place & Pension Leidger No. 21'. New-
castle, in *Byng Return'd: or the Council of Expedients* [Plate 77],
holds a long scroll of paper, 'A Charge of the Change of the M–y
An 1755', on which is recorded an involved transference of pension
money to accommodate a shuffle in the ministry.[74]

More important than the bribe or pension was the corruption
of places: the innumerable offices of household and state. Offices
were legitimate, and in many instances necessary, but they could
be twisted to evil purposes. The Opposition inveighed for years
against placemen, as ministers' creatures entitled to seats in the
Commons. 'The Septennial Act begot Placemen, Placemen begot
Corruption.'[75] This was the assertion of the country interest,
which recognized the proprietary nature of public office and
assumed that as the duration of Parliaments was lengthened, the
worth and security of places were made all the greater.

The prints' creators had a fairly specific understanding of the
various public offices, as the elaborate device of the crown in *The
Screen* and the exchange of places in *A Cheap and Easy Method*
indicate. Excise and customs officers were especially hated,
though, of course, these officers—a considerable number in the
eighteenth century—were excluded from the Commons. The
places in the last-mentioned print include commissioners of the
Treasury and Board of Trade at the top to clerks, tidewaiters in
the customs office, and landwaiters (presumably in connection with
the excise office) at the bottom. Also mentioned is the 'Paymaster
of the Pensions' at the Exchequer.

Criticism of pensions and places varied between a simple
condemnation of the spoils system (by which ministers and their

[74] The change brought Henry Fox into the Government as Secretary of State for
the Southern Department, replacing Thomas Robinson.

[75] *A Proposal for Redressing the Grievances of the Nation, under the following
Heads, viz., the National Debt, Taxes, Excise Laws, Penal Laws, Army, Navy, Riot
Act, Septennial Act, Placemen, Corruption, &c., &c.* (London, n.d.), p. 25. This tract
probably first appeared in 1753. Mary Cooper was the publisher and mention is
made in the text of the Marriage and Naturalization Bills.

creatures nurtured themselves at the nation's expense) and the actual use of such allurements to corrupt the otherwise uncorrupted. The lure of pension and place was a strong one. The typical courtier, pensioner, or placeman belonged to the same host of plaguing locusts: rapacious, unprincipled, selfish minions. The satirists recognized but would not accept what was an axiomatic and even respectable principle of public conduct in the eighteenth century: 'a Place is a Place & every one should make the most Int[erest]'.

The Compleat Vermin-Catcher of G– B–n [BMC 3269, Plate 74] turns this profession into complete selfishness and lack of conviction. The M.P.s to be corrupted exclaim: 'Jews & no Jews',[76] 'A fair push for a Post', 'I'll follow Instructions', 'I am us'd to Dirt', 'Father us'd to say, they Who Won't take a Good Bribe when offer'd Ought to be hang'd', 'I have been us'd to Stick at Nothing, thick or thin throall', 'Every one for themselves, ther's something inviting offers itself'.

Criticism of political corruption assumed there was an unbreakable bond of loyalty and obedience between the corruptors and the corrupted. The fourth scene of *Robin⁵ Reign* [Plate 9] shows the interior of a room (possibly Walpole's residence at Chelsea). A bishop and other courtiers stand at a counter, on which there is money. Walpole, at the right, distributes it. Suggesting a form of bastard feudalism, several of the courtiers wear, as badges of livery in Walpole's service, 'RW' on their shoulders.

> Speak then Spectator—is Corruption high.
> Mark well the Visage of each slavish Tool.
> The Blackhead Hippocrite, & gaudy Fool,
>
>
>
> Like Judas thus for Gold betray the State,
> His Crimes they share, & may they share his Fate.

The top line of these verses, if filled in, might read 'See Robert Orators, Lords and Bishops buy.' Ministers, according to their critics, found it particularly useful to 'buy off' effective speakers, to strengthen the Government's position in the Commons.

[76] A reference to the Naturalization Act. A minister's man would vote for it and then against it, as his master commanded. See below, chap. vi.

The prints implied, instead of depicting in a specific way, the actual corruption of Parliament. 'All our Writers upon Government have told us, that *England* can never be enslaved but by Parliament, and I think there are but two Methods of fitting Parliament for this pious Work, one is by purging, the other by poisoning the House.'[77] Since Parliament was sovereign, a malign Parliament was a greater danger than the ministers who corrupted it. Even the *Craftsman* was cautious, however, in impugning the Lords and Commons at Westminster. Its editorials confined themselves to generalizations and the abstract, or to allegorical allusions, as in this description of a curious monster discovered in Channel-Row near Westminster:

The Body of this Creature covered at least an Acre of Ground, was party-colour'd, and seemed to be swelled and bloated as if full of *Corruption*. He had Claws like an *Harpy*; his Wings resembled *Parchment*, and he had above *five hundred Mouths* and as many *Tongues*; from whence he took the Name of *Poly-Glott* . . . he greedily swallowed every thing that his *Keeper* gave him; but as *Ostriches* eat *Iron*, his favourite Dirt was *Gold* and *Silver*. . . . They [these creatures] are in one Respect like the *Phoenix*; for the young ones rise from the Death of the old ones; which used to be formerly every *three* years, but now it is generally every *seven*. . . .[78]

Graphic satire which is directly concerned with the politics at Westminster is, for the most part, confined to the early 1740s in the climax and aftermath of Walpole's fall. *The Protest*, one of the *Motion* series, but critical of Walpole, takes the façade of the Treasury and St. James's Park as its setting. Seated on a small chair in the foreground is the pygmy figure of Walpole, holding a purse in his right hand, offering the money to 'Majority', a female personification standing in front of him with a protective shield. Justice, with sword and balances, threatens her. Walpole is also supported by a 'Placeman' who looks at Justice with scowling eye; by a figure representing 'Standing Army', and by another man designated 'Excise'. At the left are the representatives of the Opposition: Britannia and 'Minority'. The latter fires arrows at Walpole and his 'Majority'.

The right design of *The C–d–n–l Dancing-Master*, etc. [Plate

[77] *Common Sense: or, The Englishman's Journal*, 9 June 1739.
[78] *Craftsman*, 22 July 1727.

40], published at the time of Walpole's resignation, celebrates the triumph of the parliamentary Opposition. The minister's corps are about to hurry Britannia into a pit, when the intercession of an angel bearing 'Place Bill' and bringing 'a Majority at last' saves her. *The Screen. A Simile* [Plate 46], published a month later, charges that secret influence will prevent open inquiry into Walpole's iniquities. Next to the screen stands the Duke of Argyll, recent champion of the patriot cause ('Glorious and Brave to shake Corruption's Seat,/ But much more Glorious in thy brave Retreat'), now suspect as a minister. A mirror shows Walpole to be behind the screen; he holds the end of puppet strings that reach down into the scene below : the House of Commons. Several M.P.s remain Walpole's manikins and shield him.

> And by his secret Strings he still
> Governs the others as he will.

The fallen minister may have 'owned' a few members. The prints neglect to mention, however, that he continued to have the more important advantage of the King's ear and the confidence and friendship of former colleagues.

The certain cure for corruption and 'screening' was, by the lights of the country-party interest, the abolition of the Septennial Act and the return to triennial parliaments. Frequent elections would open the Commons to men of independent integrity and make the expense of corruption unworthwhile. Another solution, to gain greater currency in the second half of the eighteenth century, was to dam the flow of corruption at its source : to reduce the influence of the Crown. Bolingbroke perceived that parliamentary corruption became a dangerous reality only when the basis and size of Crown revenue changed after the Revolution.[79] Patriots complained about the civil list and growing expenditure, advocated place bills, but were as yet unwilling to attack the Crown directly, either in piecemeal or radical fashion.

In the first half of the century, the most radical scheme to eradicate the vast superstructure of venality that evil ministers had built around themselves was not the gradual reduction of Crown influence but a visionary dream, the core of patriot doctrine : a change in the spirit of the Crown itself.

[79] 'A Dissertation upon Parties', *Works*, iii.277ff.

5. *The Patriot King*

The importance of the king in the constitution and everyday politics being what it was, the quest for salvation from all the ills of the political world at the foot of the throne seemed natural. Professions of adoration for and loyalty to the reigning dynasty were a tedious but necessary part of political survival. Satire ridiculed monarchy and authority but in its more serious moments argued that due obedience must go with just authority.

Bolingbroke's *Idea of a Patriot King* turned the reverence for monarchy into an eschatology for political opposition and a new *Enchiridion* for kings. He carried patriotism beyond the Opposition to the king himself. Only a 'royal patriot'[80] could sweep away the degeneration of the present age.

This philosophy combined the majesty and assertiveness of Stuart kingship with the constitutionalism of the Revolution Settlement. The conjunction was ingenious: Tory romance and Whig ideals. The king, Bolingbroke argued, must be a constitutional monarch, acting within the strict confines of his executive authority, to return government to its lawful bottom. By acting assertively the king could stamp out the twin evils of faction and corruption. In personal conduct and through association he would set the proper tone. He would cleanse his court of the venal and selfish, and would remove from the hands of ambitious ministers the patronage with which they built their power. The patriot king was to employ only men of virtue and ability who shared their sovereign's principles (i.e. patriots). As patriots, owing allegiance only to their sovereign and the constitution, they would be tied to no party or faction. The king would rule through a broad-bottomed government of independent men. The body politic could then return to the character of a patriarchal family in which a just king and free people stood united.

Bolingbroke's fantasy was a brilliant synthesis, though it contained ideas that were not especially original. Commonplace notions filled much of it—including the scheme of royal intercession and the exalted ideal of royal conduct. A broadside published in the 1720s, *The Tale of the Robbin, and the Tom-Titt, Who All the Birds in the Air Have Bitt*,[81] is an historical fable about evil men

[80] The phrase appears in the *Craftsman*, 28 Nov. 1730: 'A *good King* therefore is only another Word for a *Royal Patriot*.'

[81] See above, chap. iii, p. 69.

who have plagued kings and people since the Civil Wars, and most recently 'Robbin' as Walpole. Eagles represent the kings: 'O! let us no more, such times see again;/ But pray for the *Eagle*, with his Feathered Train.'

Implicit is the myth of the 'king in toils'. Bolingbroke does not clearly express this idea in his tract, but it is implied. He was not much concerned with the duration of George II's reign, for he had set his eyes on the king to come. The belief in a captive sovereign, exploited and befuddled by conniving ministers, was a logical derivation of the legal fiction that the king could do no wrong—a stock charge of Leicester House Oppositions. This myth does not begin to appear in the prints until the era of the Pelhams.[82] *The Court Fright* [Plate 53] shows George II as a put-upon monarch, 'bled' by the follies and treacheries of his ministers, with Britannia, representing the nation, lying wanly at his feet. Addresses from the people, about which the King is able to do nothing, rest at his side. *A very Extraordinary Motion* [Plate 55] reveals George II's reluctance to accept a broad-bottomed government, especially the inclusion of the Tories and Cotton: 'Hounsfoot me no Stomach him!'

The king in toils appears in several prints of the 1750s. In his last years George II gained much sympathy and even popularity— no longer the controversial figure and butt of satire that he had been in the 1730s. A widower, without his son to succeed him, George appeared as a lonely old man, plagued by grasping politicians. *Optimus. Britons Behold the Best of Kings* [BMC 3537], published in 1756, has a design with a bust of the King in the Roman style. Beneath it are these words of praise: 'Beloved by the bravest of People,/ Justly admired by all,/ . . . No Evil and Corrupt Ministers Dare to Approach his Sacred presence;/ Let none but such as Imitate his Virtues/ have any Power,/ Then shall Britannia be Blest for Ever.' The explanation of this print in the *Political and Satyrical History* observes that 'what a Pity it is then, that so good a Master should have so many bad Servants about him as he had at the Time when this was published'.[83]

[82] Quarrels with Prince Frederick, a notorious temper, visits to Hanover, and adultery made George II an unpopular figure in the early years of his reign. In the period 1742–6, years of political instability, ministerial changes were made which thwarted the wishes of the King, who no longer had the support and service of Queen Caroline and Walpole.

[83] *Political and Satyrical History of the Years 1756 and 1757*, p. 9.

Other prints against the Newcastle ministry develop this idea. One, *The 3 Damiens* [BMC 3558], went so far as to imply in its title that Newcastle, Lord Chancellor Hardwicke, and Lord Anson were no better than royal assassins.[84]

The *Idea of a Patriot King* appeared in print in 1749 and by the middle 1750s was a standard exposition of popular dissent and patriot Opposition, whose champion was now William Pitt. Two prints of 1756 celebrate the idea of the King breaking free of his bonds. *The Downfall* [BMC 3480], published by Darly and Edwards, shows a stone staircase, with the top step labelled 'Break Neck Stairs'. 'The Bottomless Pit' forms a cavern in the foreground at right. In the centre foreground is the King, represented by a lion, throwing Newcastle, Hardwicke, and Fox— desperately hanging to him—off his back; the lion exclaims: '*All three!—All three!* . . . And so my Old Boys off you go by Jupiter, and the next time you catch me carrying Treble, spit in my face and call me *Ass.*'

The other print, without title [BMC 3488], shows a royal receiving-room with a raised throne at right; on one of the steps leading to the throne is written 'Optima'. George II, dressed in the Roman style, sits on the throne and orders the Newcastle ministry from his presence with: 'Hence Fools & Knaves begone, no more offend my Sight.' Liberty and Justice attend the King. In the right corner rests a couchant British lion: 'I shall Rouse by & by then wo be to ye.' 'The wisest and best of Princes may be often imposed on. . . . Yet the superior Motives of Justice and Liberty will, at one Time or other, prevail, to the total overthrow of Corruption and Venality.'[85]

An interesting print, published about the same time by Thomas Kitchin, *The Mirrour: Or the British Lion's back friends detected* [BMC 3487], presents the King as a lion in the centre foreground, avowing:

the good People of England have always had the first place in my Paternal affections & Esteem. I'm now convinced by their numerous Addresses and Remonstrances that their complaints are not groundless; there shall be a speedy Enquiry and the injured Nation shall be redressed of all the grievances complain'd of, occasion'd by bad M–st–l measures; delinquents in high Stations shan't escape punishment. . . .

[84] Robert Damien attempted to assassinate Louis XV at Versailles in January 1757. [85] *Political and Satyrical History*, p. 4.

Peacocks carrying several borough and county addresses stand beside him. The lion's front legs are in fetters, attached to chains which four members of Newcastle's government hold at the right side of the lion. Just to the left is a 'patriot', kneeling. He holds a mirror up to the king; the mirror shows the image of a partially freed lion, about to be securely fettered again. The inventor of the print has in this way interpreted the role of a true patriot: 'Look into this Glass you'll see your back friends have forged a strong Iron Chain to enslave you. Beware of them. Hear the Groans of the People and redress them.'

> The Lion, Type of royal Power Behold!
> (No longer by insidious Wiles controll'd)
> Attentive hears the Pleas of patriot Zeal,
> Assures Redress and ev'ry Wound to heal.
>
>
>
> Britain shall ever great and Free remain,
> And all her ravish'd Honours soon regain.

Prints and tracts both indicated a belief in the righteous triumvirate of king, patriots, and people; Bolingbroke emphasized that the interest of king and nation must rise or fall together. Britannia's position next to George II in *The Court Fright* conveys this idea. *The Court Cards or all Trumps* pairs George and Britannia together as the king and queen of hearts.

The 'patriot king' motif, at one time believed to be a disguised apology for renascent Toryism, was turned round against the Bute ministry in the early 1760s. Though a few 'Tory' pamphlets talked about George III asserting his independence,[86] the 'Whig', or more accurately, 'patriot' Opposition employed the same tactical weapons used against the Pelhams in years past. The minister–patriot and court–country axis proved more relevant than one based on old party distinctions.

The myth of a king in toils once again appeared. *The couchant Lion or Sawney in the Secret* [BMC 3940] shows the young George III as a lion, spurred in the eye and weighted down by a large jackboot, in which Bute is standing. In *A Wonderful Sight* [BMC 3885], a print of 1762 criticizing the impending peace settlement, a street scene is shown with 'The Old British Coffee House' in the centre background. Britannia sits above one of its

[86] e.g. *Seasonable Hints from an Honest Man.*

porch windows. Along the foreground moves a triumphant procession: a carriage pulled by Bute and the Princess. In the carriage rides a tiny lion, as the King, with a jackboot on its head.

The true British Ballance [BMC 3807], however, asserts the eventual triumph of king, nation, and patriots, in a scene of grand style: a throne room with classical archways, balustrades in the background, leading to a distant prospect. A good portrait likeness of George III sits on the throne at left. He welcomes Pitt, with Britannia accompanying him, into his presence: 'Come to my Arms, thou best of men.' Britannia also praises Pitt: 'My dear Son, you're an Honour to your Country.' Justice stands in the centre of the design, with Pitt to the left of her, Bute to the right. She decides in favour of the former: 'Lett Merit bear the Sway.'

Prints such as these celebrated a hope not a reality. Many of the polemicists of the Opposition were aware of the King's obvious predilection for Bute's counsel. Some abandoned, in part, the vision of a patriot king. *Tempora Mutantur* [Plate 107] pointedly rebukes the King's folly and ignorance. *The Jack-Boot Kick'd Down or English Will Triumphant: a Dream* [BMC 3965], another of the wishful visions, takes a more balanced perspective. The scene is again a royal chamber. The King's uncle, the Duke of Cumberland, kicks a large jackboot off the steps leading to the throne; George III's brother, the Duke of York, encourages him. On the throne sits the lion-king, muzzled and inactive, as the royal dukes have assumed his role.

Most of the criticism of George III was circumspect, not like the vicious ridicule to which caricaturists of later years subjected the King. The attitude towards monarchy continued to sway between the stale and impersonal glorification à la Bolingbroke and a sometimes fresh, more candid criticism. *Long Live His most Excellent Britannic Majesty King George the Third* [Plate 100] belongs to the former category—an ironic introduction to a stormy reign. Like Bolingbroke's millennarian ideal, prints such as the above were unclear in the specifics of what a good king should be and do—and how he was to bring forth the reign of patriotism. The king, it is true, was considered to be the proper champion of the country-party programme:

a *Patriot Prince* who will resolutely break forth from the shackles of courtiers and ministers, throw himself on the affections of his people, and demand a virtuous parliament to examine past measures, and to

restore freedom and frequency of elections, who will remove that artillery which corruption and faction plant round a throne to be discharged against truth and liberty. . . .[87]

But the country-party programme, with its scheme of reformation and restoration, its superficial or unworkable policies, and its unreasoning spite for court machinations and financial complexities, often seemed as chimerical as the patriot king who was to bring it about.

Bits and pieces of this dream appear in the prints, but it is unwise to draw simple conclusions about political philosophy from their conjunction of words and images. Graphic satire borrowed from the rag-bag of Opposition ideas, which because of their lineage were properly associated with the country-party interest. A 'country party', however, is not prominent in the prints—perhaps because of the amorphous nature of that party itself. The satirists sometimes see the country gentlemen as Tories, sometimes as the embodiment of the character of the House of Commons. Sometimes they appear as the stout-hearted English breed, the backbone of patriot oppositions, other times as the dupes of ministers and erstwhile patriots.

More substantial in support of the country-party programme, in fact, was the 'City' interest. By the middle of the century the City of London, in its official and unofficial capacities, was assuming a dominant role in political opposition outside Parliament. The strength of the City interest made itself felt in the prints.

[87] *The Abuse of Standing Parliaments, and the Great Advantage of Frequent Elections. In a Letter to a Noble Lord* (London, n.d.), p. 30.

CHAPTER VI

The City Interest

The most effective support of the country-party programme came from the City of London. The great metropolis, with its concentration of population, its proximity to Whitehall and Westminster, and its vital merchant and financial institutions, was an important political force. Long before it became a nest of radicalism in the reign of George III London had proved itself to be a valuable asset for Opposition. It was the bane of Walpole during his long tenure; it proved instrumental in the frustration of the excise scheme and the precipitation of the war with Spain. London supplied a major buttress of Pitt's political strength.[1]

The political prints, originated and marketed in the environs of London, were influenced to a large degree by the City's role in national politics. And the inventors of the prints, quite naturally, sometimes magnified its political importance out of true proportions. London frequently became synonymous with the country or nation, when in opposition to or unity with the court and Government. In *Court and Country United against the Popish Invasion. 1744* [BMC 2609] officials and citizens of London represent the 'country' as they appear in the royal chamber with members of the court. In divisive matters representatives of the city are almost always in the front of the patriots' ranks.

London had its own personification: a female companion to Britannia, with the armorial shield of the city as her attribute. Often she carries with her the emblems of Liberty. The genius of London sits opposite Britannia in *The Vision: Or Justice Anticipated and the Addressers redressed* [Plate 86]. Similarly, in *Patriotism Rewarded* [BMC 3590], a print of 1757 concerning the

[1] Lucy Sutherland has contributed several essays and books to the understanding of the political role of London in the eighteenth century, among them: 'The City in Eighteenth-Century Politics', *Essays Presented to Sir Lewis Namier*, edd. R. Pares and A. J. P. Taylor (London, 1956), pp. 49–74, and *The City of London and the Opposition to Government, 1768–1774: A Study in the Rise of Metropolitan Radicalism* (London, 1959). A. J. Henderson, *London and the National Government, 1721–42* (Durham, N.C., 1945) is a study of the City's opposition in the age of Walpole.

gift of Freedom of the City given to Pitt, the personification appears, attended by Plenty, Commerce, Justice, and Wisdom. The Temple of Virtue and an outline of the city under a radiant sun can be seen in the background. Below, Liberty and Truth overcome the Hydra of Oppression and Fraud. In the vein of animal symbolism, the dragon of the city appears as the premonitor of danger in *Now Goose; Now Turkey; or the Present State of England* [BMC 3409], as it tries to arouse the sleeping British lion.

Despite a remarkable degree of corporate solidarity, political sentiment in the city was never completely homogeneous. In the Corporation the Lord Mayor and Court of Aldermen tended to be less recalcitrant in dissent. There were outstanding exceptions. William Beckford, who was Lord Mayor in 1762–3 and 1769–70, was a leader of the radicalism of the 1760s. On crucial issues such as the excise bill, the convention of the Pardo, and the military crisis of 1756 the Corporation as a whole took a strong position in opposition to the Government. Addresses and petitions, to King and Parliament, were the city's principal constitutional weapons. Graphic satire accepted these remonstrances as telltales of national opinion and vindications of the parliamentary Opposition's cause.

The Court of Common Council, elected by the freemen ratepayers of the city, was more attuned to the prejudices and feelings of the citizenry as a whole. It was always a bed of anti-ministerial sentiment. Country-party ideas were the substance of the formal instructions sent by the Council to newly-elected M.P.s. The opposition was consistently successful in winning part of London's representation to Parliament.

In addition to the power and prestige of the Corporation, there existed a complex of social and economic interests in London—merchants, financiers, tradesmen, artisans, labourers, and riffraff—which could exercise a significant influence on national politics. The trading and financial interests were the mainstays of London's economic life. As they had increased in importance and prestige, their values and aspirations had become common currency, almost synonymous with national wellbeing:

In very few periods in English political history was the commercial element more conspicuous in administration . . . a competition of

economy reigned in all parties. The questions which excited most interest were chiefly financial and commercial ones.[2]

The prosperity of trade and the security of public credit were cherished values. 'Trade' and 'Publick Credit' form the chief pillars of the state in *Britannia in Distress* [Plate 89].

'Trade is of a very particular Concern to us, by Reason it is from it we have, if not our Being, at least our *Wealth* and *Greatness*.'[3] The eminence of trade is frequently expressed in the prints. *King George. Sea Dominion the Honour of the British Flag. Liberty, Property, Trade and Commerce for Ever* [Plate 101] celebrates the accession of George III and extols the nation's maritime and mercantile genius. The design, with Britannia as an ornament, shows a placid seascape; a cluster of ships at anchor suggests the halcyon greatness of power and prosperity:

> O *Britain*, chosen Port of Trade
> May Lux'ry ne'er thy Sons invade
>
>
>
> What is't, who rules in other Lands?
> On Trade alone thy glory stands.
>
>
>
> Be Commerce then thy sole Design;
> Keep that, and all the World is Thine.

The Quere? which will give the best heat to a British Constitution links trade with Magna Carta, as the foundations of Britain's greatness. Britannia sits at the right with the Charter on her lap and a bale of 'Wool' beside her.

The traditional personification of Trade or Commerce was Mercury, carrying a purse in addition to his caduceus.[4] Another conventional figure is the classically dressed female, sometimes carrying the attribute of a ship in her hand (as in Plate 58). In the majority of prints, however, Trade presents a wholly different kind of image: one which is contemporary. The figure is that of a man, usually in shadow, dejected, leaning against his emblems: bales and casks. The image suggests 'trade in decay', the standing indictment of all ministries. Typical is the representation in

[2] William E. H. Lecky, *History of England in the Eighteenth Century*, (7 vols., New York, 1892–3), ii.44.

[3] *Britain's Glory Displayed, or Ways and Means found out, whereby to raise Men and Money towards the Support of the present War* (London, 1756), p. 66.

[4] Tervarent, i.57–8.

Excise in Triumph [BMC 1918, Plate 11] and the figure in the centre of the design of *The Present State of a Certain Great Kingdom* [BMC 2336, Plate 21]. A variant of the conventional image appears in *The Protest* of 1741, which displays Walpole's alleged repression of trade with five men, chained and weighed down by the burdens of taxes and impositions.

Merchants, like the landed interest, were perpetually dissatisfied (in varying degrees). Ministerial writers ridiculed their presumption to meddle in political affairs.

If any faction can be pernicious in a state, it is a faction of merchants. Men nursed in the narrow paths of life, incapable even of forming any extensive ideas of general commerce, but only reasoning from those acquired by them in a particular corner of the vast complicated machine of human intercourse . . . are certainly very ill judges of the great interest of nations.[5]

Rarely are merchants made the butts of ridicule or criticism in the prints. A pro-Bute print of 1762, *Britannia guided by Justice* [BMC 3865], recognized that the strength of opposition was in the business interests of the City. The scene is set in front of the Royal Exchange: Britannia bestowing laurels on Bute, while at the left English merchants and placemen complain: 'Tell me Brother Traffick Why our Brethren Hate this new Favourite;' 'Because he's an Honest Man.' Underneath the left portico of the Exchange a crowd declares: 'We are resolved not to allow of the Decision of Justice, Now, more than Usual.'

'Public credit' had more recently become part of the nation's palladium. For older Tories and many of the country gentry it symbolized the incomprehensible and pernicious scheme, once invented by the Whigs to buy support for the Revolution Settlement and, later, the Succession. But despite these traditional suspicions, the more sober-minded, even among the popular polemicists, championed the health of public credit as much as the Constitution which it supported. '*Publick Credit* is the Basis whereon is built the Welfare of the State; when that is played Tricks with the whole Superstructure totters. . . .'[6] Addison, in his description of the great hall of the Bank of England, offered

[5] *Political Considerations; Being a Few Thoughts of a Candid Man at the Present Crisis. In a Letter to a Noble Lord Retired from Power* (London, 1762), p. 60.

[6] [Lord Granville], *The State of the National for the Year 1747, and Respecting 1748. Inscribed to a Member of the present Parliament* (London, 1747), p. 25.

this personification of public credit: 'a beautiful Virgin seated on a Throne of Gold.'[7] The walls around her, he said,

were hung with many Acts of Parliament written in Golden Letters. At the upper end of the hall was the Magna Charta, with the Act of Uniformity on the right Hand, and the Act of Toleration on the left. At the Lower end of the Hall was the Act of Settlement which was placed full in the Eye of the Virgin that sat upon the Throne. . . . Behind the Throne was a prodigious Heap of Bags of Money. . . . The Floor, on her right Hand and on her left, was covered with vast Sums of Gold. . . .[8]

The revolution in public fiscal policy, with the beginning of long-term borrowing and a funded national debt, had created a large body of public creditors, dominated by the so-called monied interest, the 'stock-jobbers'. This body of creditors included the great financial houses, banks, and corporations, and a large number of independent merchants, financiers, and small shareholders.

'When a free government is able to contract great debts by borrowing from its own subjects, this is a certain sign, that it has gained *the confidence* of the people.'[9] This financial confidence was closely linked with the security of the new dynasty. The Pretender's march into England in 1745 caused a small financial panic; the necessity of shoring public credit increased the national emergency. Bickham published a print in October 1745, entitled *Publick Credit* [BMC 2686], showing the full-length portrait of a man, in finely trimmed coat and waistcoat, bag-wig, and a gold collar. Under his left arm he carries a book, 'Solutus omni faenore', in his right hand, 'Bank Notes'. The personification, as the print describes it, is 'a Man in ye Vigour of his Years, healthy, strong, and Active, nobly clothed, having his Senator's gown and a Gold chain about his Neck, that seems to command Esteem & Honour. . . .' At the left side of the man is a griffin, 'a Symbol of Safe Custody', and behind, the threat of the Pretender, represented by the personifications of Sedition and Rebellion. In the

[7] Quoted in R. G. M. Dickson, *The Financial Revolution in England: A Study in the Development of Public Credit 1688–1756* (London, New York, 1967), from *Spectator*, No. 3, 3 March 1711.

[8] Ibid.

[9] [Robert Wallace] *Characteristics of the Present Political State of Great Britain. The Second Edition, With Corrections and Additions by the Author* (London, 1758), p. 53.

distance is a seascape with two ships, showing the importance of commerce to public credit.

Critics of the Government complained about the impending fall of credit as much as they did about the decline of trade. The peril was especially great in time of war, when fortunes took a bad turn. *Merit and Demerit made Conspicuous; Or, the Pillers of the Publick Prov'd* [BMC 3482], a print of 1756, shows a broken column labelled 'Public Credit' in the centre of the design, with a dilapidated statue of 'Funds' atop it. A Frenchman has touched it with his sword: 'Prov'd Rotten by Monseurs Touch'. The print is led away in disgrace at the right. The British fleet lies idle in the background. Two devils drop the 'Public Treasure'('wasted') into the sea.

In addition to the prestige of the City Corporation, the political importance of the trading and financial interests, London had another political force in its midst, unpredictable, difficult to analyse, but sometimes of great use in the struggle for power: the mob. Public disorder was a common occurrence in London; rioting almost a respectable institution.[10] There are few clues about its nature and composition in the prints. The political prints gave little attention to the 'inferior sort' of people—the artisans, labourers, vagrants, and criminals. Mobs on a small scale are often present in the prints, when the inventor wished to reveal the great unpopularity of a man or measure. This is the case in many of the prints attacking Byng.[11]

The 'inferior sort' are distinguished from the middle classes and from gentlemen by their dress. The men usually wear a jacket and trousers, long, stringy hair, and wide-brimmed caps. Women have simple gowns, sometimes with aprons, lappets, slouch hats, or milkmaid hats on their heads. The clothing is often tattered. The butcher was a favourite social type, always identified by his robust stature, apron, knife, hatchet, and steel. Butchers, holding cleavers and bones, form part of the London mob worshipping the figure on stilts in Hogarth's *The Times*

[10] See George Rudé, 'The London "Mob" of the Eighteenth Century', *The Historical Journal*, ii (1959), 1–18, and chapter one of his *Wilkes and Liberty: A Social Study of 1763 to 1774* (Oxford, 1962).

[11] *Bung Triumphant* [BMC 3361] pays mock tribute to the Admiral with an arch of triumph in the foreground. In the background is a London street where a mob carries his effigy to be hanged. Garbage and rocks are thrown at him.

Plate 1 [Plate 115].[12] Aldermen of the City kneel in worship before it.

Politically, the mob was 'Tory'. The slowest to change the garb of values and prejudices, the ignorant and illiterate could still be swayed by the simplistic hatreds and ideals of earlier generations.

1. *Excise*

The frustration of Walpole's Excise Bill in 1733 is one of those few instances in the eighteenth century when extra-parliamentary opinion was effectively brought to bear to scuttle a persuasive Government measure in Parliament. It revealed the successful use of propaganda by the Opposition. Charles Delafaye, Under-Secretary to Newcastle, wrote to Thomas Robinson (then ambassador to Vienna), after the withdrawal of the bill:

I have already acquainted your Excy with the Scheme of turning the Customs upon the Tobacco & Wine into an Excise . . . the Misrepresentation of this Design, artfully spread over the Kingdom, had raised too much Dissatisfaction, that the Sheriffs of the City of London, accompany'd by some of the Aldermen and many substantial Merchants & Traders, attended the House with a Petition from the Common Council against it, and there was reason to expect like Deputations from many other Corporations . . . and the Clamour that had been raised, it was thought advisable to drop it . . .[13]

The bill was a sensible one. It was part of Walpole's extensive reform of government finance and revenue. He initially hoped to lift part of the burden of the land tax by reviving the excise on salt. When this revenue proved insufficient, he proceeded with a larger plan to convert the customs duties on imported tobacco and wine into an inland excise, levied on the commodities when removed from bonded warehouses for sale. Supporters of the bill pointed out that the conversion was not the addition of new tax revenue, but rather the effective collection of revenue that customs frauds and smuggling had prevented.

[12] See below, chap. viii; the conjunction of the mob and a man of high place and stature was used by the satirists to denigrate the latter. *The Scotch Yoke; or English Resentment* [BMC 4033] depicts the popular disapproval of Bute's proposed excise on cider and perry. Bute sits on top of a pole, with faggots burning underneath. A crowd jeers at him from below. A woman in modest dress at the right exclaims: 'See his Arse there! See his Arse.'

[13] B.M., Add. MSS. 23788 (Robinson Papers), ff. 101–2; the letter is dated 12 Apr. 1733.

The serious criticism of the measure was, however, at least plausible.[14] Opponents argued the possible hindrance to the smooth flow of trade which might result; they voiced concern with the increase in the number of Crown officials, their wide powers of search and seizure, and the summary nature of trials for possible infractions.

The popular appeals of the Opposition, disseminated by what ministerial writers described as 'disaffected Writers, Coffee-house Orators, Makers and Spreaders of false News, busy Agents for the Pretender, Popish Priests, Tale-bearers, Ballad-Singers',[15] went much further. 'It was *necessary* in the first Place to spread a *general* Terror, and thus to *inflame* and *interest* the whole *Body of the People*.'[16] Wild distortions and the resurrection of old fears moved the controversy out of the context of the original issue. This was particularly true in the prints, ballads, and handbills that were widely circulated.[17]

The most telling charge of the Opposition was that the excise on tobacco and wine was the preliminary to a general excise: an assertion so often repeated that general excise seemed already at hand.

To support this *useful* Notion of a *General Excise*, there was *Nothing* offered by the *Inventors* of it, but *bold* Assertions, which were *strongly affirmed* and vigorously *propagated* by those who found it *necessary* to form a *powerful Party*. Not the least pretended Proof of their Assertions; when we called for an *Argument*, they repeated *a Song*, and to enforce this produced *a Picture*.[18]

The Monster, Excise, an image given lasting form by Marvel's poem ('*Excise*, a Monster worse than e'er before/ Frighted the Midwife, and the Mother tore./ A thousand Hands she hath, a thousand Eyes . . . With hundred Rows of Teeth the Shark exceeds'), was part of the political folklore, a reminder of the

[14] The best-known are the several pamphlets by William Pulteney.

[15] *A Letter from a Member of Parliament for a Borough in the West, to a Noble Lord in his Neighbourhood there, concerning the Excise-Bill, and the Manner and Causes of losing it* (London, 1733), p. 20.

[16] *The Rise and Fall of the late Projected Excise, Impartially Considered. By a Friend to the English Constitution* (London, 1733), p. 20.

[17] E. R. Turner, 'The Excise Scheme of 1733', *English Historical Review*, xlii.34–57, is the best study of the controversy; Turner ignores, however, the political prints.

[18] *The Rise and Fall of the late Projected Excise*, p. 22.

terror of a general excise. An assortment of creatures appeared in the propaganda of 1733: 'new Dragons hung up to affright the People'.[19] A hydra appears in the broadside, *Britannia Excisa* etc. [BMC 1937, Plate 16] whose verses, however, describe a more awesome beast:

> See this Dragon, *Excise*
> Has Ten Thousand Eyes,
> And Five Thousand Mouths to devour us.
> A Sting and Sharp Claws,
> With wide-gaping Jaws
> And a Belly as big as a Store-house.

The hydra in the woodcut devours an assortment of objects connected with the consumption of wine and tobacco (tankard, pipe, wine-bottle) and a joint of meat which has no relation to the excised commodities. One head of the monster spews forth the revenue of its consumption into the hand of its 'grand projector', Walpole.

More interesting are the almost identical creatures in Plates 13 and 14: resembling a prehistoric reptile like the *tyrannosaurus*. Propagandists substantiated the threat of general excise by reminding their audience of the commodities already subject to the inland duty. These goods have been carefully inscribed on the bodies of these two monsters.

Parliament introduced excise in 1643, after the Dutch example, and this method of taxation was retained and expanded after the Restoration. Its effectiveness soon made it a dreaded word and bugbear. Appealing to the virtues of the constitution and the nation's insularity, the Opposition in 1733 argued that excise was unknown to the 'founders' of English government, that it therefore must be an alien idea, brought from absolute monarchies abroad.[20] They spread the notion that excise was a French scheme and that it carried with it the trappings of French tyranny.[21]

[19] Ibid., p. 37.

[20] e.g. *An Argument against Excises, In several Essays, lately published in the Craftsman, and now collected together. By Caleb D'Anvers of Gray's-Inn, Esq.* (London, 1733).

[21] *French Excise: or, a Compendious Account of the Several Excises in France, and the Oppressive Methods us'd in Collecting them* (London, n.d.) is a serious attempt to establish similarities and suggest origins.

[the Opposition] have wrought the People up into Persuasion . . . that the Government will soon be *arbitrary* and *tyrannical* . . . that *Slavery, Beggary,* and *Wooden Shoes* of the *French* are preparing for them; and . . . that a great many Pair of *Wooden Shoes* were lately *imported,* on purpose to be carried about the City on Poles or Sticks, as *Emblems* or *Signs* to the People, of what a dismal State they are coming to . . .[22]

Wooden shoes appear on the British lion and unicorn in *Excise in Triumph,* showing the would-be effects of Walpole's scheme. The tails of both animals are cut: the lion wears a dejected look, as a yoke weighs down upon him. Wooden shoes and the manacles of slavery rest in the lighter scale held by Justice in *The Noble Stand: Or the Glorious CCIIII* [BMC 1921, Plate 12]. Walpole holds manacles and chains as he offers the 'Excise Scheme' to Britannia in *The Scheme Disappointed,* etc. [Plate 15].

The inventor of the above print has introduced Popery, in the presence of a female personification, wearing the habit of a nun and holding a book, rosary, and crucifix ('Rome ready to seize Brittain if she accepts the Scheme'). Reviving Protestant fears was also a reliable ploy. Where the tyranny of France extended itself, the persecution of Rome was sure to follow.

> This Monster, Plague rot him!
> The Pope first begot him,
> From *Rome* to King *Lewis* he went;
> From a *Papist* so true
> What Good can ensue?
> No Wonder he'll make you keep Lent! [Plate 16.]

The fan in Plate 13, which compares Walpole with Cardinal Wolsey, calls to mind the troubles of the Reformation; in the background a monk stands in front of a church, the tower of a second church is collapsing. Another building has inscribed above its door 'Inquisition', from which the defeat of excise has saved the nation.

With the tyranny of France and the persecution of Rome is fundamental evil, represented by the Devil. He holds the 'Excise Scheme' in *The Scheme Disappointed,* etc.; in the second design of Plate 16,[23] he counsels Walpole.

The vanguard of this Continental tyranny, already stationed in

[22] *London Journal,* 17 Mar. 1733.
[23] This is a folio broadside with three ballads and three illustrations. It incorporates the verses and design of BMC 1936.

England, is the standing army: the twin evil of excise, also
spawned during the Civil War and Interregnum. The propa-
gandists exploited the association in popular lore of these two
evils. In February 1733 came the annual attempt by the Opposi-
tion in Parliament to reduce the 'Standing Army in time of
Peace'. Representations from various boroughs, critical of the
Excise Bill, also complained about the continuance of the land
forces.[24] The *Craftsman* repeatedly linked the two ideas together
and argued their mutual interdependence: a large army required
burdensome taxes and a general excise demanded a standing army
for its support and execution.[25] Graphic imagery afforded a simple
association, for a standing army itself was sometimes described as
a monster.[26]

> The great *Trojan Steed*,
> Of outlandish Breed,
> An Army contain'd in his Belly;
> So does the *Excise*
> Or else *Caleb* lies,
> And as *fatal* 'twill prove, let me tell Ye
>
>
> But if we don't keep out this *Dragon*,
> What with the *Excise*
> And *Standing Armies*
> We shan't have much left Us to brag on. [Plate 16.]

In *Excise in Triumph* a menacing grenadier leads the triumphant
Walpole from Westminster, where the scheme has just passed
(like all ministerial measures, because of 'Interest'); the soldier
has cowed the nation—lion and unicorn—into accepting it. At
the rear of the procession follows the remainder of the standing
army, ready to enforce the measure.

[24] See *Excise: Being a Collection of Letters, &c., Containing the Sentiments and
Instructions of the Merchants, Traders, Gentry, and Inhabitants of the principal Cities,
Counties, Towns . . . to their Representatives in Parliament, against a New Excise*
(London, 1733).

[25] See *An Argument against Excises . . . in the Craftsman.*

[26] The author of *The Sense of the Nation; In Regard to the late Motion in Parlia-
ment; In a Letter from a Freeholder to His Honour* (London, 1741), describes a
standing army as a 'hydra' from which sprung a 'prodigious List of Excisemen'
(p. 22); the same metaphor ('Monster') was used by American pamphleteers
before the Revolution: Bernard Bailyn (ed.), *Pamphlets of the American Revolution*,
i.74.

Dejected *Trade* hangs down its drooping Head,
While *Standing Armies* daring Colours Spread;
By these encourag'd, on the Barrel strides
Excise in Triumph, and like *Bacchus* rides.[27]

Appropriately, the contrivance on which Walpole is riding in the above print rolls over 'Mag–a F—a': the artist's manner of showing excise to be contrary to the constitution: 'to bring the People of *England* under the *Laws and Offices of Excise*, in Opposition to *Magna Charta* itself and the fundamental Principles of our *Constitution*'.[28] Fears that the constitution was in peril gained the support of many country gentlemen, whose interest the Excise Bill purported to serve.

Suggestions that there would be a denial of trial by jury and increased powers of search and seizure are largely missing in the prints, save for vague allusions in such phrases as 'Liberty & Property'. Ballads, however, proclaimed the inviolate nature of a man's hearth and home, against the intrusion of the excisemen.

The Multitude frightened by false Stories, and blindly following their Demagogues, run like a Current one way. Besides the regular Infatu-ation from daily and weekly Papers, little *Hand Bills* were dispersed by thousands all over the City and Country, put into People's Hands in the Streets and Highways, dropped at their Doors, and thrown in at their Windows; all asserting that Excisemen were (like a foreign Enemy) going to invade and devour them, and ready to enter their Houses; into all Houses, private or public, at any time, by Day, or by Night. They might as well have asserted, that these Excisemen were to be invested with Power of Life and Death.[29]

Violation of private property, it was charged, would even go beyond, to the violation of a man's wife and daughters. 'Our Forefathers Houses, their Cellars, their Wives were open to a *slovenly* Monk or *bare-footed Fryar*; and shall we repine at the same Freedom in a *Protestant Gentleman* of the *Excise*. . . .'[30]

[27] From the first state of *Excise in Triumph*. There is a copy of the print in the British Museum, *The Triumphant Exciseman* [BMC 1919].

[28] *An Argument against Excises*, p. 76.

[29] *A Letter from a Member of Parliament for a Borough in the West*, p. 9.

[30] [William Pulteney], *A Letter from a Member of Parliament to his Friend in the Country; Giving his Reasons for opposing the farther Extension of the Excise Laws* (London, n.d. [1733]), p. 24. *Oppression display'd*, a print of 1763 attacking Bute's proposed excise of that year, shows a group of excisemen breaking into a house, destroying property, and threatening the inhabitants. A child clings to his mother's

Excisemen appeared as an alien host, the blackest kind of Crown officials. They are distinguished in the prints by the tools of their trade: the gauge and tally book, which Walpole himself holds in *Excise in Triumph*. In *The Downfall of Sejanus* [BMC 1939], celebrating the fall and demise of Walpole, excisemen walk in a line of mourning, with an assortment of measuring instruments in their hands.

Extension of the excise would, by increasing the number of excise officers, enlarge the power of the Crown and spread the influence of the Treasury into all the counties, boroughs, and cities of the kingdom. Freedom of elections was as much in danger as trial by jury, all the more great because of the imminent general election. Excisemen with their gauges and books are part of the court party's interest in the *Kentish Election* [Plate 18]. A gentleman of the country party exclaims 'No Excise'.

The core of the Opposition remained, however, in the trading interest of the city of London—the merchants whom ministerial writers attacked as selfish and fraudulent. The culmination of the crisis was the petition of the Corporation to the Commons, commemorated in *The Lord Mayors Speech and the City Petition about the Excise* [BMC 1926, Plate 14], which shows the meeting of the Common Council on 9 April. The petition was delivered to Westminster on 10 April, after a stately procession led by the sheriffs, aldermen, common councilmen, and merchants of the city, followed by a large concourse of people. The reduced majority of the Government in the vote to reject the petition swayed Walpole to drop the measure.[31]

The petition argued that the bill would 'prove extreemly detrimental to the Trade & Commerce of this great City, as well as to That of the whole Nation', that the burden of taxation was already great, and that the system of inland duties would be vexatious and oppressive. The economic aspects of the bill are not well presented in the prints. The depressed state of trade, expressed in the conventional image, is taken for granted. The complexities of the issue are passed over. Two of the designs in

side: 'O they'll Kill me, Mother!' She asks: 'What have my poor Children done to be starved?' This print is found in *The Butiad, or Political Register; Being a Supplement to the British Antidote to Caledonian Poison. Containing Forty-three of the most Humorous Political Prints* (London, 1763), No. 42.

[31] See Delafaye's letter, above, p. 153.

Plate 16 show a building in the background, possibly intended as a customs house or warehouse; a Tudor rose decorates its freize, to which are attached labels that read: 'cockets' and 'permits'. The former is a certification under the king's seal of a customs duty paid; the latter is an authorization required for excised commodities to leave a warehouse.

The prints concentrated, instead, on the simplest economic issue: the popular theme that excise would reduce the nation to a state of poverty and would deny the people the cheap enjoyment of tobacco and wine. *The Publican's Coat of Arms, Explain'd and Figur'd* [BMC 1920], a satiric piece employing the symbols of heraldry, displays in its field a reproduction of *Excise in Triumph*. A brewer replaces Walpole on the barrel; he holds in his hand a label: 'Gets by the Act 5000'. In the lower right corner of the field is a female gin-seller. A pewter mug forms part of the crest; it is marked: '3ᵈ1/2. Short Measure Pays House Rent.' The supporter at left is a landlady with a label in her pocket: 'Punch in small Quantities pays House-keeping.' A landlord who is the supporter at right, has pipes and packages of tobacco at his feet: 'Tobacco pays for Candles Pipes & Newspapers.' The print suggests that these entrepreneurs will themselves make a profit from the increased prices on the excised commodities.

The frontispiece to *The State Juggler: or, Sir Politick Ribband. A New Excise Opera* [BMC 1940][32] shows Britannia seated on a cask of wine, smoking a pipe 'Without Excise'. A rampant British lion at her right side also smokes 'the Best in Christendom'. Behind are a soldier and exciseman. The defeat of the bill meant that tobacco and wine were now relatively cheap and plentiful; this was the occasion for celebrations. *The London Merchants Triumphant (or Sturdy Beggars are Brave Fellows) being a Sketch of the Rejoyceings in the Citty &c. Occation'd by the Excize Bill being Postpon'd* [BMC 1927][33] commemorates the burning of Walpole

[32] *The State Juggler: Or, Sir Politik Ribband. A New Excise Opera* (London, 1733). 'N.B. With this Opera is given gratis, Britannia Excisa, in Two Parts; and the Excise Congress, with Three Emblematical Pictures, Printed on a large Sheet of Fine Paper, fit to be fram'd.' The frontispiece has little to do with the subject of the piece, which is a court and love intrigue, involving the major political figures of Government and Opposition.

[33] The verses of this broadside were popular; they appeared in the ballad opera, *The Sturdy Beggars*. The excise crisis was the occasion of several ballad operas attacking Walpole.

in effigy; in the design it takes place in front of the Royal Exchange. In the centre is a bonfire with a crowd of people—some intended to be merchants, other being shopkeepers with aprons, labourers with jackets and loose breeches. Four porters, one in tattered dress, carry Walpole's effigy to the fire. A few men in the crowd carry clubs. Some are smoking pipes. 'Wine & Tobacco for ever', 'Brave news for Virginia'. In the right foreground is a large cask of wine, its contents pouring from several holes, consumed by the celebrants.[34] A similar crowd appears in the lower design of *The Lord Mayors Speech*, dancing around the slain monster. Ships in the distance celebrate the victory of trade and navigation. A sailor joins the ring of dancing merchants in *The Noble Stand*. The figure of Plenty flies above. Grapes and tobacco leaves decorate the pole.

The names of Micajah Perry and Sir John Barnard also adorn the pole in the above print. They were the two London M.P.s who voted with the Opposition. The crowd in *The London Merchants Triumphant* raise toasts 'To my L.ᵈ Mayor', 'To Pulteney & Wyndham', 'Perry & Barnard for ever', and the usual 'Long Live K. George &c.'. The success of the parliamentary Opposition in aborting Walpole's scheme was followed and celebrated in the propaganda. While *Britannia Excisa. Part II* and the *Excise Congress* [Plate 16] heralded Opposition newspapers for their part in the defeat of excise, the prints also extolled the 'glorious 204'— the minority vote in the first division on the bill. *Britannia Excisa* provided 'An Exact List of those who Vote *for* Bringing in the Excise Bill' and 'An Exact List' of those who voted against it; the placemen voting with the Government were carefully noted:[35]

> Long, Long live the Glorious Two hundred and four;
> And may we such Senators have evermore,

[34] 'The City tryumphs [*sic*] on this Victory, the Windows are all illuminated, those which are not thus distinguished were broke by the Mob. Bonfires were made every where, and Walpole with his blue Ribband was carried in Effigie and at Temple Bar burnt in a Tobacco Hogshead. In short the City look'd from the River as if it had been on Fire from one End to the other. The Lord Mayor and all our Friends are full of Spirit, and partake of the general Joy at their Success against the Court.' A letter written in English under the pseudonym of 'Ravele' (probably Nathaniel Mist, then acting as an informant for Jacobites on the Continent) and dated 27 Apr. 1733, Boulogne. The letter is found in the Archives des Affaires Étrangères, Correspondance Politique d'Angleterre, vol. 380, f. 128.

[35] Such reports were still considered a violation of Parliamentary privilege.

Whom Places nor Pensions will never persuade
To give up our Juries, and Fetter our Trade. [BMC 1927.]

Prints and ballads celebrating the defeat of excise measured the
pulse of the Opposition's expectations for the coming election.
Pamphleteers hoped to make it the major issue. Though the bill
ceased to be a vital matter after 1734, popular literature kept
excise as an albatross around Walpole's neck for many years.
'And Standing Armies do the Brave controul/ And French Excises
crush the merchant's Soul' ran the charge against him in *The Fall
and Rise of the British Liberty* [Plate 44]. *Merlin, Or the British
Enchanter* [Plate 37], a pre-election print of 1740 or 1741,
reminded its viewers of the continued threat of excise. Years later,
in 1763, the Bute ministry's attempt to introduce an excise on
cider and perry revived all the ghosts of 1733 and inspired prints
and pamphlets whose substance was hardly distinguishable from
that of their predecessors.

2. *The Jew Bill*

Like the withdrawal of the Excise Bill the repeal of the
Naturalization Act of 1753 showed how popular opposition
outside Parliament could defeat a Government measure.[36] As in
1733 the propaganda that was disseminated buried the original
issue under a heap of wild distortions and charges. The purposes
of the Act were modest and well-intentioned: to allow foreign-
born Jews living in England to be naturalized by acts of Parlia-
ment, and without the sacramental test. They would obtain the
rights of British subjects (most important, greater rights in the
exchange and sale of property), though, of course, they would
remain—like the Dissenters—politically disabled. The bill passed
both Houses without considerable difficulty, but then was
immediately greeted outside Parliament by outcries and hostile
literature:

one would think from the Clamours, that have been raised, that the
Question was, Whether the Temple at *Jerusalem* was to be rebuilt;
Whether the *Jews* were to be re-established in their *own Land*, and
their Levitical Sacrifices and Ceremonials to be revived again . . . that
Great Britain is *Judea*,—That *London* is *Jerusalem*,—The Synagogue in
Duke's Place is Mount *Zion*,—and the Liberty granted to buy Lands and

[36] See Thomas W. Perry, *Public Opinion, Propaganda, and Politics in Eighteenth-
Century England: a Study of the Jew Bill of 1753* (Cambridge, Mass., 1962).

Merchandise is an Order to set up an Altar for offering burnt Sacrifices and Oblations.[37]

London, where most of the nation's 5,000 Jews lived, was the centre of the storm. The cry went out that the great metropolis was about to be besieged and then inundated by a flood of aliens. *A Prospect of the New Jerusalem* [BMC 3204] offers a distant prospect of the city and a column of Jews moving towards it, arms raised in greeting to the new promised land. *Vox Populi, Vox Dei, or the Jew Act Repealed* [Plate 71] shows another view of London, in the right background—'London Preserved'—dominated by the outline of St. Paul's standing as a symbol of the Christian church as well as the outstanding landmark of the city.

The City itself was divided on the issue. Certain of the most powerful and influential merchant and financial interests were in favour of the act; they believed it to be beneficial to the commerce of the city. Some members of the Corporation were also in favour. Sir William Calvert, M.P., who voted for the bill, was singled out for attack by the Opposition. *A Prospect of the New Jerusalem* shows him in his aldermanic robes, watching the Jews' entry with approval. He holds the 'Naturalization Bill' in his hand.

Other economic interests, led by the merchants engaged in the Portuguese and Spanish trade, opposed the measure and found strong support in the Common Council. Under its impetus the City Corporation presented a petition to Parliament, expressing apprehension that 'should the Bill be passed into a Law, the same will tend greatly to the Dishonour of the Christian Religion, endanger our excellent Constitution, and be highly prejudicial to the Interest and Trade of the Kingdom in general, and the said City in particular'.[38]

Pamphleteers in London forewarned the gentry that an influx of poor immigrants would crowd their parishes and overburden parish relief. Lesser merchants, shopkeepers, journeymen, and labourers were affrighted by the spectre of increased competition. Common to all was religious bigotry and nativism. Supporters of

[37] Josiah Tucker, *A Letter to a Friend Concerning Naturalizations: Shewing, I. What a Naturalization is not; II. What it is; III. What are the Motives for the present Clamours against the Bill passed last Sessions for enabling the Parliament to Naturalize such Jews, as they shall approve of*, etc. (London, 1753), p. 15.

[38] Quoted in *Considerations on the Bill to Permit Persons professing the Jewish Religion to be Naturalized by Parliament. In Several Letters from a Merchant in Town to his Friend in the Country* (London, 1753), p. 4.

naturalization like Tucker argued that the religious issue was wholly irrelevant, or at least paid lip-service to hopes for conversion and appealed to the virtues of Christian charity and toleration. In the hostile propaganda, especially of the most vulgar sort, the religious issue was fundamental. Jews were attacked as the original and principal enemies of Christianity, the murderers of Christ, the race accursed by God

> God's Word declares the Jews a Vagrant race,
> Till they their Messias [sic] Laws embrace;
> Therefore Deistical attempts are Vain,
> Still must they Wander Like that Murderer Cain,
>
>
>
> Consider this & to your Duty Turn,
> And Look on him whome you have pierc'd, & mourn,
> Go hear ye Deaf, & Look you Willfull Blind,
> And then you wilt a Happier Canaan find. [Plate 71.]

Prominent in the centre of *Vox Populi, Vox Dei, or the Jew Act Repealed*, and next to the view of London, is Calvary, with the cross atop it, 'Protected by the Eye of Providence' and by two angels, carrying the sword of vengeance and banner. In the divine balance at the right 'The Gospels' and 'Mag[na] Charta'— intended by the artist to represent the foundations of church and state—outweigh bribery money and the Naturalization Act. In the foreground is 'The Ark over set', 'Levitical Law', a broken 'Circumcision knife', and rabbinical vestments. Before Calvary is a 'Mob of Jews & Deists', who threaten the cross with swords and spears; they are led by 'S–n G–d–n' and Lᵈ B–l–k'— Sampson Gideon and Bolingbroke. Gideon was a leading Jewish financier in the City and an adviser to Henry Pelham. Bolingbroke, of course, was the most conspicuous advocate of natural religion.[39] Pamphleteers and preachers exploited the widely spread hatred of Deism and its popularity among the upper classes.[40] Those advocating toleration of the Jews were suspected of the new heresy. Orthodox divines maintained that the Jewish religion provided the Deists with the weapons of their assault on Christianity.

Opposition also turned on the bishops who, faithful to the

[39] An edition of his works that appeared in 1754 helped reduce his already declining reputation by revealing how extensive were his Deist convictions.

[40] See Plate 89 and above chap. v.

Government, had supported the bill in the House of Lords. They were hypocrites, Judases in lawn sleeves, who had sold the duties of their calling for money. The apple-cheeked bishop in *The Grand Conference or the Jew Predominant* [BMC 3203, Plate 72] piously expresses his guilt: 'We have done those things which we ought not to have done.' Lord Chancellor Hardwicke, at the right end of the table, assures him: 'Don't mind that my L—, the Right of presenting is invested in You & Your Brethren, it's so decreed.'[41]

The Circumcised Gentiles, or a Journey to Jerusalem [BMC 3205] shows a bishop and a Jew riding on an ass, presumably in the direction of London, since the dome of St. Paul's appears in the right background. The Jew says: 'Me am Naturalize and have Converted mine Broder dat is behind.' The bishop, with eyes turned to heaven, holds the 'Talmud' under his left arm; he confesses: 'We have err'd and stray'd from thy ways like lost Sheep.' The 'New Testament' lies discarded in the lower right part of the design. The inventor of *Vox Populi, Vox Dei*, etc., to bring discredit to these apostolic successors, treats the Methodists with a degree of sympathy. The bishop in the lower left has been bought with '£1000,' as his mitre indicates. George Whitfield and Charles Wesley accompany him. The latter says: 'Thou Mitred Infidel has Dignity made thee forget God.'

The Jewish stereotype in *The Circumcized Gentiles*, etc. is a good caricature; the model is taken after the poorer sort of Ashkenazi or North European Jew.[42] He wears a large slouch hat, simple jacket, shirt, and trousers. He has a prominent nose and short beard. The Jew in *Vox Populi*, etc. is similar, distinguished by his nose and beard, though he wears more conventional dress. The ethnic characteristics of the Jews in London, like those of all immigrants, were favourite butts of ridicule.[43]

[41] Hardwicke seems to be pointing at the Jew, opposite, or at Newcastle, but the sense of the bishop's remarks coincides best with his; the mention of presentment is a vague allusion to a key issue in the controversy. Contrary to many assertions, the Act took away the privilege of presentation to a benefice or ecclesiastical living, from Jews holding estates to which that privilege had formerly been attached.

[42] The Jew is an old subject of caricature in Western art. See James Parton, *Caricature and Other Comic Art in All Times and in Many Lands* (London, 1878), pp. 62–3.

[43] See M. Dorothy George, *London Life in the Eighteenth Century* (New York, 1964), pp. 125ff.; and Gerald B. Hertz, *British Imperialism in the Eighteenth Century* (London, 1908) chap. iii, pp. 60–109, '"No Jews; No Wooden Shoes." A Frenzy of 1753'.

Contemporaries still believed that the purity of Christian religion and culture was essential for the health of the civil polity. They drew horrible pictures of the deracination that would result if the Jews were let in. *The Jews Shaving the Par*l*m**t or the Christians Taken Inn* [PML iii.29.92, Plate 73] shows a group of men in a barber shop. One of the Jews says to the figure seated in the centre: 'Now Crucify Christ Again.' A Jew cleaning a wig at the right promises: 'I'll make a New Jerusalem.' Four Jews towards the left exclaim: 'Long live Solomon the Second'; 'Money Wise King of the Jews.' A rabbi says (perhaps to the figure in the chair—Newcastle?): 'I hope your Grace will Petition the King for a Temple.' Another Jew assures: 'Yes Any Thing for Money.' An Englishman waiting in a chair at the right says: 'They will Circumcise me Next.' This Jewish custom drew special ridicule. The Jew on the ass in *The Circumcized Gentiles* carries a box on which is written: 'Israel's Court Plaister for [ci]r Cum Wounds.' Another print, without title [BMC 3209], 'Publish'd for M^r Foreskin at the great pair of Breeches in the Parish of Westm^ter', takes the same subject to ridicule the Duke of Cumberland, in the vein of those notorious prints of the late 1740s. Cumberland stands spread-legged in the centre of the design, hands on his hips. A woman at his right shoulder warns: 'Can you bear circumcision youl have nothing left then', to which he replies: 'Whats that to me it cant do me much Harm.'

At the far right of this design is an open cashbox, filled with coins: a reminder of the nature of the Jew's power and influence. Pecuniary covetousness, like circumcision, was regarded as an ethnic characteristic and made it convenient for opponents of the Act to insinuate that bribery had secured its passage. A Jew in the above print, standing at the cashbox, asks an Englishman: 'Where's the *Bill*?' The Englishman responds: 'My Master wants the Money.' Two other Jews rejoice: 'We can buy Estates now' and 'Ah and have places to [sic].'

Defenders of the Act did not ignore the political implications of the clamour against it. A general election was near. The scattered and reduced array of Opposition were grasping at an opportune straw. Tucker spoke of the '*Jockeyings of Electioneering*, the Cabals of Party, and the secret Machinations of Disloyalty and Disaffection'.[44]

[44] *A Letter to a Friend*, p. 18.

Special ire was directed at the Pelhams, as those most responsible for the Act's passage. The two brothers appear in *A Prospect of the New Jerusalem*: standing on the height at the extreme left and looking down on London. *The Grand Conference*, etc. shows Pelham and Newcastle seated at the table. Pelham holds in his hand a bag of money, which has its way: 'The Prerequistes always prevailing.' Farthest left is the Jew—perhaps Gideon—carrying a list which purports to show how international Jewry has provided the funds for Jews to gain access to England. 'Dare Gentlemens & my very good Friends Dis be de Puss collected by our Tribe for de great Favour.'

> Borrow by Br–b–y and by V–e they pay,
> As Judas did from pelf betray our Lord,
> Grant Heav'n that they meet their just Reward!

Henry Pelham died in 1754 with the onus of the Jew Bill upon him. In *His Arrival at his Country Retirement & Reception* [BMC 3264], he is greeted in Hell by former ministers including Walpole who praises the attempt at naturalization as the blackest of achievements. Newcastle forced the repeal of the Act, in a less dignified retreat than the one Walpole made in 1733. The Government had bowed to pressure 'without doors'. Once more graphic satire was a manifestation of that benighted consciousness, always present in the shadows and recesses of the political arena: the same which had declared the riddance of Fleet marriages and the reform of the calendar to be heinous and perverse sacrilege.

3. *The Patriots' Wars*

The war which began in 1739 marked the end of twenty years' peace and the beginning of a conflict which extended, intermittently, through the middle decades of the eighteenth century. Foreign affairs occupied a major place in public discourse, dominating but also including the perennial issues of political corruption, finance, and constitutional matters. The task for Opposition dissent, which followed the currents of popular sentiment and usually espoused the cause of war, was to cavil with the objects and means of government's strategy and diplomacy. An Opposition alternative appeared: a 'patriots' programme, nurtured in the parliamentary debates preceding and following the

outbreak of war with Spain.[45] 'The strength of England is its
wealth and its trade: take care of them, you will always be
formidable: lose them, you are nothing, you are the last of
mankind.'[46] The patriots assumed that Britain, by providential
design, was an insular seafaring nation, relying on the oceans as
the buttress of her defence, and as the high road, through far-
flung trade, to prosperity and greatness. Spain and, behind her,
the greater power of France were her natural rivals in the struggle
for overseas trade and empire. They could be defeated, however,
if the nation put its trust and strength in its naval power: the
pillar of Britain's honour and prestige. Most fatal was any trust
in a large, standing army and continued entanglements and
imbroglios on the Continent, particularly those connected with
Hanover.

'You know the *English* Greatness depends on Liberty, Trade,
a large naval Force, Numbers of Inhabitants, a frugal Govern-
ment, and national Reputation, the Result of all the rest.'[47] Little
in the patriot strategy was actually new. Mercantilist preconcep-
tions, the glorification of trade and maritime supremacy had long
existed. It was an effective amalgam of popular ideas. The will-o'-
the-wisp of unlimited trade attracted the merchants. The preser-
vation of national honour and prestige, the denunciations of
costly subsidies and alliances perked up the ears of the landed
interest. The promise of a truly patriot war was the springboard
of Opposition for almost twenty years, until Pitt carried it
through, with certain compromises, in the Seven Years' War.

At the foundation of the patriot programme was a strong dose
of national self-righteousness and militant nationalism, embodied
in graphic satire by Britannia and the British lion. The verses of
the prints continually exude 'pooled self-esteem', in the same vein
as the new anthems, 'God Save the King!' and 'Rule, Britan-
nia!' This strident patriotism could be truculent and cruel.
Horace Walpole noted, without much exaggeration, that the
failure of the Carthagena expedition in 1741 would not be greeted
with tolerance and understanding: 'What bad blood it will set in

[45] After the foremost apostles of the new creed, the so-called 'patriot boys' of
Lord Cobham.

[46] A remark of George Lyttelton, one of the patriots: *Cobbett's Parliamentary
History of England, From the Norman Conquest, in 1066, to the Year 1803* (36 vols.,
London, 1806–20), x.1347.

[47] *Old Common Sense: or, The Englishman's Journal*, 17 Feb. 1739.

motion in England! You know there, that to tell the people it was an impossible thing, will be no argument with them.'[48] While a Vernon enjoyed uncritical adulation, a Byng was consigned to unredeemable infamy and disgrace. *The Contrast: or Britannias Distributive Justice, exemplified in the Rewards she assigns the Illustrious, Brave and Magnanimous General Blakeney, on her right Hand; and to the Inglorious Cowardly Admirable A–l B–g on her left* [BMC 3365][49] shows Britannia standing between the two men, with the island of Minorca in the background. She hands to Blakeney the riband and medal of the Garter ('The Christian Hero'). Byng, on the other hand, receives a halter and broken sword: 'these Emblems as a Reward for your Cowardice and Ignominy and Disgrace you have brought upon the British Flag'.

The maintenance of national honour was all-important in the conduct of foreign affairs. 'The *reputation* of kingdoms may be justly reckoned a matter of the greatest weight in the scale of government, and 'tis a self-evident truth, that the security of nations is encreased in proportion as they maintain their respect.'[50] The upholders of this cavalier attitude were quick to take offence and regarded the conflicts between nations as so many private duels, where insult demanded satisfaction, and injury recompense.

Satire liked to contrast the present shame of Britain (represented in a variety of insults and injuries to the noble Britannia and valiant lion) with a glorious past. The days of Cromwell were considered to be a particularly illustrious period in the nation's history. *The Naked Truth*, published in 1739, shows the obverse and reverse of a medal, with a bust portrait of the Protector on the former side. The reverse shows the seated figure of Britannia, profile right, with Cromwell kneeling in front of her, his head on her lap. His arse is exposed, inviting the kisses of two figures representing France and Spain.[51] 'But now, alas! things change their face:/ The C–d–l usurps *Noll's* Place;/ And on V–H– retorts

[48] Walpole to Mann, 19 July 1741; *Correspondence* xvii.93.

[49] Blakeney was in command of the British garrison at Fort St. George on Minorca; Byng's failure to lift the French seige of the island forced Blakeney's eventual surrender.

[50] *Letter to Her R–l H–s the P–s D–w–g–r of W— on the Approaching Peace. With a few Words concerning the Right Honourable the Earl of B—, and the General Talk of the World* (London, 1762), p. 16.

[51] See above, chap. iv.

the Farce,/ Bids *him* and *W*— kiss his *A*—.' *Oliver Cromwell's Ghost* [BMC 3340] is decorated with a bust of Cromwell and words of advice to the Newcastle ministry in 1756, concerning the ill-fated war. He urges renewed and aggressive action on the part of the navy, after the example of Blake. 'If the *Spirit of Cromwell* appear in our *Councils*, we have now *Blakes* ready to vindicate the Nation's Rights, humble the proudest of *England's* Enemies, and make the Name of *Briton* as universally formidable as ever was that of *Roman*.' To 'make the figure in *Europe* [as] we did in the days of *Cromwell*'[52] was the coveted goal: '*Britain* would then maintain her dignity, and not meanly cringe to every power. . . .'[53] Pusillanimity on her part must necessarily cause obstinacy and insolence on the part of her enemies.

This posture stood on a narrow line between righteousness and arrogance. The two extremes were sometimes confused. This was the case in the clamour for war with Spain. Spanish claims to the rights of protecting their trade were not only, according to one English pamphleteer, an insult to English understanding and an infringement of English rights, but also a sign of contempt for English power.[54]

The niceties of the disputes over the sanctions of past treaties and the extent of authority of the *guarda costas* were, for the most part, passed over in the prints. They reduced the complexities of the Anglo-Spanish conflict in the New World to a few emotional issues. 'Liberty' and 'no search' were the rallying cries, supported by exaggerated stories of English merchants and sailors, abused and made slaves of by the haughty Spaniard.[55] Much of the propaganda of 1738 concentrates on this alone. *Slavery* [Plate 24] shows a group of English traders and seamen, driven in bondage to work the plantations of New Spain. In the background a Spanish *guarda costa* attacks an English merchantman. On the promontory at the left Capt. Jenkins is relieved of his ear. Jenkins also appears in *In Place* [Plate 23], as he tries without success to call Walpole's attention to his misfortune.

[52] *The Counterpoise. Being Thoughts on a Militia and a Standing Army* (London, 1752), p. 28. [53] Ibid.

[54] [George Lyttelton], *Considerations upon the present State of our Affairs, at Home and Abroad. In a Letter to a Member of Parliament from a Friend in the Country* (London, 1739), p. 9.

[55] The propaganda is reminiscent of the atrocity stories which attended England's struggle with Spain in the sixteenth century.

The Great man easy sits in Borrow'd State,
Tho' Millions suffer by the Yoke of fate,
Values not Widows Cries or Orphans Tears,
Nor Depredations or the loss of Ears.

.

But Britons Boldly shew Imperious Spain,
What tis to rouze the Masters of the Main.

With all the protestations about justice and national honour the
advocates of war agreed that trade was the legitimate and profi-
table *casus belli.* 'Liberty & Trade' was the slogan that joined the
two issues. The merchant interest, quite naturally, was the
loudest in its complaints to the government. The prints frequently
alleged Walpole's neglect of the trading interest. As Don Diego
says to Walpole in *The Negotiators. Or, Don Diego Brought to
Reason*:

Merchants! ha! they were once *Sturdy Beggars*, I think,
And were I in your Place, I would let them all sink.
　　They oppos'd your *Excise*;
　　Thus: if you are Wise,
　　Reject their Petitions, be deaf to their Cries;
And let us like Brothers together agree,
You *Excise* them on *Land*, I'll *Excise* them at Sea.

In February of 1738 a merchants' petition was presented to the
Commons. *In Place* shows a dog chewing up 'Merchants Com-
plaint' while a courtier at the right pushes a merchant out of the
door. The prints show no great attention to the exact nature of
merchant complaints nor, save for a mention or two of Campechy
wood,[56] to that trade which was at issue. The all-important role
of the South Sea Company is ignored.

In popular attitude England's rush to war was not so much a
contest for trade nor extension of empire (though these were
included) as it was a maintenance of national honour. The public
saw the outbreak of war with Spain as the first step in an irrecon-
cilable conflict with France. Political folklore had changed little
from King William's or Queen Anne's day and still contained the
spectre of 'Universal Monarchy'. 'To humble *France* ought, I
think, to be the *ruling Passion* of every *Englishman*—Her Interest,

[56] In the second heat of the *European Race* Englishman are gathering 'Log Wood'
that has been cut in the 'Bay of Campechy'.

her Government, her Maxims, her every Thing, are incompatible with ours—In Short, *to humble France* ought to be the *delenda est Carthago* of an *Englishman. . . .'* [57]

France was regarded as Britain's natural enemy, first because of religion. Untutored and parochial minds continued to accept the religious demarcations of the Reformation as politically descriptive; England was the traditional head of the Protestant interest, and France the head of the Roman Catholic. In prints and pamphlets hatred of France and Rome were inextricably mixed. *The Glory of France* [Plate 62] recalls in a picture the St. Bartholomew's Day massacre. A Jesuit carries the fire of 'Persecution'. In *Britain's Rights maintained; or French Ambition dismantled*,[58] a print of 1755, behind a female representing the 'Genius of France' is a naked figure being burned at the stake. 'Ave Maria', the Genius says, 'que serons Nous; after our Massacres, and Persecutions, Must Hereticks possess this promis'd Land, which we so piously have call'd our Own!' The alliance with Prussia in 1756, because it represented a 'Protestant' union against the two great Catholic powers, France and Austria, made Frederick the Protestant hero. *Protestantism & Liberty, or the Overthrow of Popery & Tyranny* [BMC 3612], first published in 1746, was reissued to celebrate the alliance. Protestant emblems, including the Bible, the banner of St. George, a Lamb, and a bishop's mitre and crozier, appear above the left half of the design, balanced against the Popish emblems on the right: bell, book, and candle; 'Bulls' and 'Anathemas'; faggots, scourge, pincers, and knife.

France was also seen as Britain's natural enemy because of the former's oppressive and aggressive political system. French tyranny, whose marks were yokes and wooden shoes, went hand in hand with religious superstition and persecution. A courtier in chains kneels before King Louis in *The Glory of France*. Beneath the gallows at right, where Justice is to be hanged, another Frenchman, riding an ass and wearing wooden shoes, hails his royal master.

France, it was argued, still aimed at universal sway. In the upper left of *The Glory of France* is the broken obelisk of 'Europa'

[57] *Old England: or, The Constitutional Journal*, 15 Sept. 1744.

[58] 'Addrest to the Laudable Societys of Anti-Gallicans, The generous Promoters of British Arts & Manufactories. By their most Sincere Wellwisher and truly devoted Humble Servant A Lover of his Country.'

with a dejected personification of the same: made so by the ambitious designs of France:[59] 'this ambitious, perfidious, restless, bigoted, persecuting, plundering Power, which has long been the common Disturber of the western World, and as long struggled for Universal Monarchy.'[60] Cardinal Fleury in *The Scheme Disappointed* reaches for a globe in the sky; it has the mark of a fleur-de-lis. The star of universal monarchy has fallen, however, in *Britain's Rights maintain'd*: 'Universal Monarchy ha! ha! ha!'

Francophobia even extended to the importation of French goods, culture, and fashion: regarded as the vanguard of eventual subjection. *The Imports of Great Britain from France* shows a ship unloading at a quay along the Thames. Casks of 'Claret', 'Burgundy', and 'Champagne', boxes of perfume, jewellery, and millinery are visible. A group of individuals disembark from a French packet. One of them is the conventional French dancing-master, carrying his fiddle. Two French actors stand on the quay. An English lady presents her two children to their new tutor, 'a cringing French *Abbé*'. 'At a distant Landing, Swarms of Milliners, Taylors, Mantua-makers, Frisers, Tutoresses . . . disguis'd Jesuits . . . Valet de Chambres. . . .'—this influx posed a threat to English manufacture and the purity of English ways. Contempt for French culture, for the French ape in his bag-wig and solitaire, involved a paradox. 'They fear, and yet despise us: we are the nation they pay the greatest civilities to, and yet love the least: they condemn, and yet imitate us, they adopt our manners by taste, and blame them thro' policy.'[61] French fashion among the wealthy and ennobled was regarded by the middling and meaner sort as a mark of disloyalty. Courtiers and ministers were especially suspect. In *Birdlime for Bunglers, or the French way of Catching Fools* [BMC 3434] a Frenchman with chains, scourges, and wooden shoes tempts the members of the Newcastle ministry with money and with labels, reading: 'Cooks', 'Valets', 'Dancers', 'Fidlers', 'Wine'. The same ministers have put the nation to shame in *England Made Odious, Or the French Dressers*

[59] The medallion on the obelisk shows a monkey and cat's paw, an allusion to the old fable; France is the monkey and its tool, the cat, may be the Pretender or Spain.

[60] *The Progress of the French, In their Views of Universal Monarchy* (London, 1756), p. 2. [61] Le Blanc, i.27.

[BMC 3543] where they garb Britannia in a piece of French finery, decorated with fleurs-de-lis.[62]

The fear of French influence even extended to *chinoiserie*. *The Present Scene or the Pensive Monarch* [BMC 3337] shows a map-landscape of England and France, with the Pas-de-Calais in the centre. The French king sits at a table at the right, reflecting on recent French defeats. On the left two Englishmen with cudgels chase five individuals, dressed in the Chinese style, out of the land: 'Look ye if you don't go Quietly of [*sic*], we'll send you & your Master that Employ'd you to Dance to the Devil, & make a Devils Dance of it you French Dogs to impose on English Bucks & Bloods.' One of the figures in Chinese dress exclaims: 'Oh King Save us for the English have open'd their eyes & will not be Deluded.'

The prints, like many of the pamphlets, display a paranoid fascination with the secretive powers of French influence. A common assumption, perhaps inspired by memories of the intrigues of the Restoration, maintained that English ministers were in the pay of France, or at the very least, the dupes of French policy. '*Wicked Ministers in a foreign Interest, may be term'd the Arch Hereticks of all Civil Policy*, but they have their Marks.'[63] Numerous prints show an agent of the Grand Monarch surreptitiously handing a bag of 'French gold' to an English head of state.

[62] Hogarth's *The Invasion* and *The Gate of Calais. O the Roast Beef of Old England* employ the essential elements of this anti-French prejudice: the barbarity and obscurantism of France's religion, her political tyranny, poverty, and effeminate culture (especially its cuisine). *The Contrast* [Plate 99] was perhaps inspired by *The Invasion* sequence. The print compares, in two designs, the treatment of French prisoners in England and English prisoners in France. In the right design, a Frenchman—the stereotype figure—is treated to roast beef and beer. In the left design an English prisoner is waited on at 'Une Rotisserie' by a shabby Frenchman of much the same appearance. The fare is unattractive: frogs' legs and 'soupe maigre'.

This print was probably published in 1758. A scrap of paper beneath the English grenadier's elbow provides the clue: 'Le Moment qu'on a percu le Duc d'Aiguillon les Anglais S— Courir; Dans. . . .' The words allude to the abortive St. Malo expedition of 1758—see Basil Williams, *The Whig Supremacy, 1714–1760* (Oxford, 1962), p. 362. French forces were commanded by the Governor of Brittany, the Duc d'Aiguillon—see *Nouvelle Biographie Générale* (46 vols., Paris, 1853–6), i. 458—and the British forces by the Duke of Marlborough, who, in the hurry of retreat, left his silver spoons decorated with the Blenheim eagles (Horace Walpole to Horace Mann, 8 July 1758, *Correspondence*, xxi.221).

[63] *Old England: or, The Constitutional Journal*, 29 Dec. 1744.

Two kinds of Patriots wou'd their zeal approve,
These smit with real, those pretended love;
The venal Courtier, he whose counsel tends,
To views of selfish, & peculiar ends,
Wou'd lull the Goddess with false dreams of peace,
And paint as trivial every past disgrace;
Much he harangues, but leaves the cause untold
Why British arms are foild by Gallick Gold.[64]

The all-pervasive power of 'French artifice' and 'French gold' was the satirist's pedestrian way of explaining the skill and ability of French diplomacy.

Abroad, French influence was everywhere. Behind the stage of European affairs worked the machinations of French policy. For a time, in the 1730s and early 1740s, this influence was embodied in the diplomacy of the wily old Cardinal Fleury: 'a Man seemingly of slow Parts, and certainly no great Genius, but the most finished Hypocrite breathing, and one who was Master of the deepest Cunning'.[65] Fleury is the principal antagonist in the *European Race* series, which purports to show his varying degrees of success in extending French influence throughout Europe.[66]

It has been no small Mortification to me to find, that *France* hath carried the Vogue from all the World, both for Politicks and Dancing. . . . the present Cardinal *Fleuri* [*sic*] is a most excellent Dancer:—All the World acknowledges his Superiority in this Science, by allowing him (contrary to the Laws of Dancing) to lead up every Dance in *Europe*. . . .[67]

The C–rd–n–l Dancing-Master, or Pl–ce–m–n in Leading-Strings

[64] *Britannia's Revival, or the rousing of the British Lyon* [BMC 3377].

[65] *Considerations on the Politics of France, With regard to the Present critical Situation of Affairs, Wherein The following Proposition, viz. That the true Interest of Great Britain Must always consist in opposing the Designs and restraining the Influence of that ambitious Power, is from Facts, as well as Arguments, clearly demonstrated,* (London, 1744), p. 20.

[66] See Plates 20 and 29. *The European State Jockies* examines the supposed reversal in Fleury's schemes in 1740: mainly the result of British successes in the war with Spain. Fleury falls from his fox at the sight of the 'Baltic Sea' fleet (Britain's recently concluded treaty with Denmark), as the Spaniard loses control of his mount, frightened by an aroused British lion. Turkey has been defeated by Russia; the Netherlands have dropped from the race into neutrality. At the right the British lion prepares to fire on a Frenchman; at the left Fleury tries to entrap the smoke of 'Universal Monarchy' with his apron.

[67] *Common Sense: or, The Englishman's Journal* 6 Jan. 1739.

[Plate 40] shows Fleury directing Walpole in 'The Spanish Step' (i.e. truckling to Spain); he requests him to do the 'French Caper'. Gold coins and bag rest on a table in the back.

Walpole was attacked as the pensioner, the tool, the dupe of France. Britain's twenty-year alliance with that country was considered 'unnatural' and therefore devious. Walpole, the Opposition charged, was guilty of collusion. One pamphleteer asserted that as early as 1721, English foreign policy fell into the hands of men who were excessively fond of peace, ignorant of the national interest, and vulnerable to French duplicity and bribery.[68] French agents were about in England, twisting policies to the French interest. These vapid insinuations increased as the Spanish problem became greater. France, it was claimed, had fomented the trouble with Spain; it was to her best interest to prolong the war by preventing England's proper execution of it. *In Place* shows a Frenchman in the centre of the design offering his services as a mediator. The frontispiece to the first fable in *Three Belgic Fables; or, Hieroglyphic Ridles* [69] shows Walpole and Fleury; the former, requesting 'Peace, peace, peace', hands money to the Cardinal, who responds 'No Peace for the Wicked'. *The Lyon in Love* [Plate 22], of 1738, suggests that Walpole and Fleury are both working to disarm the British lion. The Devil, standing behind Walpole, points to a Spaniard who, in the shadows, hands a piece of paper ('All Safe') to Fleury, hiding behind the wall.

> Call Home Your Fleet, cries Artful *Spain*,
> And *Britain* shall no more complain.
> But should we be such Fools,—What then?
> We should be Slaves;—be drubb'd again.

After the outbreak of war the Opposition attributed the passivity and undistinguished conduct of the war to Fleury's influence. Critics moaned about '*Spithead Parades* and *mock Armaments*'.[70] The second design of *A Skit on Britain* displays the

[68] *French Influence upon English Counsels Demonstrated from an Impartial Examination of our Measures for Twenty Years past* (London, 1740), p. 20.

[69] *Three Belgic Fables: or, Hieroglyphic Ridles. Containing I. The Fable of the Crafty Statesman and Subtle Cardinal. II. The Passive Goose. III. The — Bull-dog and Tooth-Drawer* (London, 1729).

[70] *The Sense of the Nation: In Regard to the Late Motion in Parliament; In a Letter from a Freeholder to His Honour* (London, 1741), p. 17.

unsuccessful siege of Carthagena; the verses below complain:

> O' would some god but set her lions free
> From warlike peace, & martial pageantry;
> Uncoy'd, as once in Anna's glorious reign,
> They soon would break all Europe's threaten'd Chain,
> Tame proud Iberia, shake ye Gallick throne,
> Give freedom to the World, and keep her own.

The fourth design of the same print shows Walpole squatting and defecating on a map of England. Bags of money rest on the ground behind him, ready for his placemen to receive. Above, a fox's face (perhaps Fleury) leers its satisfaction. *The Evil Genius of England Represented in Several Scenes relating to the War* [BMC 2418, Plate 25] shows in a series of designs how the demon of Walpole has guided him to impair and eventually ruin England's conduct of the war. The central design, 'The Evil Genius and his Levee', shows the genius, a devil with harpy's claws and a bloated stomach, with a beard and mask, trampling on 'Liberty' and 'Trade'. He provides Walpole with money, who in turn disperses it among his minions. The rest of the designs, all with gargoyle-like representations of the genius at their bases, depict various stages of the war.[71] The top design, 'The Pacific Fleets', shows part of the coast of Spain, with Gibraltar, guarded by an English squadron that warns the approaching Spanish: 'Keep off or we must take you.' A Spanish column near 'Majorca' notices: 'These are Friends not foes.' The last design, at lower left, reveals the evil genius in all his malevolence: 'The Tables turn'd, or Spain gotten uppermost.' A map of the English coast and France appears. In the French part is a medallion likeness of Fleury, inscribed 'A Cardinal Wind', from which issues a stream of gold coins moving towards England and covering the fleet at

[71] The print attempts to imbue with sinister purpose and meaning the rather confused, inept, and mostly uneventful actions of 1739–40. The fourth scene celebrates Vernon's triumph at Portobello. The fifth scene is an interpretation of Haddock's decision to lift the blockade of Cadiz and move the fleet to the defence of Minorca. The sixth and seventh scenes concern movements in the Atlantic and the Channel. Norris, with secret orders, was stationed at Spithead. It was feared that the Spanish were arming a squadron at Ferrol, to aid the Pretender in a descent upon the British Isles. Norris may have been ordered to abort this possible expedition, but bad weather kept him in English waters. The French fleets, as the designs suggest, were giving *de facto* support to Spain and were free to move at will. See W. L. Clowes, *The Royal Navy: A History from the Earliest Times to the Present* (7 vols., Boston and London, 1897–1903), vol. iii.

Spithead. The French and Spanish fleets move at will; the genius has gained his end.

In prints such as the above much is made of the failure to employ British naval power as it should be used. Effective use of the navy was a cardinal doctrine of patriot strategy.

Our *Maritime Force* is undoubtedly our Chief Bulwark against *foreign Invasions*, and what hath given us so great a Weight and Influence over our Neighbours. It is *This* only, which raised us from a *little despised, inhospitable People* to a *great, polite* and *formidable State.* To *This* We are obliged for our *Trade,* our Riches . . . our valuable *Colonies* and *Plantations* abroad, as well as the *Dominion* and *Sovereignty* of those Seas, which surround us at Home.[72]

Sanguine estimates of British supremacy at sea were the heady wine which Opposition pamphleteers liked to offer to their readers. So it was with the prints. *The Grand Monarque in a Fright* [Plate 76], a print of 1755, proclaims the Royal Navy to be 'the Bulwark of Britain, and Terror of France'. The British fleet is under sail in the background. The French king, filled with terror by an aroused British lion, stands in the foreground. Britannia encourages the lion as Newcastle tries to restrain him. *The Gallic Cock and English Lyon or A Touch of the Times* [Plate 26] is similar. The British fleet rests in the background, while the French cock attacks the British lion who is unable yet to respond:

> The *Gallic Cock* no way can find
> To beat the Lyon, but to blind:
> No other Boon the Lyon begs,
> But leave to tear him all to rags.
>
>
>
> Then let Britania's [*sic*] Fleets advance
> To curb the Insolence of France;
> For Vengeance arm, and bravely dare
> In Thunder to proclaim the War.

To extol Britain's naval power was always a useful tactic, since the senior service enjoyed a special affection and popularity over the army.[73] 'Jack-Tar' is the stereotype of the British sailor; he

[72] *Craftsman,* 21 June 1729.

[73] Lord Fisher, writing in 1912: 'ever since Cromwell it has always been "*The People's Navy*" and "*the Court Army*".' *Fear God and Dread Nought: the Correspondence of Admiral of the Fleet Lord Fisher of Kilverstone.* ed. Alfred J. Marder (3 vols.; Cambridge, Mass. and London, 1952–9), ii.461.

appears in the prints with a dark jacket, shirt, kerchief, and
trousers, often barefoot, and usually with a brimmed hat.[74] He
always presents a more sympathetic and human figure than the
imposing grenadier. The sailor, too, could be august, as he is in
The British Hercules [BMC 2332], a print of 1738, in which the
mythological hero stands on the shore at Spithead: the personifi-
cation of heroic virtue. He wears the dress of a sailor; his arm
rests on an anchor, and on the ground are his attributes: a lion's
skin and knotted club. This print conveys the idea of idleness and
neglect. Hercules holds in his hand a paper: 'I wait for Orders.'

The popularity of William Pitt in part depended upon the
aggressive and effective use he made of British sea-power. He was,
in the prints, the champion and hero of the jack-tars.[75]

> Go, *Mars*, inspire
> *Americans* with manly Fire:
> I'll teach the *British* Fleet to reign
> Triumphant o'er the watry Main.[76]

is an imperfect expression of Pitt's strategy, more so of patriot
sentiment, for Mars, as representative of military might on land,
was to occupy himself in America, while British effort would
concentrate itself in Neptune's domain: the sea. Standing armies
and any large military involvement on the Continent were, to the
patriot strategy, accursed. *Old Time's advice to Britannia or
English Reflections on G–m–n Connections* [BMC 3826], a print
of 1761 or 1762, is a typical expression of this prejudice. A large
map, showing the coasts of England and Germany, fills the scene.
Within the boundaries of the former is Britannia. The Marquess
of Granby[77] stands in Germany. He complains to Britannia about
the German troops in English pay: 'I find these Leeches are
Sucking the blood and brains of my Country men, and while they

[74] British sailors can be seen in Plates 45 and 65. [75] Below, chap. viii.

[76] *The Assembly of the Gods* [PML iii.59.130]. A corollary of the idea of a naval
war with France was, of course, the seizure of French trade and territory in the New
World. Realization of the importance of the contest for North America (or India,
for that matter) is almost completely absent from print and pamphlet literature until
the early 1750s, when territorial disagreements in America precipitated the
renewed conflict. Save for vague dreams of expanded trade, naval expeditions into
the Caribbean (the importance of the sugar islands), the retention of Cape Breton
and the Newfoundland fisheries, British public opinion cared little for the American
problem.

[77] John Manners, Marquess of Granby, commander of the British forces in
Germany, in the army of Prince Ferdinand.

are regularly paid, will take care to prolong the War.' German soldiers, showing contempt for English folly, stand behind him. Next to Britannia rest the emblems of trade. She requests Granby to return 'to your native Country, nor longer be the Dupe of mercenary A[llie]s'. Pitt, beside her, protests at these Continental connections. A British sailor, waving a cudgel, exclaims: 'By the Strength of our Navy, we'll soon make them Slaves. Then Huzza Britania Britania rule the Waves.' The figure of Time counsels Britannia to cease wasting her blood and treasure in the defence of rights not her own.

The debate about Britain's proper role on the Continent in a war with France began in the early 1740s.[78] The 'Continental' school, traditionally identified with Whig diplomacy, adhered to the strategy of William's and Anne's wars: the construction of a grand alliance against France, with the vigorous intervention of troops and subsidies. The Continentalists argued that it was visionary and impractical for Britain to turn her back on Europe. Her Continental trade was vital and the Channel too narrow for Britain to allow a possible French hegemony.

The patriots of the 'maritime' or 'blue-water' school embraced more popular (if not more practical) ideas. War at sea was to be preferred over a Continental one because the latter meant a large army and/or extravagant subsidies: 'for we have had Experience enough of Continental measures to be assured, that they cannot answer any salutary Purpose of this Country'.[79] A naval war, it was supposed, would be cheaper and the fruits of victory (French trade) more rewarding. The entire patriot scheme appealed to a deep-seated xenophobia and isolationism. 'Surrounded by the *Seas*, and having nothing to acquire, or defend upon the *Continent*, it cannot be our Prudence to mix with any of its Interests.'[80]

The reading public was not ignorant of European affairs.

[78] See Richard Pares, 'American versus Continental Warfare, 1739–63', *English Historical Review*, li (July 1936), 429–65.

[79] *The Necessity of a War, and of Confining it to a Naval War* (London, 1755), p. 12; the author also criticizes the hiring of mercenary troops: '. . . might not the People of *England* murmur to see their Strength diverted from a favourite Service which has always been the Terror of *France*, to a Service from which we have never yet been able to reap any National Advantage', p. 18.

[80] *The British Sleepers; or, the Sons of Britannia Sleeping, While She, in a Discourse in three Parts, laments the Ruin which, without a Change in their Conduct, must be inevitable* (London, 1749), Part II, p. 10.

Newspapers and pamphlets show much knowledge and interest in the twists and turns of diplomacy. The prints delighted in depicting, though usually in a superficial way, the jockeying of the European states, represented by their monarchs. The national stereotypes never change: few are portrayed sympathetically. Maria Theresa, a sentimental heroine in 1741, becomes the bigoted, termagant queen of 1762.[81] Frederick of Prussia, the juvenile and selfish martinet of the early 1740s, became the Protestant hero. Britain's interest remained the only constant. She appears, especially in extremity, a sheep among wolves; even her allies cannot be trusted. *The Auction* [Plate 85], a commentary on the dismal turn of events of 1756, shows the several states of Europe vying for 'John Bull's' goods. The selfish, unprincipled Dutchman—'Nick Frog' in the above print—was particularly despised. The Dutch alliance had been the linch-pin of the old system, and was now useless. The prints reflect a disenchantment with the Netherlands. *The Contrast 1749* [BMC 3028] shows how the fat and affluent Dutchman has gained more profit from his neutrality than the Englishman from honouring his commitments.

If Britain had no interests of her own on the Continent, any interventions on her part must be foolish, quixotic 'knight errantry'. 'Balance of power' meant nothing to the isolationists.[82] At best it was the subterfuge for a policy of securing the King's German dominions. Hanover was more an object of ill-directed prejudice and hatred than a serious issue, at most a convenient focus for the anti-Continental position. The heated controversy over Hanoverian connections was almost entirely limited in prints and pamphlets to 1743, the year of the Treaty of Worms and the government's decision to retain 16,000 German troops in British pay.

The H–r Bubble, with the usual reminders of the Act of Settlement, suggests that lotteries, new votes of credit, and raids on the

[81] *The Present State of Europe: A Political Farce, of four Acts. . . Act II* [BMC 3821] shows the Emperor and Empress-Queen in a tent, the former sleeping. Maria Theresa sneaks away from the bed with her husband's breeches: 'He may Sleep now for I will Govern.' The Devil, standing nearby, says: 'By her Ambition my Dominions will be Peopl'd First.'

[82] Oddly, the phrase, so easily adaptable to graphic representation, was rarely employed by the satirists; the idea does appear in *The European State Jockies* [Plate 29], where the Imperial cause has outweighed that of Fleury and France.

sinking fund would be required to subsidize the mercenaries.[83] One of the illustrations to *A List of Foreign Soldiers in Daily Pay for England* [Plate 52] shows a bloated Hanoverian horse with the legs of a cockatrice or harpy. It also holds a mask (perhaps with the face of George II or Carteret) and receives a purse of money. The horse, not surprisingly, stands on 'Liberty' and 'Trade': the original and only legitimate reasons for which Britain went to war. A statistical table beneath this design purports to show the scale of payment to foreign troops, according to rank and kind (the Hanoverians receive the most). And beneath this is the smaller design, showing the German nurse feeding the baby, Britannia, 'Bon pore Nicole'.[84] The most emotional aspect of the anti-Hanoverian furore of 1743 was the imagined neglect and mistreatment of British soldiers in the Pragmatic Army during the campaign that culminated in the battle of Dettingen. Prints helped spread the story of George II's preference for the yellow riband at the battle and the rumours about the cowardliness and inactivity of the Hanoverian troops there. One, *The Confectioner General Setting forth the H–n Desert* [BMC 2583],[85] shows Carteret viewing the battle from his carriage: 'God be praised a great Victory.' George II, in the familiar profile, bug-eyed, thin-lipped, with a high, straight nose, stands upon the discarded riband of the Garter ('Poor E–g–d'). The massive figure of General Ilten stands at the King's shoulder; he wears a riband with 'H–n–r for ever' on it. And he observes: 'I must preserve the K–gs Troops.' Hanoverian troops ('The Tribe of Benjamin') sit idly on the ground, as English cavalry engage the French in the distance.

Carteret was roundly attacked in England as the overseer and guardian of the King's German interests. He was the perfect statesman of the Continental school, trying—almost with success—to encircle and entrap France with an elaborate web of alliances and subsidies. *Old England: Or, The Constitutional Journal* [Plate

[83] Mention is made of the Danes, Austrians, and Hessians in British pay, as well as the Hanoverians.

[84] The phrase is supposed to have originated in a story of a Frenchman who, in Hanover during the campaign, was unable to find eatable bread; the best he could find he gave to his horse: 'Bon pour Nicole.'

[85] A more subtle commentary on the inactivity of the Hanoverians is Bickham's *A Plan of the Battle of Dittengen, the River Mayne, and Places Adjacent* [PML ii.55.173] which shows the placement of the German troops, far removed from the battle.

50] assails him as the author of the Pragmatic Army, a showpiece of fruitless inactivity in the Low Countries and along the Rhine. The designer has placed the British troops in the rag-tail of the kite: the lowliest position, most susceptible to 'The Sport of Winds'. The meaning of the project, as the letter-press below explains, is really a 'Kite let fly to amuse that Spirit [i.e. the King] abroad'.

The vulnerable point in the case of those who would turn the nation's back on the Continent was the threat of French invasion: a more than possible one in 1744, 1756, and 1759. Every invasion scare set the nerves of public credit atwitter.[86] England's south-east coast was vulnerable; under favourable conditions, many thought, flat-bottomed boats could easily cross the Channel. *The French King's Scheme for an Invasion* [PML iii.39.130], published in 1756, has an inventive design, employing a caricature of King Louis's face to approximate the French coastline along the Channel. Dunkirk and Boulogne are marked. A line of flatboats, filled with men and munitions, stretches along the coast: 'Whither wilt thou.' Two ships at sea represent the British fleet; they are labelled 'Hawk' and 'Anson'.

The menace of invasion could be met, the patriots argued, by relying on that ancient and constitutional institution, the militia: 'the natural Strength of this Nation, as long as we preserve our Liberties, must always consist in the Number of our Seamen and Ships of War, and the good Discipline of our *Militia.*'[87] Revived and given new shape after the Restoration the militia had in subsequent years fallen into abeyance. War with France in 1744 and the Jacobite uprising renewed an interest in reform of the militia, as the popular alternative to a standing army of hired mercenaries. The Government resorted to the last alternative in 1745, and more conspicuously in 1756—to the delight of Opposition propagandists. Prints attacking the hated mercenaries abound in 1756. Their prevalent theme is the insult to national pride and the waste of national expenditure that such a policy entailed.

[86] Pitt, according to Horace Walpole, described in a speech of 1756 the consequences of a French invasion reaching London: '. . . a flagitious rabble, ready for every nefarious action: of the consternation that would spread through the City, when the noble, artificial, yet vulnerable fabric of public credit should crumble in their hands!' *Memoirs of the Reign of King George the Second* (3 vols., London, 1846), ii.87.

[87] *French Influence upon English Counsels Demonstrated*, p. 48.

The 2H,H,'s shows a monument in the middle of its design. Two German soldiers, with a large bag of money, guard the monument. Chained to the pedestal are two English soldiers (perhaps militiamen), one with his musket blocked by a fleur-de-lis. 'Oh! Shame to Nature, Shame to Common Sence [*sic*],' read the verses below, 'Must Britain for its own Defence,/ Depend on Champions not her own.' In *Britannia's Pocket Pick'd by Mercenaries* [LWL][88] German soldiers reach for Britannia's dress, in an apparent attempt to violate her. *Hengist & Horsa* [BMC 3346] shows her being assailed by a Hessian and a Hanoverian. She exclaims: 'These Foreign Friends will bleed me to death Oh! my Country.' Newcastle, Fox, and Hardwicke, viewing the assault, wish they could quiet her.

The designers of the prints liked to decorate these mercenary soldiers with long, handle-bar moustaches (always the mark of the German) and martial regalia. They also ridiculed their supposed accent. 'Put is tere war is Petter as to Blum Boodden & de peer', says the Hessian in *The 2H,H,'s*. The sentiment in all of these prints is highly xenophobic. *The Flat Bottom Boat or Woe to England, 1759* [BMC 3703] is rather indiscriminate in its contempt for foreigners. The boat occupies the foreground of the design. Newcastle sits at the rudder and promises his fellow passengers: 'I'll Land you in Sussex I hate a Militia.' With him in the boat is a Spaniard, a Scot ('I am only a French Tool'— perhaps the Pretender), a Dutchman, a Catholic monk, and several Frenchmen, one of whom says: 'I don't like to face the English Bull Dogs.'

The graphic satirists cared little for the practical issues involved in militia reform. *Forty Six and Fifty Six* with two designs, one showing George II and Cumberland reviewing English volunteers in 1745, the other showing the Newcastle ministry in a view of mercenary troops, conveys the erroneous impression that the militia had rendered valuable service during the Forty-five.[89] *The English Lion Dismember'd* [BMC 3547, Plate 90], however, does contain passing allusions to one specific problem of militia reform.

[88] Part of a series which includes Plates 91 and 92.

[89] What militia there was in 1745 consisted of volunteer associations at a local level and regiments organized by the nobility; the best authority on the subject is J. R. Western, *The English Militia in the Eighteenth Century: The Story of a Political Issue, 1660–1802* (London, 1965).

The design is an efficient and succinct expression of the military situation in 1756. The British lion stands in the centre. His right forepaw, labelled 'Minorca', has just been severed. Two Frenchmen prepare to remove his other limbs. The Lord Mayor and representatives of the City of London enter from the right, making enquiry about the loss of Minorca. An Admiralty court at the left deliberates on the fate of Byng. In the background a group of English yeomen, carrying forks and rakes, are at odds with a group of Hanoverian soldiers.[90] One of the farmers complains: 'We want none of your blood, was it not for Hares & Partridges we could defend ourselves.' The game laws had greatly reduced the general use of firearms and were popularly considered to be a mark of selfishness on the part of the nobility and gentry, even a sinister measure of the court to secure the presence of a standing army 'Our Enemies have Guns, Our Arms are only Rakes and Flails. The Gentry are more concern'd to preserve the Game then [sic] their Country.'

Mercenaries in lieu of a militia, entanglements in the cause of Hanover, idleness of the Navy, and the varieties of French influence and ministerial treachery—all were parts in the mechanics of failure in the nation's wartime strategy. To these must be added the distrusted institution of treaty-making. It was traditional to view the complicated and usually secret process of diplomatic negotiations—still much the preserve of the royal prerogative—with jaundiced eye. Treaties, like alliances, were made to be broken. Impatient merchants and country gentlemen saw in the collection of treaties, alliances, and conventions that had been accumulating over many years little that had promoted England's true interest. Paper agreements, as the fifth design of *Robin's Reign* [Plate 9] suggests, were nothing against military strength. Treaties that ended major wars became special victims of popular virulence; they were, by nature, 'give-aways' and 'sell-outs'. Again, the past came to haunt the present. The Treaty of Utrecht was the symbol of ignominy in the political folklore. Polemicists, inclined to historical comparison and affinities, likened subsequent treaties to Utrecht's shame. 'Utrecht' appears occasionally

[90] The preponderance of German troops were stationed near the south-east coast, especially in Kent. A scattering of incidents involving the local inhabitants caused great outcry and the usual complaints about immunity from English law; Hardwicke says of Britannia in *Hengist & Horsa*: 'If they kill her thier [sic] own people shall try 'em.'

on scraps of paper in the prints attacking the Peace of Aix-la-Chapelle and Paris.

Utrecht offered a prime example of French dexterity in negotiations. England produced great warriors, France, great negotiators (e.g. 'Mons^r Le Politiciene' in *Britain's Rights maintain'd*). What France lost on the battlefield she usually regained at the peace table, by means of cunning, artifice, treachery, and bribery. *The Congress of the Brutes* [Plate 64] [91] implies the French domination at Aix-la-Chapelle by placing the French cock at the head of the table. It sits high on its chair as it crows the success of 'The Definitive Treaty' it holds in its talons.

The secrecy of negotiations aroused the chronic fears of French influence. *Mon^r Bussy^s secret embassy discovered* [BMC 3810] has Bussy, the French emissary sent to London in 1761 to find a basis for negotiations, entering a room where Newcastle and Fox, both decorated with fleurs-de-lis, receive him. Fox holds a bag of gold: 'I like a French Goose when they lay Golden eggs.' The print concludes with this admonition: 'N.B.: if any Frenchman or Frenchified Englishman shou'd be offended or made sick by the above print let him repair to the Author (or quit the Kingdom) & he shall be cur'd Gratis with a few shakes of heart of Oak mixt with a Sufficient quantity of Balsam of Liberty.' The same ideas appear in the companion to the above print, *Mon^r Bussys politics or Goody Mahon outwitted* [BMC 3813],[92] which displays a room interior with two pictures on the wall. One of the pictures shows a fool's cap and the other, a coiled serpent with a fleur-de-lis in its mouth. Newcastle and Bussy sit at a table. Newcastle professes England's inability to carry on the war, 'for all what Pitt says, or the Bosts [sic] of the great City of London'. Bussy claims the same condition is true in France. An Englishman, watching at the door, expressed his astonishment: 'is that wretch fitt to take the rudder in hand, a fool to let this french Ape sift his Numbscull.' In *Scotch Paradice a View of the Bute[eye]full Garden of Edenborough* [Plate 118] a Frenchman in the tree of temptation helps Bute distribute the 'golden Pippins' to gain the peace.

A popular myth in the criticisms of peace settlements was the idea that the enemy was on its last legs, that it could not carry on another year, and that peace would provide the almost defeated

[91] Scattered on the table and floor are various treaties, including that of Utrecht.
[92] Both prints are probably by Darly.

with a respite, in order to fight again. *The Peace Offering* [LWL, Plate 66] of 1749, a general attack on Aix-la-Chapelle, concludes with 'An Abstract of a Letter from the Q— of H—' (Maria Theresa), in which she complains of an English betrayal: 'Ye Gods! is it Possible all these the Brave E— who so lately profess'd 'emselves, in such Strong Terms to be my Friends! Curse on their mean Spirit, Had they continued the War but one Year longer, they might have obtain'd what Conditions they Pleas'd . .'. *The Politicians* [BMC 4018], a general attack on Bute, shows a large group of individuals standing in a London street, discussing among other things, the new peace. One says: 'Surely this *Peace* was a Master Piece.' Another asks: 'How long d'ye think it will last?' Another answers: 'Why til our Enemies are in a Condition to declare War again.' 'The French only want to recover Breath.' The moral of *The Caledonian Pacification* [BMC 3902, Plate 109] is:

> Yet tho' from Peace declining States revive,
> The Dupes of hasty Treaties never thrive:
> To make it sure, be its Foundation fast;
> A Peace in Haste concluded cannot last.

Aix-la-Chapelle and Paris, like Utrecht, showed how defeat had been snatched from the jaws of victory. The most unpopular provision of the former treaty was that which provided for Lords Cathcart and Sussex to remain as French hostages, until the return of Cape Breton by England. This insult to national honour is the theme of *Tempora mutantur, et Nos mutamur in illis* [Plate 65]. *The Contrast 1749* maintains that English trade has profited nothing from the war, but fails to explain why. More informed is *The Peace Offering*, mentioned above, which shows the French king seated in ceremonial attire, his foot resting on the head of a defunct British lion. Cathcart and Sussex are led by the nose before the King. In the background is a delapidated fortification and town: 'A dis mantled Town to be deliver'd up in Exch. for C–B—.'[93] Britannia, with broken lance, sits at the lower right. Three Englishmen behind her are talking; one says: 'by G–d this is an H–r T–y,' echoing the old assertion that England's colonial and mercantile expansion were being sacrificed in favour of

[93] Probably Dunkirk, though perhaps one of the towns captured by the French in Germany.

Hanoverian interests.[94] Another Englishman, perhaps a merchant, makes allusion to the real failure of Aix-la-Chapelle: 'not a word concerning ye 95,000 £ due to us, or ye Security of our Trade for ye future.' Failure to settle the original dispute with Spain was a major weakness in the treaty.

The Treaty of Paris caused an even bigger stir, for added to it were the currents of anti-Scottish prejudice, the popularity of Pitt, and exhilaration in the great success of the war. Graphic satire, true to form, indulged in silly exaggerations of British concessions in the preliminaries. *The Political Brokers or an Auction à la mode de Paris* [BMC 3892] is a print with two designs; at left is a room interior with Bedford, Bute, Mansfield, and Fox discussing Bedford's departure to Paris for the negotiations. Bute says: 'I think then we are all aggreed therefore we will send one over to sign the Pr–l–m–s.' Mansfield, in judicial robes, adds: 'I will prove them just by Act 13 Regn Ann—Article Utrecht.' Another minister adds: 'These are the Conditions:—All Hesse Hanover & Canada only requires the three kingdoms in return.' At right Bedford presides over the auction of English properties in Paris. In *The Caledonian Pacification* [Plate 109] the King of France is made to state equally ridiculous terms: 'We will have for de presant, only Canada, & Martinique, & Guadelupe, Senegal, & Goree, & Newfoundland, & Pondicherry; You shall have all Hanover, & votever else be dear to Great B–n.' Bedford, the headless figure in the centre, returns with the 'Pr–l–m–n–s'. He, like Sandwich before him in 1748 (the figure stabbing the British lion in *Tempora mutantur*), was mocked and ridiculed.

Canada versus the West Indies was the principal bone of contention in the public discussion of the peace settlement of 1762–3. A consensus of opinion (influenced by the trading interests) favoured the retention of the French sugar islands instead of Canada. The latter, it was argued, had not been an original object of the war and would not indemnify the war's expense. Its economic value seemed meagre in comparison to that of Guadaloupe and Martinique. The prints barely touch upon this issue. *The Congress; or, a Device to lower the Land-Tax* [BMC 3887][95]

[94] Plates 65 and 70 show the Hanoverian horse appropriately licking up the blood of the British lion and Britannia respectively.

[95] The pamphleteer supporters of the government appealed to the landed interest by explaining Bute's desires for economy and an end to the war.

shows Bute handing to a Frenchman 'Guadaloupe Martinico &c &c &c &c &c.' The Frenchman responds: 'Dere is Canada & N.F. Land, Now Tank de grand Monarque for his royale bountie.' At Bute's foot is a piece of paper that reads 'Barren Canada' and 'Part of Newfoundland'. Newfoundland became a major issue, as a result of its loss to the French in 1762 and because of the importance of the Newfoundland fisheries. *The D–kes Exchanged or the Sc–h Hobby Horse* [BMC 4001] depicts the exchange of negotiators of the treaty, Bedford and Nivernois, both riding on hobby-horses that hang on a wooden structure, with the Channel below it. Two pieces of paper dangle from Bedford's pocket: 'Wolfs Monuments defaced' and 'Conquests restored'. From Nivernois' pockets hang 'utrecht's Definitive Treaty', 'Congress of Sc–h', and 'Right of fishery to fra—'.

Above the warehouse-door in the background of *The Evacuations. or An Emetic for Old England Glorys* [Plate 112] is a sign that reads: 'Fine Cod & From Newfoundland sold here by Louis Baboon.' In the foreground Bute, Fox, and a third figure (Tobias Smollett or perhaps Bedford), standing on the shield of the City of London and the Cap of Liberty, force Britannia to relinquish England's conquests overseas, into a basin held by an apish Frenchman. The City's opposition to the peace settlement and to Bute is especially important in the prints of 1762.

A minor consequence of the Treaty, given much attention in the prints, was the plight of discharged sailors and soldiers—another indication of graphic satire's taste for plebian causes. In the right design of *France and England or a prospect of Peace* [BMC 4002] is a gibbet and its victim; a Scottish executioner presides on a ladder to the left, as an Englishman below laments: 'This is always the Consequence of peace in England we neglect those in Peace that were our Bulwarks in War.' A sailor, meanwhile, robs him: 'I may as well Risk hanging for Something as I have being Shott for nothing and I cannot starve.'[96]

Graphic satire showed little concern that the Government had deserted Prussia in its settlement with France. To this extent the prints were loyal to the old patriot programme; they were preoccupied with the return of colonial conquests and showed a disregard for the results of the Treaty of Paris on the Continent.

[96] Similarly, the sailor in *Tempora mutantur*, etc. complains: 'Pray Your Honour—Pitty a Poor Disbanded Seaman'.

The irony, however, of Pitt and his Opposition supporters demanding fidelity to European connections was not missed by Bute's pamphleteers, who gleefully pointed out how Pitt had betrayed his patriot past. There was some irony in Bute's attempt at a 'patriot war' during his last year of office: his concentration on naval action in the West Indies and his desire for a reduction in Continental subsidies and ties. This irony is certainly missed on the prints and is testimony to a degree of waywardness in their logic and attitude. But it is perhaps as true to say that the adherence of graphic satire to certain basic convictions and prejudices from political folklore proved it to be more consistent than the behaviour of men or the specifics of programme.

Equally important, the prints, like the 'country party' and the City of London, were invariably in Opposition. They followed the Opposition's lead and shared the Opposition's inconsistencies.

CHAPTER VII

The Statesman's Progress

'If Impeachments at *Westminster*, like the Gibbets and Fires at *West-Smithfield* in former Times, are to be the Doom of Statesmen . . . what Road shall the publick Servants of this Nation take to be safe?'[1] The harrying of ministers was the earnest business of parliamentary oppositions before the Hanoverian Succession and a major cause of the chronic political instability of the period. Impeachment served as a favourite weapon. For some unfortunate victims, like Clarendon, Danby, Somers, Halifax, and—at the beginning of the new dynasty—Oxford and Bolingbroke, imprisonment or exile was a likely fate. These were real dangers for all those who wished to brave the perils of office and responsibility.

The growth of responsible government gradually replaced impeachment with censure, which in turn eventually gave way to mere disrepute and the loss of office. The pursuit of fallen ministers with the rigours of the law ceased to be useful or practical. Minister-baiting in its most virulent forms remained, however, popular sport throughout the eighteenth century. The images of axes, halters, and gibbets—portents of the fate befitting all evil governors—continued as part of the political folklore: vestiges of a more violent age and an old mentality that died hard.

1. The 'Great Man'

More abuse probably fell upon Sir Robert Walpole than upon any other English minister in the eighteenth century. First among causes was the completeness and longevity of Walpole's political success. Already a figure of controversy after his resolution of the Bubble crisis, Walpole achieved the primary place in the King's councils by 1724 and after 1729 he stood alone in power. He was

[1] *Observations on the Conduct of Great-Britain, in Respect to Foreign Affairs. In which All the Objections that have been thrown out in some late Pamphlets and Discourses are fairly answered, and the Measures of the Present Ministry fully Vindicated* (London, 1742), p. 47.

the 'first minister' *par excellence*. 'Prime' or 'first' minister was still a term of disapprobation. The popular imagination, always tardy in its recognition of constitutional changes, regarded first ministers, along with favourites, as evils of the worst sort. Walpole, with his apparently unshakeable power, seemed the exemplar.

The *Craftsman* played a major role in building a corpus of literature and a form of satire dedicated to a single theme: the rise and fall of criminal ministers.[2] Inspired by this journal's lead, writers of the Opposition press combed the history books, discovering parallel cases of evil ministers, overgrown in power, who met a tragic end. The satirists delighted in uncovering the most obscure similarities: anything that could be construed as an allusion to Walpole's career.

To this End, was not all History ransack'd for the Names of disgraced Statesmen, whose Stories were tortur'd, and forced into Parallels, and the Ministry from Time to Time pull'd down, or executed, in Effigy, in a thousand different Tables, historical or allegorical?[3]

English history proved to be a storehouse of apt parallels. Perversely interpreted they took the measure of Walpole's evil. Half-forgotten politicians and court creatures like Robert Dudley and Robert Carr (whose Christian names were obviously useful) gained renewed notoriety. The memories of the more infamous lived on: Buckingham, Strafford, Clarendon, and especially Cardinal Wolsey.[4] Biographies and engraved portraits of Henry VIII's minister appeared in the late 1720s and early 1730s. Walpole's enemies found an odious parallel in Wolsey's rise from humble beginnings and in his engrossment of power, wealth, and honours. Plate 13 is one expression of the affinity. Above Walpole in the design is a medallion of Wolsey with the inscription:

[2] The theme was also carried in the extensive ballad literature of the day. See Milton Percival (ed.), *Political Ballads Illustrating the Administration of Sir Robert Walpole* (Oxford, 1916). The ballad was an older, though still flourishing, form of popular satire and propaganda than the print. Print and ballad not only often accompanied one another; they shared the same themes, ideas, titles, and metaphors. What the ballad lacked in explicit imagery, it made up for in the ringing cadences of its verses.

[3] *The False Accusers Accused; or the Undeceived Englishman: Being an Impartial Enquiry into the general Conduct of the Administration . . . In a Letter to the Pretended Patriots* (London, 1941), p. 17.

[4] Whose initial was probably the major reason for this popular comparison.

'Wolsey and His Successor Here in One Behold, Both Serv'd Their Masters, Both Their Country Sold.'

Comparisons were found abroad, all the better to support the contention that prime ministers were first spawned by alien tyrannies. The DeWitts in Holland and mysterious grand viziers and viceregents in Turkey and Muscovy were held up to execration. Ancient history produced a distinguished villain in Sejanus, best known to contemporaries in Ben Jonson's play of the same name.[5] A letter to the *Craftsman* in 1729 observed ironically: 'I have often observed, with Pleasure, that *Ben Johnson's Fall of Sejanus* hath not been acted for many Years; and I could wish that the *Fall of Cardinal Wolsey*, as drawn by *Shakespear*, in his *History of Henry the Eighth*, may not be exhibited any more. . . .'[6] Sejanus, as Jonson shows, met with a horrible death, which was the subject of another print of the excise crisis: *The Downfall of Sejanus*. The scene is a courtyard. In the foreground left a decapitated body is dragged across the cobblestones. Dress and appearance identify the figure as Walpole. The man pulling the body offers the moral of the print: 'this is the fate of all Oppressors'. In the background rests the severed head, exclaiming 'Ex–Ex–Ex–Exciseise' (probably intended as a grotesque pun), with the executioner standing above it. A crowd of women at the far left celebrate the tyrant's fall, while at the right a line of excisemen proceed in mourning.[7]

The horrible ends in all these obvious allusions increased the sting of their meaning. In a half-serious way they anticipated Walpole's fall by slaying and desecrating his effigy. '*Just Published*, (*Proper for* New-Year's-Gifts *to* Children *of* Quality *and* Distinction) *Political Cards*, describing, in beautiful and instructive Prints, the terrible, tragical Ends of *wicked Ministers* in all Ages and all Nations; *viz*. 1. *Sejanus*, the Favourite of the Emperor *Tiberius*. . . . To be sold in *Westminster-Hall* and at the *Royal Exchange*.'[8] A pamphlet published in 1733, *A Short History of Prime Ministers in Great Britain*, concluded with a statistical table of the fates met by the nation's first ministers:

[5] The satirists ignored the ticklish point that in Jonson's play Sejanus' master, Tiberius, was as much a tyrant as he.

[6] *Craftsman*, 8 Mar. 1729.

[7] The artist may have also had in mind the murder of the De Witts, who were torn to pieces by a mob at the Hague in 1672.

[8] *Craftsman*, 30 Dec. 1727.

Dy'd by the Halter– – – – – – 3
Ditto by the Axe – – – – – – 10
Ditto by *Sturdy Beggars* – – – – 3
Ditto untimely by private Hands – – 2
Ditto in Imprisonment– – – – – 4
Ditto in Exile – – – – – – – 4
Ditto Penitent – – – – – – – 1
Saved by sacrificing their Master– – 4
 ——
Sum Total of *Prime Ministers* – – 31[9]

The stories of evil ministers followed a plot that rarely changed: a rise from humble and/or obscure beginnings; the enjoyment of unparalleled success; an inevitable denouement and calamitous end.

Like Jonson's *Sejanus* the story was usually a tragedy: a criminal spectacle of great evildoers whose vices, triumphs, and contests with fate figured on a grand scale. This tragic form was a screen, of course, for political satire that disguised itself in pretentious moralisms. Overweening ambition, satisfied by treachery, fraud, and expressed by avarice, brought nothing but ill. As with the trite simplicities of Bunyan's *Life and Death of Mr. Badman*, they made the substance of a morality tale. The story often took the form of a pilgrimage or 'progress' (the inversion of *Pilgrim's Progress*), showing the way of the sinful into Hell. *The Statesman's Progress*,[10] a pamphlet published in 1741, adapted Bunyan's theme to political satire; the author, in a dream, tells the story of how 'Badman' (i.e. Walpole) makes his progress along 'Vice-Road' to 'Greatness-Hill'. The story includes Badman's departure from his native 'Land of Dumplings', his experiences at 'Vice-Castle' and in the 'Slough of Preferment', and his conflicts with the 'City of Wealth' (i.e. London). Another pamphlet, *The Statesman's Progress: or Memoirs of the Rise, Administration, and Fall of Houly Chan*,[11] published in 1733, describes how Houly Chan

[9] [Eustace Budgell], *A Short History of Prime Ministers in Great Britain* (London, 1733), p. 31.

[10] *The Statesman's Progress: or, A Pilgrimage to Greatness Deliver'd under the Similitude of a Dream. Wherein are discovered, The Manner of his Setting out. His dangerous Journey, and the safe Arrival at the desired Country; with the Manner of his acting when he came there. By John Bunyan* (London, 1741).

[11] *The Statesman's Progress: or Memoirs of the Rise, Administration, and Fall of Houly Chan, Premier Minister to Abenfadir, Emperor of China. In a Letter from a Spanish Missionary Father to his Friend at Madrid* (London, 1733).

attain, a position of wealth and power, how his ambition to become the all-engrossing minister finally overwhelms him, as nepotism and corruption bring a popular revolt and his execution.

Throughout the parable of Houly Chan is the theme of Fortune's minion: riding the crest of her favours and waging all on her support. The notion that prosperous ministers were the 'insolent *Creatures of Fortune*' was the usual explanation of how vice could temporarily gain triumph over virtue. *R–b–n's Progress in Eight Scenes* [Plate 17] is a graphic adaptation of this idea. The designs follow Walpole's career from his first election to Parliament— for Castle Rising—in 1701. The first scene shows him kneeling on a cobblestone street before his 'genius', Fortune, resembling the conventional image of a semi-naked female, with a long tress of hair blowing in the wind. He promises her: 'I'll stick at Nothing', while she pledges: 'Push on & Prosper thou Monstrous Son of Promise.' The subsequent scenes pursue his political career: his temporary setback in 1712 when he was imprisoned by the Tory government for alleged peculation of a forage contract; the South Sea Bubble, when he first became the great 'screener' of corruption; his attainment of unchallenged power. The genius then warns him that she cannot protect him forever: 'Remember Wollsey [*sic*] & tremble, trust me not forever.' But Walpole does not heed her: 'I'll make hay while the Sun shines.' At the end of the sequence Fortune is about to turn against Walpole, though the print only implies this. The last scene has him atop the pyramid of success, with money bags in both his hands.[12] In the background his effigy can be seen, hanging from a gallows with a crowd and bonfire beneath it. Fortune attends Walpole in several other prints, including the frontispiece to *A Dissertation upon Parties*,[13] in which she sits next to Walpole on a cloud, a symbol of transitory favour, with her arms resting upon her wheel. Fortune brings an end to Walpole in *The Wheel of Fortune, or, the Scot's Step, Completed* [Plate 43], for which her wheel provides the motif.[14]

The final destination of a statesman's progress was Hell: that

[12] As Sir Politick says in *The State Juggler: or, Sir Politick Ribband. A New Excise Opera*: 'It is natural for all Men to endeavour to climb up the Hill of Fortune', p. 17.

[13] *A Dissertation upon Parties; In Several Letters to Caleb D'Anvers, Esq.* (London, 1735); the frontispiece is BMC 2150.

[14] 'The Wheel being continually in Motion, so Fortune is fickle, and ever and anon changes, sometimes abusing one, and exalting another.' Tempest, *Iconologia*, p. 33.

preserve where satirists in all ages consigned their victims. *A Courier just Setting out. (Who has any Letters to Send?) Sketch'd from ye Life while his Boots were greasing* [BMC 2629] comments on Walpole's death in 1745. In the design he appears as a mail-carrier, seated on an ass, about to depart for the nether world. Riches, taxes, and exchequer tallies load the ass, as well as 'A Mail for Pluto'. Walpole's successors in office stand around him for the send-off. 'For whatso'er on Earth they seem,/ All Pluto's Minister's we deem.'

A variation on the theme of a statesman's progress is the allegorical motif made popular by Arbuthnot's John Bull tracts. Great Britain is the estate, the King is its squire, and the first minister the squire's steward. *The History of the Norfolk Steward*,[15] published in 1728, tells of Walpole—alias 'Mr. Lyn'—becoming steward to the estate of 'Sir George English'. The allegory shows how Mr. Lyn flourishes in his position, rewards relatives and friends, grows fat and wealthy. The estate goes to ruin, but once again ambition gets the best of its man and the tenants of the estate rebel. *The Night-Visit, or the Relapse* [Plate 48] offers much the same story: *the Pranks of Bob Fox the Jugler, while Steward to Lady Brit, display'd on a Screen.* The signal events of Walpole's public life—his imprisonment, the Bubble and Excise crises, the conflict with Spain, his fall—appear on the folds of the screen; the series concludes with a fanciful presentation of his disgrace: the 'Trial' with Tower Hill, an axe and gibbet in the background.

The above allegorical piece also includes in its scenes the major charges, echoed with tedious monotony by the Opposition year after year against Walpole's statecraft. The second design shows 'Lady Corruption' in the 'House of Pl–m–n and Pensioners'. The next two folds have the Fury of persecution driving two merchants, burdened with sacks of 'Gin Act', 'Dutys', 'Taxes', and 'Debts'. 'Trade Neglected' is the charge. The first fold in the second row assails Walpole's Sinking Fund; he is about to stab a boy (personifying the fund) with his sword: 'He murdered his own Child, whom he pretended a more than ordinary Fondness

[15] *The History of the Norfolk Steward Continued. In Two Parts. Part I. Containing an Account of Mr. Lyn's Private Character, and the Methods by which he grew Rich. Part II. Containing some farther Account of Mr. Lyn's Management, and also of his Stating and Ballancing Accounts* (London, 1728).

for.'[16] The scene labelled 'French Councils' shows Walpole kissing Fleury's arse; 'After this, he turns Papist, and takes a *French* Jesuit for his Confessor, to whom he discoverd all the Secrets of his Lady's Family.' The scenes showing Houghton Hall and Lady Brit's mansion-house suggest Walpole's attempts to subvert the constitution.[17]

The cavilling with Walpole's policies rested upon two basic charges: 'notorious Corruption and Waste of the public Treasure at home . . . the open and manifest Sacrifice of the *British* Interest and Glory abroad.'[18] Most of the issues attached to these charges— devious financial schemes, peculation, oppression of trade, political corruption, subversion of the constitution, truckling to France and Spain[19]—are discussed in the preceding two chapters.[20] Walpole's enemies raised other incidental issues. There were complaints about the lack of Government patronage of the arts and sciences. *The Present State of a Certain Great Kingdom* [Plate 21], in which Walpole is accompanied by Fortune and a corrupted Justice, presents an interesting summary of the case against the evil minister, including in its indictment: 'Art–ts Starving'. The satirists liked to argue that Walpole's system of government had ushered in a reign of venality, tedium, and dullness, which were sapping the moral fibre and creativity of the land. Verses from Pope's *Dunciad* inspired a print of 1743, entitled *The late P–m–r M–n–r* [Plate 54].[21] Reflected in the gaping yawn of its figure is

[16] Walpole was sometimes forced to 'raid' the Sinking Fund, whose original purpose was to reduce the principal of the national debt.

[17] See above, chap. v.

[18] *The Case of the Hanover Forces in the Pay of Great Britain, Impartially and freely examined: with some Seasonable Reflections on the Present Conjuncture of Affairs* (London, 1743), p. 3; the author (Lord Chesterfield) is characterizing the policies of Walpole's twenty-year rule.

[19] One of the most effective statements of these charges is Plate 44.

[20] Prints in defence of Walpole are few, far fewer than the tracts and pamphlets in support; this comparison uncovers a basic limitation in the graphic medium: more effective in casting aspersions than making apologies. *To the Glory of the Rt Honble Sr Robert Walpole* [Plate 10] is one of the few encomiums and it proved quite easy to transform into an ironic satire (see above, chap. ii). Plate 33 is another formal panegyric, in the traditional heroic style. All the stock imagery is there: the Temple of Fame, Minerva the rewarder of Virtue, and the evil personifications that Walpole has overcome: War, Envy, and Sedition. Such formal apologies are stale in comparison to the stinging satires they try to refute. Walpole's defenders were also put at a disadvantage by the undramatic nature of his accomplishments: peace, stability, and prosperity.

[21] This print, or a variant of it, is advertised in the *London Daily Post*, 29

the insidious boredom that characterized Walpole's years of power.

> More she had spoke, but yawn'd—all Nature nods:
> What Mortal can resist the Yawn of Gods?
> Churches and Chapels instantly it reach'd,
>
>
>
> Then catch'd the Schools; the Hall scarce kept awake;
> The Convocation gap'd, but could not speak.
> Lost was the Nation's Sense, nor could be found,
> While the long solemn Unison went round:
> Wide, and more wide, it spread o'er all the realm;
> Ev'n Palinurus nodded at the Helm . . .[22]

The prints reveal a rudimentary understanding of the nature of Walpole's system and the basis of his power. At the simplest level Walpole's supremacy was explained as being wholly dependent upon the power of money. This was a facile notion, implied in the ever-present bags of coin, but which Bolingbroke adapted to a clever parable in the 'Vision of Camilick'. The vision begins with the signing of Magna Carta:

I lifted my eyes, and I saw a vast Field, pitch'd with Tents of the mighty, and the Strong ones of the Earth in array of Battle. I observ'd the arms and ensigns of either host: in the banners of the one was pictur'd a Crown and Sceptre, and upon the shields of the Soldiers were engraven scourges, chains, iron maces, axes and all kinds of instruments of Violence. The standards of the other bore the Crown and Sceptre also; but the devices on the shields were the Ballance, the olive wreath, the plough-share, and other emblematical figures of justice, peace, law, and liberty: Between these two armies, I saw a King come forth and sign a large *Roll of Parchment*, at which loud shouts were heard from every Quarter.[23]

Oct. 1743, with an alternate title: *Great Britain and Ireland's Yawn!* The advertisement offers an explanation of the verse: 'First it seizeth the Churches and Chapels . . . Westminster-Hall, much more hard indeed to subdue, and not totally to silence . . . even the House of Commons, justly call'd the Sense of the Nation, is lost . . . it spreads at large over the rest of the Kingdom . . . the Effect of which, tho' even so momentary, could not cause some Relaxation, for the Time, in all publick Affairs.'

[22] Alexander Pope, *The Dunciad*, ed. James Sutherland (London, 1943), Book IV, lines 605–7, 609–14.

[23] *Craftsman*, 23–7 Jan. 1727; Bolingbroke's vision was probably the inspiration for the frontispiece to the first volume of the *Craftsman*, a reduced copy of which appears in *Robin's Reign* [Plate 9].

The author goes on to describe the apotheosis of the Charter and the veneration accruing to it through the centuries. He then approaches the moment of his story with a description of the sacred covenant under a canopy in Westminster Hall. Nobles of the land stand worshipping before it.

In the midst of these execrations enter'd a man dress'd in a plain habit, with a purse of gold in his hand. He threw himself forward into the room, in a bluff, ruffianly manner. A Smile, or rather a Sneer, sat on his countenance. His Face was brouz'd over with a glare of Confidence. . . . Nothing was so extraordinary as the effect of this person's appearance. They no sooner saw him, but they all turn'd their faces from the Canopy, and fell prostrate before him. He trod over their backs, without any ceremony, and march'd directly up to the Throne. He open'd his Purse of Gold, which he took out in Handfuls, and scattered amongst the Assembly. . . . Some of the people began to murmur. He threw more Gold, and they were pacified.[24]

Walpole then seizes Magna Carta and puts it into his pocket. Eventually his purse runs empty and his power over the people at once expires. The Charter is returned to its rightful place.

The outward sign of Walpole's power, and its guarantee, was his engrossment of public patronage. To his monopoly of the royal bounty most of the hatred of 'first' and 'prime' ministers directed itself. From this unnatural achievement stemmed all his corruption, and by it, as Lord Egmont charged in 1730, he had perverted the ancient and honourable purposes of royal generosity: to reward men of 'character and fortune'[25] for their services to the state. *Idol-Worship or The Way to Preferment* [Plate 28], alluding to Wolsey, shows how subservience to Walpole has become the sole path to honour and place in public life.

And Henry the *King* made unto himself a great *Idol*, the likeness of which was not in Heaven above, nor in the Earth beneath; and he reared up his Head unto ye Clouds, & extended his Arm over all ye Land; His Legs also were as the Posts of the Gate, or as an Arch stretched forth over ye Doors of all ye Public Offices in the Land, & whosoever went out or whosoever came in, passed beneath, & with Idolatrous Reverence lift up their Eyes, & kissed ye Cheeks of ye Postern.

[24] Ibid.
[25] Historical Manuscripts Commission. *Manuscripts of the Earl of Egmont. Diary of the First Earl of Egmont (Viscount Percival)* (3 vols., London, 1920–3), i.85.

The setting of the print is the front gate to St. James's Palace; its implication is that Walpole stands between the king and his people, as an intermediary to the royal bounty. The designer has indicated on the arches beyond the departments in which pre-ferment resided: Treasury, Exchequer, and Admiralty. The wheel which the placehunter in the foreground is moving has inscribed upon it the vices requisite for preferment: wealth, pride, vanity, folly, luxury, want, and dependence.

The traditional and popular assumption argued that the origin and true basis of a minister's power must be found at court. He was first of all master of the king's closet, monopolizer of the king's ear. One of the panel designs of *The Scheme Disappointed*, etc. [Plate 15] shows a 'serpent twisted round a Throne': the conventional device for suggesting that evil counsel resided near the seat of power.

Queen Caroline's hold on George II was common knowledge ('You may strut, dapper George ... We know tis Queen Caroline, not you, that reigns.'). The Queen's confidence in Walpole was an important security of his success. Together with the King they formed the trinity of power. *The Festival of the Golden Rump* [Plate 19] has Walpole and Caroline presiding as priest and priestess at a rite, highlighted by the frenetic activities of the satyr-like King.

George's passion for Lady Wallmoden after the death of the Queen in 1737 provided more ammunition for malicious lam-poons.[26] Walpole, it was believed, hustled her to England where, in 1740, she became Countess of Yarmouth. Walpole appeared the procurer, ready to do anything to keep the King happy and his own position at court secure. A new trinity was formed. *Bob's the Whole* [BMC 2464], a Bickham print of 1741, shows the trinity perched together in the upper left of the design. A hiero-glyphic message below expresses the required political creed:

t[hat] we serve & obey 1 Mon[arc] in a tripple Conjunc[eye]on, Neither confounding ye Conjunc[eye]on tripartite; nor [die]viding the Per[sons] in Tripli[eye]ty: For there is 1 [body] of the Mon[arc], another of the prime [minister], & another of ye []tess of Yar[mouth]. But the Interest of the Mon[arc], of the [minister], & of

[26] *Solomon in his Glory* [BMC 2348] shows George II and Lady Wallmoden embracing; his mourning attire and a portrait of Caroline hang on the wall.

the []tess is [awl] 1: Their Pride equ[awls], & their Honour co-oeval. . . .[27]

Bickham published even more outrageous impieties. His 'The [Cha]mpion; or Even[ing] Adver[tiser] [Plate 31] includes a 'Political Creed' for all those 'who ever would be in Office'.

I Believe in King [George] ye 2nd., ye [grate]est [cap]tain, ye Y-est Mon-arch [bee]tween [Heaven] & [Earth], and in Robt [Wall][pole] his only [minister] our [lord?], who was [bee]gotten by [barrel] ye Attorney, born of M^rs [wall][pole] of Hough[town] [axe]cused of corrup[eye]on exp(1-)ed & im[prison]'d he went down into Nor[fork] the 3 [ear] he came up again, he [ass]sended into ye Ad[minister]-tra[eye]on & [sit]teth at the [head] of ye Treas[ur]y, from thence he shall pay [?] those who *vote* [ass] they are [comb]manded. . . .[28]

Contemporary prints show some appreciation of the fact that the 'plenitude' of Walpole's power came, in part, from his position at the Treasury; the status of first minister depended on the control and exercise of that influential office. The frontispiece to *A Collection of State Flowers* [BMC 2025][29] has a design with a large sunflower running up the left side (Walpole, himself, in the bloom of his prosperity). Beneath the sunflower and to the right of it are five small flowers in a row: 'Five Treasury Pinks', with guineas for petals; they represent the five commissioners of the Treasury, and the very heart of the Court and Treasury party.

Some attention, though not much, is given to Walpole's use of secret service funds. In *The Grounds* [Plate 35] 'For Secret Services' appears on his state wagon. From the Treasury flowed all the pernicious schemes that enhanced the minister's power and made it more oppressive. Into the 'Gulph of Secret Iniquity' and onto the floor in *The Political Vomit for the Ease of Britain* [Plate 41] Walpole is forced to divest himself of 'Ex–se Scheme', 'Reversions', 'S–k–g F–nd', 'Private P–ns–ns', and, most important of all, 'Ch–r of the E–r' and 'First L— of ye T–y'.

To the third basis of Walpole's power, minister to the House of Commons, graphic satire gave little attention. Opposition

[27] The rebus in the '[]tess of Yarmouth' is the female sexual organ.

[28] Walpole's mother was Mary Burwell, daughter of Sir Geoffrey Burwell, attorney-at-law; the hieroglyphic makes the outrageous charge that Walpole's real father was '[barrel] y^e Attorney'. One of Walpole's brothers was named Burwell.

[29] *A Collection of State Flowers* (London, 1734).

pamphlets and journals, however, fearlessly explained how
Walpole turned the vast resources of patronage to the corruption
and control of Parliament: a Government majority of 'Roberts-
men'. There he stands in the fourth scene of *Robin⁵ Reign* [Plate
9] buying his Lords and Commons. *The Protest*, with the
'Tr–s–y' building in the background, exhibits a dwarfish figure
of Walpole protected from the assaults of an Opposition minority
by his own mercenary 'Majority'.

The *Craftsman* gave a name to Walpole's system of govern-
ment: '*Robinarchy* or *Robinocracy*'.[30] The system was 'com-
pounded of a *Monarchy*, an *Aristocracy* and a *Democracy*', con-
forming to the ideal of mixed government, but unnaturally tied
together by 'the *Robinarch*, or Chief Ruler ... nominally a
Minister only and Creature of the Prince; but in Reality a
Sovereign; as despotick, arbitrary a *Sovereign* as this Part of the
World affords', the same Robinarch who rides supreme in *The
Grounds*. The considerable attention in the anti-Walpole litera-
ture to engrossment of royal patronage and parliamentary corrup-
tion indicates contemporary recognition of the fact that Walpole's
tenure did represent a departure from (or thorough refinement of)
the old order of politics and government. His critics charged that,
while corruption had existed before Walpole, he was the first to
reduce it to a system.[31]

Walpole's enemies were fascinated by the idea of the 'over-
grown Monster of Power'.[32] They saw his strength and influence
as pervasive and—save for the self-destructiveness of his own
ambition—practically unshakeable. He was the colossus, Punch
the puppeteer, the great 'skreen-master', who protected the
guilty in 1721 and himself in 1742. Walpole plays the affable
Punch on the right in *The Screen* [Plate 45], in which he rejoices
at the parliamentary defeat of attempts at inquiry. He is 'Punchi-

[30] *Craftsman*, 18 Oct. 1729.

[31] J. H. Plumb, in *The Origins of Political Stability: England 1675–1725* (Boston,
1967), argues that Walpole—a 'politician of genius'—deserves credit for laying
the basis of political stability in England. His ruthless use of patronage and the
spoils system brought one-party government, eventually dominated by a single
minister, into existence. In these endeavours he achieved unparalleled success. It
appears, therefore, that the complaints of men such as Egmont, the charges of
Bolingbroke and the *Craftsman*, and the ideas humorously expressed in such prints
as *Idol-Worship or The Way to Preferment* were more than mere cant.

[32] Quoted in *A Short History of Prime Ministers*, p. 23.

nello' the puppeteer in *The Screen. A Simile* [Plate 46],[33] as he still pulls the strings in Parliament:

> But when *Punch* is turnd off the Stage,
> Some other Puppets come t'engage:
>
>
>
> *The Puppet Man,*—behind the *Screen,*
> Is the same Man,—although not seen.

'*Robin* playeth the *Broker* in all his affairs', the *Craftsman* asserted in a parable about Queen Elizabeth's Earl of Leicester, 'and maketh the uttermost penny of her Majesty every Day'.[34] A bad minister was, by definition, one who ran contrary to his sovereign's and nation's interest in the steady and ruthless pursuit of his own. Walpole was accused of using his office and influence to enrich himself and to reward his relatives and friends.

... since his entering upon the A–n, he has spent upon one Article of Luxury, more Money than he could claim as the accumulated Sum of the lawful Perquisites, and Sallary [*sic*] of all the visible Posts and Places he has enjoy'd under the Crown for these twenty Years past . . .[35]

'Bob-Booty' had enriched himself by peculation. Charges were made about nepotism, complaints about the rebuilding of Houghton, about its sumptuous entertainments, Walpole's extravagant wine-cellar, his art collection, his suspicious investments and holdings. 'There's little *Robin*, in *Debt* within these few Years, grown *Fat* and *Full.*'[36]

The prints, by and large, ignored Walpole's private life and clung instead to the same, threadbare issues. This is surprising since there was, in his personal affairs, the meat of scandal. His estrangement from his wife and his relationship with Maria Skerett (who eventually became his second wife) were commonly known.

Horatio Walpole, the loyal but sometime erratic brother and colleague, was the butt of many jokes; he occasionally appears in

[33] A pamphlet of the same period, *Politicks in Miniature: or, the Humours of Punch's Resignation. A Tragi-Comi-Farcical-Operatical Puppet-Show* (London, n.d.), tells how Punch, against whom all the puppets are conspiring, manages to exercise control after his fall.

[34] *Craftsman,* 24–7 Feb. 1727.

[35] *Reasons Founded on Facts for a Late Motion. In a Letter to a Member, &c.* (London, 1741), p. 52.

[36] *Craftsman,* 24–7 Feb. 1727.

the prints. He sits on the back of the wagon in *The Grounds*: the figure labelled 'Balance Master' who says: 'Lawfull plunder, by G–d, Lawfull plunder.'[37] Horatio is the major subject in *A Political Battle Royal* [Plate 49]: a grotesque figure, *sans* wig, in the centre of the design. The print was occasioned by a duel which took place in 1743, between Horatio and John Chetwynde, after the latter had made a disparaging remark about Robert Walpole in Parliament.

If the prints barely touch the incidents of Walpole's private life, they come only a little closer to showing a true appreciation— even negative—of his personality. He is the grand corruptor, and not the corrupted. Walpole's character in the prints fits more of a stereotype than an individual person. His vices are those expected of an evil minister: ambition, avarice, and cunning. His image is that of a rather colourless, awesome, cold, and aloof person, much as Plates 32, 33, and 44 suggest. Walpole's affability, good-naturedness, and earthy coarseness are absent.[38] A few prints like *The Funeral of Faction* [Plate 36] will suggest an element of jocundity: Walpole laughing at the foibles of his enemies. But the personality generally throughout the prints is a rather bland one: perhaps the satirist's failing, perhaps—but not likely—a sugges-tion of that phlegmatic stability that was part of his nature.

The prints fared better with Walpole's physical appearance. In his later years he was a man of great bulk, so corpulent, in fact, that Queen Caroline wondered how any woman could be attracted to so coarse a nature in so repulsive a figure.[39]

The satirists liked to draw attention to his fatness, though not to the point of excessive exaggeration. The Walpole in Plates 22, 27, 32, 33, and 44 is typical: a queued, full-bottomed wig; a

[37] Horatio Walpole, Baron Walpole of Wolterton, was minister at the Hague and ambassador to France; he played an important role in the shaping of foreign policy. His enemies dubbed him the 'Ballance Master of Europe'. In Plate 19 Horatio is the shadowed figure holding the scales on the left.

[38] Two contemporary characters, *The Character of Pericles; A Funeral Oration. Sacred to the Memory of a Great Man* (London, 1745), and [Thomas Davies], *The Characters of George the First, Queen Caroline, Sir Robert Walpole, Mr. Pulteney . . . and a Sketch of Lord Chesterfield's Character* (London, 1777) call attention to the attractiveness of Walpole's personality. The latter, a balanced analysis, observed that 'Walpole had so open a countenance, and such expressive features, that it was almost impossible for a skillful painter not to draw an exact likeness of him.' (p. 17.)

[39] John, Lord Hervey, *Memoirs of the Reign of King George the Second*, ed. J. W. Croker (2 vols., London, 1884), ii.143.

paunchy belly, awkwardly hidden under a coat buttoned at the waist; stocky calves. The figure in *Funeral of Faction* perhaps inclines towards exaggeration. The Walpole falling off the wheel of Fortune in Plate 43 offers a profile of his great paunch. Obesity was considerably more noticeable in the later years. '*R–b–n's Progress* [Plate 17] shows a youthful Walpole: rather tall, handsome, with shapeless legs.

Walpole's face is less easily distinguished. The satirists made few attempts at caricature. Good likenesses of Walpole are scarce. The earliest portraits, like Kneller's, seem flattering and impersonal.[40] A more convincing study is the terracotta bust by Rysbrack in the National Portrait Gallery. The Roman mode is distracting but in other respects the sculpture shows much realism and attention to detail. The face is full and well-rounded, the nose is straight, not long or blunted. Most noticeable are the heavy brows, the straight lips, inclined towards thickness, the lower one protruding. The figure has a fat neck and double chin.

One of the best of the mezzotint portraits is the three-quarter-length reproduction of Bockman, after Gibson.[41] The thick brows, the full, heavy-jowled face, the straight, thick lips, the bulging neck are evident. The nose, if Rysbrack's likeness is more accurate, seems too pudgy. Bickham used the Bockman mezzotint as the model for his *Stature of a Great Man*, etc. [Plate 32].

Most studies of Walpole's face in the prints are too small to be judged critically. The bust portrait in *The Triumph of Justice* [BMC 2501] offers a good profile: bloated neck and jowls; blunt nose; thick lips. Plates 19 and 33 are more typical, if not more interesting.

The face is usually emotionless, save in a few instances as in Plate 23 and where a grotesque malevolence is suggested. *The Political Vomit for the Ease of Britain* [Plate 41] makes an amusing study, with the look of pain and anguish on the face. *The late P–m–r M–n–r* [Plate 54], a form of proto-caricature, is a fascinating piece, but hardly consistent with other likenesses. The face is too oval and the features too sharp; it more closely resembles William Pulteney.[42]

[40] O'Donoghue, ed., *Catalogue of Engraved British Portraits*, iii.375–6.

[41] Plate 2; a copy of No. 1 in the *Catalogue*.

[42] Pulteney, in body, resembled Walpole; they are sometimes difficult to tell apart. See the large man in the foreground of Plate 34.

Walpole was sometimes subjected to the stock devices, used by graphic satire to demean his person and dignity. His buttocks are exposed in Plate 28; he farts in Plate 35, tumbles down in Plate 43, and is carried through the mire of corruption in *The Devil upon Two Sticks*.

More often, however, Walpole stands flat-footed, in a pose of formal dignity. There he is in *The Fall and Rise of the British Liberty* [Plate 44] and *The Stature of a Great Man*, as if the artists meant to portray the imposing figure of the 'great man' in all his power. One misses the sense of much of the anti-Walpolean satire if the intended irony of that phrase is passed over. The phrase is common in the political literature of the time.[43] Its meaning is only partially ironic, in the implication that the great men ('Why Man, he doth bestride the narrow World/ Like a Colossus!' [Plate 32])[44] were not all they seemed to be. Walpole was, perhaps, when all the titles, ribands, equipage, and simulation were stripped away, no better than the common footpad. Fielding's *The Life of Mr. Jonathan Wild the Great* exploited the idea by turning the life of a notorious criminal into an heroic tragedy and the criminal into a 'great man'.[45] Throughout the burlesque is a double irony: the comparison of Wild to Walpole. Gay had employed the same technique several years earlier in his *Beggar's Opera*.

[43] The association of 'prime ministers' with the phrase 'great man' dates back at least to the Restoration. See *The Sentiments. A Poem to the Earl of Danby in the Tower. By a Person of Quality* (London, 1679).

[44] Bickham's print is the only instance of the graphic comparison of Walpole to a colossus. Several years before, the *Craftsman*, 19 May 1728, describes in an account of 'triumphant Edifices, Arches', etc., the statue of a colossus on a pedestal: 'a vast and prodigious *Giant*, being no less than *three and Twenty Feet* high. . . . This Statue was made *hollow* within side. . . . His aspect was altogether . . . Cruel, Horrid and Tyrannical . . . his Eyes, fiery, lowering and hollow; his *Brows* rough and hairy . . . Over one Shoulder hung a kind of *Scarf*, of a delicate *Scarlet* Colour, though some Manuscripts indeed say that it was a *Blue* one; in his right Hand he held a large *wooden* Sceptre, and by his left Side he wore a vast, crooked and dreadful Scymeter.' *The Night-Visit*, etc. [Plate 48] does show in one of its scenes a colossus crumbling.

[45] *Jonathan Wild* was written in 1743. In it Fielding observes: '. . . while greatness consists in power, pride, insolence, and doing mischief to mankind;—to speak out—while a great man and a great rogue are synonymous terms, so long shall Wild stand unrivalled on the pinnacle of *Greatness* . . . that Jonathan Wild the Great, after all his mighty exploits, was, what so few *Great* men can accomplish— hanged by the neck till he was dead.' *The Works of Henry Fielding, Esq.* (8 vols., London, 1771), iii.622. Compare with the last scene in *R–b–n's Progress*.

Walpole's rise from relatively modest circumstances to the very pinnacle of power made his 'progress' so remarkable and—for those who hated him—so unbearable. Constant reminders of his origins added sting to the appellation of 'great man' and made the comparisons to common criminals more amusing. The reiteration of such epithets as 'Little Robin', the 'Norfolk steward', the 'Norfolk dumpling' proved doubly effective. The squirearchy from which Walpole came were reminded of his uppish ways and affectations: the classic case of the country gentleman gone to court and corrupted. The great oligarchs, the presumptive heirs of power, could see his effrontery and intrusion into their prescriptive rights.

Walpole left his family better off in wealth, position, and prestige than he found it: a commendable achievement by the moral standards of the day. But in the eyes of many his success was too great. What more than anything else attracted scorn and jealousy was Walpole's reception into the Order of the Garter in 1726. In 1725 Walpole revived the Order of Bath (the red riband), in order to augment the royal patronage. To enhance the Order's prestige he himself became a knight. Then in 1726 George I awarded him the blue riband of the Garter. The honour, celebrated in an impressive ceremony, caused much surprise and criticism:

everyone was surprised that Mr. Walpole, who is a plain gentleman and has no title, should obtain an honour which so far has scarcely, I may even say has never, been given to a simple, untitled gentleman, but only to princes and peers of the realm. Other persons are less surprised, knowing that Mr. Walpole is the first minister and the King's favourite.[46]

Walpole proudly wore the riband and 'George' of the Order. His enemies found in this precedent a most perfect symbol of all that was wrong with first ministers and favourites. Snobbery was insulted. The epithet of 'great man' gained greater sting.

The Mind of Man being naturally subject to Pride, Vanity and Ambition, it makes us all eager in the pursuit of Honours, Titles and Distinctions of preheminence [sic], either in Dress or Appellation. For this Reason a Monosyllable prefix'd to a Man's Christian Name, a Medal hung about his Neck, or a piece of Colour'd Ribband cross his

[46] Saussure, *Foreign View of England*, p. 175.

Shoulders are esteem'd of great value, and by some persons prefer'd even to Riches or Power . . .[47]

Walpole became 'Sir Blue-string the Great' in print and broadside, always identified by the Garter riband hung proudly across his chest. The first of the panel designs in *The Scheme Disappointed*, etc. [Plate 15] shows 'an Axe ty'd up in a Ribbon', the sense of the image implying that in Walpole's pursuit of honours was his own destruction.

Walpole is supposed to have hated the ceaseless vilification, scurrility, and misrepresentations, thrown up against him year after year.[48] A contemporary and partially sympathetic character of him noted that Walpole was quick to take offence at any attack upon him.[49] Certainly he moved swiftly against the Opposition press. The prints, however, seem to have gone almost untouched.[50] As outrageous and libellous as some of them were, Walpole, with his earthy sense of humour, might well have chuckled at the best. His political career was sufficiently long and experienced for him to know that an open distrust of power and the baiting of ministers were part of the game, the prerogative of free-born Englishmen. '*If a great Man be* lawful Game, *He ought to be* fairly chased.'[51]

2. The 'Jack-Boot'

'The title of *Favourite*, let him be ever so deserving, has always been odious in *England*.'[52] If Walpole was the stereotype of 'first minister' during the reigns of the first two Georges, John Stuart, third Earl of Bute, seemed the exemplification of court 'favourite' at the outset of the reign of George III. Bute became, like Walpole, a victim of historical parallels, and he was as readily accepted into that notorious company of favourites and ministers from the past. *Sawney Below Stairs* [BMC 4048] employs the stock theme of a fallen minister entering into Hell, there to be greeted by his counterparts from former times. Bute, having

[47] *Craftsman*, 1–5 May 1727. The writer goes on to praise the fineness of 'esquire' as the best status of true-born Englishmen; he complains about the confusing and mixing of social degree: that rank and station are no longer clear.

[48] See J. H. Plumb, *Sir Robert Walpole: The King's Minister* (London, 1960).

[49] *The Characters of George the First, Queen Caroline*, etc., p. 22.

[50] Above, chap. iii.

[51] *Craftsman*, 28 Sept. 1728.

[52] *Guthrie's peerage*, quoted in [J. Almon], *A Review of Lord Bute's Administration. By the Author of the Review of Mr. Pitt's* (London, 1763), title-page.

crossed the Styx, is pushed by a collection of devils and demons towards a reception line, consisting of Count Bruhl, Mortimer, Walpole, Wolsey, the Despensers, and Sejanus, each with his own appropriate words of praise and greeting.[53]

(All favourite Statesmen to Monarchs of Yore)
To give his Scotch Lordship a welcome to shore.

The corpus of anti-Bute literature is large—there are more prints than the number devoted to Walpole—even though the length of Bute's public career was short. The substance of the more pedestrian literature suffers from two major weaknesses: mindless exploitation of basic prejudices; a preoccupation with falsehoods and irrelevances. This literature is testimony, however, to the extreme animosity which Bute's brief tenure aroused.

Bute was just as much a 'great man' as Walpole. There is an implicit comparison in *The Stature of a Great Man, or the Scotch Colossus*, a partial transformation of Plate 32. Bute's face and wig have replaced Walpole's and some of the inscriptions have changed. Otherwise, the print suggests a mutual applicability.

The anti-Bute satire is more virulent and scandalous than the attacks on Walpole. Endemic to Bute's great unpopularity—stridently exploited by his adversaries—was the accident of his Scottish birth. With a degree of plausibility the Opposition writers argued that not only was Bute an unknown in affairs of state, not only was he lacking in administrative experience, but as a Scot, without a drop of English blood in his veins, 'he has no natural interest in *South* Britain'.[54] His alien origins gained Bute a colourful series of epithets: 'Gisbal, Lord of Hebron', the 'Highland Seer', 'Sawney Gesner', the 'Northern Machiavel', and the '*Novus Homo*' in England.

For meaner souls Bute's Scottish nationality was sufficient taint. As the *North Briton* remarked: 'A *Scot* hath no more right to preferment in *England* than a *Hanoverian* or a *Hottentot*.'[55] Anti-Scottish prejudice was as much a part of the nativism of the middling and lower classes as was hatred of the French. Charles

[53] Heinrich von Bruhl: Saxon and Polish minister in the middle of the eighteenth century; the elder and younger Hugh Despensers were baronial powers in the reign of Edward II.
[54] [John Butler], *An Address to the Cocoa-Tree. From a Whig* (London, 1762), p. 5.
[55] *North Briton*, 22 Jan. 1763.

Churchill, in his savage *Prophecy of Famine*, cogently expressed the Englishman's view of his island's northern parts:

> Consider'd as the refuse of mankind,
> A mass till the last moment left behind,
> Which frugal nature doubted, as it lay,
> Whether to stamp with life, or throw away;
> Which, form'd in haste, was planted in this nook,
> But never enter'd in Creation's book . . .[56]

Londoners, particularly, cherished their stereotypes. With the chattering, apish French fop and the swarthy Spanish don, there was the 'beggarly Scot'. The image of the Scot in the prints is fairly consistent. As he appears in *The Jack-Boot, Exalted* [BMC 3860, Plate 104], *The Laird of the Posts or the Bonnett's Exalted* [BMC 3862, Plate 105], *The Butifyer* [Plate 116], and *We are all a comeing* [Plate 102], most of the features of Highland garb are on him: tartan kilt, scarf, and stock; plain bonnet and jacket.[57] The designers were usually very casual in their designation of tartan: a simple plaid of criss-cross lines was deemed sufficient. They sometimes made a point of distinguishing between the haughty and proud Scottish grandees and the miserable generality of their countrymen. The Scots of wealth and position are marked by bag- or tye-wigs and they often appear in conventional, eighteenth-century dress (though with a piece of tartan to indicate their nationality). The poorer sort are always designated by wild, stringy hair and sometimes by tattered clothing [Plates 102 and 104].

The degradation of the Scots was proverbial. English travellers to the North in the seventeenth and early eighteenth centuries remarked at the poverty and sloth of the country.[58] Coarseness of living and beggary became identified in English minds with Scotland. The Scots in the prints are, as would be expected, pictured as thin, bony, and scraggy. The Scottish bagpiper and his family in *The Butifyer* carry a wretched, tattered look. The faces are usually thin, with sharp features: protruding nose and chin.

[56] *Poems by Churchill. In Two Volumes* (London, 1766), i.118.

[57] The scarf was usually the extension of the material of the kilt, draped over the shoulder.

[58] See Wallace Notestein, *The Scot in History: a Study of the Interplay of Character and History* (London, 1946), p. 197.

> Pale *Famine* rear'd the head; her eager eyes,
> Where hunger e'en to madness seem'd to rise,
>
>
> Her hallow cheeks were each a deep-sunk cell
> Where wretchedness and horror lov'd to dwell;
>
>
> Such filthy sight to hide from human view,
> O'er her foul limbs a tatter'd Plaid she threw.[59]

Just as proverbial was the Scotch 'itch', caused by the lice and dirtiness of the coarse clothing: a 'scrubby, *prickly* throng'.[60] One print of the *Post* series,[61] entitled *The Scrubbing Post* [BMC 3946], shows four Scots in Highland dress. One is rubbing his backside against a rough post; another is scratching himself. In *Sawney Discover'd or the Scotch Intruders 1760* [BMC 3825] the motto 'Nemo Me Impune Lecessit'[62] is translated as 'No one touches me but gets the Itch.'

English satirists also turned their ridicule on Scottish customs and supposed national characteristics. Like the speech of the German mercenary, the French negotiator, or the Jewish merchant, the quaint dialect of the Northerner is mimicked; the Scots speak in a mixture of English and native words. 'Soul' becomes 'saul'; 'much', 'muckle'; 'cannot', 'canna'; and 'the Devil take me' turns into 'the Deel tak me'. The Scottish diet of haggis and oatmeal is belittled. In *John Bull's Kitchen-Furniture selling by Auction* [BMC 3991],[63] a Scot chases English cooks away: 'Awa wi ye Loons ye ken not how to make a Scotch Hagoist [*sic*].' A Scot on his way to England in *The Caledonian Voyage to Money-Land* [BMC 3856][64] exults in the knowledge: 'I'll have nae mair Oatmeal & Water.' The bagpipe and broadsword of the Highlander are common accoutrements in the prints.

The Scots in English eyes showed all the character-weaknesses

[59] *Poems by Churchill*, i.117.

[60] *The British Antidote to Caledonian Poison: Consisting of the Most humorous Satirical Political Prints, for the Year 1762* (London, n.d.), p. 8.

[61] *The Posts* [BMC 3944], an engraving with ten designs, each using a post as a theme; each of the designs appears separately in the *Political and Satyrical History* and *British Antidote*, etc.; see Plate 113.

[62] The Latin motto appears on the Scottish coat-of-arms and the medal of the Order of the Thistle.

[63] The print was occasioned by Lord Talbot's (Lord Steward) economic reforms of the Household.

[64] Contemporary satire used the Roman name for Scotland.

of a provincial, backward people. Even the poorest of them
seemed haughty, proud, and overbearing. 'Scotch pride' and
'Scotch insolence' rubbed against English self-esteem. In
Sawney Discover'd, a Scot, wearing bag-wig, bonnet, tartan stock
and breeches, exclaims: 'I have a large recommendation besides
my Impudence.'

Another prejudice, especially bitter, was the association of
Scotland with rebellion.

The restless and turbulent disposition of the *Scottish* nation before the
union, with their constant attachment to *France* and declared enmity to
England, their repeated perfidies and rebellions since that period, with
their servile behaviour in times of need, and overbearing insolence in
power, have justly rendered the very name of *Scot* hateful to every true
Englishman.[65]

The identity of Scotland with rebellion and political chaos was
old but the Forty-five gave it fresh meaning. Scotland's political
heritage was equated with Jacobitism [Plates 57 and 60].
Scotch politics were Stuart politics. 'A *Scot* is a natural hereditary
Jacobite. . . .'[66] *The Politicians*, a print of 1762, shows a Scot using
'Magna Charta' as toilet paper.[67] Memories of the Rebellion were
not forgotten sixteen years later. *The Raree Show a Political Con-
trast to the Print of the Times by W*m *Hogarth* [BMC 3975] has a
collection of show curtains, one of which is entitled 'Then', and
shows Fame awarding laurels to a triumphant Duke of Cumber-
land. Coincidences such as Cumberland's opposition to the Bute
ministry only strengthened false inferences.[68]

Englishmen imagined the Scots as subject to ravenous cupidity.
They had trickled in small numbers to London and many had
found success there. It was assumed that all Scots looked upon
England as the land of milk and honey. An ironic piece, written by
a 'Scot' in the *North Briton*, asserts:

[65] *North Briton*, 2 Apr. 1763.

[66] Quoted in *The Thistle; a Dispassionate Examine of the Prejudice of Englishmen
in general to the Scotch Nation; and particularly of a late arrogant Insult offered to all
Scotchmen, by a Modern English Journalist. In a Letter to the Author of Old England
of Dec. 27, 1746* (London, n.d.), p. 12. William Murray, later Lord Mansfield, is
the probable author of the tract. The original letter to *Old England* from which the
quotation is taken, is included. Murray was a Scot.

[67] 'Scotsmen, before the union, it was remarked, had no Magna Charta; they
never were so happy as to be in possession of such a bulwark of freedom.' *Review of
Lord Bute's Administration*, p. 60.

[68] Nor did Bute's surname enhance his popularity.

The *Union* indeed placed the preferments in *England* within our view, but the partiality of their statesmen, and their utter detestation of *Jacobitism*, a crime regularly charged on us, prevented our obtaining them in such proportion as our consequence to the state, and our *known loyalty* gave us reason to expect. These obstacles are now removed, our principles are no longer enquired into, the management of affairs is placed where every *Scotsman* both for the glory of the nation and his own interest, would wish to have it . . .[69]

Bute's rise to power and influence was to bring a swarm of locusts from the North, in search of profit and preferment in the 'Promised Land'. The Biblical analogy was used:

> But times of happier note are now at hand,
> And the full promise of a better land:
> *There*, like the *Sons of Israel*, having trod,
> For the fix'd term of years ordain'd by God,
> A barren desart [sic], we shall seize rich plains,
> Where milk with honey flows, and plenty reigns.[70]

Gisbal's Preferment; or the Importation of the Hebronites [BMC 3849] has a map-landscape as its setting. In the upper left foreground is 'The River Jordan' with the 'Hills of Hebron' beyond. The remainder of the design is labelled 'Land of Israel' (i.e. England). Coming south are wagonloads of beggarly Scots. One Scot, walking, exclaims: 'O Jubal gin I could find a Scrubbing Post twould gie me muckle glee.' Bute, as Gisbal,[71] stands in the foreground and points to his invading Highland band: 'Behold are they not Hungry as Wolves! Rapacious as the Savage Tiger when with-held from Food! Numerous as the Fowls of the Air and their Country barren as the Deserts of the Wilderness!'

There are other prints in the same vein. *We are all a comeing* [Plate 102] shows the way 'From Edinbr. to Londo[n]', along which a procession of wagons and carriages is moving.[72] Their

[69] *North Briton*, 26 June 1762.

[70] *Poems by Churchill*, i.118.

[71] Hebron, a city in the hills of Judah, figures prominently in the revolt against Joshua. Here Absalom raised the standard of rebellion. 'Gisbal' is a corruption of 'Esh-baal', the younger son of Saul and the last of his line. Esh-baal led the rebellious tribes against the house of David. He then betrayed his cause, went over to David, and was assassinated. He was buried at Hebron.

[72] 'To that rare soil, where virtues clust'ring grow,/ What mighty blessings doth not *England* owe?/ What *waggon-loads* of courage, wealth and sense./ Doth each revolving day import from thence?' Churchill, *Poems*, i.102.

many occupants proclaim the posts in government and household they hope to obtain in London: 'Il be an Admiral'; 'Il be a Bishop'; 'Il be an Exciseman or Lord of the Bedchamber.' *The Caledonian Voyage to Money-Land* has a Scottish harbour for its setting, with a ship in the centre, about to lift anchor. A pennant flies from the mast: 'The Caledonian Transport, Donald Ginger, Master; just taken into the Service for Transporting Scotch Laddies, She has likewise a large Cargo of Pride & Ambition, Consign'd to the Laird Sawney Muckleboot, Lately turn'd Post Broker and Dealer in Money-Land.' Scots of high and low degree make for the ship and scramble aboard.

Opposition polemicists relentlessly charged that Bute's rapid elevation, especially his acceptance of the Treasury, brought a large preferment of Scots, in disproportionate numbers. They argued that this was an issue of fundamental importance:

Was the English, or the Scotch, to enjoy the chief power of administration, and, along with it, the power of bestowing all posts of profit and emolument? Or, in plainer words, was the English to pay all, and the Scotch run away with the plunder?[73]

And as the author candidly pointed out:

The disposal of most of the revenue employments, and of many others, being vested in the first lord of the treasury, that nation was and ever will be jealous of that high post being filled by a Scotsman, from a rational fear of Englishmen losing that share of employments which is their due, from proportionate right.[74]

The old warhorse declamations against corruption were once more trotted out, but made to run a slightly different course: the new recipients of the spoils were bad, not the spoils themselves.

The Jack-Boot, Exalted expresses the popular assumption that Scots, exclusively, enjoyed the manna of the new reign. *The Northern Con-star-nation: or wonderfull Phoenomenon, from the observatory at Scone* [BMC 3864] has Bute on a large treasure-chest, placed up in the sky; next to him is a cornucopia, from which issues an assortment of papers, including 'Post for Mᶜ', 'Patent for Sawney Mᶜ', 'agencys', 'Commission', 'Excise', and 'Bishopricks'. A group of Scots are standing below to receive them; one says: 'I shall have a bonny chance if I get in his sunshine.'

[73] *Review of Lord Bute's Administration*, p. 62. [74] Ibid., p. 61.

The Laird of the Posts or the Bonnett's Exalted is typical of the fanciful imaginings and irrelevancies produced by this satire. Anticipating or depicting the 'Massacre of the Pelhamite Innocents'[75] in 1762, the design shows Bute as the laird, leading his clan to the conquest of English posts, literally pictured as such.[76] 'Come awa my Bonny Lads, I'll provide for ye au!' An Englishman complains: 'ye Locusts are Coming.'

The alleged favouritism of Scots, though a common topic in the prints and persistently argued in the *North Briton*, was never an issue of great weight. Nor was specific evidence brought forth to substantiate the charges.[77] Bute's public career unfortunately coincided with a great flowering of Scottish cultural life—the so-called 'periclean age'—when a number of Scots were making a name for themselves, in the universities, the arts, and in letters (among them, Smith, Hume, Ferguson, Ramsay, the Adam brothers). Thomson and Smollett had already established themselves in the south; many more were beginning to find fame and fortune in London.

Smollett was repeatedly attacked in the prints for his support of the Bute ministry in the *Briton*. James Macpherson, the poet and 'translator' of the Ossianic epics, was patronized by Bute; both *Fingal* and *Temora* are mentioned in the prints.[78] *It's All of a Peace, or French Leuisdors for English Bricks* [BMC 4043] suggests that the building of Bute's London mansion (subsequently Lansdowne House) by Robert Adam was financed by French bribes for the peace.

Coincidence or not, this popular satire and propaganda re-

[75] The ouster and proscription of Newcastle's placemen in the autumn of 1762 and winter of 1762–3, carried out, by and large, not by Bute but by Henry Fox; nor were the appointees, in large part, Scotsmen.

[76] The designer, in employing this metaphor, has combined the two themes of Scotsmen moving south on London and taking away places there.

[77] Fingers, of course, pointed at Lord Mansfield, of Scottish birth, and at Sir Gilbert Elliot and James Oswald, both Commissioners at the Treasury. Elliot and Oswald had been in government, however, for some time before 1760. Oswald had served on the Board of Trade during the Pelham ministry; Elliot had been an M.P. since 1753 and, in 1756, was a Lord of the Admiralty. Attention was also drawn to Bute's brother, James Stuart Mackenzie, a competent and highly regarded diplomat. Bute's friendship and patronage of John Campbell, John Home, and Macpherson gave some credence to the charges.

[78] A print without title [BMC 4041], probably published in 1763, has two portrait studies of Bute and John Wilkes; climbing up Bute's left arm are two Scottish imps, 'Temora' and 'Fingal'.

quired little factuality for its indulgence of nativist prejudices.
England was about to be 'scotchified' to the full:

> Our Manners now we all will change-a,
> Take Erse and get the Sc–tt–sh Mange-a,
> On *Oatmeal*, *Haggise*, we will feed-a,
> And Smithfield Beasts no more shall bleed-a.
>
>
>
> A Tartan Plaid each Chield shall wear-a,
> With Bonnets blue we'll deck our Hair-a,
> And make an Act, that no one may put,
> A Felt, or Beaver, on his *Caput*.

In the print to which the above verses are attached, *The Congress;
or, a Device to lower the Land-Tax*, Britannia is identified exclu-
sively with England. In many prints she becomes a patron goddess
to the 'English' Opposition. Both she and John Bull—whose
development in graphic satire owed much to the nativist feelings
against Scotland[79]—serve as embodiments of the spirit of 'Old
England'. John Bull, in particular, represented English character
and virtue, humiliated by the northern aliens.

Some time since died Mr. John Bull, a very worthy, plain, honest old
gentleman, of Saxon descent. He was choked by inadvertently swallow-
ing a *thistle*, which he had placed by way of ornament on the top of his
sallad [*sic*].[80]

Some prints expressed the fear that London was about to be
inundated from the north. Others implied that London would be
eclipsed by Edinburgh, that the very seat of government was to be
carried off to north of the Tweed. *The Laird of the Boot, or Needs
must when the De'el drives* shows Bute and the Princess Dowager
riding the coach of state north towards the Tweed. *The Zebra
loaded or the Scotch Pedler a Northern farce now playing in the
South* [BMC 3899] shows the Princess riding a zebra, led by
Bute who struts proudly in front of it. One of three Scotsmen who
follow exclaims: 'Scotland & France for ever, no Anglicisms, no
pitts.' A woman says: 'how impertinent the city of London
grows, as if equal to Edinburgh, truely.'
 The verses to *The Laird of the Boot* describe its scene: 'See the
Squire's old Coach fill'd with proud *Scotish* [*sic*] Thanes/ A Petticoat
Driver directing the Reins.' The 'Driver', of course, was Princess

[79] Above, chapter iv. [80] *North Briton*, 17 July 1962.

Augusta. Bute's ethnic origins and his rapid rise to power (the 'Northern Meteor') were the two principal causes of his unpopularity. Opposition propagandists were left with the task of accounting for his secure position as favourite. Walpole's status as first minister had been, comparatively, easy to explain: his long and checkered progress towards supremacy; his patiently created system of corruption; his careful nurturing of the friendship of the Queen Caroline and Lady Wallmoden. This explanation ignored the most important consideration: that the King had given full support to his minister. Again in 1761 and 1762 the Opposition polemicists hesitated to state the obvious: Bute enjoyed the confidence of George III.

Another device had to be found. Some sinister influence was at work, enabling Bute to hold his high position in closet and court. With relish the popular satirists fell back upon the old rumours bruited about Bute's supposedly illicit relationship with the King's mother.

Princess Augusta enjoyed little popularity after the accession of her son. A domineering, strong-willed woman who stood at the centre of Leicester House politics in the 1750s, she continued, as many believed, to exercise influence after 1760. She loved power. In *The Scotch Broomstick & the Female Beesom* [Plate 103] she says to Bute: '. . . the rusian bear is not more carniverous I love power as well as she.'[81] Bute and the Princess are an inseparable duo of power in the prints. 'No Scotch politicks, no petticoat government' became a popular street-cry; the jackboot and the petticoat appeared everywhere in street demonstrations.[82] The Princess was supposed to have been Bute's mainstay. *A View of the Origin of Scotch Ministers & Managers* [BMC 4023] shows two devils, flying in the air, holding a large petticoat, and shaking out its contents. Various persons tumble from it, including Bute. Bute and the Princess, together, it was supposed, held a monopolizing

[81] Elizabeth, Empress of Russia, who died in 1762. James Townsend, Member for West Looe, said in a Commons debate of 1771: 'There was an aspiring woman, who, to the dishonour of the British name, was allowed to direct the operations of the despicable Ministers of the Crown. . . . It is the Princess Dowager of Wales. I aver we have been governed ten years by a woman.' Quoted in *A Prime Minister and His Son. From the Correspondence of the 3rd Earl of Bute and of Lt.-General the Hon. Sir Charles Stuart, K.B.*, ed. The Hon. Mrs. E. Stuart-Wortley (London, 1925), p. 58.

[82] 'Jack-Boot' a pun on Bute's name.

influence on the King. In *Tempora Mutantur* [Plate 107] they stand closest to George III on his throne.

Bute's friendship with Princess Augusta began in 1747, when he was introduced to her and Frederick, Prince of Wales. He became Groom of the Stole in 1751 and remained attached to Leicester House after the death of Frederick. Malicious insinuations and gossip about Bute's relationship with the Princess probably began in the 1750s; there is no evidence of it, however, in the satirical prints of those years. Later, after the Princess's complete retirement from public life, Bute's frequent attendance at Carlton House, clumsily effected by secretive entrances at the side door in the evening, added fuel to the fire. Whether or not their relationship was illicit will probably never be determined.[83]

Gossip in this vein provided the substance for the most outrageous attacks upon the minister. The *North Briton* cautiously raised the subject in essays on Roger Mortimer, favourite to the Queen Mother Isabella in the early years of Edward III's reign. The parallel to Bute seemed obvious. Jonson had written a play, entitled the *Fall of Mortimer*, which was now remembered.[84] Bute was sometimes called 'Mortimer' in the prints.

Wilkes probably pursued the subject, confident that the government was unlikely to risk the notoriety that a prosecution for seditious libel might produce. Graphic satire—never chary of obscenity—went much further. Many of the most salacious prints survive. Some quite ignore any historical guise and deal explicitly with the supposed relationship:

> Bra' *John o' Boot* was a bonny muckle Mon,
> Fra' *Scotland* he came wi his Broadsword in his Hand,
> He came at the Head of a bra' bonny Clan
> Who the De'el cou'd his muckle *muckle Suit* withstand?

[83] 'The late Prince of Wales, who was not overnice in the choice of ministers, used frequently to say that Bute was a fine showy man, who would make an excellent ambassador in a court where there was no business. Such was his Royal Highness's opinion of the noble earl's political abilities; but the sagacity of the princess dowager has discovered other accomplishments, of which the prince her husband may not perhaps have been the most competent judge.' James Earl Waldegrave, *Memoirs from 1754 to 1758* (London, 1821), pp. 38–9. There is no tangible evidence, however, to prove anything improper in their friendship.

[84] A new play, entitled *The Fall of Mortimer. An Historical Play Dedicated to the Right Honourable John Earl of Bute* (London, 1763) was published. See the *North Briton*, 3 July 1762.

> He looked so neat,
> And he kissed so sweet
> That a *Dame of Renown* soon gave Ear to his Suit.[85]

The goat as a symbol of lust appears frequently; it signifies one of the two bases of Bute's power in *The Colossus* [BMC 4178, Plate 122]. In *Multum in parvo or A New Card for a Scotch Courtier* [BMC 4078][86] a print similar in design to *The Fire of Faction* [Plate 114], a goat with long horns and a jackboot rides a she-goat that has the head of the Princess.

At least two prints were published with the clever device of an impression on a semi-transparent piece of paper, through which a second design underneath can be seen. One of these, *The Curtain* [BMC 3824],[87] shows a room interior; in its centre is a large curtain or screen, in tartan pattern, through which Bute and the Princess can be seen, standing close together. The latter says: 'My dear Sawney Il never give out, lets dance away.' In the outer room are two Englishmen who comment: 'Upon my Honour he plays Scotch tunes finely,' '& therefore he is sure of preferment.'

In *The Highland Seer, or The Political Vision* [BMC 3867], Bute is half-seated, half-reclining on a bed, with a look of terror on his face. The objects of his fear are five apparitions who appear before him, the ghosts of favourites Peter des Roches, Hubert de Burg, Robert Devereux, and Mortimer, together with Simon de Montfort. The last warns Bute: 'Let not ambitious Love thy Heart ensnare,/ Lest thou the Fate of *Mortimer* should share.' From behind the drapery of the bed comes the voice of the Princess: 'Fly, Sawney, to the Middle of Wallachia & in its Blissful Vales forget your Fears.'[88]

Much of the obscenity of this satire was crudely disguised in double meanings and puns. *The Scotch Broomstick & the Female*

[85] *The Masquerade; or the Political Bagpiper* [Plate 106].

[86] In *The Opposition* [BMC 4036] Bute rides on a she-goat, with a likeness of the Princess for its head; she, more than Bute, is associated with lust.

[87] Part of the impression is coloured. *Sawney Discover'd or the Scotch Intruders* 1760 uses the same device. Again, Bute and the Princess are half-seen through a screen. They intimately caress each other. Scots outside eagerly await their preferment.

[88] Wallachia was a province in eastern Europe coveted by the Austrian empire. The inventor of the print may have wished to suggest the Princess's German origins (Saxe-Gotha); or, perhaps, make a comparison to Maria Theresa, known for her ambition and domineering ways (see above, p. 181). 'Sawney' or 'Sawnie' is Scottish dialect for 'Sandy' and is a national nickname.

Beesom has Bute and the Princess riding in the air, at the top of the design. Both the broomstick and the besom (the bundle of twigs on a broom) carry obvious sexual connotations. A Scottish cupid at the left blows on his bagpipe: 'Oh! the broom the bony, bony broom, with broom-stick stout and strong.' A group of figures watching from below make ribald comments. One Scottish lady asserts: 'I have besome enough on my heath, if I coud [*sic*] but procure so fine a handle.' Another lady studies Bute closely: 'I can see it through my fingers, but I shall know its dimensions better when its brought closer.' A man pointing at the Princess says: 'Theres a road, thro bushy park.'[89]

Bute's 'bagpipe' and 'jack-boot' had the same meaning as the broomstick. In *The Triumvirate & the Maiden* Bute and the Princess are walking in from the right; Bute points at three persons (the Opposition triumvirate of Pitt, Newcastle, and Cumberland) and says: 'By my Sol but I've a mind to put my Boot to their Arses.' The Princess responds: 'I shou'd [not] mind what you do with the Boot so as you preserve the Spur for me.'

Best of all was the sobriquet, the 'staff of Gisbal'. Beneath a canopy at the lower right of *Gisbal's Preferment* sits the Princess, dressed as she usually is in low-cut bodice and stomacher, finely trimmed hoop-skirt, with a necklace. Her ladies in waiting are gathered about her. They all view the figure of Bute, who stands to their left. The Princess avers: 'My Palace and Lofty roof be thine, thine be also the Care of my Household.' The ladies talk explicitly about Gisbal's 'staff'. One says: 'Never was Such a Staff seen in Israel.' Another: 'What a ravishing Length.' To which the Princess adds: 'It moves me greatly.'

In *The Montebank* [BMC 3853][90] Bute stands on a platform and tells his countrymen gathered beneath him how he found a cure for the itch:

. . . having a gued Staff to depend upon, I resolv'd to travel into ye South, to seek a Cure [for the Itch], By my Saul Laddies, I tell ye truly, I went round about, & I thank my gued Stars, I found a passage through Wales which conducted me to au ye muckle Places in the Land, where I soon got Relief and straightway commenced Doctor, for ye Benefit of my sel, & Countrymen.

The *reductio ad absurdum* of this explanation of Bute's political

[89] Bushy Park, a royal game preserve and residence near Hampton Court.
[90] In this print Smollett appears as Bute's 'zany'.

success is the notion that he owed it all to his sexual prowess and physical endowments. *Gisbal, Lord of Hebron* [BMC 3848], whose design is a three-quarter-length portrait of Bute, contains verses at the bottom which tell the story, in mock epic, of the staff of Gisbal:

> Thou Spirit of Ossian, great Son of Fingal,
> Assist me to sing of the Staff of Gisbal!
>
>
>
> When this notable Chief of the Hebronites Land
> Before Bathsheba stood, with his Staff in his Hand,
> The Damsels around her cry'd out, one and all,
> 'What a *wonderful* Staff is the Staff of Gisbal!'
>
>
>
> If Madame Pompadour had this Prodigy seen,
> She'd have own'd it was fit for the Use of a Queen;
> And that Louis le Grand, with his Baton Royal
> Was less *magnifique* than the Staff of Gisbal.
>
>
>
> Entombed with his Fathers where Gisbal lies rotten,
> Though worn to a *Stump*, it shall ne'er be forgotten;
> As a *Trophy* we'll bear it to Westminster Hall,
> And hang up the *Remains* of the Staff of Gisbal.[91]

Such prurient verses were graphic satire's vulgar way of ridiculing Bute's great renown as a man of comely figure and grace.

Lord Bute, when young, possessed a very handsome person, of which advantage he was not insensible; and he used to pass many hours every day, as his enemies asserted, occupied in contemplating the symmetry of his own legs, during his solitary walks by the side of the Thames.[92]

The prints in general draw attention to Bute's theatrical airs and the stiff formality of his carriage. In *The Colossus* the viewer is made aware of the just proportions of his body and his shapely legs. Bute's kilt and posture in *The Caledonian Pacification* [Plate 109], attracts attention to Bute's legs. In *The Scotch Ovation; or, Johnny Boot's Triumphal Entry into the City of Gutland* [BMC 3817] Bute rides in a carriage; he sits in such a way as to draw the viewer's eyes naturally to his legs.

[91] For Stephens, the editor of the *Catalogue*, these verses proved too indelicate to transcribe. He includes only a few of them: 'Below the design are the motto and objectionable verses beginning . . .', vol. iv, p. 58.

[92] Sir N. W. Wraxall, Bart., *Historical Memoirs of My Own Time* (Philadelphia, 1845), p. 148.

Bute did not present an easy subject for the designers to carica-
ture. He was, as the Ramsay portrait shows,[93] quite handsome.
Though his formal attire covers most of his body, the parting of
the robes and the crossed legs are definitely intended for effect.
His face is thin and—because of the style of wig—distinctly oval.
A high forehead, thick brows, a shapely mouth and nose, and a
soft, gentle expression in his eyes are most characteristic. His
hair-piece is in the short and close tye-wig style.[94] There is little
in his physical person to mock, distort, or exaggerate.

The Bute of the prints is a rather colourless personality, poorly
or faithfully depicted, depending on the abilities of the draughts-
man. *The Colossus* has the truest likeness of him. One of the poorest
is the crude, etched figure in *Gisbal's Preferment*. More typical is
the Bute atop the tree in *Scotch Paradice a View of the Bute[eye] full
Garden of Edenborough* [Plate 118]: a diminutive figure, almost
boyish, with tiny features.

There are some better studies, that give life and personality to
the subject. The half-naked Bute in *John Bull's House sett in
Flames* [Plate 108] is a grotesque image; thin and bony, with
dishevelled hair, but not unlike Bute. The figure In *Jack After-
thought or the Englishman Display'd* [Plate 119] makes a lovely
theatrical pose; he wears a plumed bonnet (a bonnet with plume
or cockade is a common accoutrement), tye-wig, and his
features include a broad nose and mouth and prominent brows.
The Laird of the Posts [Plate 105] gives Bute a distinctive but
wholly unappealing and probably inaccurate Roman nose. *The
Congress; or, a Device to lower the Land-Tax* has a fine caricature,
with Bute in a walking pose. He wears a plumed bonnet and con-
ventional dress (though with a tartan scarf). He makes a gawkish
figure, with thin, slightly bowed legs. He has an angular head,
with high cheek bones, thick brows, and a 'ski-jump' nose. The
caricature in *The Wheel of Fortune or England in Tears* [Plate 121]
is similar. Bute sits on top of Fortune's wheel, abusing Fortune
with his left hand and—with his breeches pulled down—farting on
Britannia below.

[93] See Plate 3, a copy of No. 1 in the *Catalogue of Engraved British Portraits*
i.305; Ramsay's portrait, done in 1760, served as the model for most of the engraved
portrait studies. Both the painting and the Ryland print were altered, after Bute
became a Knight of the Garter (the substitution of Garter for Thistle regalia).

[94] The tye-wig is sometimes difficult to distinguish from the simple toupee with
side curls.

Bute's character was more colourless than his person; he seems to have hardly lived up to the indictment of his enemies:

to his Prince a tutor without knowledge, a minister without ability, a favourite without gratitude! the very anti-genius of politics; the curse of Scotland; the disgrace of his master; the despair of the nation; and the disdain of history.[95]

He was an aloof and retiring person, not readily given to any strong expressions of feeling, of some intelligence but not much strength of character.

Save for a few allusions to his proclivity for masquerades and architecture,[96] the prints treat him as a conventional stereotype: the overgrown minister of power. He shares, in this context, all the vices of the ministerial craft: ambition; pride; deceit. As in the case of Walpole, vanity and ambition were especially emphasized. Again, ridicule and hostility greeted a seemingly unwarranted admission to the Garter. Bute became a Knight of the Order in 1762, after going to the Treasury. He was knighted at the same time as Prince William (George III's brother). English nativism, if not snobbery, was outraged. The honour became a symbol of excessive and unnatural favouritism. *The Magical Installation or Macbeth Invested* [BMC 3896] shows Bute at the extreme right, in contemporary dress and the Garter riband across his chest. He reaches up to grab a sceptre. At left are the three witches of Shakespeare; one says to Bute 'Henceforth be *Knight*—the first that ever graced the Scottish Annals.' Below are these audacious verses in hieroglyphic:

Deluded by [witch]craft, Re[bell]ion and Pride
Macbeth even [Death] and Damn[ace]on def[eye]d:
As Shakespear h[ass] told us the fat[awl] disaster,
The Thane was a [favour]ite, who murdered h[eye]s Master.

.

And oft a good [King] like a Victim has bled,
That his [crown] might devolve [toe] a proud Re[bell]'s
 [head].[97]

[95] 'A Portrait, Drawn in the Year 1776', found in [J. Almon], *Anecdotes of the Life of the Right Honourable William Pitt, Earl of Chatham; and of the Principal Events of His Time . . . to the Year 1778* (3 vols., London, 1796), i.474.

[96] *Its all of a Peace, or French Leuisdors for English Bricks* and Plate 106.

[97] The last rebus shows a traitor's head on a pike.

The Windsor Apparition, or the Knight of the Blazing Star. A Song [BMC 3897] shows Bute in tartan coat and Garter regalia, ready to be invested. The ghost of Edward III appears before him. Britannia and Prince William stand together at the right.

> And shall *Dastards* like these, the stern Monarch rejoin'd,
> Receive the Reward for true *Valour* design'd?
> Forbid it, ye Pow'rs, that my grand *Institution*
> Should ennoble a Scot who deserves ———.[98]

The print concludes with this epigram: 'A Clown in his dress may be honester far,/ Than a Courtier who struts in his *Garter* and *Star*.'

The interest and attention of the prints were scarcely directed to more serious issues. They reveal nothing about Bute's supposed harbouring of 'autocratic' notions and the young King's inculcation of them.[99] Any associations with Jacobitism come from the coincidence of Bute's name and the accident of his birth. *A Prophecy The Coach Overturn'd, or the fall of Mortimer* [BMC 3966] includes in the left background two Scotsmen, one of whom is the Young Pretender. He watches the attack on the ministry's coach and warns: 'My Laird had better make a Retreat, as I did in A—.'

Nothing is said in the prints about any intentions of reform or changes in the political system; much of Leicester House theory about royal independence and virtue in government is used against Bute and on behalf of the Opposition. In this the prints remained consistent.[100] The prints indicate nothing about the rebirth of 'party' or the revival of Toryism; the designations of 'Whig' and 'Tory' are almost completely absent.[101]

There were, of course, the usual charges about ministerial

[98] The print contains a footnote: 'The Author's Manuscript having unluckily fallen into the Dripping-pan during his Absence, was seized upon by the eternal Cat, who had actually devoured the last Word entirely, when the timely Intervention of the Printer's Devil, who came at that Instant for the Copy, happily rescued the Remains from the voracious Jaws of that Animal.'

[99] The myth about George's tutors and the teachings of Bolingbroke did not become part of the folklore of the period until Horace Walpole's *Memoirs* were published, some eighty years later.

[100] Above, chap. v.

[101] The print mentioned in footnote 78, with the portrait studies of Bute and Wilkes, has verses in which Wilkes says: 'I'll be true to Old England, the Whigs, and the King.'

tyranny and oppression—perhaps more than in the past. *The Vision or M–n–st–l Monster* [Plate 117] is the best graphic expression of this idea. But the charges are not new. *The Triumphal Car or Scota's—Victory 1762* [BMC 3846] is similar in metaphor and idea to several of the anti-Walpole prints. The design shows Bute, the Princess, and George III (with a child's rattle) riding in a coach, that rolls over Magna Carta, trade laws, the broken staff and cap of Liberty, and the ensign of the City of London. *The Wheel of Fortune* [Plate 121] has a personification of 'Monopoly & Oppression', holding money and a sheaf of wheat, and trampling on the poor: 'A fart for the Gallows and a fig for the Law. I've Money enough to bribe them all.'[102] Bute says: 'Mind your duty Mon, and let your P–m–t be such as I order you to chuse, Fortune is on my side and a fart for you all.'[103]

The Politicians, concerned primarily with the peace settlement, indicates that arbitrary power was an issue. Near the centre of the design two gentlemen are talking; 'Mr. Macdonald, will you undertake to write me a short Remonstrance against Arbitrary Power?' The other responds: 'By my Soul, Sir, I Canna do it, for fear of offanding his Lairdship, for ye ken he's a Mon o' muckle Authority.'

The liberty of the press became an issue; it had been raised thirty years before, during the struggles for survival of the *Craftsman*. The prints of 1762–3 consider the issue more frequently and special attention is given to the press warfare of the period. The struggle of Government and Opposition is often seen in terms of *Briton* versus *North Briton*, *Auditor* versus *Monitor*.[104] Churchill and Wilkes are as much heroes as Pitt and Cumberland. Charges that Bute was persecuting the press were made before April 1763 (largely unfounded),[105] but the *North Briton*, No. 45 and the general warrant transformed the issue and gave real meaning to the old, stale charges of dissent. *The Political Mouse-Trap; Or, A Great **** in an Uproar* [BMC 4067], published in the autumn of 1763, shows Bute about to assault a supine, exposed Britannia, only to be alarmed by a tiny mouse (i.e. Wilkes).

[102] Compare this personification with that of 'Bribery & Corruption' in Plate 35; the latter is an alluring and dangerous strumpet, the former is a crude, repulsive, and brutal male.

[103] Bute's corruption and domination of Parliament is rarely a subject for the prints. [104] e.g. *The Scotch Butt or the English Archers* [BMC 3956].

[105] See above, chap. iii.

Charges about ministerial oppression first received impetus when a new tax upon cyder and perry was included in Grenville's budget of 1763. The measure immediately became—in popular outcry—Bute's act, and was attacked as a further extension of the excise laws. All the bugbears of 1733 revived. A fresh stream of calumny ushered Bute from office.[106] *The Roasted Exciseman or The Jack Boot's Exit* [BMC 4045] shows him in tartan kilt and stock, strung up on a gallows, with a sign inscribed 'For giving a stab to Liberty.' The effigy holds two bags, marked 'Bribery 300,000£' and 'Corruption 500,000£'. A fire, with a jackboot amidst the flames, burns beneath him. Britannia, with the Cap of Liberty, and Cumberland watch approvingly. *The Seizure. or give the Devil his due* [Plate 120], consisting of two designs, is similar. Bute hangs from an apple tree, while his effigy, with jackboot, burns in the fire; the apple farmers celebrate. The scene entitled 'Resignation' shows Bute pulled away by a devil to the fires of Hell. The Princess, wearing a dress with low-cut bodice, laments his departure; there are the usual obscene overtones to the inscriptions.[107]

> He who your *Magna Charta* sold,
> Old *Nick* at last has got in hold
> And swears he'll send him, with all speed
> Across the *Styx* instead of *Tweed*.
> While *Madam's* Tears too plainly tell
> She mourns his loss who *Pip'd* so well.

Bute resigned from office in April 1763. Though his political career was finished he remained a public figure for several years: the bogy of 'secret influence'. In this capacity he continued to be a character in the prints. *The S— Puppitt Shew or the whole Play of King Solomon the Wise* [BMC 4049][108] reveals a stage on which are five puppets, including the King, the Princess, Fox, and Grenville. Fox professes: 'We're first Rate Actors in the Shew.'

[106] Indicative of his great unpopularity and the effectiveness of propaganda is the way in which a small fiscal matter, of economic consequence only to a minority of farmers in the western counties, was turned into a controversy that could stir up the rabble of the metropolis. The affair suggests, as well, the eighteenth-century Englishman's inveterate hatred of the very word 'excise'.

[107] The Devil says: 'I'll soon Spoil your Pipeing I warrant you', to which Bute replies: 'O Spare my Monhood, and I'se gang quietly.'

[108] Probably published in late April or early May 1763.

Bute, dressed in Highland attire, holds back the curtain at left: 'Tho I am out it's known for Certain,/ I prompt 'em still behind the Curtain.' Behind the curtain at right is the Devil: 'The Devil in Time will have his due.'

Bute's continued friendship with the King and his attendance at Carlton House helped spawn the rumours about secret influence. For graphic satire the notion was merely a variant of the screen metaphor, used against Walpole in 1742 and 1743. The logic of conventional lore could not accept the retirement of an evil and hitherto all-powerful minister as entirely free of suspicion. This familiar prejudice was the original germ of the idea of 'double cabinet' in Burke's ingenious and fanciful *Thoughts on the Cause of the Present Discontents.*

CHAPTER VIII

Pictorial Characters

Ideographs and setting belong to the stagecraft of the prints; the great men of the day are their *dramatis personae*. Much of the charm and interest of eighteenth-century graphic satire is found in the public figures—most depicted in varying degrees of anti-pathy or derision—that come before the eye. Inventors and draughtsmen were clever, amusing, and often quite perceptive in their studies of contemporary statesmen. They not only employed stock conceits and procrustean stereotypes, but also—in freer fashion—captured the individualities and eccentricities of men within the graven image. The best of these studies deserve the name 'pictorial characters'.

Character sketches, like emblem books, had been a popular literary fashion in the seventeenth century. A close relative of the allegorical *exemplum*, the 'character' served didactic purposes. Characters were 'collections of descriptive notices of various characteristic types and fashions of men'.[1] They dealt with types: the elucidations of those features which a man shares in common with others of a category of men. The character books of Over-bury, Earle, and Hall were, for the most part, collections of social and moral stereotypes: the devilish usurer; the idle gallant; the grave divine; the courtier; the busybody; the country gentleman.[2] The literary merit of the sketches depended on the conceits and the efficiency of the prose: a 'quick and soft touch of many strings, all shutting up in one musical close. . . .'[3]

The word 'character' gradually acquired a wider meaning—or a variety of meanings. The historical character, a brief description and assessment of an actual individual, appeared frequently in the pamphlet literature of the second half of the seventeenth century.

[1] Haliwell's definition, quoted in Richard Aldington (ed.), *A Book of Characters* (London, n.d.), p. 1.

[2] On the subject of seventeenth-century characters, see the above and Henry Morley, *Character Writings of the Seventeenth Century* (London, 1891); Gwendolen Murphy (ed.), *A Cabinet of Characters* (London, 1925); Isobel Bowman (ed.), *A Theatre of Natures: Some XVII Century Character Writings* (London, 1955).

[3] Sir Thomas Overbury's definition, quoted in Aldington, p. 167.

This meaning of the word became generally accepted in the eighteenth century, particularly as it applied to distinguished or well-known persons. The 'sketch' of a specific individual replaced the wholly impersonal stereotype. This change was in part owing to the influence of French writers, like La Bruyère, who disguised their satirical shafts within descriptive types, sometimes given classical pseudonyms. *A Collection of Modern Statues and Caracters* [BMC 2829, Plate 61][4] shows this influence. Statues of venerated ancients and moderns decorated many eighteenth-century gardens.[5] The print shows, arranged in a semicircle, the statues of seven 'illustrious' politicians of the day, each given a classical pseudonym. Neither the statues nor the 'caracters' beneath pretend to any artifice of impersonality. The figures are realistic portraits. The character sketches, though brief and pungent, leave little doubt as to their subjects. The aged figure of Bolingbroke, in the pose of a writer, carries the name of 'Proteus': 'has changed Sides almost as often as he has shifted Cloaths, without being much the better for any, the greater Part of his Life spent in a Variety of Follies and Extravagancies. . . .'

The more character came to mean the moral and mental constitution of a given individual, the more difficult it became to distinguish a character from a portrait, or character from caricature. A technical distinction would show portraits to be concerned with individuality, as characters were with typal features. In practice the two skills became mixed: the character sketch concerned itself as much with the eccentricities and peculiarities of the person as it did with the measurement of a man's constitution by objective norms.

The graphic character must differ somewhat from its literary counterpart. It cannot rely (or at least limit itself to) verbal skills: the well-turned phrase, the witty conceit, the clever epigram. The limitations of the medium demand even greater abbreviation. But in the effectiveness of this abbreviation is its great appeal. The character built upon the apt use of conventional symbolism and caricature takes the sense of the word back to its origins: to engrave, stamp, or provide with a distinctive mark:

[4] The spelling suggests that the draughtsman of the print was of French extraction.

[5] The most famous, perhaps, is the 'Temple of British Worthies' at Stowe, the Cobhamite Patriots' ironic satire on Robert Walpole.

'taken from an Egyptian hieroglyphic, for an impress, or short emblem; in little comprehending much . . . it is a picture . . . quaintly drawn, in various colours, all of them heightened by one shadowing.'[6]

The graphic characters discussed in this chapter are pictures 'quaintly drawn' of three eminent men, in their public capacities, their several parts, ruling passions, outstanding virtues and vices, and the peculiarities of body and nature. Both stereotype and individuality have their place. The latter is perhaps subsumed in the former. Newcastle, Fox, and Pitt—like Walpole and Bute—fall victim to the prosaic dicta about evil ministers and virtuous patriots.

Eighteenth-century divines described the Deity in terms of His attributes: power, wisdom, and goodness. Governance by man, justly based, consisted of power directed by wisdom and virtue. This trinity constituted the proper exercise of authority.[7] Any minister, by definition, was as deficient in wisdom and virtue as he was excessive in the possession of power ('that nobody who approached the King had sense and virtue').[8] The major theme in the anti-Walpole and anti-Bute satire is the 'first minister' who holds an excess of power. The satire dealing with Newcastle and Fox changes the emphasis. They were, for the most part, 'half ministers'. The latter never attained, the former only briefly and tentatively, the zenith of power. So, instead, the satirists pointed to Newcastle's lack of sense and Fox's lack of virtue. Fools and knaves at the helm of state were as worthy of censure as overgrown monsters of power.

William Pitt moved in a different orbit. He came as close as any contemporary to the role of 'patriot': possessed of a plenitude of virtue and wisdom, though for long denied the power for its use. Yet he too, on taking office, incurred the onus of another stereotype: 'sham patriot'.

[6] Overbury, quoted in Aldington, p. 167; Richard Flecknoe in his 'Author's Idea of a Character' said 'Tis a *Portraiture*, not only th'*Body*, but the *soule* and *minde*; whence it not only delights but teaches and moves withall. . . .' Murphy, p. 267.

[7] 'The *Romans*, after the great *Revolution* of their Government, had too little Virtue to be kept in Awe *by Authority* without *Power*, and too much to be kept in Subjection by *Power* without *Authority*. . . . *Authority* is *Power* founded upon *Opinion* of *Virtue*; *Power* is *Authority* arising from *Possession* of *Office*.' Old England: or, The Constitutional Journal, 4 Feb. 1744.

[8] Quoted in Horace Walpole, *Memoirs of the Reign of King George the Second*, ii. 70.

1. *'Tom Chat-enough'*

Thomas Pelham-Holles, Duke of Newcastle, served three sovereigns in high office for over forty years. He was the most enduring English politician of the eighteenth century. The opinions of contemporaries and the judgements of most historians seem to indicate that no man had as little excuse for political longevity. Survival of the fittest is not necessarily survival of the best.

George II complained that Newcastle 'was unfit to be Chamberlain to the smallest court in Germany'.[9] Horace Walpole, the first maker of Newcastle's unsalubrious reputation, had nothing but contempt and aversion for the man: 'he was a Secretary of State without intelligence, a Duke without money, a man of infinite intrigue, without secrecy or policy, and a Minister despised and hated by his master, by all parties and Ministers, without being turned out by any!'[10] Smollett, another backbiter, delighted in castigating the Duke in his picaresque tales. *Humphrey Clinker* contains a rancorous satire on one of Newcastle's levees, in which his victim's unctuous behaviour and absence of mind are put on display.[11] Newcastle appeared a 'comedian, hired to burlesque the character of a minister',[12]

The historiography of the nineteenth century did not raise the Duke's reputation any higher; Newcastle became the embodiment of corruption, incompetence, and mediocrity. Lecky, though striking a note of fairness in judging Newcastle's character, none the less saw 'the most peevish, restless, and jealous of men, destitute not only of the higher gifts of statesmanship, but even of the most ordinary tact and method in the transaction of business, but at the same time so hurried and undignified in manner, so timid in danger, and so suffering in difficulty, that he became the laughing stock of all about him'.[13]

Historians of the Namier school have in the last few decades

[9] Lecky, *History of England*, ii. 346.

[10] Walpole, *Memoirs of the Reign of George the Second*, i. 166. See George L. Lam, 'Walpole and the Duke of Newcastle', *Horace Walpole: Writer, Politician, and Connoisseur. Essays on the 250th Anniversary of Walpole's Birth*, ed. Warren Hunting Smith (New Haven, Conn., 1967), pp. 57–84.

[11] Tobias Smollett, *The Expedition of Humphrey Clinker* (2 vols., Oxford, 1925), i. 155. Smollett was a hireling of Bute's and a man of Tory sympathies.

[12] Ibid., p. 161.

[13] Lecky, ii. 346.

attempted some revision.[14] John Owen argues that Newcastle was honest, knowledgeable in foreign affairs as well as in domestic politics, and endowed with a fund of common sense—all virtues that were largely hidden by the eccentricities of his personality.[15] Namier's withering analysis of Newcastle is, however, only deprecation of another sort, using the weapons of modern psychology: the picture of a compulsive neurotic, torn by self-affliction:

His nature and mind were warped, twisted, and stunted, and his life must have been agony, though he perhaps did not clearly realise how much he suffered . . . with an abundant substratum of intelligence and common sense, he looked a fool. . . . There probably never was another man in a position outwardly so great who felt so wretchedly poor in soul. . . . He was not equal to greatness and success, and paid a heavy price for them.[16]

There was an element of self-mortification, perhaps, in his sacrifices in public life: 'all one can say is that he was unable voluntarily to leave his treadmill.'[17]

Contemporary political prints, by and large, confirm the old picture of a ridiculous, folly-ridden buffoon. Chesterfield, fairest of all Newcastle's contemporaries, said that public opinion put him below his level. The prints, reflecting public opinion, certainly did not raise it.

Newcastle fell victim to all the enduring platitudes, hurled at every minister. Specific truth can, however, perhaps be found in the nuance. How differently was Newcastle treated? What weaknesses were probed and exposed? Graphic satire discovered his character in colourful and sometimes convincing ways.

Newcastle had been in office for twenty years before he became a prominent figure in the prints. The years as hanger-on to

[14] Anticipated, to a certain extent, by D. A. Winstanley, before the First World War, in his *Lord Chatham and the Whig Opposition* (Cambridge, 1912).

[15] Owen, *The Rise of the Pelhams*, p. 128.

[16] Sir Lewis Namier, *England in the Age of the American Revolution* (2nd edn., rev., London, 1961), pp. 68–9. Namier, in his review of *Some Materials towards Memoirs of the Reign of King George II*, ed. Romney Sedgwick, confessed: 'There is something very peculiar about that period in the way it affects us who work on it; when Sedgwick and I meet, we talk eighteenth-century gossip, and tell each other funny stories about the Duke of Newcastle, and laugh at the old man whom, somewhere at the bottom of our hearts, we both love.' 'The Memoirs of Lord Hervey', *Crossroads of Power: Essays on Eighteenth-Century England* (London, 1962), p. 157.

[17] *England in the Age of the American Revolution*, p. 83.

Walpole afforded him considerable anonymity, for the attention of the prints rarely extended beyond the characters who occupied front and centre stage. Walpole provided target enough. *The Court Monkies*, etc.,[18] a collection of satirical verses with frontispiece, published in 1733, does make passing mention of the Duke:

> His *trusty Grace*, that *Northern Son of Fame*,
> Whose Parts extend but to *subscribe His Name*.

Not until Walpole's fall does attention turn to the longtime Secretary of State.[19]

The Newcastle prints of the 1740s are studies of the two Pelham brothers together. They abuse the King in *A very Extraordinary Motion* [Plate 55]. Amused, they watch together the unsuccessful attempts of Bath and Granville in *The Noble Game of Bob Cherry* [BMC 2850, Plate 63], a satire on the ministerial crisis of 1746.[20] Together they desecrate Britannia in *The Conduct, of the Two B*****rs* [Plate 70]. Horace Walpole compared them to Castor and Pollux.[21] In appearance it is sometimes difficult to distinguish them: Tweedledum and Tweedledee. Only Newcastle's Garter riband and star identify him. In *The Grand Conference*, etc. [Plate 72] however, Pelham's robust figure and placid countenance offer a noticeable contrast to the thinner visage of the Duke.

The satirists were kinder to Henry Pelham. He seemed, at least, a minister of the mettle of Walpole. *His Arrival at his Country Retirement & Reception* celebrates Pelham's death in 1754;

[18] *The Court Monkies. Inscrib'd to Mr. Pope* (London, 1734). The frontispiece is BMC 2026.

[19] There is no suggestion in the prints that Newcastle betrayed Walpole in the latter's fall (the supposed origin of Horace Walpole's grudge).

[20] When the Pelhams and their corps resigned their places, Granville (formerly Carteret), possessing the King's favour, attempted to form a ministry. The attempt was unsuccessful. This print depicts the failure of Granville and his cohorts to obtain and, more importantly, hold office. The pictorial metaphor of the print is the game of bob cherry—'A children's game, consisting in jumping at cherries above their heads and trying to catch them with their mouths.' Alice B. Gomme, *The Traditional Games of England, Scotland, and Ireland* (2 vols., New York, 1964), i. 41. The offices are 'cherries' hanging from the signpost of the 'Crown' tavern in front of St. James's Palace.

[21] A satirical illustration to *Memoirs of the Last Ten Years of the Reign of George the Second* [BMC 3728]. In Greek mythology Castor tamed wild horses; Pollux was an agile boxer. It would be an attractive interpretation to see Walpole implying Newcastle's abilities to keep placemen in line, and Pelham's dexterity in Commons, but it is doubtful whether he intended the allusion to be carried so far.

employing a conventional theme, the print shows the deceased led by demons into the depths of Hell, there to be greeted by his illustrious predecessors including Wolsey and Walpole. The latter hails him: 'O This is a Child of my own bringing up I found him a promising Genius for dirtty [*sic*] Work Therefore did all I could to gain him the Succession at my Retirement hither.'

> *Tom* was the eldest of the Pair,
> Him Fate ordain'd the Booby Heir;
> *Harry* was youngest of the Twain,
> The deftest Lad in all the Plain;
> They both were early put to School,
> Where soon 'twas known which was the Fool.[22]

While 'Tom' inherited the family fortune, titles, and their attendant influence, Henry had, with agility and application, to work his way to success.

Newcastle's association with his brother still provided him with a degree of anonymity in the prints. Not until he succeeded Pelham at the Treasury did Newcastle become a distinct personality. The fiascos of the war, the Byng tragedy, and the frustration of the popular militia bill brought much odium and ridicule— some of it in Townshend's card caricatures—down upon him. The Duke fell heir to the usual indictments levelled at 'delinquents in high station'. There is the prevailing idea, expressed in many ways, of a selfish disregard for and indifference to the national interest. Newcastle is among those endeavouring to pull down the fabric of the state in *Britannia in Distress*, etc. [Plate 89],[23] by means of ministerial profligacy and corruption. Once again appear the accusations of temerity and back-stabbing in wartime. *The Grand Monarque in a Fright* [Plate 76] shows Newcastle trying to restrain the British lion. There are charges of betrayal and sell-

[22] *A Tale of Two Tubs: or, the B–rs in Querpo; Being a Humourous and Satirical Description of Some principal Characters that have long shone, in this Hemisphere, like Stars of the first Magnitude . . . are discover'd to be no better than stinking Meteors, engender'd in a Fog, and after glittering a-while, sink into a Caput Mortuum* (London, 1749), p. 5; the pamphlet contains a satirical frontispiece [BMC 3070].

[23] 'This Sampson of a Minister in blindness, and mere brutal strength, pulls down the pillars of the constitution, and buries himself and his fellow-subjects beneath its ruins.' *Letters on the English Nation: By Batista Angeloni, a Jesuit, Who resided many years in London. Translated from the Original Italian, By the Author of the Marriage Act a Novel* (2 vols., London, 1756), ii. 168.

out. *The Auction* [Plate 85], in which the nation's possessions—including pictures of king and country—are sold to the highest bidder, shows Newcastle, acting as a porter at the door, welcoming the buyers: 'Selling by Auction Gem'men selling by Auction.'

Newcastle, like Walpole before him, is accused of betraying his country to the French. *The Dis-card* [BMC 3421], a print celebrating the fall of his ministry, shows Britannia dismissing its head; Newcastle laments: 'Had I but serv'd my K— with half the Zeal I Serv'd my Appetite you would not now discard me.'[24] He holds in his right hand a piece of paper: 'Recd of Monr Le D— de M— the Sum of. . . .'[25] *England Made Odious, Or the French Dressers* shows Newcastle and Fox dressing Britannia in Gallic finery. Accusations of a partiality to French taste stuck with special effect to Newcastle. His extravagance and his French cooks were a source of amusement and ridicule. *The Duke of N–tle and his Cook*, a print of 1745, shows the Duke in his kitchens, presumably at his town house in Lincolns Inn Fields. His hands are raised and clasped, a look of agitation covers his face as he says to the cook next to him: 'O! Cloe if you leave me; I shall be Starv'd by G–d!'[26] French cuisine decorates a table in the centre foreground: 'Soup A la Reigne Carpe Chambour Granade de Quales Woodcocks Brains Nul of Patridges Carps Tongues Popes Eyes.'

Newcastle's prodigality and supposed love of fine things explained his French tastes. The prints made much of his taste for luxury. Justice in *The Vision: Or Justice Anticipated* [Plate 86] decrees that the Duke's 'Es–te & Si–b–d be appropriated to the payment of Foreign Subsidies and be obliged to dine every day on the Viands & Delicacies of Fee Lane . . . His Sideboard furniture to be Trenchers Woodenspoons &c.'[27] The satirists wrongly

[24] An allusion to Wolsey's last speech in Shakespeare's *Life of King Henry VIII*, iii. ii. 456–8: 'Had I but serv'd my God with half the zeal/ I serv'd my king, he would not in mine age/ Have left me naked to mine enemies.'

[25] Newcastle's subservience to French influence is usually indicated by fleur-de-lis decorating his Garter riband.

[26] In December 1745 a proclamation was issued ordering all Jesuits and Catholic priests from London and threatening enforcement of the Elizabethan and Jacobean anti-Catholic laws.

[27] 'Such wardrobes as he has . . . a set of gold plates that would make a figure on any sideboard in the Arabian tales.' Walpole to Mann, 6 Jan. 1743. *Correspondence*, xviii. 137. See Walpole's letter to Mann, 25 June 1749 (*Correspondence*, xx. 71), for a description of the sumptuousness of the festivities which accompanied Newcastle's installation as Chancellor of Cambridge University.

associated Newcastle's extravagance with cupidity and sometimes pictured him as avaricious as Henry Fox.[28]

The prints make clear, however, the striking differences in Newcastle's and Fox's deficiencies: the former was as lacking in wisdom as the latter was in virtue. This traditional distinction was carefully observed. In a print without title [BMC 3488], published by Darly and Edwards in September 1756, George II— with Newcastle and Fox standing behind him—declares: 'Hence Fools & Knaves be gone, no more offend my Sight.' *Oliver Crom[well]s S[peach] [toe] the [ass] & [fox] 1756* [BMC 3508] shows a profile bust of the Lord Protector, facing two likenesses of Fox and Newcastle; he offers the following admonition: 'Those [men] t[hat] [love] t[hare] [king] & count[rye] [shoe]d [knot] let [knave]s or [fool]s govern, [butt] let the [axe] & [halter] Re[ward] their Malead [minister]at[eye] on.'[29]

> Tom was the Dunce, his comrades tell,
> And scarce could learn to read or spell,
>
>
>
> The Master took the utmost Pains,
> But Masters cannot furnish Brains.[30]

Newcastle is consistently the dupe to Fox's knavery, though he himself plays the knave of spades in *Mons.: Dupe* [BMC 3504],[31] a card caricature of 1756. If Walpole and Pelham were wanting in public spirit, honesty, and selflessness, Newcastle was supremely lacking in wisdom and knowledge. For this reason the satirists were sometimes inclined to be less acrid in their attacks. *The Bankrupts with Anecdotes* [BMC 3429, Plate 82], a collection of five characters of the ministry, pretends to mercy in its judgement of the Duke: '. . . a great many People are Sorry for this Man, as it appears 'twas more want of knowledge that he fail'd than any

[28] See, for example, *Birdlime for Bunglers, or the French Way of Catching Fools* or *The Cole Heavers.*

[29] In these hieroglyphics the 'knave' is taken from the design of playing cards, and the 'fool' is the image of a fool or court jester.

[30] *Tale of Two Tubs,* pp. 5, 6.

[31] Newcastle is the knave of hearts in *The Court Cards or all Trumps in the present Rubbers 1756.* Britannia, as Queen of Hearts, complains: 'Must Knaves & Fools my Council guide/ And France on land & main deride.'

Design.'³² *Exit Unworthies. Enter Worthies* [BMC 3427] dismisses the Duke with a verse of consolation: 'No more thy Gracious Mind Perplex.' The prints provide few specific examples of Newcastle's ineptitude or ignorance. *The Court Fright* [Plate 53] does suggest his incompetence as a war minister. 'I'm ignorant of ye Marine' he confesses to a distraught king.

Newcastle's considerable dependence upon others attracted a great deal of ridicule: the minions who tried to cover up for the mistakes of 'Old Blunder'. One of his stalwarts was Andrew Stone, private secretary to the Duke for many years. *The Old Woman & her Ass: a Fable* [BMC 3497]³³ shows Newcastle riding his overburdened beast, which has the face of Stone: 'Thro Dirt & Mire,/ I'm forc'd to plash,/ And Patient bear, This Beldam's lash.' *The Still Birth* [BMC 3385] has Newcastle and Fox 'delivering' a progeny of French gold. Stone, watching at far right, laments: 'I have Certainly no more Brains than a Stone Block to let this Old Bitch mislead me.'³⁴

To convey a sense of Newcastle's ineptitude the satirists employed animal symbolism. Merging the image of an individual with that of a common animal not only degrades the former but associates him with the anthropomorphic qualities of that animal.³⁵ The 'ruling passion' of the character can in this way be expressed. Animal caricature is to be found in many prints of 1756. Lord Hardwicke, for instance, is often identified as a vulture. *The Vulture* [BMC 3502, Plate 87] is a simple character of the Lord Chancellor. Two pictures on the wall in the background show the overthrow of Justice and Loyalty. Hardwicke, in judicial robes, is

³² 'In fact, My Lord, the World is strangely inclined to think well of your *Heart* whatever it may of your *Understanding*.' *A Letter to His Grace the D— of N–e, on the Duty he owes himself, his King, his Country and his God, at this Important Moment* (London, 1747), p. 13.

³³ 'Shews the Deficiency of every bungling Statesman's Head-piece, who being incapable of any Thing himself, is obliged to keep a hireling Schemer, whom he is sure to load with Rubbish enough. . . .' *Political and Satyrical History*, p. 5.

³⁴ Stone was also a figure of controversy in the 1750s because of his involvement in allegations of Jacobite sympathies of the Prince of Wales's sub-tutor and sub-preceptor. There is, however, no allusion to this scandal (which was proved to be unfounded) in the prints. Designers of the prints delighted in the opportunity for puns which Stone's name provided. *Lusus Naturae. A Curious Petri-Faction* [BMC 3417, Plate 81] uses the pun for its design and offers caricatures of Fox and Newcastle. Stone is described as a 'sort of Petrified Fungus to which they adhere'.

³⁵ Above, chap. ii.

seen as his animal counterpart.[36] He stands on several bags of money () one marked 'My Soul'(), the broken sword of Justice, the emblems of Liberty, and the Bible, 'reversed'.[37]

The designers of the prints chose a variety of animals to represent Newcastle, most of them associated with stupidity and silliness. *The 3 Damiens* depicts Hardwicke as a vulture, Fox as a fox, and, in the centre, a curious figure with an ape-like chest, an ass's rear and legs, and the head of Newcastle.

Horace Walpole chose the peacock as an appropriate attribute for the Duke: a symbol of strutting vanity.[38] *The Ostrich* [BMC 3396] is a satire on Newcastle's behaviour and machinations behind the scenes after his resignation in the autumn of 1756. The design shows a half-human, half-ostrich figure, its head in the ground, its breeches down, posterior exposed: 'Ah you can't see me now I am sure.'

a sarcastical Stroke upon a late great Man, who under the Mask of a Resignation from his Office, was still playing the old Game, and imagined no Body saw through it.[39]

The most common animal symbol, however, is the awkward, hissing goose. In *The Present Managers* [BMC 3589], concerned with Pitt's abortive attempts to establish a government in 1757, Newcastle waddles in front of the new minister; he says, 'When thou art Seated on my Seat,/ Remember me, there is no Dirt but I can waddle through.'

The image of the goose was suggested by Newcastle's association with Fox in 1756, which called to mind the fables about fox and geese. The goose symbolized Newcastle's helplessness in the face of craftier colleagues. The foolishness and stupidity of the goose was proverbial. The image also conveys a sense of the

[36] Contemporary characters saw avarice as Hardwicke's greatest fault; Horace Walpole described him as 'ravenous . . . arbitrary, and ambitious', *Memoirs of the Reign of King George the Second*, ii. 218. 'Hardwicke's avarice subjected him to much obloquy: his general parsimony, and the mean economy of his table even on days of festivity, procured him the vulgar appellation of *Judge Gripus*.' *The Characters of George the First, Queen Caroline, Sir Robert Walpole . . . Lord Hardwicke, Mr. Fox, and Mr. Pitt, Reviewed*, p. 61. See the 'character' in Plate 82.

[37] Hardwicke's role in the passage of the Marriage Act earned him much unpopularity. *Null Marriage* [BMC 3522] is one satire on him.

[38] Part of the illustration mentioned on p. 233.

[39] *Political and Satyrical History*, p. 10.

Duke's restless hustle and bustle and his noisiness. Agitation was endemic to his nature.

Those hands that are always groping and sprawling, and fluttering and hurrying on the rest of his precipitate person. . . . If one could conceive a dead body hung in chains, always wanting to be hung somewhere else, one should have a comparative idea of him.[40]

Equally precipitate was Newcastle's speech: his 'confused, tangled, unconnected talk.'[41] 'Tom Chat-enough', the sobriquet in Plate 82 and a clever pun on his name,[42] ridicules his loquacious-ness. *The choice Spirits, or Puffers for Sig Mingotas Operas* [LWL][43] shows members of the 1756 ministry playing musical instruments. Newcastle, appropriately, handles the 'puff wind'. Several prints suggest a vapid senselessness in his speech. He offers a silly comment—'It comes seasonably to me at this Juncture Circum-cision or any thing'—in *The Grand Conference*, etc. [Plate 72]. Or peevish babble, as in *England Made Odious*, when he threatens Britannia: 'Hussy be quiet you have no need to Stir your Arms, why sure? What's here to Do?' Or unctuous ingratiation, as in his remark to the British lion in *The Grand Monarque in a Fright*: 'Peace Peace my brave Fellow, be quiet, rely on the equity & veracity of the most Christian King. . . .'

The goose, of course, is the female of the species; the satirists often intended to associate Newcastle with feminine characteris-tics. Many prints transform him into an old woman—the beldame —usually an old fishwife with apron and tub.[44] The image displays

[40] Walpole to Montagu, 1 Aug. 1745. *Correspondence*, ix. 22.

[41] Lecky, ii. 347. 'His vast, tumbling correspondence, millions of words in his own hand and tens of millions dictated, stretches like a vast *sudd* across the eight-eenth century', Plumb, *The King's Minister*, p. 75. A contemporary satire, *Rodondo; or, the State Jugglers, Cantos I and II* (London, 1763), asserts: 'My Lord, . . . you *drivel*, tho' in Truth/ You have but *drivel'd* from your Youth' (p. 27). The verses go on to say: 'They say your G–ce is like a *Mule,/ Ambigenous* of Knave and Fool.'

[42] A corruption of the French for Newcastle (*chateau neuf*); Newcastle is so addressed in Plate 86. Pun and *double entendre* inspired many of the pictorial con-ceits of the prints and are generally common throughout. Puns became especially popular in the 1750s and 1760s, when hieroglyphics were again in style.

[43] One of the playing-card designs.

[44] An allusion to the coincidental association of his title with Newcastle-upon-Tyne, a centre of the salmon-fishing industry. This association, with no political significance, was used in a number of prints. Newcastle was also associated with coal (and 'cole', i.e. money). The two associations of salmon and 'cole' are effectively combined in *The Cole Heavers* (see above, chap. v).

all the attributes of aged femininity:[45] silliness, childishness, jealousy, shrewishness, and especially fear.[46]

In *Harry the Ninth to Goody Mahon* [BMC 3511, Plate 88] Pelham's ghost appears before his brother, dressed as an old woman in a long dress and emaciated face, with an expression of terror on it. *Punch's Opera with the Humours of Little Ben the Sailor* [BMC 3394] has Fox as the presiding Punch and Newcastle as 'Punches Wife Joan'. The Duke is a hunched figure, wearing a dress, shawl, and an apron decorated with fleurs-de-lis. The hobbled, doting fishwife appears in *The Devil Turnd Drover* [BMC 3416, Plate 80]. He displays a helpless pique as Cerberus (closely resembling the English mastiff) bites his dress. The caricature of Newcastle's face is typical.

Newcastle's physical appearance—his face, dress, accoutrements, and manner—was thoroughly examined in caricature. The Duke was, in many respects, a walking caricature. Actual portraits, however, do not indicate this. Most of the portraits of Newcastle were done in his early years; they are not very distinctive. The oil by Kneller, *Thomas Holles-Pelham, Duke of Newcastle, and Henry Clinton, Earl of Lincoln,*[47] shows the two men seated at a table. The half-profile of Newcastle provides just a suggestion of a sharp, aquiline nose; the lips, in true Kneller fashion, are full and deeply cut; the face is expressionless.

The portrait by William Hoare, done much later in life, is more characteristic.[48] It is a half-length study, in private dress, with Garter riband and medal. The sharp features of the nose, the thin lips, and the high, thick brows are apparent.

Much better, especially for the comparison with the caricatures,

[45] Newcastle's appearance in the prints of the 1750s no doubt reflects his advancing age. 'An old superannuated Lady, who in the best of her Days was hardly capable of any Thing above the common Affairs of the Kitchen.' *The Voice of Liberty. An Occasional Essay. On the Behaviour and Conduct of the English Nation, In Opposition to M—n—st—l Oppression* (London, 1756), p. 20.

[46] Walpole delighted in anecdotes about Newcastle's phobia-ridden personality. One of the best, perhaps true, tells how the Duke was so terrified of lying in a room alone, that his footman had to rest near him when the Duchess was away. Walpole to Montagu, 5 Aug. 1746, *Correspondence*, ix. 40–1.

[47] The painting, part of the Kit-Cat Club series, now in the National Portrait Gallery, was probably done in the early 1720s. An engraving after it appears in Horace Walpole, *Reminiscences Written in MDCCLXXXVIII, for the Amusement of Miss Mary and Miss Agnes Berry* (London, 1805). Kneller painted another portrait study of Newcastle, in full Garter regalia, which is equally impersonal.

[48] In the National Portrait Gallery.

is the full profile wax relief by Isaac Gosset [Plate 4].[49] This likeness shows—with amusing grotesqueness—the beak nose, the insipid lips, the hunched, jutting head and neck of the finest caricatures.

The caricatures only become frequent in the 1750s. Most of the earlier representations show either impersonality or attempts at literal realism. One of the best caricatures, however, appeared in 1744, in *The Court Fright* [Plate 53]. Here a more youthful Newcastle wears a dark, queued, full-bottomed wig, that dangles helter-skelter on to the top of his back. The figure is stubby. A 'Punch and Judy' nose, twisted grotesquely, and a large pair of spectacles define the face. A similar caricature appears in *A Cheap and Easy Method* [Plate 51].

The caricatures of 1756, so numerous in the *Political and Satyrical History*, are of a simpler and more efficient style. The image, originated by Townshend, is fairly settled. Newcastle in the *Pillars of the State* [Plate 78][50] is characteristic. The right profile resembles Gosset's relief, with the hooked nose, the hunched head and shoulders, and the drooping physical wig.[51] The Duke holds a reading-glass in his left hand. Reading-glass and spectacles seem to have been common accoutrements. Horace Walpole has an amusing story about Newcastle's trip to Nestleroy in 1748:

... at a review which the Duke made for him as he passed through the army, he hurried about with his glass up to his eye, crying 'Finest troops! finest troops! greatest general!' then broke through the ranks when he spied any Sussex man, kissed him in all his accoutrements ... in short was a much better show than any review.[52]

[49] From the collection of the late Admiral, The Honourable Sir Herbert and Lady Meade-Fetherstonhaugh, of Uppark. A reproduction of this wax portrait and a similar one of Henry Pelham appear in L. P. Curtis, *Chichester Towers* (New Haven, Conn., 1966).

[50] The profile in *Lusus Naturae* [Plate 81] has a more beak-like nose; it is very similar to the design in *Mons.ʳ Dupe*.

[51] The physical wig, which replaced the full-bottomed wig in popularity in the middle 1750s, is a simple hairpiece, without queues, with or without a centre parting, swept straight back, and usually covering the neck and top part of the shoulders. Newcastle usually wears it in the prints of 1756, though a few prints, especially in the later 1750s and early 1760s, give him a campaign wig (see the figure wearing a riband in Plates 108 and 116). See Cunnington, *Handbook of English Costume in the Eighteenth Century*, pp. 243–4.

[52] Walpole to Mann, 14 July 1748, *Correspondence*, xix. 495.

With a look of fear he watches Robert Walpole through a glass in *Poor Robin's Prophecy* [BMC 3383, Plate 79]. The inclusion of spectacles and reading-glass might be nothing more than perceptive observation on the part of the satirists. It is hard to escape the impression, however, that mental as well as visual myopia is implied. Certainly the Duke's appearance and remark in *The Court Fright* suggest this connection. And in the later years these visual aids help convey a sense of doting age.

How well do the prints 'define' Newcastle as a distinct personality? Their attention to the details of his physical person is considerable. The caricatures correspond, albeit with exaggeration, to the best of the supposed likenesses and they are far more revealing than most of the portraiture. The character and personality which graphic satire elicits coincide with the gist of contemporary opinion. The prints in a variety of ways express his failings of character: his stupidity and ignorance; his vanity. They successfully capture the eccentricities of Newcastles' personality: the phobias, the childishness, the restive agitation, and the garrulousness. With attention to detail, with caricature, symbol, pun, and imagination, the graphic satirists constructed an interesting character. At least in a superficial way it is a plausible one.

They were less successful—less so than pamphlet literature—in assessing Newcastle's public career. There is little appreciation of the source and basis of the Duke's political power: the propertied wealth and influence, scattered over almost a dozen counties in England. Consistent with their court and London orientation, the prints give scant attention to local politics—Newcastle's forte—where his greatest value as a politician rested. Sussex, the Duke's own political preserve, is rarely mentioned.[53] There are only passing references. In *The Flat Bottom Boat or Woe to England, 1759* Newcastle welcomes the foreign invaders: 'I'll Land you in Sussex I hate a Militia.' *The Western Address* [BMC 3392] points out the discomfort of the Newcastle ministry at the numerous addresses and petitions of the late summer of 1756, in protest to the conduct of the war. Discussing one petition, Newcastle avers: 'If it had come any where out of Sussex I cou'd have Smug'd it.'

Newcastle's skill as a patronage-monger is apparent, though

[53] Exploiting the puns and associations of his name, the satirists sacrificed truth to wit.

always in the context of the conventional themes of corruption.[54]
In *A Cheap and Easy Method*, Newcastle, as 'Bacon Face 1st
Hogg-man gleaning the garbage', sweeps up the refuse of a group
of pigs, the largest of which, 'Sussex', is his brother. *The Compleat
Vermin Catcher* [Plate 74],[55] credits him with being a corruptor of
the scale of Walpole, a buyer of Parliaments.

Newcastle's work as Secretary of State in foreign affairs is not
scanned.[56] There is little attention to his labours as an 'ecclesi-
astical minister'.[57] About the only print on the subject is *Haw'y
Haw'y L–b–th Haw'y* [BMC 2873],[58] a satire on the turnover in
church offices and the race for preferment. In the design the
Pelham brothers stand on the near side of the Thames; Lambeth
Palace can be seen beyond, on the far side. Bishops in lawn sleeves
race up and down the river, as watermen fight to take them
across. Newcastle promises one of the ecclesiastics: 'You shall be
Arch B——.'

The Duke's renowned jealousy in office and love of power are
often mocked. *The Ostrich* is one variation of the old idea about
machinations of fallen ministers behind the scenes. He figures in
several prints expressing the idea of a king held in oligarchical
shackles.[59] *The Treaty or Shabears Administration* [Plate 96], a
clever print with good caricatures, ridicules Newcastle's struggle
to remain in office—or inversely, the difficulties in removing him
therefrom because of his special ties with the king and court.

> See Gawkee & P–t how they Sue for a place,
> See perch'd on a turn stile his unsteady Grace,
> Holding fast on each Side that he may'nt tumble down,
> Half his face to his Foes, half his Ar–e to the Crown.

[54] '*Bribing!* . . . Into a system, by its *founder* wrought,/ Was to *perfection*, by
N–le, brought!' *An Ode, Sacred to the Memory of a late Eminently Distinguish'd
Placeman, on his retiring from Business* (London, 1763) p. 5.

[55] The figure bears little resemblance to Newcastle and might be Pelham, though
he died about a month before the publication of the print.

[56] Particularly, there is no examination of Newcastle's fanciful scheme to subsi-
dize the election of the Archduke Joseph of Austria as King of the Romans, after
the Peace of Aix-la-Chapelle. *The Vision* [Plate 86] attacks his foreign subsidies:
more likely an allusion to the hiring of mercenary troops.

[57] See Norman Sykes, 'The Duke of Newcastle as Ecclesiastical Minister',
English Historical Review, lvii (Jan. 1942), 59–84.

[58] The impression in the Lewis Walpole Library has written below the design,
in Horace Walpole's hand: 'The Man whose place they thought to take/ Is still
alive, and still awake.'

[59] Above, chap. v.

Opposition proved the only pale of immunity from satirical abuse, as Newcastle's last years out of office demonstrate:

and the opposition cursed him, as an indefatigable drudge of a first mover, who was justly stiled and stigmatized as the father of corruption: but this ridiculous ape, this venal drudge, no sooner lost the places he was so ill qualified to fill, and unfurled the banner of faction, that he was metamorphosed into a pattern of public virtue.[60]

The Laird of the Posts [Plate 105] marks, bemusedly, Newcastle's climactic fall from power. In many of the prints attacking Bute the satirists pay tribute to Newcastle's achievements and new-found patriotism. In *The Triumvirate & the Maiden* he indicts Lord Bute: 'When I was Young I thought it my duty to spend my Fortune to serve my King, but here's a fellow from the devils arse . . . would sell his Country to get a Fortune.' *John Bull's House sett in Flames* [Plate 108] shows him among the body of English patriots, trying to put out the fire of faction. Newcastle usually plays second fiddle to Pitt, however, and there is sometimes an element of irony in his patriotic pretensions. He leaps the wall with Pitt in *Scotch Paradice*, etc. [Plate 118] and says with innocent enthusiasm: 'Aye, Aye it never shall be said the Middlesex Militia ever flinch'd.'[61]

Graphic satire's assessment of the Duke of Newcastle adds, for the most part, to the vein of ridicule and aspersion tapped by Horace Walpole and Smollett. The satirists see little of Newcastle's actual capacity as a public figure. The prints display better appreciation of his character, better still of his personality. When the satirical criticism is substantive and specific—the Duke's culpability in the Byng affair[62]—it strikes home; when it clings to conventionalities—the moralizing about national betrayal and political corruption—the criticism strays from concrete reality. The prints moralize on Newcastle's lack of virtue when they should have noted his incapability, especially in the area of foreign

[60] *Humphrey Clinker*, i. 140.

[61] An allusion to Newcastle's opposition to the militia bills.

[62] See *Byng Return'd: or the Council of Expedients* [Plate 77]. The print suggests that the Newcastle ministry is a group of conniving rascals, making Byng the scapegoat for their blunders. The figure at the left of the table, picking his nose, is probably Lord Sandwich, or perhaps Lord Holdernesse. Sandwich was formerly at the Admiralty; Holdernesse was a Secretary of State in 1756. Both were patrons of music (the piece of paper on the table contains a reference to Madame Mingotti, the opera singer).

policy. They ridicule his lack of intelligence and ability when they should have judged his want of virtue: the petty jealousies and intrigues that engendered ministerial instability in the post-Walpolean era.

2. 'Volpone'

Henry Fox's surname proved both a boon and snare to satire. The name made one form of caricature inevitable, and almost unavoidable. Fortunate it was, then, that the qualities of Fox's character, in the eyes of contemporaries, coincided with the proverbial qualities of his namesake: guile, perfidy, and rapacity.

Fox had the reputation of a bad man. Smollett described him as 'without a drop of red blood in his veins . . . a cold intoxicating vapour in his head; and rancour enough in his heart to inoculate and affect a whole nation'.[63] The prints indicate that from the zenith of his career in 1755 to its end he endured the blackest and most unredeemable disrepute.

Lecky described Fox as a man 'almost destitute of principle, patriotism, and consistency' who 'possessed rare talents for business and for intrigue'.[64] The satirists, determined to make him play the fox, stressed the man's craftiness. Fox is the perfect knave in the card caricatures: *Mons⸱ Surecard* [BMC 3506][65] to Newcastle's *Mons⸱ Dupe*. In a large number of the prints of 1756 cunning and self-sufficiency are consistently Fox's distinguishing marks of character. 'No more the wily Fox' declares the verse in *Exit Unworthies. Enter Worthies*. The print, *A Scene in Hell, or the Infernall Jubilee* which vilifies Newcastle, Byng, and Fox for the loss of Minorca, associates the first two with 'Luxury' and 'Cowardice' and Fox with 'Sublety'.

With Fox's guile went deception and treachery. *The Court Cards or all Trumps* identifies him as 'Vulponus the Scribe', holding the mask of deception. His motto is 'Pro Sibi non *Patria*'. *The Lying Hydra* [BMC 3633], published in 1757 as part of the polemical exchange involving George Townshend, is one of the

[63] *Humphrey Clinker*, i. 138.

[64] Lecky, ii. 349.

[65] 'Infers by the Sharpness of the Nose that Craft and Subtlity which is natural to Creatures of a similar Kind, known by the Name of Foxes. . . .' *Political and Satyrical History*, p. 6.

most vicious indictments of Fox.[66] His full-length figure stands on the emblems of Liberty. A rotting heart, marked with a fleur-de-lis, appears on his chest. He has six fox's heads (which a label, 'Proteus Janus', explains). Various promissory notes suggest bribery; other papers suggest Fox's hostility to the City of London.[67]

Fox accepted the seals of Secretary of State in the autumn of 1755 and thereby agreed to help rescue Newcastle's foundering government. The supposed cynicism and ambition behind his decision brought to mind the fables of fox and geese and provided a theme for many prints. One of the first, without title [BMC 3330], comments on Fox's entrance into the ministry, and suggests a comparison of his abilities to those of Newcastle. Fox and George II, as a lion, sit at a table,[68] and a limp, perhaps defunct, goose hangs from the back of Fox's chair.

> For Passive Goose, let Foes deride
> and Factious Parties did divide
> But now since F** has chang'd yᵉ Scene
> And Goose Inactive now is Seen
> We hope true Courage will advance
> And once more Crush yᵉ Pride of France.

The sense of many of these prints is that Newcastle, in taking on Fox, laid the basis of his own and the country's ruin. Walpole warns in *Poor Robin's Prophecy*: 'W[hen] [fox]s l[eye]ke [wolf]s Infest th[eye]s poor land and th[ear]s Nothing [butt] [geese] th[ear] vile tricks 2 withstand . . . [yew]ll wish for poor Bob [hoe] so oft [yew] d[eye]d Curse.'[69] *The Devils Dance Set*

[66] Fox and Townshend were bitter enemies because of the former's connection with the Duke of Cumberland and his opposition to the militia bill. Townshend attacked Fox on these grounds, and also for his scheming against the Devonshire–Pitt ministry.

[67] Fox was never popular with the City because of his apparent indifference to public opinion, his contests with Pitt, and his associations with Cumberland; Fox's effective use of military patronage (while Secretary at War) and his support of the Duke brought declarations against 'military administration'. See Thad W. Riker, *Henry Fox First Lord Holland: A Study of the Career of an Eighteenth-Century Politician* (2 vols., Oxford, 1911), ii. 121.

[68] Fox's good relationship with George II at this time proved an important trump card in his quest for power.

[69] One print, *A List of the Pedigrees of some Eminent Geese Shortly to appear in Public* [BMC 3412] suggests that Newcastle was not Fox's only prey; the print contains characters of some of the other members of the ministry, including Lords

to French Music by Doctor Lucifer of Paris suggests that Fox, in ruining Newcastle, might also be destroying himself. The design shows a map of the British Isles, linked to France by 'Villany', 'Treachery', and 'Folly'. Fox, Newcastle, and Byng, in dancing pose with cloven feet, stand next to the Devil and a Frenchman. Fox stands on 'Justice', 'Love', 'Honour', '[Com]mon Sense', 'Honesty', 'Liberty', and 'Property'. He holds a limp goose in the crook of his arm: 'The Goose that laid the Golden Eggs'.

Fox's reputation for untrustworthiness was not diminished by his alleged intrigues and negotiations in the autumn of 1756, when he succeeded in bringing down the Government. Hardwicke complains in *The Mirrour*, etc., showing the British lion shaking off his ministers, '. . . I fear Renard will betray all, and leave us in the Lurch, to save his own Neck.' Fox protests: 'You had given up M–n–r–a before I came amongst you; and next Gib–l–r and the American C–l–n–s go to Pot I'll resign and have nothing more to do with you. No more Bribes, Sabsidies [*sic*], or Pensions!'[70] *The Fox & Goose or the true Breed in full Cry* shows Newcastle as the impotent goose, resting in the mouth of a fox, that is chased by a pack of dogs (the Pittites); Newcastle says: 'Oh! Lord dont let me fall.' Fox promises: 'I'll drop him in a ditch presently by G–d.'

Fox's value to the ministry, the reason for his union with Newcastle and one of the causes of their eventual disengagement, came from his supreme talents as a parliamentarian. His skill as a manager was highly touted. 'He had very great abilities and indefatigable industry in business, great skill in managing, that is, in corrupting, the House of Commons, and a wonderful dexterity in attaching individuals to himself.'[71] *Guy Vaux the 2ᵈ* [Plate 83], in a coincidental way,[72] expresses the idea that Fox is a menace to

Anson, Holdernesse, and Hardwicke. In *The Cole Heavers* Fox exclaims: '. . . by Sounding forth . . . a Great deal of Honesty, I have deceiv'd a whole Flock of Credulous Geece, & have demolish'd them all.' See also the sentence rendered to him in *The Vision*, etc. [Plate 86].

[70] Fox's embarrassment and dilemma in having to defend the blunders for which he was, at least relatively, less responsible, is discussed by Riker, i. 421. 'I am abused and prints made of me, and I am to be hanged with the Duke of Newcastle. . . .' Ricker, ii. 22.

[71] [Lord Chesterfield] *Characters of Eminent Personages of His Own Time, Written by the late Earl of Chesterfield; and Never Before Published* (London, 1777), p. 39.

[72] The similarity in pronunciation of 'Fox', 'Vaux', and 'Fawkes'.

the life of Parliament. The design shows a clandestine Henry Fox, with cape and lantern, sneaking along the outside of the Houses. He is bent upon mischief, only to be discovered by the 'Eye of Providence'. To Fox was delegated the task of defending the ministry and the conduct of the war in Commons against the assaults of the Opposition. *Byng Return'd*, etc. [Plate 77] shows his predicament. He sits in a chair at right and holds a balance in which the Opposition—'Pitt', 'leg', 'Pultney', 'Townsends', and others—prevail against 'Innumerable Place Men and Pentioners'.

In *The Bawd of the Nation or the Way to Grow Rich* [BMC 3636, Plate 97] Fox has replaced Newcastle as the master of corruption and peculation. Fox sits on a chest of money. Wearing the dress of a woman, he offers ribands for sale. 'This Gents is not that old State Jade you have heard of so long ago but a pretty Miss—Miss did I say Ay Ay Miss-Honour. . . .' The personification of Honour complains: 'Oh! for Heavens Sake Use me not thus I can bear any thing but Prostitution.' Two small foxes (his sons, Stephen and Charles James) can be seen in the background; one of them is passing money through a gridiron, 'Unaccountable.' 'See Daddy is this right pray.' 'Let me try.'[73]

Fox shared with his counterpart a reputation for avarice and venal self-interest: not the possessive vanity of Newcastle, but the hunger of a man of modest origins, self-seeking without self-deception: 'resolute in Mischief, determined to exert every Faculty and try every Effort however pernicious to the State, to aggrandize himself and Family.'[74] Reduced to the simplicities of satire he made, like Jonson's Volpone, the pursuit of gold his lodestar.

> Dear Saint,
> Riches, the dumb good that giv'st all men tongues,
> That canst do nought, and yet mak'st men do all things;
> The price of souls; even hell, with thee to boot,
> Is made worth heaven! Thou art virtue, fame,
> Honor, and all things else. Who can get thee,
> He shall be noble, valiant, honest, wise.[75]

[73] Cumberland obtained for Fox, in April 1757, the reversion of the Clerkship of the Pells in Ireland, for his life and the lives of his two sons. The care which Fox took to utilize public offices for the material wellbeing of family and friends was a signal cause of his unpopularity.

[74] *A Letter to His Grace the D— of N–e*, p. 26.

[75] Ben Jonson, *Volpone or the Fox*, ed. A. B. Kernan (New Haven, Conn., 1962), p. 39. Jonson's character is a creature of materialism, sensualism, and self-interest.

Fox expresses his great faith in riches in *The 3 Damiens*, in which he consoles himself: 'I have Sav'd therefore shall be Sav'd.' He is one of the ministers in *Britannia in Distress*; a fox emblem at the end of a riband identifies him, as does a label: 'Poverty, Excess, and Avarice Insatiable'.[76]

The character of Fox in *The Bankrupts with Anecdotes* [Plate 82] makes a vague insinuation of peculation or bribery—'Harry Renard French Broker, this Person traded very High, and amass'd large Sums, but his Creditors are not Satisfied, nor ever will be its thought'—though its sense suggests nothing more than the power of French gold. More specific and substantive are the charges that begin in 1757, when Fox became Paymaster General of the Forces. Acceptance of the Paymastership proved the turning-point in his career; Fox sacrificed his abilities and whatever chance he had for the seat of power to the acquisition of a fortune. *The Bawd of the Nation* was no doubt occasioned by his decision, as was, perhaps, *The Recruiting Serjeant* [Plate 93].[77] Peculation of a sort was, of course, a prerogative of the office, but which Fox appears to have exploited far more thoroughly than his predecessors.[78] The prints make no specific attacks on his conduct in this capacity, but there are several allusions. In Plate 117 Fox appears as an appendage of the Butian monster; he devours a soldier. Fox prepares to follow Bute across the Styx in *Sawney Below Stairs*: 'While Reynard at distance waits old Charon's Boat/That he too may join such Traytors of Note.' Charon quiets his impatience: 'Coming, Coming, Zounds you're in a plaguy hurry, Egad Mr. Reynard I shall expect my Fare first as I hear you're a bad Paymaster.'

One of the best-known stories about Henry Fox is the tale bruited by Horace Walpole, about how Fox opened a shop at the Pay-office and bribed a sufficient number of M.P.s with bank bills

'Volpone' was a sobriquet given to Sidney Godolphin, Lord Treasurer in the reign of Queen Anne.

[76] An allusion to the prodigality and excess of 'gaming' in Fox's youth.

[77] This print may have appeared, however, before Fox went to the Pay-office. Charges of the misuse of military patronage had stuck to him during his tenure as Secretary at War.

[78] See Lucy S. Sutherland and J. Binney, 'Henry Fox as Paymaster General of the Forces', *English Historical Review*, lxx. 229–57. Fox's critics liked to contrast his conduct with the impeccable (and somewhat ostentatiously honest) behaviour of Pitt in the same office.

to purchase support of the Peace in Commons.[79] Fox had, in the autumn of 1762, agreed to 'manage' the House of Commons for the Bute ministry, in return for the promise of a peerage.

He shares Bute's great unpopularity in the prints of 1762 and early 1763. He is generally portrayed as the loyal minion or time-server.[80] Despite their simplistic notions about corruption, however, the prints provide only a few clues as to Fox's actual role in the passage of the preliminaries. He is not neglected in the cant about French bribery. *Scotch Paradice* [Plate 118] shows him receiving his rewards from the Devil in the tree: 'By G— the Pippens Smell as rank as a Fox.' *It's all of a Peace*, with the same suggestion of a French-bought peace settlement, shows the secret presence of Fox, hiding under the stairway of Bute's mansion; the meaning of his presence, however, is indiscernible. Also ambiguous is *The Places (being a Sequel to the Posts) a Political Pasquinade* [BMC 4079] which shows in one of its designs a 'Pay Office'. Fox distributes money to a group of persons, while a disbanded sailor is turned away. Both *The Evacuations*, etc. [Plate 112], and *Jack Afterthought or the Englishman Display'd* [Plate 119] credit Fox with a role in securing the peace. The former shows him about to administer an emetic to Britannia, to aid the expropriation of the nation's colonial conquests. The meaning of the latter print is unclear. The fox riding away from John Bull's barn on a horse representing the overseas conquests might be Fox or the symbol of France. The man in the lower left corner of the design bears some resemblance to Fox, though his statement and the 'Definitive Sentences' hanging from his pocket seem to identify him as Bedford, England's principal negotiator.

There are few physical likenesses of Fox in the prints.[81] The coincidence and appropriateness which favoured animal symbolism also circumscribed the possibilities of a graphic character. And

[79] Horace Walpole, *Memoirs of the Reign of King George the Third*, i. 124; for Namier's refutation of Walpole's story, see *Structure of Politics at the Accession of George III* (London, 1957), p. 182 and following.

[80] See Plates 106 and 108. Fox rides as postillion in *The Laird of the Boot* and in *A Prophecy*, *The Coach Overturn'd, or the Fall of Mortimer*.

[81] A profile of Fox can be seen behind Bute's right foot in *The Colossus* [Plate 122]. The designer of *The Wheel of Fortune* [Plate 120] may have had Fox in mind for his personification of 'Monopoly & Oppression'. The figure bears a striking likeness of him. This print was published, however, in 1766; Fox retired from office and public life in 1765, though he is connected with Bute in several prints of the following years.

this was unfortunate. The few portraits of Fox show him to be a heavy-set man; his thick brows, dark eyes, and heavy beard give him a swarthy look.[82] Caricaturists could have effectively exploited this murky countenance and given it the appropriate sinister overtones.

The qualities of his face and body scarcely matched the sleek, sharp features of the fox. The satirists were, therefore, forced into awkward compromises: Fox's bulging figure squeezed into the linear outline of a fox. Sometimes the conventional fox represents him. However opportune were its associations, the pictorial character presented becomes as stale as it is simplistic. It is a poorer character than that of Newcastle, and perhaps that of Pitt as well.

3. 'Will of the People'

William Pitt was the darling of the political satirists: the embodiment of patriotism; the nemesis of ministers. His virtues and abilities provided the perfect foil to ministerial vice and folly. *The burning Pit* [BMC 3462, Plate 84], published by Darly in December 1756, is a simple but interesting attempt to show how the qualities of Pitt's character were the positive inversions of his enemies' respective shortcomings. The image of a volcano, marked with 'Honour' and belching the flames and smoke of 'Zea[l]', captures the essence of Pitt's tempestuous personality.[83] Members of the Newcastle ministry attempt, unsuccessfully, to reach the pit, each set back by a thunderbolt that asserts Pitt's superiority. Newcastle is struck down by the bolt of 'Wisdom', Fox by 'Public Spirit', Hardwicke by 'Generosity', and Lyttelton by the bolt of 'Eloquence'.[84] Pitt's brother-in-law, Richard, Earl Temple, is represented by a temple in the background.

[82] Plate 5 is an etching by J. Haynes, after a painting by Hogarth. It is No. 1 in the *Catalogue of Engraved British Portraits*, ii. 545. 'In his person Mr. Fox was of the middle size; he was, like Ulysses, more graceful in his seat than when he stood up. His features were strongly marked, his brow large and black, his aspect more penetrating than pleasing.' *The Characters of George the First*, etc., p. 56.

[83] '. . . his venerable form, bowed with infirmity and age; but animated by a mind which nothing could subdue:—his spirit shining through him, arming his eye with lightning, and cloathing his lips with thunder, for the compass of his powers was infinite', *Anecdotes of the Life of the Right Honorable William Pitt, Earl of Chatham*, iii. 356.

[84] Here the implication is not that Lyttelton lacked eloquence, for he was an effective speaker, but that Pitt's skill surpassed his.

The Temple and Pitt [Plate 98],[85] a Darly print of 1757, ex-presses another confrontation of patriotic virtues and ministerial vices. A temple, crowned by a statue of Fame and the Eye of Provi-dence, stands in the centre. Pillars of 'Public Utility', 'Mercy', 'Probity', 'Generosity', 'Justice', and 'Vigilance' support the structure. 'Virtue', 'Honor', and 'Merit' form the base. Personifications of 'Envy', 'Malice', 'Treachery', and 'Folly' work to destroy the temple. They have already brought down the column of 'Wisdom'.

More simple is the measure taken in *Magna est Veritas et Praevalebit*. Pitt sitting in one scale of the balance, with a laurel wreath under him, outweighs the ministry, seated in the other scale: 'We are Weigh'd in ye Ballance and found Wanting.' The moral: 'Thus Vice and Virtue Sums upon a just Account.'

Pitt was used as a kind of *deus ex machina*, the instrument of justice, through which the moral order asserted itself. *The burning Pit* suggests a preternatural phenomenon, the very nemesis of evil and folly. *The Fox in a Pit* [BMC 3399] shows how Henry Fox, chased by his great adversary on the horse of 'Integrity' and bearing the flaming sword of 'Justice', has been caught in a 'pit': 'this *Pit* was designed by Nature to destroy every Thing of a subtle and crafty Disposition.'[86] The pun on Pitt's name proved useful. *The Downfall* shows the Newcastle ministry about to fall down 'Break Neck Stairs' into 'The Bottomless Pitt.'[87]

In that Assembly, where public good is so much talked of, and private interest singly pursued, he set out with acting the patriot, and per-formed that part so ably, that he was adopted by the public as their chief, or rather their only unsuspected, champion.[88]

Pitt 'formed popularity into a system'.[89] The bulk of prints in

[85] The print, perhaps invented by Townshend, was occasioned by Fox's and Cumberland's success in bringing down the Pitt–Devonshire government in the spring. Much of the design is concerned with Cumberland's command of the expeditionary force in Germany, one condition for the acceptance of which was Pitt's removal.

[86] *Political and Satyrical History*, p. 3.

[87] The image of a 'pit' also appears in *The Temple and Pitt*, at left. Britannia is being rushed towards a pit in *The C–rd–n–l Dancing Master* [Plate 40], though it is doubtful that the allusion, in this case, is personal.

[88] Chesterfield, *Characters*, p. 47.

[89] *An Appeal of Reason to the People of England, on the Present State of Parties in the Nation* (London, 1763), p. 30.

which he appears were published in 1756 and 1762, the great years of Opposition. He is defined in terms of trite aphorisms, attendant upon the role of patriot and Opposition. His watchword is: 'Prio Patria et Rege': he is the champion of king and country. Britannia usually represents the latter.[90] She is Pitt's steady companion, and he her chosen son. In *Mon* *Bussy*s *secret embassy*, etc., Britannia watches Newcastle's bungling negotiations and confides; 'If I part from my Pit I shall break my heart he has won me by his Steady Patriotism.' Pitt, standing next to her, responds: 'I am pleas'd with the applause of my dear Country & nothing but death shall sepperate [*sic*] my affections.' Britannia and Pitt prove inseparable, especially in the prints which follow his resignation in 1761. They join in mutual commiseration. *Tempora Mutantur* [Plate 107] shows Pitt giving solace to a dejected nation. *The Laird of the Boot* has him rushing to Britannia's aid, as she is about to be crushed under the coach's wheels: 'My Poor Britania [*sic*] I can only Pitt y you.' Britannia is, of course, the patron goddess of Opposition. She stands with the leaders of the parliamentary and journalistic Opposition—the 'British Worthies'—in *The Raree Show a Political Contrast*. Among the worthies are Pitt, Temple, Cumberland, Newcastle, Churchill, and Beckford, the Lord Mayor of London.

Most prominent in Pitt's system of popularity was the adulation of the City of London.[91] *The True Patriot* [BMC 3599], which the publisher dedicated to 'the R.t Hon.ble the Lord Mayor Aldermen & Common Council of the City of London', has in its design a formal bust portrait of Pitt, the champion of 'Magna Charta et Libertas', supported by the personifications of Liberty and Loyalty, who triumph over Envy and Treachery (the latter represented by a fox).

The twin pillar of Pitt's support, the King, was subjunctive instead of actual, so long as Pitt remained in opposition. *Tempora Mutantur* expresses this anomaly, as it shows Pitt secure in the support of the nation but denied, temporarily, the confidence of a misguided and abused monarch. Graphic satire shares all of Pitt's

[90] Above, chap. iv.

[91] Bute, writing to Lord Melcombe in 1762, observed: 'Indeed, my Lord, my situation at all times perilous, is become more so, for I am no stranger to the language held in this great city: "Our Darling's resignation is due to Lord Bute, who might have prevented it with the King."' Stuart-Wortley, *A Prime Minister and His Son*, p. 29.

visionary faith in and reverence for an independent and exalted king, the rewarder of merit and virtue. *The true British Ballance* suggests that Pitt is the one patriot capable of bringing the interests of king and country together. Backed by Britannia he approaches the throne to receive the royal grace: 'Come to my Arms, thou best of Men'.[92]

The substance of this drama, in which Pitt is made to play the part of the great redeemer, is trite and shallow, just as was much of the Opposition mythology. Platitudes aside, there is no specific programme that the prints attach to the cause of the Great Commoner. There exist commonplace notions about constitutionalism. In *The Quere? which will give the best heat to a British Constitution Pitt: Newcastle or Scotch Coal* Pitt's altar is judged the best: 'built of Freestone & is Furnish'd with Pit coal dug out of the bowels of Liberty by a West Country Miner'.

There are these associations with the country-party interest. Pitt may be the foxhunter in pursuit of Fox in *The Fox & Goose or the true Breed in full cry*. More likely he is the lead hound, 'West Country sweet lips', who barks: 'pro Patria non Sibi'. 'West Country' is an allusion to the roots and connections that Pitt had in the western counties.[93] It also calls to mind one of the regions of his greatest support: he was the darling, especially in the middle 1750s, of those forces of permanent opposition: the Tory squirearchy in the south-west of England.

There is an absence of commentary in the prints on Pitt's triumphs in the Seven Years War. The grand strategy, the imperial conquests go almost unnoticed. *Old Time's advice to Britannia*, condemning the German subsidies and British troops in Germany, does express Pitt's basic commitment to the maritime strategy: 'Did I not always rail against Continental Connections till they were Cram'd down my Throat & I must have been Choak'd If I had not accquiessced [*sic*]?'

In a half-dozen other prints the identification of Pitt with the

[92] Above, chap. v.

[93] The family roots lay in Dorset; Pitt's grandfather, upon returning from India with his fortune, bought up estates in Dorset, Cornwall, Devon, and Berks. Old Sarum was the family borough for over a generation. Gout forced Pitt to spend much of his time, especially in later years, at Bath. Pitt's cousin, John Pitt, was known as the 'Great Commoner of the West'. See Sir Tresham Lever, Bt., *The House of Pitt: A Family Chronicle* (London, 1947).

'blue-water' school is implied. *The Caledonian Voyage to Money-Land* shows in the background—in contrast to Bute's transport—'The Pitt Frigate now out of Commission, lately commanded by Cap.ᵗ Will.ᵐ Truman, has taken many valuable Prizes this War.' A sailor complains in *A View of the Old England*: 'If Will Honest had been still our Pilot he would have steer'd into Port Safety'. Pitt's popularity among the English jack-tars is a theme in the anti-Bute, anti-Peace prints of 1761 and 1762. *Merit Rewarded or Truth Triumphant* [BMC 3814], which praises Pitt's contributions to the nation's singular victories, shows a group of sailors at a table on the left, idly drinking and smoking. 'Damn me, Tom English Calls for help the Old England is a Ground;' If Will Steady had Been at the helm we might have Boosd Safe.' 'Why did he Leave us;' 'Will Proped our [sailing?] for Spain;' 'But those Fair Weather Jacks Opposed it.'

Pitt was, essentially, a creature of Opposition. The logic of the prints sometimes seems to imply that in Opposition he should stay. 'For your Schemes are too good your Intentions to [*sic*] Just/ And Coruption [*sic*] must reign still by Jove Sʳ it must.'[94] The prints showed little care for even a popular hero in charge of affairs. Pitt, in office, incurred the familiar dilemma of all who had espoused the pretensions of Opposition: the charge of 'patriot turned courtier'.

The onus of 'sham patriot', the man of inconsistencies and hypocrisy, was Pitt's Achilles' heel, though this indictment is more frequently and vociferously expressed in pamphlets than in the less factional graphic satire. The charge dates from early in his career when he, like so many of the Opposition that brought Walpole down, clamoured for office and finally won it. 'By their shameless Breach of twenty Years Engagements to the Public, the very Name of Patriot became an Object of Contempt, and Love of Country a Subject of Ridicule.'[95] *The Claims of the Broad Bottom*, an anti-Opposition print of 1743, depicts the dismay of the Opposition bands at their former compatriots, now turned ministers. The tall, angular, swan-necked figure of George Lyttelton and a thin, diminutive Pitt stand with their patron, Lord

[94] *Oliver Cromwell to honest Wil Pat Esqᵣ* [BMC 3596]; the subject of the print concerns Pitt's difficulties in sustaining his ministry in early 1757.

[95] *The Constitution. With an Address to a Great Man* (London, 1757), p. 7.

Cobham. Pitt consoles himself: 'Who knows but I may be puff'd into Something by and by'.[96]

Pitt gained office in 1746, first in the jointly held position of Vice-Treasurer of Ireland and shortly thereafter as Paymaster General of the Forces, after many unsuccessful attempts by the Pelhams to assuage the feelings of George II.[97] He was immediaately attacked as a betrayer of the cause. In *A Collection of Modern Statues and Caracters* [Plate 61] he is styled as 'Museus':

... whilst under the Hands of the Fates, struggled, scolded, and raved himself into Asses Milk Diet but no sooner Destiny moved its Pains, than, as if Thunder had impelled him, he was struck Dumb ... will never in this Road be able to pay what he owes his Country. Wisdom in him was profound Policy; but a Man can never be forgiven the forgetting of himself, but cheating his Country of a Patriot; who, in Want was steady, and in Affluence a Turn-Coat.

Pitt's desertion of the patriot ranks occasioned another print, *The Ghost of a D–h–s to W–m P— Esq[r]* [BMC 2786]. The ghost of Sarah, Duchess of Marlborough appears before a terror-stricken Pitt, late at night in his chambers. The apparition projects bolts of lightning at him, and accusations: 'Furies-Wheres my 1000 £', 'Voted for ye C–t', and 'Taken a Place'. Across Pitt's forehead reads the mark of his betrayal: 'Hanover T–s.' Above and in the background is the head of Walpole, with an inscrutable smile on his face. The Duchess's complaint: 'Ungrateful P–t,/ You have me Bitt!/ Ten Thousand Pound, / My Will you found/ And did Obtain,/ The long sought gain./ Then fair'd your Way,/ To C–t for Pay.'[98]

Some thirteen years later a pamphlet appeared, *A Letter from the Duchess of M–r–gh*,[99] in which Pitt is again reminded of his gross inconsistencies. His former benefactress points out the unsteadiness of his principles and his opportunism, how he had

[96] A paper near him reads: 'Am not I an Orator? Make me Secretary at War.' Pitt's and Lyttelton's frustrated ambition are ridiculed in Plate 49.

[97] Because of Pitt's strong-worded denunciations of the Government's Hanover policy.

[98] The Duchess had left a stipend for Pitt in her will, to aid his endeavours in Opposition. The Duchess was often referred to as 'Mount Etna' because of her fiery and turbulent personality. As Pitt's benefactress, therefore, she might figure in the imagery of *The burning Pit* [Plate 84].

[99] *A Letter from the Duchess of M–r–gh, in the Shades, to a Great Man* (London, 1759).

hectored himself into a place. Long the opponent of Continental connections, he supported the German war. The Duchess also inveighs against his 'political Quixotry', his 'rodomont-airs', and the 'stale harlotry of patriotism'.[100]

'Will of the People'[101] became, for his detractors, a 'Will-o-th' Wisp'. He was as inconsistent in his honour as he was in his principles. Bute's pamphleteers made much of Pitt's acceptance of a pension upon his resignation in 1761. They assailed his haughtiness, his vain-glory, his audacity, and the popular infatuation that he enjoyed. Hogarth attacks his demagogy in *The Times Plate I* [Plate 115] in which he shows Pitt, in the guise of Henry VIII,[102] on stilts, receiving the huzzas of the Corporation and mob of London.

The best of the unsympathetic characters of him, *Sic Transit Gloria Mundi* [BMC 3913, Plate 111],[103] exposed the vacuity of Pitt's pretensions and his popularity. The champion of the people straddles the large bubble of 'Pride Conceit Patriotism Popularity', floating in the air above Palace Yard, Westminster. The air is filled with bubbles, emanating from Pitt's pipe as deceptive lures to the people: 'Vanity', 'Adulation', 'Self Importance', 'North America', 'Spanish War', 'Honesty', and 'Moderation'. Fading into the distance are other bubbles: 'Beer', 'Taxes', 'Blood & Treasure', 'Sinceri[ty]', 'Changing Sides', and 'Pension'. A string of bubbles, as if coming from below, reads: 'Poverty'.

The figure of Pitt in the above print is a good study: the tall, thin, long-legged frame; the ill-fitting clothes; the physical wig; the hawk-like nose.[104] The best likenesses and caricatures of Pitt appear in those prints whose aim is ridicule, not praise. The best caricature is *The Distressed Statesman* [Plate 95], probably published in 1757 as a terse commentary on Pitt's difficulties in the first months of that year. There is deliberate exaggeration in the

[100] Ibid., p. 72.

[101] The title of a print [BMC 3986].

[102] Hogarth apparently chose Henry VIII for the purpose of comparison and contrast. Alike in their tyranny, Henry and Pitt differed in their physique. In another state of the print Hogarth substituted the likeness of Pitt.

[103] One of the few pro-Bute (or, at least, anti-Opposition) prints of the early 1760s.

[104] Pitt was quite tall. Plate 49, however, pictures him as a waspish snippet; the design seems to indicate that in his youth, Pitt wore a bag-wig.

long, shapeless torso, the gangly arms, and the thin, spindly legs. His wig is extended in front almost to the eyebrows, so that large eyelids, nose, and a drooping chin are left to define his face. The caricature in *The Treaty or Shabears Administration* [Plate 96] is similar.[105]

The few prints that are in some sense unsympathetic to Pitt explore quite effectively the oddities of his person. The great majority of prints in which Pitt appears offer poor studies; there is little more than the bare image of the man, no sense of his commanding presence. 'He enjoyed every requisite to command attention in popular assemblies; a striking figure, a sonorous voice, a dignified action—add to this, a keen and ardent look, which occasionally terrified and disarmed his opposers.'[106] Caricature could uncover that element of the ridiculous in the oddities of his person, especially when combined with his histrionic style. Pitt was capable of turning, with a studied and dramatic flair, his peculiarities to advantage: the sharp, withered features of his bony face, cutting like a razor's edge; the eyes that darted fire; the wasted body, especially in later years, wrapped in flannel, supported by crutches, from which so much fervour, with startling, compelling effect, emanated. But the line between sublimity and absurdity was, in this case, a fine one. To capture the force of the latter proved beyond the capability of the makers of political prints. Ironically, perhaps, the prints made him into the glorified 'straw man' patriot that he sometimes appeared and wanted to be. But that special magnetism is lost amidst the banality and vulgarity of the medium. The prints could not do full justice to the man who, more than any other, gave voice to the cant and simple ideals of their political lore.

[105] Plate 6 is a reproduction of No. 20 in *Catalogue of Engraved British Portraits*, i. 418.

[106] *The Characters of George the First*, etc., p. 68.

CHAPTER IX

Conclusion

In the year 1763 Lord Bute resigned from office amidst a hail of calumny, John Wilkes was seized on a general warrant, and a decisive resolution of the colonial struggle with France was made formal in the Treaty of Paris. A year later Hogarth died and about two years later James Gillray, age nine, drew his first sketch.

'With the overthrow of Bute's ministry, we may consider the English school of caricature as completely formed and fully established.'[1] Certainly by 1763 the existence of the political print as an indigenous, current, and popular form of political commentary was secured. This position was the result of developments in the period 1727–63, which coincides with the career of Hogarth, who, though he did not generally apply his talents to politics, ranks as the first great English graphic satirist.

Before the 1720s there were few prints designed and published in England. Between 1727 and 1763 an influx of draughtsmen and engravers from the Continent and an increasing number of English artists spurred the development of a native enterprise. Before 1727 the bulk of graphic satire occupied a subsidiary place, as frontispiece and illustration to pamphlet and broadside. By the 1760s the political print, in which the graphic design was the focus of attention, with verses and commentary in ancillary roles, flourished. The publication of collections of prints in book-form, beginning in the late 1750s, is proof of the independent identity of this satiric form. Before 1727 the print was an occasional piece, inspired only by events of the greatest moment. Starting in the 1730s, the production of prints as a continuous form of journalism, almost as regular as newspaper and pamphlet, began.

By the early 1760s prints were, like tracts, beginning to drop the old artifice of deleting names as a protection from the libel laws. Throughout the period the Government's suppression of

[1] Thomas Wright, *History of Caricature & the Grotesque in Literature and Art*, p. 453. Wright based his generalization on the large increase in the number of prints at this time.

graphic satire had, in fact, been capricious, perhaps indifferent; certainly it was inefficient. Printselling enjoyed freedom—a curiosity noticed by foreigners—and great numbers of scandalous, savage prints attacking the Bute ministry went untouched.

The maturation of the art in the reign of George II owed much to political developments. The birth of English 'caricature' is sometimes associated with the South Sea Bubble. This is a misapprehension. Most of the satire connected with this event is of a social, not political, nature. Many of the Bubble prints are Dutch in origin. The genesis of the English print was, rather, coeval with the beginning of an organized, constitutional, and parliamentary Opposition. The firm basis of such an Opposition came into being during the long tenure of Robert Walpole. The prints were not necessarily specific weapons of Opposition propaganda; there is no evidence of direct subsidization. Politicians wrote pamphlets but, with the exception of George Townshend, they did not design prints. Political opposition spawned in a variety of ways, however, a journalism of protest. From its corpus of material the designers of the prints borrowed ideas and inspiration. The prints of the late 1720s and early 1730s approximate the ideas, and occasionally even the imagery, found in the *Craftsman*.

A large degree of uniformity of attitude, a common point of view, exists in the prints. Scholars who have studied them in the past looked upon them as haphazard, disconnected incidentals: the passing reflections of a mercurial, rootless 'public opinion'. This is the approach of the cataloguer, Stephens, and, to a certain extent, the historian, M. Dorothy George. The substance of the prints was not seen as a whole; a common ground was not uncovered. One does exist. The prints were an expression of a political mythology, of—in part—an Opposition programme, and of certain fundamental preconceptions and ideas that are also found in the pamphlets of the day.

A cross-reference of ideas, of phraseology, and of imagery shows the connection between print and pamphlet. The relationship of the modern political cartoon to the newspaper's editorial page is analogous: the former capsulizes and expresses succinctly the ideas elaborated in the writing of the editorialist. Though the eighteenth-century print was a more independent medium than the modern cartoon, it captured efficiently the ideas and arguments

of the pamphleteer. As with the cartoon, the print reached a larger audience.

The historian wishes he knew more about the process of conception. Who were the inventors? How did they get their ideas? How typical is their degree of informedness? Prints and pamphlets often came from the same shops. They were found in the same stalls, displayed in the same windows, and lay on the same tables in the coffee-houses. They shared a world that carried as far as the hawker's cries in the streets.

The great majority of prints support the cause of political opposition, at least to the extent that they are anti-Government and anti-ministerial. Prints favourable to Government and ministry are rare. Graphic satire thrived on criticism, ridicule, and negation. Travesty and burlesque can be powerful weapons in the hands of the satirist. They tear away the aura of respectability and replace it with a familiarity that breeds contempt. Employed in political satire they produce the 'humour of release': inhibitions satisfied in the mockery of authority and convention.[2] In a society where deference and authority were ideals, this humour, like the mob, provided a useful outlet.

Prints that take a defensive posture are dull and lifeless panegyrics. Prints attacking the Opposition are also few, but they are better. The *Motion* series of 1741—the first study of a parliamentary Opposition in the prints—raises the cry of faction and disunity. But these prints, too, appeal to the sentiments of the permanent Opposition with their charges of hypocrisy and mock patriotism.

Graphic satire served, by and large, as an expression of the Opposition because of the absence of major issues and ringing controversies, and because of the nature of government itself. Government had few policies. There was no sense of government as the agent of a legislative programme. The king's ministers were managers, not legislators; they tended to the existing machine and mended it only when necessary. Parliament, when it was not occupied with a myriad of private bills, talked about finance, war, and foreign policy. Genuine excitement arose infrequently. Parliamentary business was usually exceedingly dull. 'A bird might build her nest in the Speaker's chair, or

[2] Stephen Potter, *Sense of Humour* (New York, 1954), p. 84.

in his peruke. There won't be a debate that can disturb her.'[3]

General interest in foreign affairs was keen, as the large space devoted to the subject in contemporary newspapers testifies. Prints also indicate the attraction of the subject; so many of them interpret with a variety of conceits the bewildering vicissitudes of diplomacy and balance of power. Matters of public finance and political economy, however, were far more common subject-matter in newspaper and pamphlet. They were too obscure, dull, or difficult for the prints to handle.

The graphic satirists relied, instead, on the issues that the Opposition selected as objects of attack. The basis is stubborn and permanent discontent: the unchanging anti-court, anti-ministerial bias that viewed all authority with suspicion or contempt. Graphic satire projects the titillating amusement of the informed observer, delighting in the absurdities and scandals at the seat of power. Horace Walpole, who was perfectly attuned to this spirit, interested himself in and enjoyed the prints of the day. He was not alone.[4]

Raised from this basic attitude was a superstructure of issues— a programme of sorts—concerned with political corruption, constitutional purity, ministerial oppression (particularly as it applied to trade and to the press), national betrayal, and foreign subversion. What genuine crises there were—the excise scheme, the Forty-five, the Jew Bill—were either manufactured or distorted. 'Public opinion . . . was . . . in the nature of a minefield through which the government could walk, at the risk of being blown up.'[5] These explosions were often like profound eruptions,

[3] Henry Fox, quoted in the Earl of Ilchester, *Henry Fox, First Lord Holland,His Family and Relations* (2 vols., London, 1920), i.179. Fox made the remark in 1751.

[4] 'The role of most men in politics at that time, as for most men in most ages, was spectatorial. Public life, and a fair proportion of private life also, was a performance to be watched and enjoyed, hissed or applauded. Everything from an election to a hanging took place on an open stage, for all to see, and everyone from the King on his throne to the Bishop in his lawn, the Judge in his ermine, the soldier in his scarlet and pipe-clay, down to the labourer in his smock-frock, dressed his part and acted in character. . . . Life was lived "in costume," and everyone, including the audience, was part of the play, down to the "mob" which acted the part of Chorus. People looked for "a good show", whether from the King riding in his glass coach to the opening of Parliament or the cutpurse riding his tumbril to Tyburn.' R. J. White, *The Age of George III* (New York, 1968), p. 27.

[5] W. L. Burn, 'The Eighteenth Century', *The British Party System: a Symposium*, ed. Sydney D. Bailey (London, 1952), p. 24.

coming from the substrata of simple prejudices in the public consciousness: nativism, xenophobia, adamantine hatreds shaped long ago.

Both the evolution of Britannia and John Bull as national symbols and the refinement of the old idea of an exalted and unifying monarchy into the myth of a patriot king are indicative of the quickening sense of patriotism and nationalist fervour in the middle decades of the eighteenth century. *King George* [Plate 101] and the many anti-French satires are typical expressions of the pride, exuberance, and strident nationalism that developed during this period.

In the main, however, the political prints of the eighteenth century show how closely its basic preconceptions were related to the seventeenth century. Semi-coherent beliefs, intellectual hand-me-downs to the untutored, fast becoming banalities—they remained common currency in the political lore. They were vestiges of half-forgotten struggles, the experiences of previous generations. The suspicions of court policy, the hatred of courtiers, favourites, and first ministers, the tales of French gold and French artifice, the national stereotypes, the curse of excise—all have their origins in the seventeenth century. In some instances, the rudiments are even earlier. 'Ages of history . . . overlap, and curious throwbacks occur, or it will happen that, as the world changes, men are slow in making their mental adjustments.'[6] The remnants of worn-out convictions sometimes force an unreal construction on new activities.

A popular culture based upon reading was also created in the seventeenth century, for it was at this time that the scale of published material greatly increased. Everything, from the plays of Jonson and the finest emblem books to the cheapest ballads, jestbooks, and chapbooks, appeared in print and was disseminated to an increasingly literate public. The prints of the eighteenth century also reflect this heritage.

In the 1760s new blood began to flow in the body politic. The *cause célèbre* of Wilkes, the birth of radicalism, the organization

[6] Herbert Butterfield, *George III, Lord North, and the People, 1779–80* (London, 1949), p. 10; perhaps echoing Burke's comment: 'I have constantly observed, that the generality of people are fifty years, at least, behind in their politics.' 'Thoughts on the Cause of the Present Discontents', *Writings and Speeches of the Right Honourable Edmund Burke* (12 vols., New York, 1901), i.442.

on a mass scale of 'opinion without doors', and the contests of
George III with his ministers and would-be ministers produced
real constitutional issues.[7] The American Revolution and the
events leading up to it introduced an entirely new issue. Imperial
affairs are generally absent from the prints before 1760. The
return of a degree of factionalism to graphic satire in the sharp
exchange of prints was another sign of the revival of issues.

This change, however, should not be exaggerated. The glacier-
like protractedness and languid movement in popular beliefs was
characteristic of the whole century. This is superficially apparent
in the continuity of iconography. Stock images changed little: a
sameness that was true, to a certain extent, of ideas as well. The
prints were quick to embrace the hero, Wilkes, but defending him,
they did not probe the legitimacy of general warrants or the
proper extent of parliamentary privileges; they relied instead on
the old generalities about Government tyranny and corrupt
Parliaments. Gillray's assaults on Jacobinism and 'Little Boney'
at the end of the century appealed as much to the hearty ideals of
roast beef and Old England (and the traditional hatred of the
French), as they did to the new ideological struggle.

Nor should there be an exaggeration of the differences in the
quality of graphic satire, ante-1763, post-1763. Great events
provide great material. Certainly the body of prints in the second
half of the century seems less stultified and repetitious. Two
qualities stand out: the increased use of the technique of caricature
with greater emphasis on personal satires; coloured prints as the
rule instead of the exception. These changes, however, were
accomplished gradually. They are already at work in the political
prints of the age of Hogarth.

Coloured prints begin in the late 1740s and appear frequently
in the next decade. Caricature, in a variety of forms, is no stranger
to the prints of this period. Though anonymity prevailed in much
of the invention and design, Bickham and Townshend must justly
be considered the forerunners of Sayers and Gillray. The quality
of design in the prints varied. The plates show that much of it
was of high calibre. Quality of design is not necessarily conjoined
with good satire and polemic. Some of the meagre etchings of the
period are effective satires.

[7] Which perhaps accounts for the greater number of ideographic representations
of the constitution and related conflicts in the prints of the 1760s and 1770s.

This study began with the observation that some of these prints appear crude and childish to the modern eye: a seeming anomaly in an age renowned for its sophistication. There is no one explanation. Political prints were still, in these early and middle decades of the eighteenth century, a nascent art, developing within the confines of traditional iconography, experimenting with caricature. The art was not yet as well equipped, it is true, to capture the essence of issues or nuances of personality as it would be a generation later. Also, printselling was a business, an enterprise in which artistry was often sacrificed to haste and volume of sales. Much of the prints' appeal, and perhaps their value as propaganda, depended on simplicity. They sought a wide audience, whose tastes were not uniformly sophisticated, especially if one confuses sophistication with elegance. And perhaps part of the answer can be found in the Georgians' supposed sophistication itself. They patronized art; they generously supported graphic art (but reproductive work more than original design). Connoisseurs and dilettantes distinguished the age—but surprisingly few graphic artists of major stature. Graphic satire—political prints included—flourished, but it was in the nature of a diversion, a fanciful indulgence.[8]

Prints were intended primarily for amusement. Once appreciated they passed from hand to hand, were consigned to scrapbook collections, or used as wallpaper. Of what value are these curious artifacts to the historian? Some are, in particular and diverse instances, of value as primary evidence: suggesting or corroborating a fact, about which other evidence is silent or obscure. Instances have been mentioned in the above pages where prints do or do not substantiate a common myth or legend.[9]

[8] As A. M. Hind has suggested (*Short History of Engraving & Etching*, p. 225), this was not a proper climate for an art (original etching in particular) which requires genuine and forceful expression.
[9] Edward Raymond Turner, in 'The Materials for the Study of the English Cabinet in the Eighteenth Century', *Annual Report of the American Historical Association for the Year 1911*, i.91–8, mentions broadsides, squibs, and lampoons as possible, though limited source materials. He refers to *In Place* [Plate 23] as one print he had seen, though he does not indicate of what use it is in the history of the cabinet. In fact, it probably has very little. More interesting in this respect are a number of prints of 1756 attacking the Newcastle ministry (e.g. Plates 77, 80, 82, and 84). Do they merely single out the most well-known ministers or do they also imply recognition of the existence of a selective executive body, a war council or perhaps an 'efficient cabinet'? The special importance of efficient cabinets

Political prints reflected, and to a certain extent affected, public opinion. However ill-defined this phrase can sometimes be, the prints help to delineate its major characteristics. They demonstrate the importance of the London orientation, the association with elements of political discontent—at most levels—within the city, the pervasiveness of country-party ideas, the pandering to the jaundice of coffee-house grumbletonians. Students of eighteenth century history have sometimes needed reminding that there was more to political life than the parochialism and family rivalries of local politics on the one hand, and parliamentary divisions and closet intrigue at Westminster on the other. A third dimension existed, opinion out of doors, and however small, inarticulate, and passive it so often was, this force cannot be neglected. Self-imposed restriction to the study of private correspondence, state papers, and parliamentary debates and divisions offers a limited view.

The historians of the nineteenth century looking at the Georgian era possessed, in this respect, an advantage. If they were vague and superficial about public opinion, as they were naïve in accepting the viability of parties and issues, they at least had latitude of perspective and a willingness to see things whole.

In recent years historians such as George Rudé and Lucy Sutherland have broken ground in the examination of extra-parliamentary opinion and politics.[10] The body of prints, to the appreciation of which M. Dorothy George has pointed the way, serves as a reminder of this wider sphere of political life.

The prints are, as well, documents of cultural and intellectual history. In the unassuming, ordinary literature of an age are often discovered styles and tastes, basic assumptions and beliefs, so fundamental that they are rarely talked about or explained. The conception of political life in the prints is at once delightfully cynical and unashamedly moralistic. The satire turned a sardonic eye on the hypocrisy and self-interest of politics. At the same time

in time of war has been noted by H. Temperley, 'A Note on Inner and Outer Cabinets; their Development and Relations in the Eighteenth Century', *English Historical Review*, xxxi.291–6.

[10] Recent work has also attempted to focus on particular aspects of public opinion in the eighteenth century. Perry's book on the Jew Bill has examined one of its more explosive manifestations. Ronald Spector, *English Literary Periodicals and the Climate of Opinion during the Seven Year's War* (The Hague and Paris, 1966) calls attention to one of the lesser-known channels of public opinion in the age.

it measured both men and issues by moral dicta: by fixed absolutes of virtue and vice, good and evil. A man's public character was but his private nature writ large. The elements of this moral structure were, in part, religious in origin: there are the inevitable quotations from the Bible; in part, classical: the epigrams of the ancients were familiar to the age. The trite moralisms also reflect a heritage of didactic literature, of which the emblem books are a part. The political clichés and conventionalities serve as expressions of contemporary knowledge of ancient and British history. The early and middle decades of the eighteenth century witnessed, in the popularity of Rapin's, Smollett's, and Hume's histories, a greater interest in and study of the nation's past. Much of this history was adapted to the purposes of factionalism. Bolingbroke's history, written under the pseudonym of 'Humphrey Oldcastle' and published in serialized form in the *Craftsman*, used the subject for clever attacks on Walpole's ministry. This history was, in a perverted way, philosophy teaching by example.

The taste of humour in the prints is vital and masculine, hearty and carefree. The burlesque of popular humour is earthy, its scurrility uninhibited. It is the product of rogue stories, jest-books, and bawdy tales, which glutted the market of printed ephemera since the seventeenth century. Bodily functions, treated in a coarse and frank way, express an indelicacy that pervades the popular tastes of the age. Vomiting, defecation, and the like frequent the prints. Satirists used such imagery for travesty and burlesque, degrading persons of high estate and issues of moment. Vomiting is the conceit in Plate 41. In *The Grounds* [Plate 35] Walpole farts to keep the British fleet from reaching open seas. Defecation is the theme is *Broad-bottoms* [Plate 56], an ironic piece that has the broadbottomed Sir John Hynde Cotton and his cohorts atop an arch, their arses exposed as they express their contempt for the group of asses (the tax-paying nation) below. In a similar show of contempt, Bute defecates on Britannia and Hibernia in Plate 121.[11] The same function provides the metaphor in *A very Extraordinary Motion* [Plate 55],[12] where George II,

[11] This was a typical way of showing disdain. Lord Chesterfield expresses his dislike for the print, *The Funeral of Faction*, by squatting over a copy of it and relieving himself in *What's all This! The Motley Team of State*. A dog urinating is another expression of contempt.

[12] *A Cheap and Easy Method*, etc. [Plate 51] uses the same idea to depict the change of offices.

bending over a table, reluctantly engorges Cotton as the latter's predecessor falls from the King's buttocks.

Humour of a sexual nature is not common in the extant prints; the publication of obscene material, however, was not rare. What sexual humour there is appears mainly in the form of puns, rarely in suggestive or indecent imagery. Lord Bute's supposed illicit relationship with the Dowager Princess of Wales produced a number of daring satires.[13]

The humour differs little, perhaps, from the tastes of male camaraderie in any age: the conversation in pubs and taverns; the graffiti on lavatory walls. Not only is much of the imagery concerned with the natural functions of man and animal; it abuses the body as well: purges, vivisections, and executions are standard expressions of satirical malevolence.

Such material so openly displayed in the political prints of the Georgian era still manages to strike the modern eye with a degree of shock and embarrassed amusement. The remnants of Victorian prudery remain with us. The grossest of these eighteenth-century satires would not be allowed in the contemporary newspaper cartoon, though most could find publication elsewhere. That taste which brought about an eclipse of Gillray's popularity and reputation in the nineteenth century has, however, disappeared to the extent that the earthy humour of eighteenth-century prints no longer makes a hindrance to their appreciation. In some cases it is a refreshing virtue.

The juxtaposition of these coarse images with conventional iconography is startling and fascinating. So, too, are the other ideographs inspired by contemporary life. Some are expressions of common conceits such as the architectural and maritime representations of constitution and state. Much of the imagery comes from the street-life of the city, much from the language and idiom of entertainments and display: puppet and 'raree' shows; gibbets, faggots, halters, effigies, and the other regalia of popular demonstrations. The imagery is more urban than rural. There is nothing bucolic about these prints. They sense the pulse of the city, of London with its landmarks, the hustle and bustle of its streets, the unceasing din, the city's noisome smells, its squalor,

[13] See above, chap. vii. *The C–t Shittle Cock*, mentioned in chap. v, is an example of the use of sexual puns.

its filth—and the cynicism and worldliness that such an atmosphere produced.

This image is impressive and not at all in accord with certain fixed preconceptions about Georgian England. Feeling for the eighteenth century has been influenced altogether too much by the remains of its showmanship: its striking architectural landmarks and worldly possessions, now carefully preserved by the National Trust, by museums, and in private collections. The Baroque and Palladian edifices; the contrived abandon of the *jardin anglais*; the quietude and complacent idealism of Reynolds' portraiture and the conversation-pieces of Zoffany; the musty perriwigs; the breeches and waistcoats; the embroidered hoop-skirts and stomachers of velvet and satin, camlet and chinz; the delicate craftsmanship of Chippendale mahogany and Wedgwood china; the bric-a-brac of *chinoiserie* and Gothic Revival—all the superficial elegance that gave style and glitter to a civilization.

The prints have absorbed some of this cultivated artificiality and a few of its aesthetic norms: the studied poses; the rigid style of entablatures; the allegorical modes to be found as well in monumental sculptures and panegyric art; the careful attention to order, proportion, and balance. But the prints are just as true to that chaos that lay beneath the imposing order, to the ugliness beneath the elegance, the humanity disguised in the studied pose. The thin, polished veneer obscures the coarseness, the exuberance, and the vitality of eighteenth-century life. Georgian England was an age of chronic disorder, waste, and inefficiency. Highwaymen, footpads, and smugglers; the violence of cudgels, pistols, knives, and fisticuffs; poorly lit streets and an ineffective magistracy—all seemed to carry the portent of imminent anarchy; an age when Tyburn claimed, in giant, metropolitan spectacles, its tribute for the transgression of two hundred laws; a period in which mob rioting was accepted as a venerable tradition. This was a time in which the savagery of popular outcry and a timorous ministry resulted in the execution of an Admiral of the Fleet on a quarter deck in Portsmouth harbour.

The eighteenth century indulged in extraordinary brutality to man and beast. Indiscriminate flogging served as the standard tool of discipline in the army, navy, and schools. Bedlam, the Fleet, and Newgate stood as monuments to ignorance, cruelty, and

insensitivity. Bear-baiting, bull-baiting, goose-riding, and cock-fighting made for popular sports.

Georgian England was not a clean time or place. Society lacked even the rudiments of hygenics. Chamberpots were kept in the sideboard for expedient use, their contents dumped casually into the streets. Smallpox and rotten teeth created many a grotesque visage. Excruciating pain and prolonged suffering were facts of life. Childbirth, gout, dropsy, and stones had to be endured as a matter of course. Surgery offered a harrowing ordeal.

So 'bottom', a combination of stamina, pluck, and stoic resignation, was cultivated. Life so precarious encouraged heartiness, verve, a lack of inhibitions, and a sense of style. Profusive displays of emotion were accepted. So was excess in drink, eating, and gaming.

This temper of living is captured in the earthiness, the vulgarity, and the candidness of the prints. Alongside Hogarth's gin-sodden mother and cruel Tom Nero are the images of Walpole, George II, and the Broadbottoms with their arses exposed, farting and defecating; Walpole again in one of his boisterous laughs; Britannia flogged or torn to pieces; George III's mother playing the lustful strumpet; Lord Sandwich picking his nose; gangly Pitt astride the bubble of his own vanity; the decrepit, hunchbacked Newcastle, babbling his inanities; the contemptuous mob, hooting the effigies of Byng, Fox, and Bute. These images make a lasting impression. Carlyle's fanciful vision of an age of pervasive artificiality, stolidity, and decorum, of "buckram masks," "the work of the Tailor and the Upholsterer mainly," disappears. The prints suggest a different mental picture of the eighteenth century.

Bibliographical Note

Collections of political prints were, by and large, formed under private auspices in the nineteenth century, after the business of printmaking itself had passed away. The basis of the British Museum collection is the private collection of Edward Hawkins. This corpus of prints was purchased by the Trustees in 1867; for some time before this, however, prints had been accumulating at the Museum. Hawkins was for thirty-four years the Keeper of the Antiquities there. He was a fellow of the Royal Society and a numismatist—a great authority on British medallic history. The quality of the Museum's collection owes much to his labours. Most of the prints are now preserved on large sheets of cardboard in the Department of Prints and Drawings. Some, including frontispieces, illustrations, and several of the books of prints, are found in the Library.

The prints in the Pierpont Morgan Library of New York City, 'A Collection of Political Caricatures, Broadsides, Portraits, etc., 1642–1830. From the Library of Sir Robert Peel, Bart., Drayton Manor, Tamworth', consist of twelve volumes. The Library purchased them in 1900.

The collection in the Lewis Walpole Library, Farmington, Connecticut, is proving to be an increasingly valuable adjunct to Walpoliana. It was begun by Mr. Wilmarth S. Lewis in the early 1950s. The donation of the Hugh Auchincloss collection provided an admirable basis. Continual purchases and gifts—one of the most important of which is the Alfred Bowditch collection, donated by Mr. Augustus Loring—have swelled its size. The late Mrs. Wilmarth (Annie Burr Auchincloss) Lewis began the task of cataloguing. This important work is being carried on by the present curator, Mrs. Richard D. Butterfield.

The Pierpont Morgan and Lewis Walpole collections duplicate, in the main, the impressions in the British Museum (for the period, 1727–63). There are, however, some interesting additions in the two former collections. A few of them are reproduced among the illustrations. In total size the collection at Farmington now rivals that of the British Museum.

The dozen or so prints in the Archives des Affaires Étrangères; Documents, Angleterre, 1737 à 1739 (Vol. XXXVIII) and Documents, Angleterre, 1739 à 1744 (Vol. XXXIX) are also found in the British Museum. The impressions include the *European Race* series, *The Festival of the Golden Rump* [BMC 2327, Plate 19], *The Naked Truth* [BMC 2417], *The State Pack-Horse* [BMC 2420], *Idol-Worship or The Way to Preferment* [BMC 2447, Plate 28], *The Scotch Patriot in contrast* [BMC 2450], *The Stature of a Great Man or the English Colossus* [BMC 2458, Plate 32], *The Motion* [BMC 2479, Plate 34], *The Motive, or Reason for His Honour's Triumph* [BMC 2485], *To the Glory of the Rt. Honble Sr. Robert Walpole* [BMC 2500, see Plate 10], *The Whole State of Europe* [BMC 2502, Plate 38], *The C–rd–ls Master-Piece, or Europe in a Flurry* [BMC 2503], *A Parliamentary Debate in Pipes's Ground* [BMC 2580], and *The H–v–n Confectioner General* [BMC 2584]. There is another print, entitled *A*

Consequence of the Motion [BMC 1868], which the British Museum *Catalogue* associates with the duel between Lord Hervey and William Pulteney in 1731. The print may have actually been occasioned by Sandys' motion on 1741. Another print, *The Female Volunteer, or, An Attempt to make our Men Stand*, printed by A. More in 1746, and showing Margaret Woffington ('Mrs. Woffington'), the actress,[1] in the dress of a soldier, is not in the Museum. It is an exhortative satire on the Forty-Five, ridiculing male indifference and cowardice in the face of rebellion.

The appearance of these prints in the French archives, alongside copies of the *Craftsman* and *Common Sense*, is interesting, not because of the number of prints, but because of what they show about French attitudes towards English public opinion. Most of the prints are either anti-ministerial or are concerned with foreign policy and English feelings about France.

An important part of the examination of the prints is the comparison of their substance to that of the pamphlet literature of the period. The collection of British tracts, 1481–1800, in the Beinecke Rare Book Library of Yale University is invaluable for this purpose. There are several hundred pamphlets concerned with political affairs in the period 1727–63. The Library also possesses the best collection of editions of the *Craftsman* on the west side of the Atlantic. The Burney collection of newspapers in the British Museum is extensive; especially useful for this study were its editions of *Common Sense: or, The Englishman's Journal; Old Common Sense: or, The Englishman's Journal;* the *Champion: or, The Evening Advertiser; Old England: or, The Constitutional Journal, By Jeffrey Broadbottom, of Covent Garden, Esq.;* and the *Public Advertiser.*

The State Papers, Domestic, both General and Entry Books, at the Public Record Office contain information about Government attitude and action with regard to the Opposition press. They also shed some light on the business of printselling and the circulation of prints. Relevant material is scattered through the bundles and books. Fortunately, most of the records are calendared.

Material in the Newcastle and Lansdowne papers in the Department of Manuscripts of the British Museum is useful in the investigation of George Townshend's role as a graphic satirist. The nature of his role needs further study. Townshend is without a modern biographer. The Newcastle and Robinson MSS. are of some help in discovering the ministry's attitude toward public clamour during the excise crisis of 1733.

The work of serious and careful study of the prints did not begin until the second half of the nineteenth century. Thomas Wright, antiquary and historian of popular humour, was one of the first scholars to show an appreciation of the subject. His *History of Caricature & the Grotesque in Literature and Art* (London, 1865) is a broad survey of humour in Western culture; it contains several short chapters on eighteenth-century political satire. Wright's *Caricature History of the Georges* (London, 1867) is a more restricted study: political satire, verbal as well as pictorial, in the eighteenth and early nineteenth centuries. Both

[1] Known for her ability in male parts on the stage and her love of masculine society.

books are highly superficial; Wright examined some of the prints in the British Museum before they were catalogued.

Frederic George Stephens undertook the job of cataloguing in the late 1860s. The *Catalogue of Prints and Drawings in the British Museum, Division I: Political and Personal Satires* (4 vols., London, 1870–3) provides a description and explanation of each print in the collection. Stephens made extensive use of the notes of Edward Hawkins (whose annotations can be seen on some of the prints). He also consulted materials in the Library, including newspapers and an occasional pamphlet, though only for the purpose of elucidating some obscure fact or allusion. The *Catalogue* has several weaknesses. Stephens' criterion for ordering the prints is the earliest historical fact with which a print has a direct connection, instead of a chronology based on the date of publication—which sometimes leads to confusion. Quotations are occasionally omitted or transcribed incorrectly. There is little integrative analysis of the prints as a whole, and no attempt to delineate a common substratum of ideas. The *Catalogue* contained for many years the standard textual description of Hogarth's prints, but has now been replaced by a definitive catalogue, Ronald Paulson's *Hogarth's Graphic Works* (2 vols., New Haven, Conn., 1965).

The late M. Dorothy George, who completed the British Museum *Catalogue* (7 vols., London, 1935–54), is the only modern historian of note to pay serious attention to the study of eighteenth-century graphic satire. Her *English Political Caricature: A Study of Opinion and Propaganda* (2 vols., Oxford, 1959) is a competent, well-grounded survey. Mrs. George made a great contribution by opening the subject to historical enquiry. She made plain the broad outlines of areas for further study, including the lineage of iconographic and thematic materials. The emphasis of her study falls on the political caricature of the last quarter of the eighteenth and first decades of the nineteenth centuries.

English Political Caricature is a survey, and though a good one, it reflects a survey's inherent limitations. There is a tendency to consider the prints as but passing and disconnected reflections of public opinion and to touch only the high peaks of popular outcry and notoriety. The book left a need for a thorough examination of the relation of prints to pamphlet literature and for the study of the printselling trade and the position of the authorities.

The historian, in breaking new ground and devising new methods of analysis, has recourse to the knowledge of other disciplines. The bibliography of iconography, emblematic literature, caricature, satire and humour, printing and publishing, engraving and etching is large. Some of the important and relevant books on these various subjects have been noted in the text.

Index of Prints

General Index

Adam, Robert, 215.

Addison, Joseph, 150–1n.

Aiguillon, Emmanuel Armand, Duc d', 174n.

Aix-la-Chapelle, Treaty of, 186–8.

Alciati, Andrea, 28, 99n.

allegorical figures, 26–8. *See also* Britannia, Fortune, iconography, John Bull, Liberty.

America, 179 and n; American Revolution, 106, 264; stereotype of the American, 89.

Anne, Queen, 119.

Anson, George, 1st Baron Anson, 143, 183, 247n.

Applebee, John, 10.

Arbuthnot, John, 97–100.

Argyll, John Campbell, 2nd Duke of, 110, 118, 122, 140.

Atterbury, Francis, Bishop of Rochester, 72–3.

Augusta, Dowager Princess of Wales, 57, 82, 145, 216–21, 225–6, 270. *See also* Bute.

Austen, Stephen, 6.

Austrian Succession, War of, 6n, 52n.

Bakewell, T., 4.

balance of power, in foreign affairs, 181, 204n.

ballad literature, 192n.

Barnard, Sir John, 161.

Baron, Bernard, 24, 44, 46.

Barrington, William Wildman, 2nd Viscount Barrington, 54.

Beckford, William, 148.

Bedford, John Russell, 4th Duke of, 188–9, 250.

Beggar's Opera (John Gay), 206.

Benoist, Antoine, 44.

bestiaries, 101.

Bickham, George, the elder, 14n, 16n.

Bickham, George, the younger, 14–16, 22, 47, 200, 264; as a caricaturist,

36n; difficulties with Government, 16, 78–81.

Bill of Rights, 125n, 133.

Biswick, John, 81.

Blake, Admiral Robert, 170.

Blakeney, General William, 1st Baron Blakeney, 169 and n.

'blue-water' school, strategy of, 168, 180, 254–5. *See also* 'Jack-Tar', and Pitt.

Boitard, Louis, 44, 46.

Bolingbroke, Henry St. John, 1st Viscount Bolingbroke, 68, 84, 115, 123, 133, 140–4, 164, 191, 198–9, 229, 267.

Book of Caricaturas (Mary Darly), 35.

Bowen, Emanuel, 72–3.

Bowles, Carrington, 5.

Bowles, family of printsellers, 5, 46n.

Bowles, John, 4, 5.

Bowles, Thomas, 5.

Breda, Peace of, 91.

Breughel, Pieter, 25.

Britain, or a Chorographicall Description of the Most flourishing Kingdomes, England, Scotland, and Ireland (William Camden), 89–90.

Britannia, 76, 84–5, 89–97, 144, 145, 149, 169, 182, 189, 224, 236n, 239, 250; abused, 95–7, 222, 225, 267, 270; as embodiment of virtue, 93–95; as guardian of liberties and the constitution, 93, 94, 127–8; as patroness of the Opposition, 95, 226, 253–4. *See also* Pitt; physical qualities of, 91 and n, 92; origins and development of, 89–91; representing martial strength, 96–7, 178–80; representing spirit of nationalism in eighteenth century, 84, 97, 105, 120, 263. *See also* 'blue-water' school and Pitt.

Britannia in Mourning: Or, a Review of

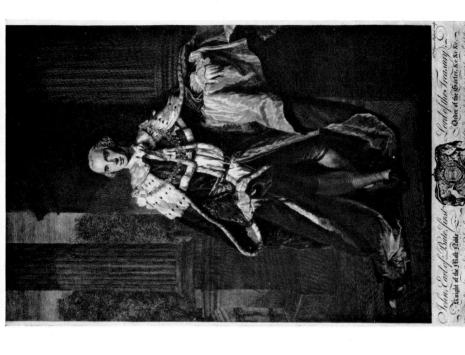

3. John, Earl of Bute, first Lord of the Treasury. British Museum

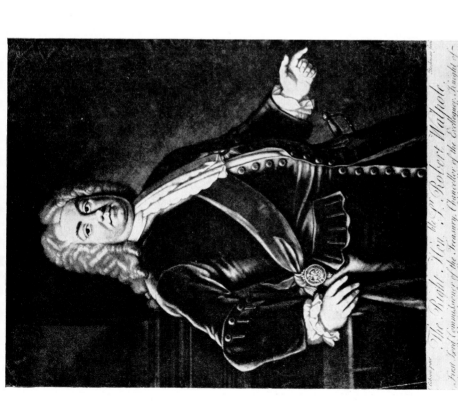

2. The Right Honble Sr. Robert Walpole. British Museum

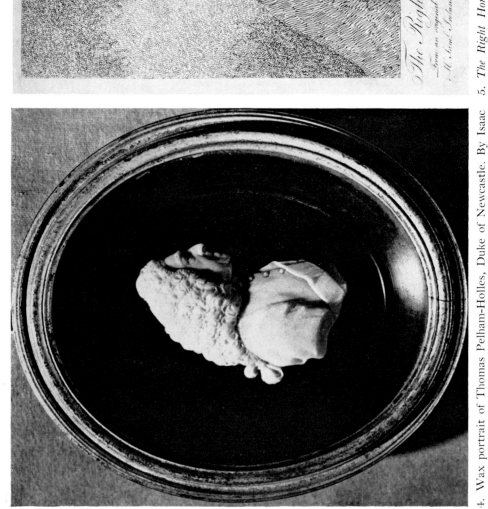

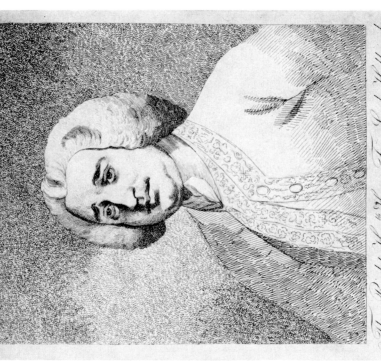

The Right Hon.ble Henry Fox, Lord Holland.

From an original Portrait in Oil by Hogarth in the Possession of
M.r Sam.l Ireland etched by J. Haynes Pupil to the late M.r Mortimer

Pub.d as the Act directs Mar. 19th 1792

4. Wax portrait of Thomas Pelham-Holles, Duke of Newcastle. By Isaac

5. The Right Hon.ble Henry Fox, Lord Holland. Lewis Walpole

6 (left). *The Right Honourable William Pitt, Esq.* British Museum

7. Portrait mezzotint of George the Second after a painting by T. Worlidge. British Museum

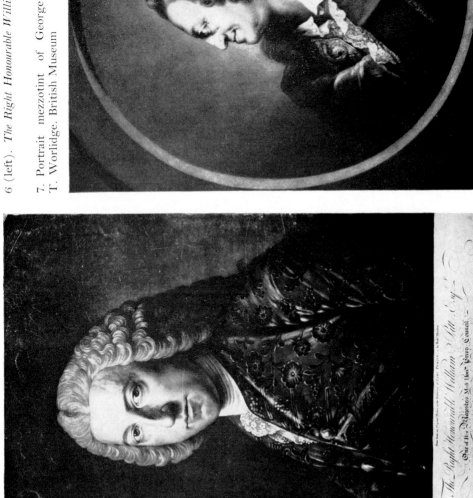

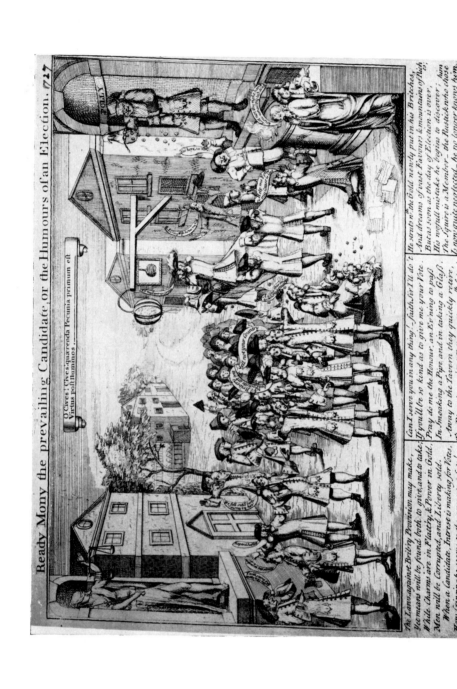

Ready Mony the prevailing Candidate, or the Humours of an Election. 727

O Cives! Cives! quaerenda Pecunia primum est
Virtus post Nummos.

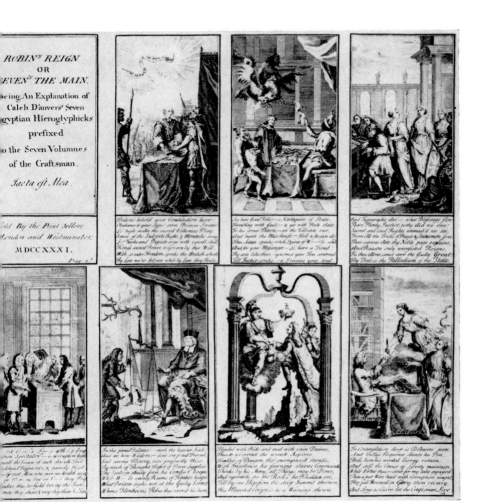

Robin's Reign or Seven's the Main. Being, An Explanation of Caleb Danvers's Seven Egyptian Hieroglyphicks prefixed to the Seven Volumes of the Craftsman. British Museum

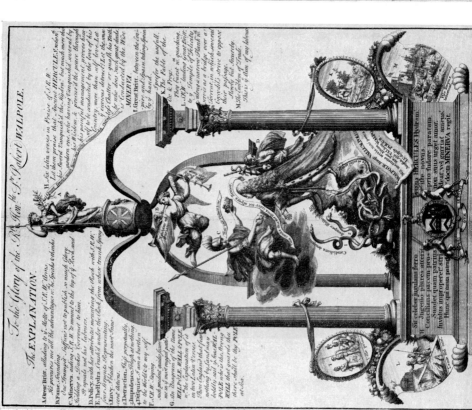

10 (left). *To the Glory of the Rt. Honble. Sr Robert Walpole*. Pierpont Morgan Library

11. *Excise in Triumph*. British Museum

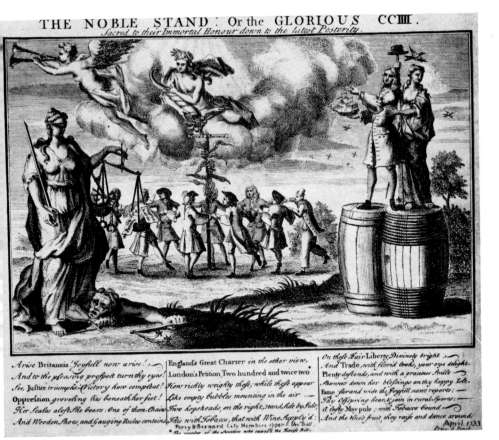

THE NOBLE STAND: Or the GLORIOUS CCIIII.
Sacred to their Immortal Honour down to the latest Posterity

Arise Britannia! Joyfull now arise! | England's Great Charter in the other view, | On these Fair Liberty, Divinely bright
And to the pleasing prospect turn thy eyes! | London's Petition, Two hundred and twice two | And Trade, with florid looks, your eye delight
See, Justice triumphs-Victory how compleat? | How richly weighty these; while these appear | Plenty descends, and with a gracious Smile
Oppression groveling lies beneath her feet! | Like empty bubbles mounting in the air | Showers down her blessings on thy happy Isle.
Her Scales aloft she bears: One of them Chains | Two hogsheads, on the right, stand side by side, | Fame far and wide the Joyfull news reports:
And Wooden Shoes, and Gauging Rules contains | This with Tobacco, that with Wine Apply'd: | Thy Offspring hear, & join in rural sports:
| Perry & Bernard City Members oppos'd the Bill. | A lofty Maypole; with Tobacco bound
| *The number of the Senators who oppos'd the Excise Bill. | And the vine's fruit, they raise and dance around

April 1733.
Price 6 Pence

12. *The Noble Stand: Or the Glorious CCIIII. Sacred to their Immortal Honour down to the latest Posterity.* British Museum

13. A satire on Sir Robert Walpole comparing him with Cardinal Wolsey. Pierpont Morgan Library

14 (left). *The Lord Mayors Speech and the City Petition about the Excise.* Pierpont Morgan Library

15. *The Scheme Disappointed. A Fruitless Sacrifice.* British Museum

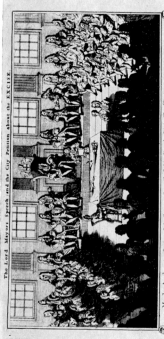

Britannia Excisa.

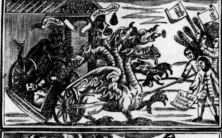

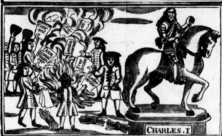

CHARLES I

BRITANNIA EXCISA. Part II.

Excise Congres.

1253

6. *Britannia Excisa. Britannia Excisa. Part II. Excise Congress.* British Museum

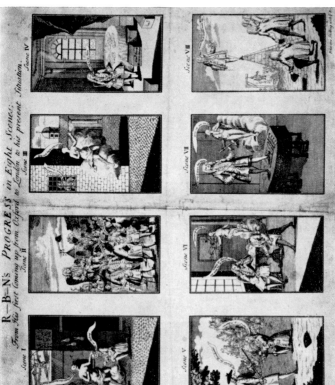

17. *R–b–n's Progress in Eight Scenes: From His first Coming up from Oxford to London to his present Situation.* British Museum

18. *Kentish Election.* British Museum

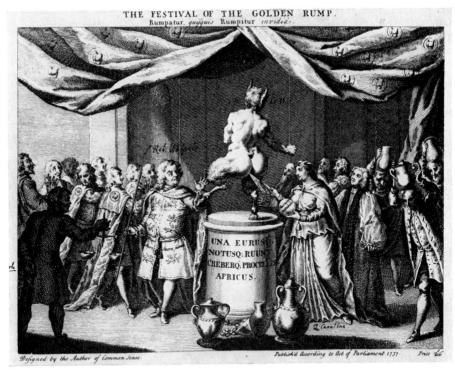

19. *The Festival of the Golden Rump.* Pierpont Morgan Library

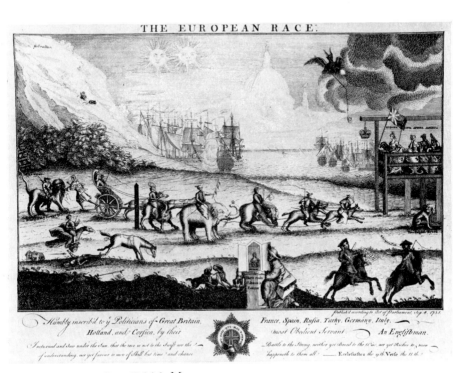

20. *The European Race.* British Museum

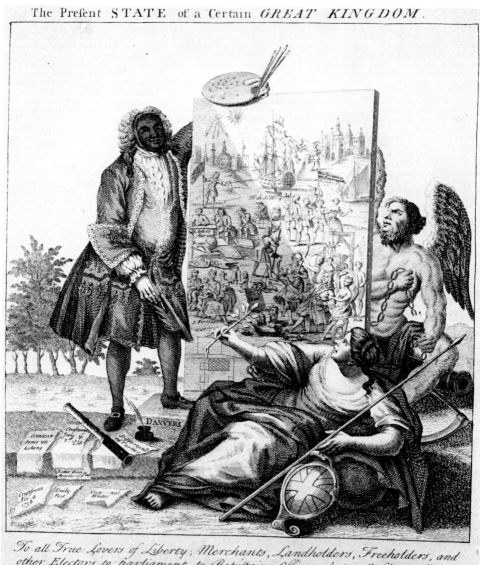

To all *True Lovers of Liberty*; *Merchants*, *Landholders*, *Freeholders*, and other *Electors* to parliament, to *Returning Officers*, & to all *Clear-Sighted* *Honest Men*; this piece is *Humbly Inscribed*

Amhurst, alias Caleb D'Anvers. Editor of The Craftsman

Publish according to Act of Parliament 1738

by their Most Obedient Servant *Dry Bob*.

21. *The Present State of a Certain Great Kingdom.* British Museum

Walpole.

THE
Lyon in Love.
OR THE
POLITICAL FARMER.
An Æsopian Tale,
Applicable to the prefent Times.

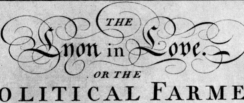

A *Lyon*, once to *Love* inclin'd,
Thus to a *Farmer* break his *Mind*:—
Your *Daughter*, Sir.—Then fetch'd a *Sigh*—
Give me Your *Daughter*, or I die.—
Hob stood aghast:—Then made a *Pause*—
But weighing well his *Length* of *Claws*,
And the huge *Fangs* between his *Jaws*,
Consented to his mad *Petition*;
But notwithstanding on *Condition*.
Poll, Sir, you know, is young & tender.—

Those *Grinders* may perhaps offender her—
Let them be *Drawn*, & pare your *Nails*,
The *Bargain's* struck:—Hang him if fails.
O'erjoyd the *Amorous* Fool complies,
And, like a whining *Coxcomb* cries,
Polly's the Only Thing I prize.
The *Job* perform'd, & all Things safe.—
Hob, & all round him grin, and laugh:—
Fearless, grow monstrously uncivil,—
And Send him packing to the D—l.

THE
APPLICATION.
Call Home Your Fleet cries Artful SPAIN,—
And BRITAIN shall no more complain.—
But should we be such Fools—What then?
We should be Slaves;—be drubb'd again.—

27 Oct. 1738

Reluctance of Walpole to engage in War: See Smollett. Bk.II.ch.vI. &v. vI. &c 27 ᵗʰ Octr. 1738 Publifh'd According to Late Act. Price 6p

22. *The Lyon in Love. or the Political Farmer.* British Museum

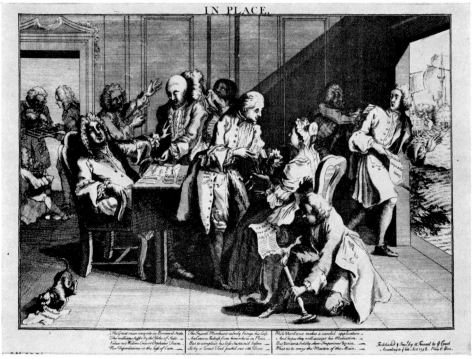

23. *In Place*. Pierpont Morgan Library

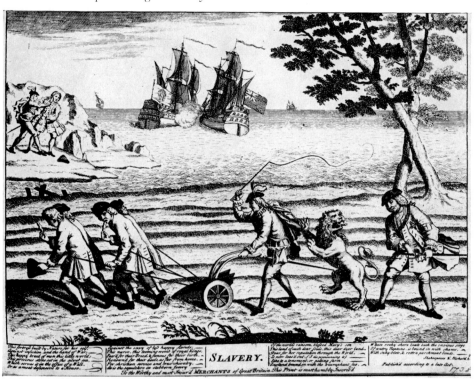

24. *Slavery*. Pierpont Morgan Library

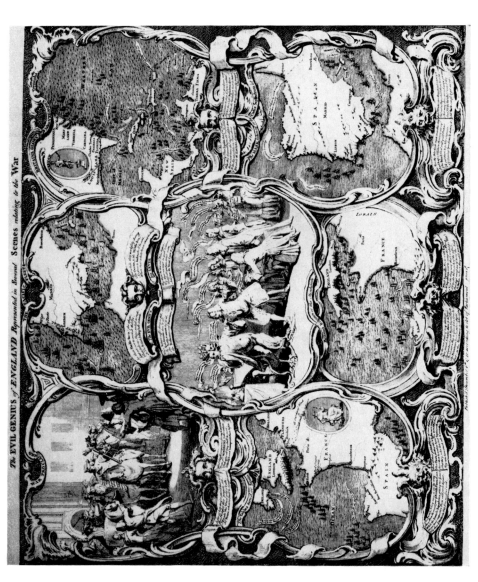

25. *The Evil Genius of England Represented in Several Scenes relating to the War.* British Museum

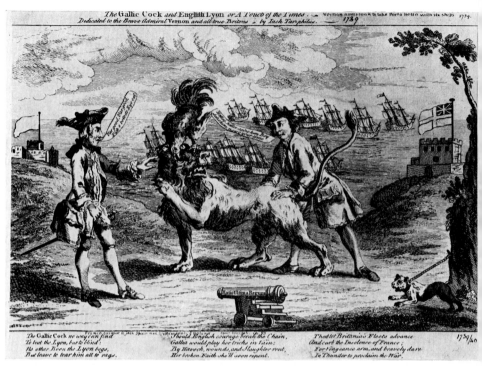

26. *The Gallic Cock and English Lyon or A Touch of the Times.* British Museum

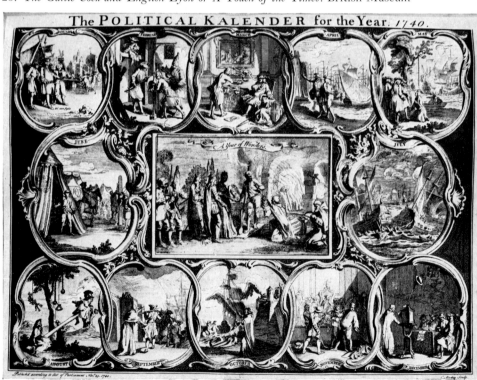

27. *The Political Kalender for the Year.* 1740. Pierpont Morgan Library

28 (left). *Idol-Worship or The Way to Preferment.* Pierpont Morgan Library

29. *The European State Jockies. Running a Heat for the Ballance of Power.* Pierpont Morgan Library

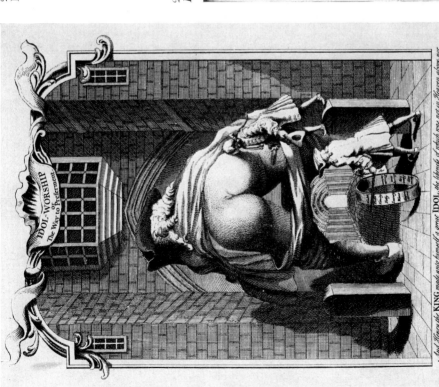

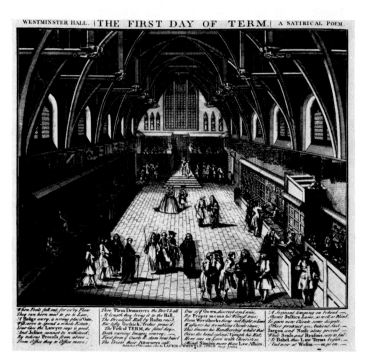

WESTMINSTER HALL. |THE FIRST DAY OF TERM.| A SATIRICAL POEM.

30 (left). *Westminster Hall. The First Day of Term. A Satirical Poem.* Pierpont Morgan Library

31. *The [Cha]mpion : or Even[ing] Adver[tiser].* Pierpont Morgan Library

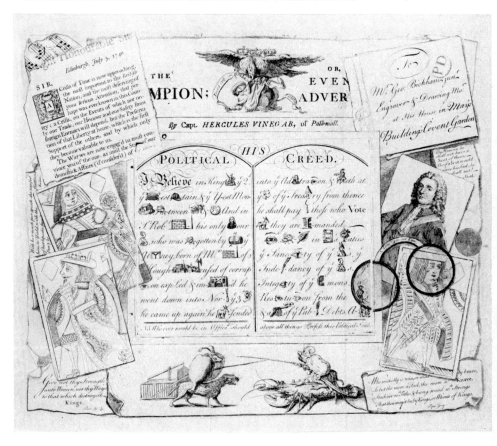

32 (left). *The Stature of a Great Man* or *the English Colossus*. Pierpont Morgan Library

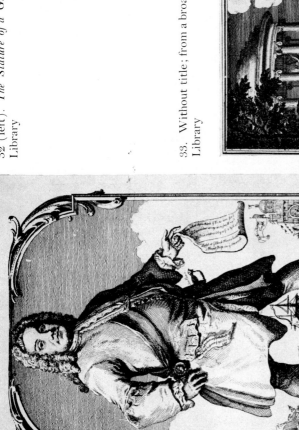

33. Without title; from a broadside entitled *The Patriot-Statesman*. Pierpont Morgan Library

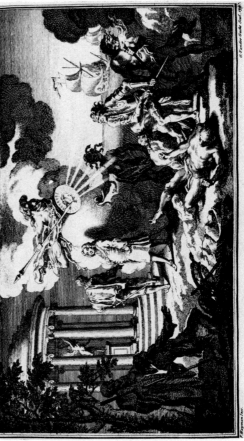

The MOTION.

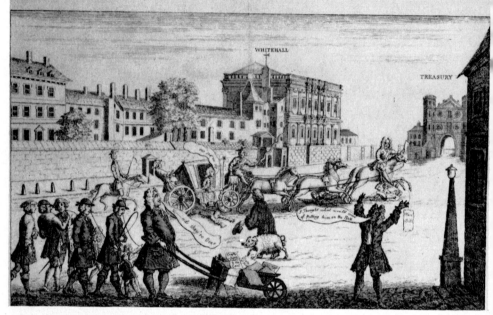

34. *The Motion.* British Museum

THE GROUNDS.

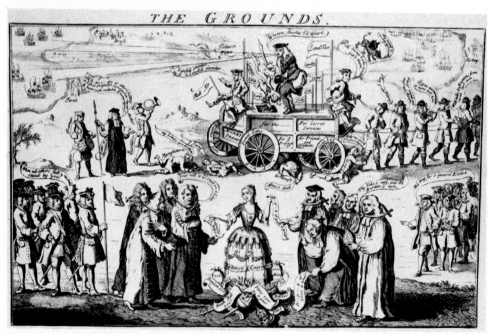

35. *The Grounds.* Pierpont Morgan Library

MERLIN, Or the BRITISH ENCHANTER.

And I looked, and, behold! there rushed forth a Beast of uncommon Size, on whose Back was fixed a Burthen of incredible Magnitude; from the Midst of which sprouted forth a Tree, whose Branches were of such Extent, that they over-shadowed Provinces and Kingdoms, and deprived their Inhabitarinoe' fac Lustre of the heavenly Luminary.

37. *Merlin, Or the British Enchanter.* Pierpont Morgan Library

The FUNERAL of FACTION.

36. *The Funeral of Faction.* British Museum

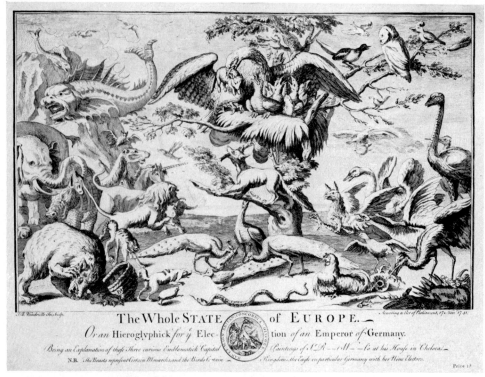

38. *The Whole State of Europe. Or an Hieroglyphick for ye Election of an Emperor of Germany.*
British Museum

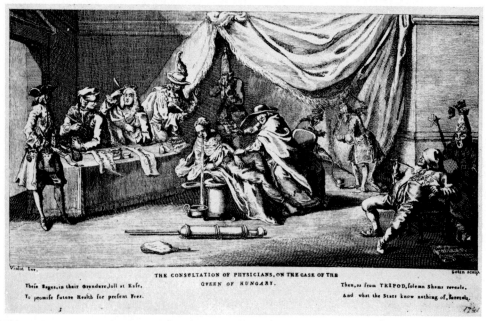

39. *The Consultation of Physicians, on the Case of the Queen of Hungary.* Pierpont Morgan Library

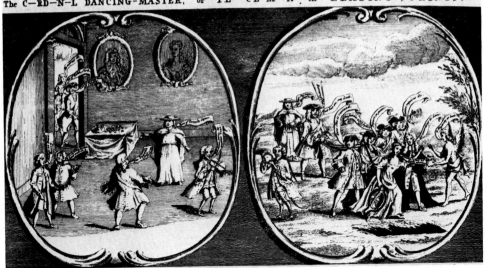

The C—RD—N—L DANCING-MASTER, or PL—CE—M—N in LEADING-STRINGS.

40. *The C–rd–n–l Dancing-Master, or Pl–ce–m–n in Leading-Strings.* Pierpont Morgan Library

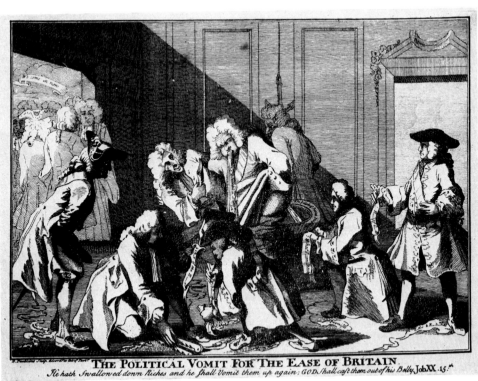

THE POLITICAL VOMIT FOR THE EASE OF BRITAIN.
He hath Swallowed down Riches and he shall Vomit them up again; GOD shall cast them out of his Belly. Job XX. 15.

41. *The Political Vomit for the Ease of Britain.* Pierpont Morgan Library

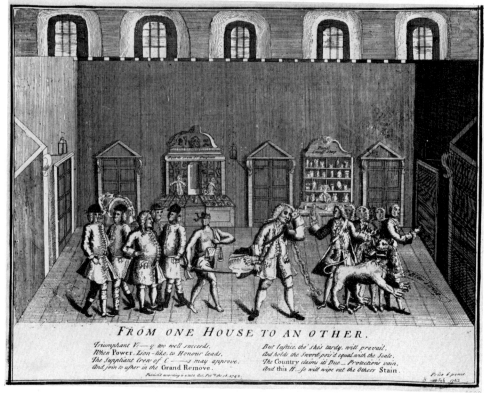

FROM ONE HOUSE TO AN OTHER.

Triumphant V——y too well succeeds,
When Power, Lion-like, to Honour leads,
The Suppliant Crew of C——s may approve,
And join to usher in the Grand Remove.

But Justice, tho' she's tardy, will prevail,
And holds the Sword pois'd equal with the Scale,
The Country claims its Due—Protection vain,
And this H——se will wipe out the Others Stain.

Publish'd according to Act of Parliament Feb 14 1742.

Price 6 pence

42. *From One House to An Other.* British Museum

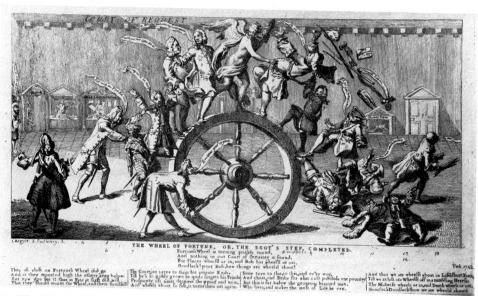

THE WHEEL OF FORTUNE, OR, THE SCOT'S STEP, COMPLETED.
Feb. 1742.

Fortune's Wheel is turning quickly round,
And nothing in our Court of Certainty is found.
For Places wheel'd us in, and Bob his wheel'd us out.
Goodluck! poor Bob, how things are wheel'd about!

They all aloft on Fortune's Wheel did go
And as they mounted high the others keep below,
But now you see it thus, as Fate it self did will
That they should mount the Wheel, and there fandsill.

The Courtier turns to Gain his private Ends,
Till he's In giddy grown he quite forgets his Friends
Prosperity oft times, deceives the proud and vain,
And wheels about, to fall, it turns them out again.

Some turn to that to that, and ev'ry way,
And cheat, and Bribe for what can't purchase one poor day
But that is far below the generous hearted man,
Who lives, and makes the most of Life he can.

And thus we are wheel'd about in Life's short Farce,
Till we at left, are Wheel'd off in a rumbling Hearse,
The Midwife wheels us in, and Death wheels us out,
Goodluck!Goodluck! how we are wheel'd about.

43. *The Wheel of Fortune, or, the Scot's Step, Completed.* British Museum

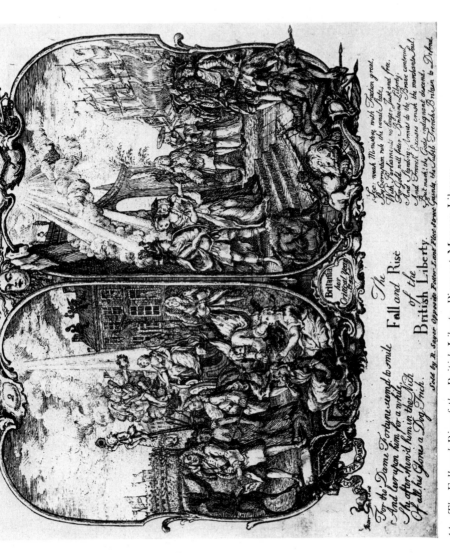

44. *The Fall and Rise of the British Liberty.* Pierpont Morgan Library

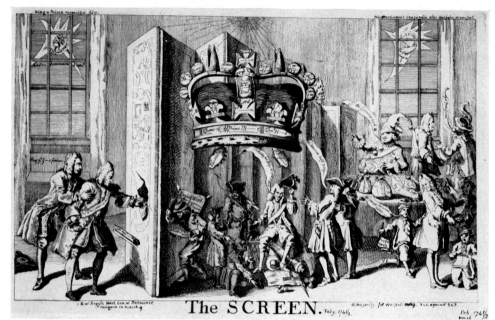

45. *The Screen*. British Museum

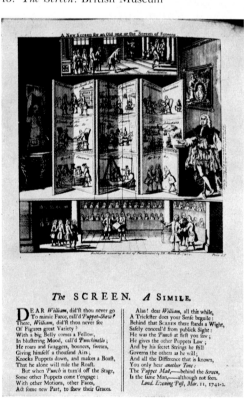

46 (left). *The Screen. A Simile*. Pierpont Morgan Library

47. *The Anti-Crafts Man Unmask'd*. Pierpont Morgan Library

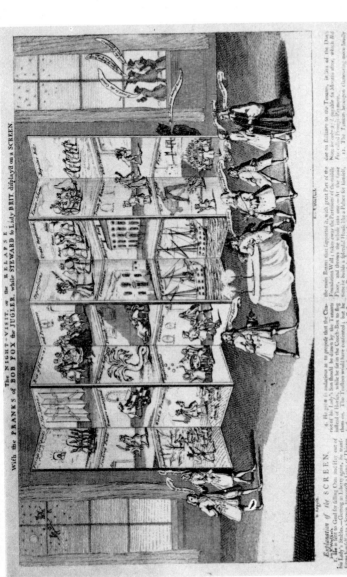

48. *The Night-Visit, or the Relapse: With the Pranks of Bob Fox the Jugler, while Steward to Lady Brit, display'd on a Screen.* British Museum

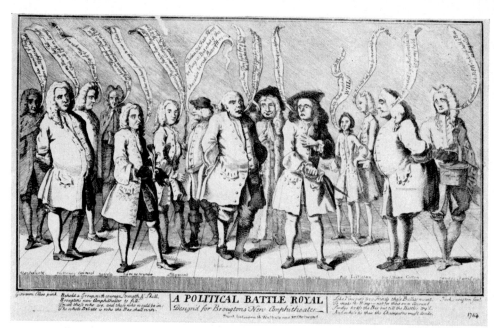

49. *A Political Battle Royal, Design'd for Brougton's New Amphitheater*. British Museum

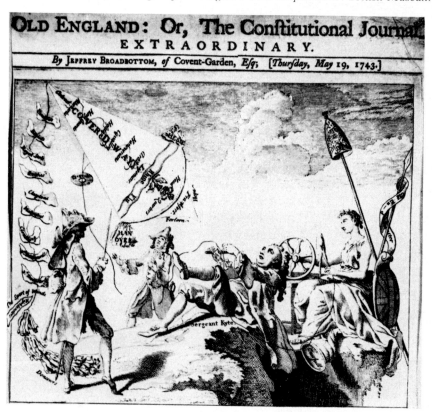

50. *Old England: Or, The Constitutional Journal. Extraordinary*. Pierpont Morgan Library

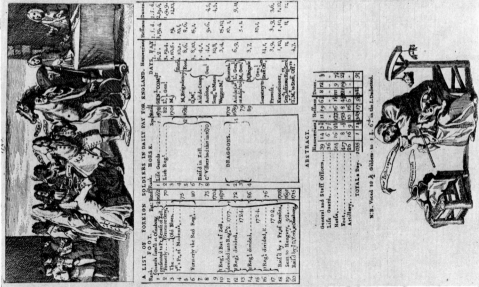

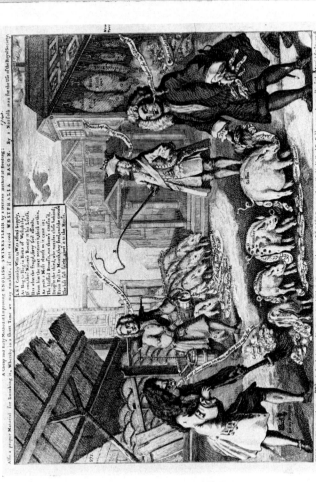

51. *A Cheap and Easy Method of Improving English Swine's Flesh by a German method of Feeding*. British Museum

52. Illustrations to *A List of Foreign Soldiers in Daily Pay for England*, etc. British Museum

THE late P—m—r M—n—r.

Lo! What are all your Schemes come to?

THE COURT FRIGHT.

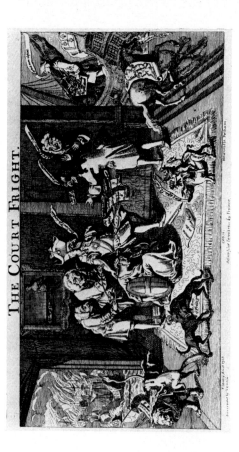

A very Extraordinary Motion.

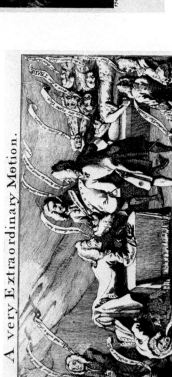

53 (above left). *The Court Fright.* British Museum

54. *The late P—m—r M—n—r.* Pierpont Morgan Library

55. (left). *A very Extraordinary Motion.* Pierpont Morgan Library

56 (left). *Broad-bottoms.* British Museum

57. *The Chevaliers Market, or Highland Fair.* British Museum

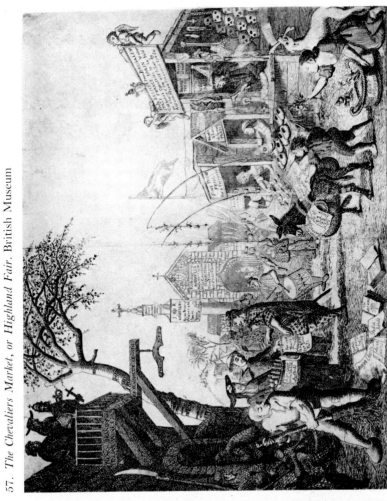

THE CHEVALIERS MARKET, OR HIGHLAND FAIR

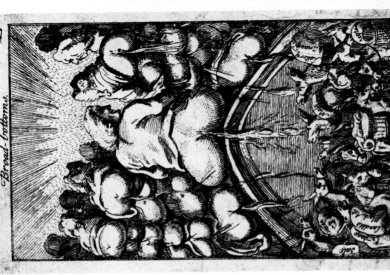

Broad-bottoms.

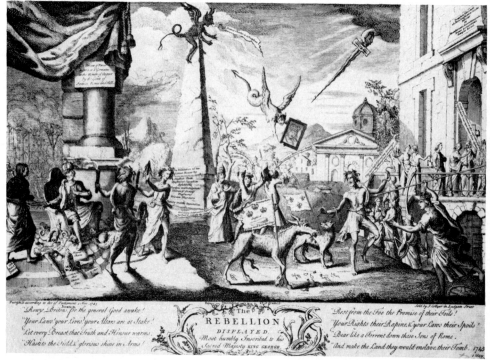

58. *The Rebellion Displayed. Most humbly Inscribed to his Sacred Majesty King George.* British Museum

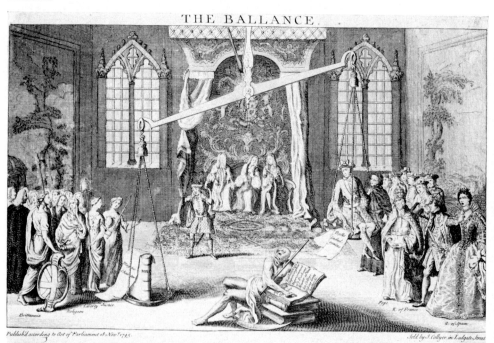

59. *The Ballance.* Pierpont Morgan Library

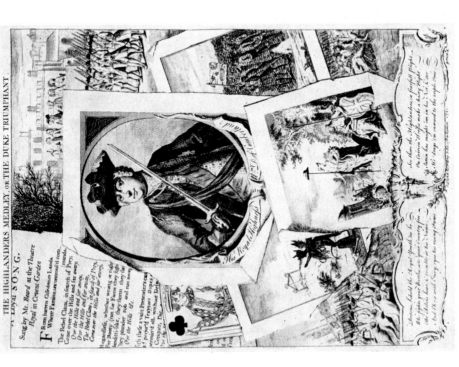

61. *A Collection of Modern Statues and Caracters.* Pierpont Morgan Library

60. *The Highlanders Medley, or The Duke Triumphant.* Lewis Walpole Library

62. *The Glory of France*. British Museum

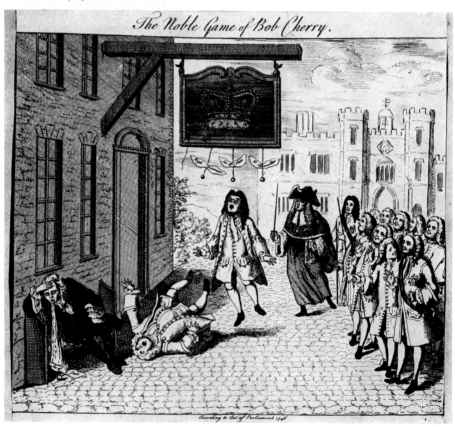

63. *The Noble Game of Bob Cherry*. Pierpont Morgan Library

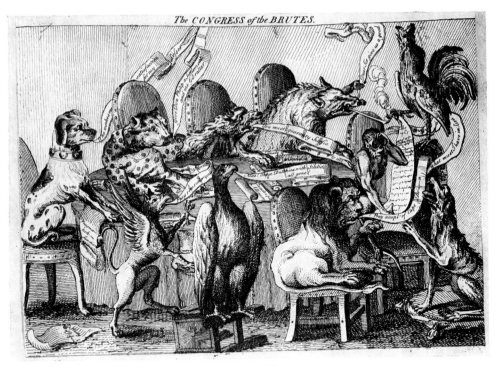

64. *The Congress of the Brutes.* Pierpont Morgan Library

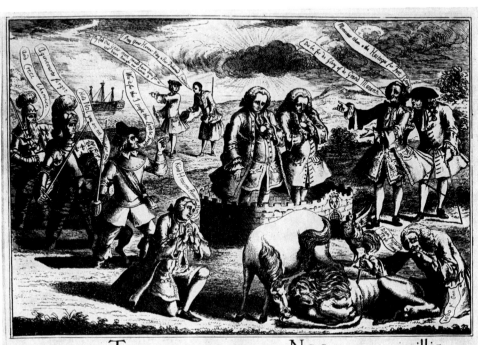

65. *Tempora mutantur, et Nos mutamur in illis.* Pierpont Morgan Library

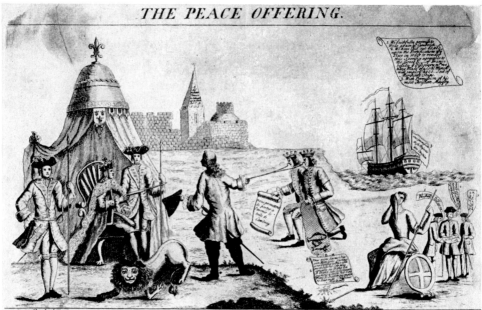

THE PEACE OFFERING.

Y.e Gods ! Is it Possible are these the Brave E—— who so lately profess'd emselves, in such strong Terms to be my Friends, ! Curse on their mean Spirit Had they continued the War but one Year longer, they might have obtain'd what Conditions they Pleas'd, but in Spite of y Advantages which they had acquired, ill managed as the War was, A Peace is concluded, No less Injurious to their Honour, and Interest than to Mine, and by no Other Reason I conceive, but to Preserve Power in the Hands of a Triumvirate, Who have Sufficiently made Manifest to the World by every measure they have taken for these 3.Years past, their Impotent Ambition in grasping at the Conduct of a War to which at length they have found themselves so Unequ
An Abstract of a Letter from the Q—— of H——

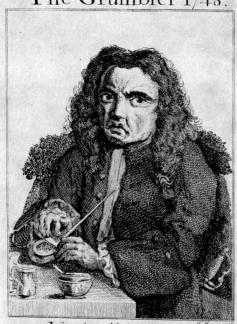

The Grumbler 1748.

You Grumbled at the War;
Here is a P——ce for you and be D——d to you

66 (above). *The Peace Offering*. Lewis Walpole Library

67. *The Grumbler 1748*. Lewis Walpole Library

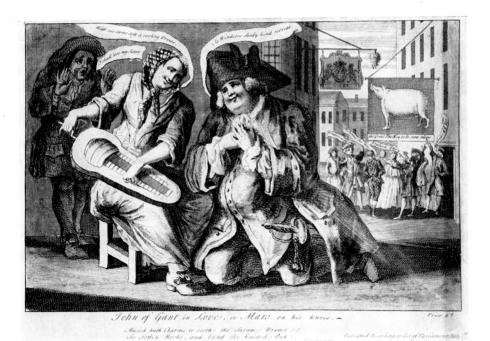

68. *John of Gant in Love, or Mars on his knees.* British Museum

69. *The agreeable Contrast between the formidable John of Gant and Don Carlos of Southern Extraction.* British Museum

The Conduct, of the two B*****rs.

O England, how revolving is thy State!
How few thy Blessing! how severe thy Fate
O destin'd Nation, to be thus betray'd
By those, whose Duty 'tis to serve and aid!
A griping vile degenerate Viper Brood,
That tears thy Vitals, and exhausts thy Blood.

A varying Kind, that no fixt Rule pursue,
But often form their Principles anew;
Unknowing where to lodg Supreme Command
Or in the King, or Peers, or People's Hand.
Oh Albion, on these Shoulders ne'er repose
These are thy dangerous intestine Foes.

71. *Vox Populi, Vox Dei, or the Jew Act Repealed. Dec^r. A.D. 1753.* Pierpont Morgan Library

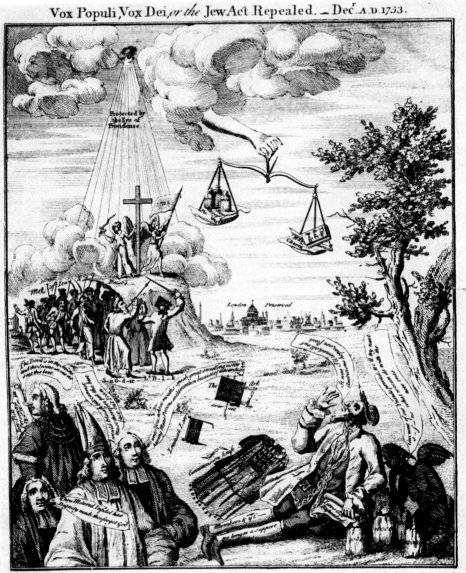

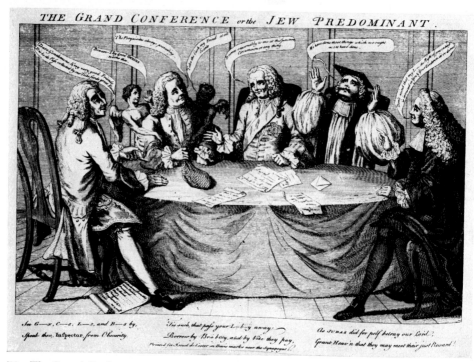

72. *The Grand Conference or the Jew Predominant.* Pierpont Morgan Library

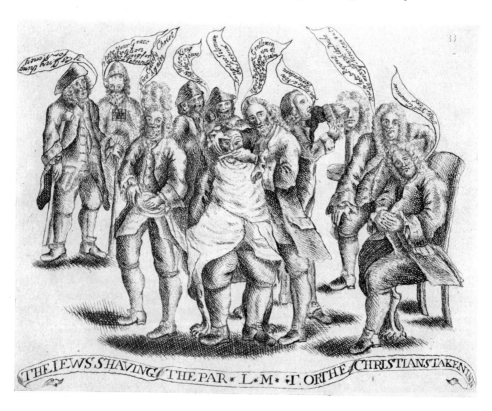

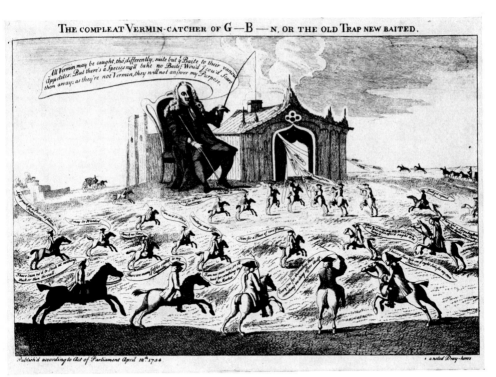

74. *The Compleat Vermin-Catcher of G–B–n, or the Old Trap New Baited*. Pierpont Morgan Library

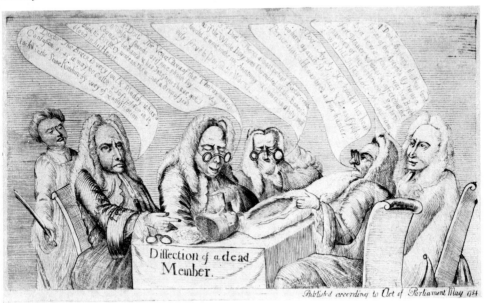

75. *Dissection of a dead Member*. British Museum

73 (*left*). *The Jews Shaving the Par*l*m**t or the Christians Taken Inn*. Pierpont Morgan Library

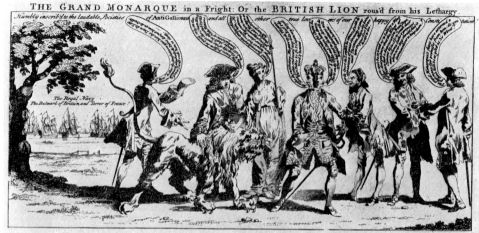

76. *The Grand Monarque in a Fright: Or the British Lion rous'd from his Lethargy.* British Museum

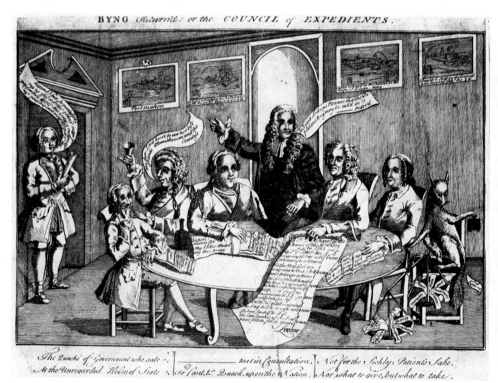

77. *Byng Return'd: or the Council of Expedients.* Pierpont Morgan Library

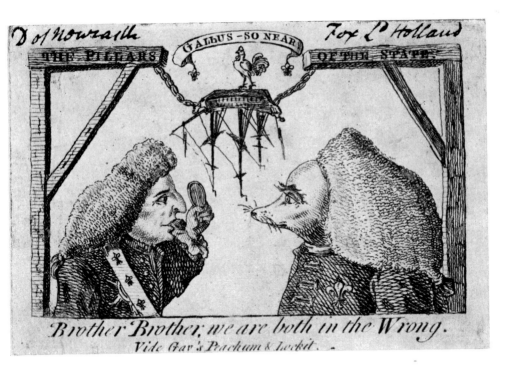

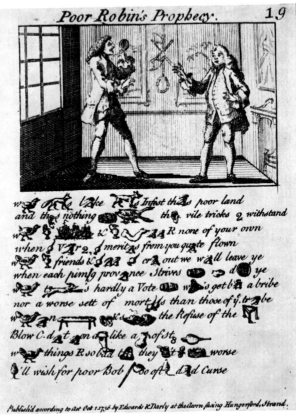

78 (above). *The Pillars of the State*. Pierpont Morgan Library

79. *Poor Robin's Prophecy*. British Museum

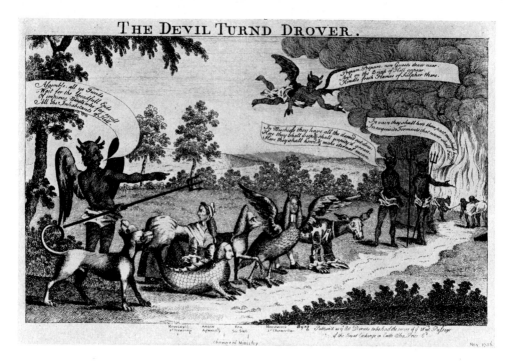

The Devil Turnd Drover.

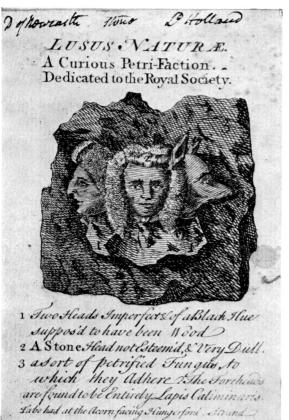

80 (above). *The Devil Turnd Drover.*
British Museum

81. *Lusus Naturae. A Curious Petri-Faction. Dedicated to the Royal Society.* Pierpont Morgan Library

Guy Vaux the 2.d

The Wicked is Snared in the Work
of his own Hands there his
see it — Psalm 10.th

Publish'd according to Act Dec. 16 1756 by Edwards & Darly in the Strand

83. Guy Vaux the 2.d. British Museum

The Bankrupts with Anecdotes
Harry Renard French Broker, this
Person traded very High, and amassd
large Sums, but his Creditors are not
satisfied, nor ever will its thought.—

Tom Chat-enough alias Old Capt.
Tom, a great many People also sorry
for this Man, as it appears t'was
more want of knowledge that he
faild than any Designe.—

Tony Pettit Auctioneer's Clerk, this
Person was what they call in Mon-
mouth Street a Barker, & usd to talk
People off as its termd in the Cant of
which he's perfect Master.—

Grum Bowels alias Misanthropos,
a Grecian by name, his Dealings were
very Lucrative both in publick & private, but
being suspected of Selling a Wrong-Box,
in which were many Valuables to y.e French,
he was forcd to Quit Business.—

Woe-full'd alias Leo Marina Styles Hus-
band, this man when in private Trade had ve-
ry good luck, but having an Itch to what's hone-
full to every Tradesman, he let all run to rack &
ruin to gratify that favourit fashion. Vivat Rex.
FINIS.

Publish'd according to Act Nov. 26, 1756 by Bardy & C.o and at the Acorn facing Hungerford Strand.—

82. The Bankrupts with Anecdotes. British Museum

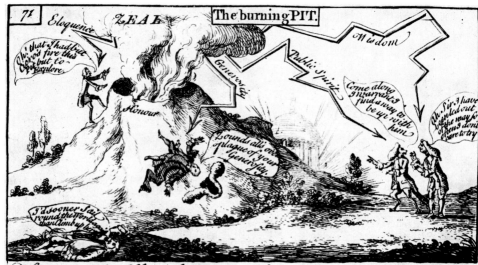

84. *The burning Pit*. British Museum

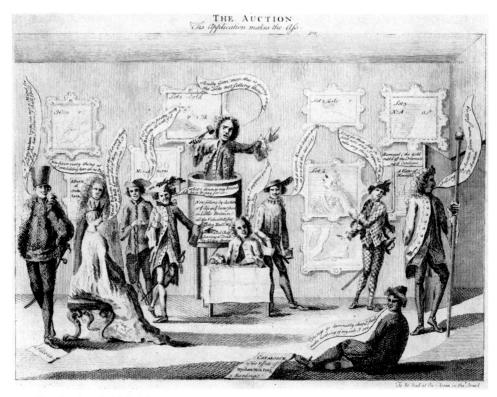

85. *The Auction*. British Museum

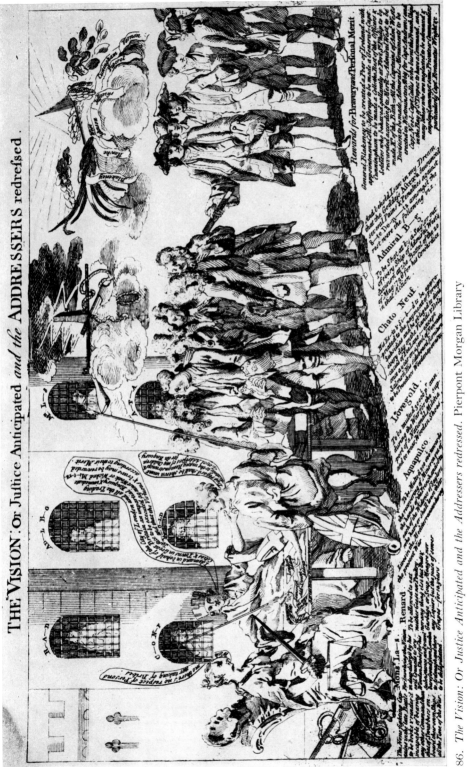

86. *The Vision: Or Justice Anticipated and the Addressers redressed.* Pierpont Morgan Library

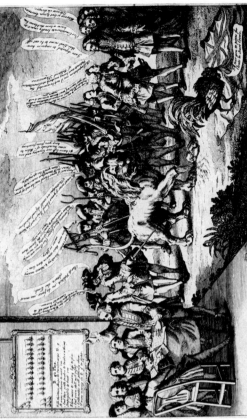

90. The English Lion Dismember'd Or the Voice of the Public for an enquiry into the loss of Minorca with Ad^l. B—g's plea before his Examiners. Pierpont Morgan Library

89 (left). Britannia in Distress under a Tott'ring Fabrick with a Cumberous Load. British Museum

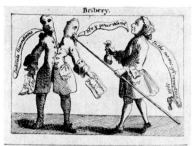

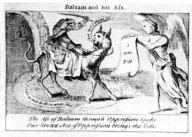

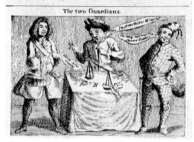

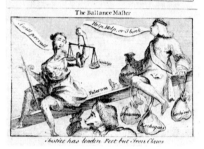

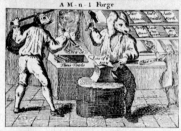

91. *Bribery. A M–n–l Forge. The two Guardians.* Satiric illustrations probably intended as designs for playing-cards. Author's possession

92. *Balaam and his Ass. A Whip for yᵉ Horse, a Bridle for yᵉ Ass, & a Rod for yᵉ Fools Back. The Ballance Master.* Author's possession

93. *The Recruiting Serjeant or Brittanniais Happy Prospect.* British Museum

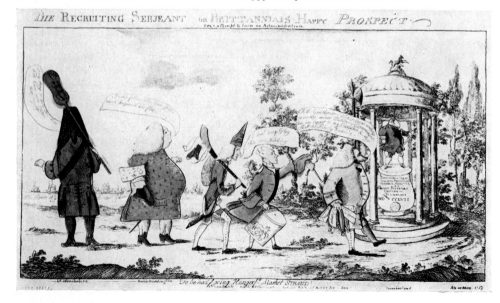

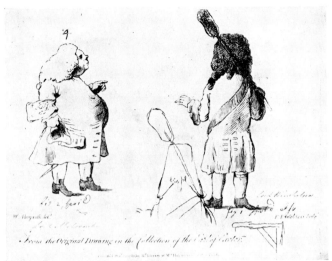

94. Caricature portraits of George Bubb Dodington and the Earl of Winchilsea. Pierpont Morgan Library

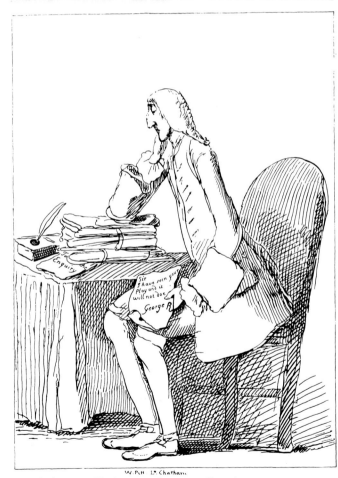

The Distressed Statesman.

1761 via. 1757.

Leonardo de Vinci Inv.

95. *The Distressed Statesman.* British Museum

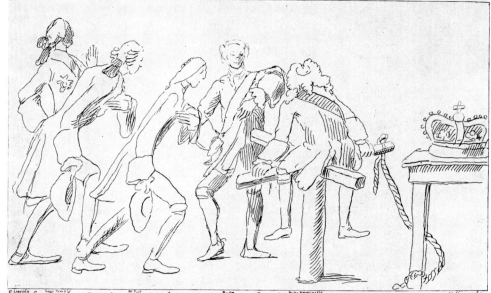

96. *The Treaty or Shabears Administration*. British Museum

97. *The Bawd of the Nation or the Way to Grow Rich*. British Museum

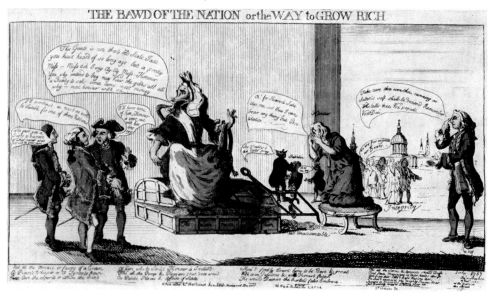

99 (right). *The Contrast*. Lewis Walpole Library

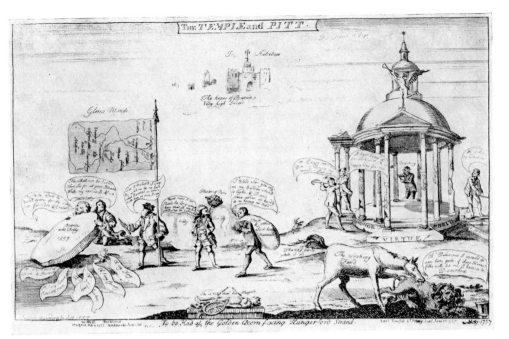

98. *The Temple and Pitt*. British Museum

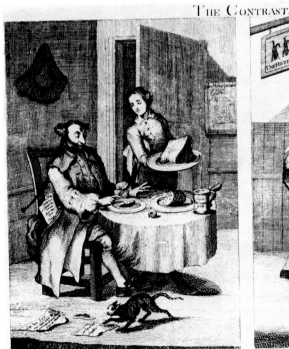
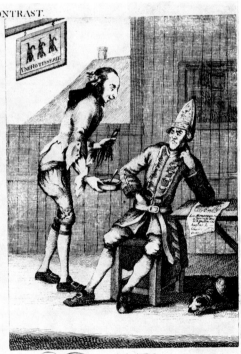

A FRENCH Prisoner in ENGLAND. AN ENGLISH Prisoner in FRANCE.

KING GEORGE

God save Great George our King,
Long live our noble King,
God save the King;
Send him Victorious,
Happy and Glorious,
Long to reign over us,
God save the King.

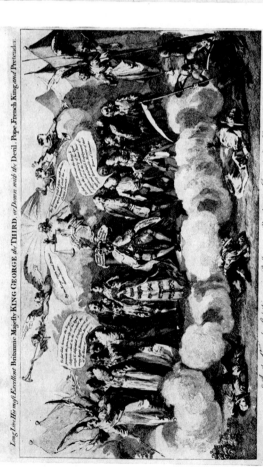

Long Live His most Excellent Britannic Majesty KING GEORGE the THIRD, or Down with the Devil, Pope, French King and Pretender.

100. *Long Live His most Excellent Britannic Majesty King George the Third, or Down with the Devil, Pope, French King and Pretender.* British Museum

101. *King George. Sea Dominion the Honour of the British Flag. Liberty, Property, Trade and Commerce for Ever.* Pierpont Morgan Library

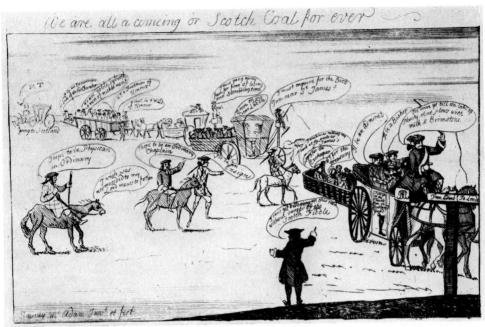

102. *We are all a comeing or Scotch Coal for ever.* British Museum

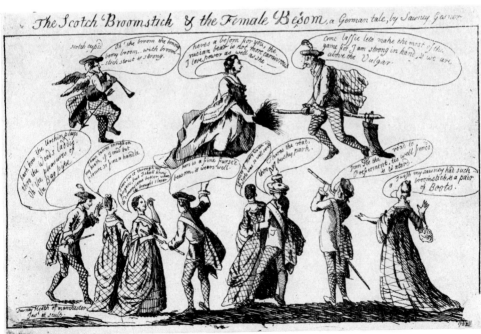

103. *The Scotch Broomstick & the Female Beesom, a German tale, by Sawney Gesner.* British Museum

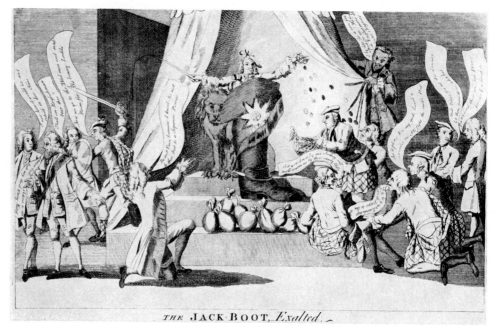

104. *The Jack-Boot, Exalted.* British Museum

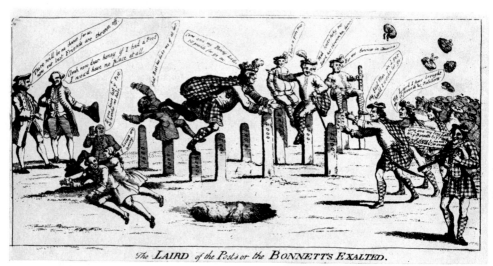

105. *The Laird of the Posts or the Bonnett's Exalted.* Pierpont Morgan Library

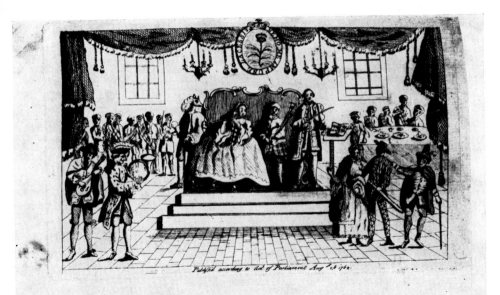

The MASQUERADE; or the

POLITICAL BAGPIPER.

106. *The Masquerade; or the Political Bagpiper.* Pierpont Morgan Library

TEMPORA MUTANTUR.

Behold Britannia mourn and Pitt implore
Her Tears to wipe, and Happiness restore;
See Pallas indicate the Patriot's Fame,
Who Envy's Snakes retird the glorious Aim:
Padlock'd that Sword so dreaded by our foes

While Gallia's Cock aloud triumphant Crows:
Is this a Scene for Britons, bold and free,
Victors on Land, and Monarch's of the Sea?
Perhaps tis just — Heav'n meant it for our Crimes
Success must change whenever change the Times.

Lives there a Briton can with Truth dispute
Pitt's is the Laurel: Fame's false Trumpet B—
Yet favrites thrive, by Merit not their own;
What Pity Folly stands so near the

107. *Tempora Mutantur.* British Museum

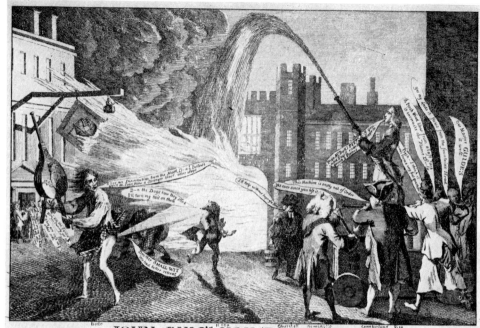

108. *John Bull's House sett in Flames*. British Museum

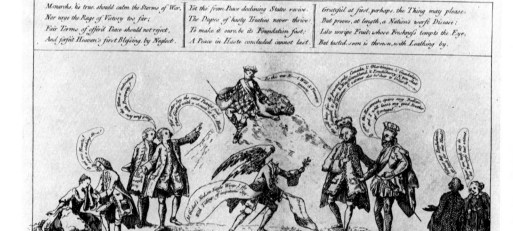

109. *The Caledonian Pacification, or All's Well that Ends Well*. British Museum

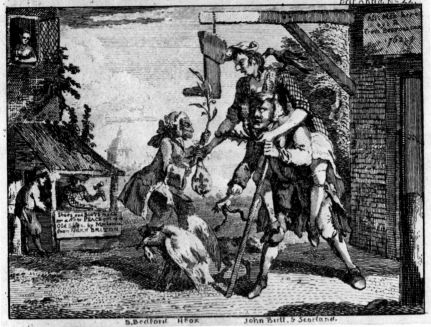

110. *A Poor Man Loaded with Mischief. Or John Bull and his Sister Peg.* British Museum

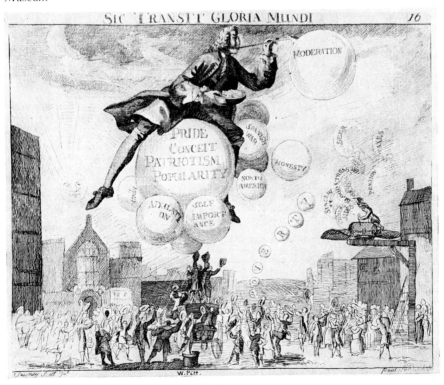

111. *Sic Transit Gloria Mundi.* British Museum

The BUTIFYER. A Touch upon the Times. Plate I

In Justice to Mr Hogarth, the Etcher of this Plate Owns to the Publick, he took the hint of the Butifyer from a print of Mr Pope White-washing Lord Burlington's Gate, at the same time, Befpatring the rest of the Nobility.

115. *The Times Plate I.* British Museum

116. *The Butifyer. A Touch upon The Times.* British Museum

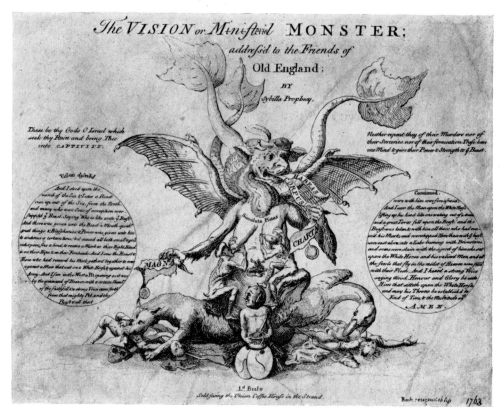

117. *The Vision or M—n—st—l Monster; address'd to the Friends of Old England; By Sybilla Prophecy.* British Museum

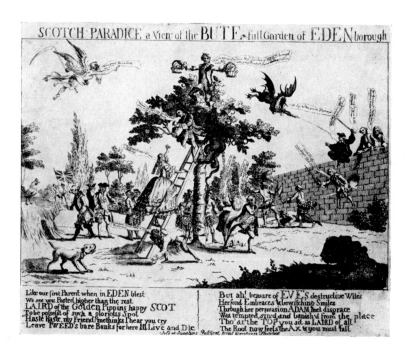

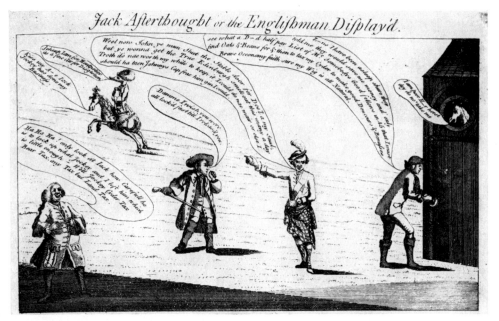

119. *Jack Afterthought or the Englishman Display'd*. Pierpont Morgan Library

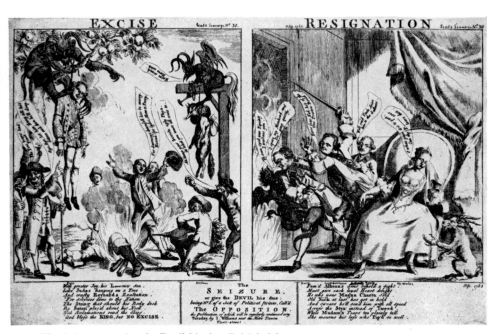

120. *The Seizure. or give the Devil his due*. British Museum

118 (left). *Scotch Paradice a View of the Bute[eye] full Garden of Edenborough*. British Museum

THE WHEEL of FORTUNE or ENGLAND in TEARS.

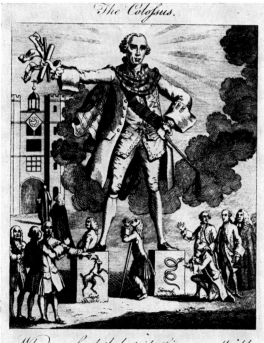

121 (above). *The Wheel of Fortune or England in Tears*. Pierpont Morgan Library

The Colossus.

Why man he doth bestride this narrow World
Like a COLOSSUS: and we petty ministers
Walk under his huge Legs, and peep about
To find ourselves Posts, Peerages, and Pensions.
 Shakespeare.

122. *The Colossus*. Pierpont Morgan Library